THE BOUNDARIES OF ART

THE BOUNDARIES OF ART

David Novitz

TEMPLE UNIVERSITY PRESS
Philadelphia

Temple University Press, Philadelphia 19122
Copyright © 1992 by Temple University. All rights reserved
Published 1992
Printed in the United States of America

The paper used in this publication meets the minimum
requirements of American National Standard for Information
Sciences—Permanence of Paper for Printed Library Materials,
ANSI Z39.48-1984 ∞

Library of Congress Cataloging-in-Publication Data
Novitz, David.
　The boundaries of art / David Novitz.
　p. cm.
　Includes bibliographical references and index.
　ISBN 0-87722-928-7 (alk. paper)
　1. Aesthetics. 2. Art—Philosophy. I. Title.
BH39.N685 1992
700'.1—dc20　　　　　　　　　　　　91-45429
　　　　　　　　　　　　　　　　　CIP

FOR
Tonia and Julian

CONTENTS

PREFACE

Most people in our society seriously underestimate the role that art plays in their lives. This arises because we are encouraged to think of the arts as detached from everyday life, as severed from everything that we regard as important by invisible, yet unyielding, boundaries.

How this has arisen, how it is to be remedied, and the extent to which art forms a part of our lives are the subjects of this book. If, at its end, my readers feel encouraged to rethink their attitudes to the arts, I shall have achieved a great deal.

In writing this book, I have been helped in many different ways by many different people. My oral and written discussions with Don Callen, Ted Cohen, Carolyn Crawford, Mary Devereaux, Denis Dutton, Richard Eldridge, Susan Feagin, Rom Harré, Bernard Harrison, Casey Haskins, Michael Krausz, Joseph Margolis, Tonia Novitz, Bo Sax, and Richard Shusterman were particularly helpful. My colleagues, and especially Flip Ketch, in the Department of Philosophy and Religious Studies at the University of Canterbury furnished the very congenial environment in which much of this work was produced. Without their fellowship and support, nothing that appears here would have been written. I am grateful, too, for the help of Rosemary Du Plessis Novitz, willingly given over many years. She alone will understand the extent of her contribution to the arguments of this book.

The editors of the journals mentioned below have kindly given permission for some of my articles to be used in an altered and sometimes extended form, as chapters, or parts of chapters, in this book. Chapter Two and part of Chapter Three appeared in *The British Journal of*

Aesthetics in 1989 and 1990; an early version of Chapter Four appeared in *The Journal of Aesthetics and Art Criticism* in 1990; Chapter Five appeared in *Philosophy and Literature* in 1989; and an abridged version of Chapter Seven appeared in the *American Philosophical Quarterly* in 1991.

Chapter

ONE

THE STATE OF THE ARTS
AN INTRODUCTION

Let us imagine a world—one rather like our own—in which gold changes hands for many thousands of dollars. Suppose, too, that in this world whole economies rise and fall on the availability of gold, that people horde and steal and invest in gold, that in times of war, treasuries are looted for their gold. In these respects, this world is similar to our own, but there is another respect in which it differs: in this world almost everyone denies that gold has any influence on their lives, their behavior, or on the political processes at large. Gold, it is maintained, is and ought to be separate from life. It ought to be admired for its luster, its weight, its texture, and anyone who fails to recognize this is poorly acculturated, does not really understand gold, is insensitive to its properties, and so on.

Such a world seems most unlikely. Its inhabitants would have to be so extensively deceived about gold and its status in their lives that it does not seem to be a real possibility. In this book, however, I want to argue that confusions on as grand a scale have actually arisen about art in the Western world. My claim is that something has gone very badly wrong with our thinking about the arts. For the most part, people are perfectly unaware of these muddles and their source, but deep confusions continue nonetheless to affect our attitudes toward the arts, and do so in ways that prevent us from understanding the role that art and artistic processes play in our lives.

Most of these confusions, I shall argue, have their origin in a growing tendency at the time of the Renaissance and beyond to distinguish

the fine arts from other arts or skills and to see them as a group of skills that have no bearing on, or relation to, the issues of everyday life. This tendency was accentuated, and our thinking about the arts greatly eroded, with the emergence of the aesthetic movement at the end of the last century. For whatever else it achieved, this movement has inclined us to think of the fine arts as the preserve of a cultured elite—as "high" art, which retains its artistic integrity or purity by refusing altogether to attend to the issues that concern people in their daily lives. This task is left to the so-called popular arts, attention to which, we are often told, is never a mark of cultivation and refinement. One result has been that the branch of philosophy traditionally concerned with the arts—aesthetics—became, in the middle years of this century, little more than an apologetic for a specific and very restricted view of the fine arts. Its concern, for the most part, was to defend the view that art was properly an end in itself, that it existed for its own sake, and that our understanding and evaluation of it should not concern itself with matters extraneous to the work.[1]

Even though the teachings of the aesthetic movement have been progressively challenged during the course of the last three decades, they have so infiltrated our thinking that they continue in many quarters to encourage a needlessly restrictive view of what genuine art is, a view, we shall see, that largely underestimates the role that art plays in everyday life. Even those philosophers of art who have taken considerable pains to criticize and dismantle the central theories of the aesthetic movement still write and speak as if art is at a remove from the transactions of daily life.[2]

A central theme of this book is that the arts are not an epiphenomenon, not a shadow of real life but deeply integrated into everyday living. The problem, of course, is to demonstrate the detail and to explain the extent of their integration into our lives. While the tendency among some in this century is to see the arts as removed from life—as if there are rigid boundaries that distinguish them and keep them aloof from our everyday, more mundane, concerns, others have argued that there are no boundaries at all between art and life, that life is art, or that life closely imitates it. The first of these views is much too simplistic and, I believe, distorts the place of art in our lives. The

second, while more compelling, is itself problematic and in need of a good deal more scrutiny than it usually receives.

Connections

Certainly there is a self-contained group of arts—the so-called fine arts—that is thought to exist apart from the cut and thrust of daily life. However, the reasons for this belief and for the resultant isolation of the fine arts need to be explored. It was not always so. The distinctions that we like to draw between the ordinary arts and the fine arts, between high and popular art, and between arts and crafts serve certain purposes that, when properly understood in their historical context, do much to destabilize the rigid boundaries that they suggest.

When we look around us, we experience not just paintings, sculptures, dramas, music, architecture, dance, and literature but also cinema, commercial advertising, television, magazines, erotica, and pornography. When we move away from what we readily classify as art—even if it is just "popular" art—and look instead at landscape gardening, tree pruning, flower arranging, leatherwork, calligraphy, conversation, potting, debating, cooking, winemaking, weaving, carpentry, thatching, embroidery, quiltmaking, and the whole area of manufacture and commercial design (which includes the ceramic tiles in my bathroom, the chrome fittings in the kitchen, my clothes in the wardrobe, the wardrobe itself, as well as motor cars, upholstery, drapes, and decor in living rooms), we begin to suspect that the arts are not readily confined within rigid boundaries. There are connections, obvious connections, so it seems, between these artifacts and the works that we refer to as fine art. Many are meticulously crafted, imaginatively designed and constructed; and they are often attractive, stimulating, and original.

The boundaries between art and the world are more permeable even than this. The design of our cities, our parks, and sometimes our countryside is very often intended to give pleasure and to create the same sorts of impressions as some works of fine art. It might seem odd

to speak of works of fine art as designed to create impressions—as if these are signs of social status. However, if we learn anything from the Medicis, the Papacy, the Rockefeller family, and contemporary France, it is that a family's, a city's, or a nation's self-image, and indeed, the image that it projects to the world, is closely allied to its art collection. When, in addition, we think of the painted faces and the sturdy tattooed arms in the village pub, the magnificent hairdos in the nearby disco, the finely crafted body, molded through countless sessions in a health studio, the well-designed and finely made clothes that one wears, we cannot but acknowledge that all are connected to the fine arts in ways that need attention. Not only this, for these examples also suggest that the arts play an important role in the development of the image that we project to the broader world. I maintain that the ways in which we develop and project our sense of self and gain acceptance as people have much in common with the ways in which artists craft and gain acceptance for their works of art. If, to use a fashionable phrase, the personal is political, it is also artistic and involves skills that are not unrelated to the skills that artists employ both in producing works of art and in negotiating the power structures of the artworld. Sometimes this seems obvious. Oscar Wilde, Pablo Picasso, and Salvador Dali so managed the impressions that they created that there is perhaps a case for saying that people themselves can be works of art.

Martial music and military ceremonies, song, the opening of Parliament, the inauguration of a president, religious ritual, the posters of the union movement, the speeches of Winston Churchill, wartime propaganda, election campaigns, journalistic jottings, autobiographies, documentaries, the evening television news, the advertisements on billboards, in newspapers, or on the television screen are all crafted with as much thought, imaginative energy, and dynamism as many of the fine arts. Unlike the fine arts, though, the aim of many of these artifacts is to enlist loyalties, to command the allegiance, summon the services, and sometimes the economic support, of the faithful.

If politics is understood not merely as the process of regulating or adjusting conflicting interests within a society but also as the activity of attempting to realize or achieve an individual's or a group's interests, then, as I shall show, we may fairly speak of the artistry of politics—

which, of course, includes the arts of seduction and artifice. These, however, tend to be overlooked in a society that insists not just on thinking of the arts exclusively in terms of the fine arts but persists in thinking of them as rarefied and elegantly useless objects that do not engage with ordinary lives. Part of my aim in this book is to reverse this trend and bring people to recognize, among other things, the extent to which art informs politics, and politics art. Plato hinted at this a long time ago, but it is an insight that has lost a good deal of its force in our century.

The claim that propaganda cannot ever be art and the tendency to dismiss art that has a political message as "mere propaganda" are remarkably widespread, and have, if anything, made people more vulnerable to the seductive power of art than they might otherwise have been. This, I think, is the insight, however vaguely apprehended, that motivates some of those who have lately turned away from the idea that an artwork is powerless—a mere end in itself—to the view that it is overwhelmingly powerful since we cannot get beyond it (the narrative, the cinema, the text, or the metaphor) in order to apprehend reality.[3] On this view, art guides our thinking and our notions of reality at every turn. It is deeply, irrevocably, political—and permeates the very structure of our lives.

Two Approaches

It is all very well to speak in these ways of the many connections between art and life; explaining the nature and the extent of these connections is a rather different and much more complicated matter. There are, we can now see, at least two ways of construing such connections. The usual and the dominant view seems to be that if art plays any role at all in our everyday lives, it is because it has cleverly inveigled its way into the corridors of the marketplace, is to be found in our homes, on our shelves, in our record albums, and on our videos. On this view, art still stands apart from everyday life, but has managed to become more accessible and has imprinted itself on the minds of many. Even so, art is not properly a part of the "real world": it is an

epiphenomenon that does not emerge from or grapple with the issues that confront us in our actual lives.

Opposed to this is a second, postmodernist, view of the place of art in our lives. Far from thinking of art as in any sense removed from life, some philosophers, I have said, tend to see art *as* life. On this view, much favored by Friedrich Nietzsche and Richard Rorty, people (or at least some of them) create their worlds and their lives poetically, and there is no way of transcending these creations in order to see how life and the world are in themselves.[4] This second view forms part of a well-established critique of Enlightenment thought that started with Nietzsche in the nineteenth century and continues to the present day in the work of thinkers as unalike as Jacques Derrida, Jean Baudrillard, and Richard Rorty.[5] It is a line of thought that has so destabilized the boundaries of art that customary distinctions between art and almost everything else seem to have collapsed in its wake; and this, of course, includes the distinctions that are normally drawn between art and philosophy. On this view, there are no boundaries between art and philosophy. Philosophy is a variety of literature, of fiction, drama, and rhetoric; and is immune to the Enlightenment strictures of reason, validity, and truth.[6]

This view of the place of art in our lives is simultaneously attractive and disturbing. It is not as silly and wrongheaded as is sometimes made out. Indeed, some of what I say would seem to support it. Philosophy, I argue, is itself an art, one, moreover, that arises out of, addresses, and is deeply enmeshed in everyday life—so that there is a strong case to be made for destabilizing and rearranging those boundaries of philosophy that we have unreflectingly taken from the Enlightenment. But even so, I mean to show that there is a need for some of the distinctions encouraged by Enlightenment thought; the discourse of reason and reason-giving cannot simply be treated in the way proposed by Rorty: as a disposable "vocabulary" that is better replaced by other idioms or modes of thought.[7]

It is at this point that the full scope of my task in this book begins to emerge. For, given the postmodernist view of the place of art in everyday life, it is impossible to theorize about the boundaries of art without also scrutinizing and theorizing about the boundaries of philosophy. This, then, is the subplot in my narrative—a theme that is

never far beneath the surface and emerges most clearly, and is only explicitly discussed, in the final two chapters of the book.

Whatever the virtues or faults of the postmodernist view about the place of art in everyday life, philosophers like Rorty, Nietzsche, Baudrillard, and Derrida do not actually offer any detailed account of the ways in which various artistic processes form part of the world at large. There is just the assertion—sometimes only the suggestion—that this is so. What is needed, I have said, is a detailed account of the ways in which, and the extent to which, art and life intersect. Only in this way will it be possible to adjudicate between the two views that I have outlined and eventually develop a third.

It is not, I maintain, that those skills that we call the arts are responsible primarily for the production of disposable commodities that we could perfectly well do without—like paintings, sculptures, operas, and novels. This suggests that the arts are skills that supervene on our lives, that are dispensable and do no more than decorate our existence. Rather, I shall argue that the arts are a fundamental and altogether indispensable part of our lives since they are the skills by which we live; the skills, one might say, that one has to possess in order to lead, and so have, a life.

On my view, art is integral to life in a very full and robust way. We tend to forget that, in the primary and most basic sense of the word, an art is a productive skill or a set of skills that is used to achieve an end: what Aristotle called *techné*.[8] Instead, we think of the arts as special and precious artifacts, a singularly exclusive group of artifacts that we call the fine, and sometimes the "high" arts, and that only a few people—those with the requisite taste, erudition, and sensitivity—can properly understand. All the many skills and artifacts that I have mentioned, and that are importantly connected to the fine arts, are simply a puzzle. They sit uneasily on the boundaries of art, are obviously connected to the fine arts, but fall beyond the reach of our received explanations.

Strategies

To think of art in the way that traditional aesthetics does—as gratuitous, as setting its own standards of excellence, as an end in itself, as esoteric, as requiring taste, sensitivity, and cultivation—is to fixate on the fine arts of the last one hundred years, and is to ignore the many phenomena closely related to the fine arts that need to be explained. It is to encourage, as well, the widely held view that fine arts, or the so-called high arts, are useless and have no bearing on our lives even though they are, at the same time and in some mysterious way, the bearers of our cultural heritage.

Many people today are still inclined to regard a putative work of art as genuine only if they also think of it either as fine art or else as high art. This has not only encouraged art theorists and aestheticians to attend to a very narrow band of artworks and artistic skills, but it has led to a correspondingly narrow theoretical understanding of the arts. This is an insight shared by John Dewey who, in the opening paragraph to *Art as Experience* writes: "By one of the ironic perversities that often attend the course of affairs, the existence of the works of art upon which formation of an esthetic theory depends has become an obstruction to theory about them. . . . [T]he prestige they possess because of a long history of unquestioned admiration, creates conventions that get in the way of fresh insight."[9]

Dewey in fact offers what is most probably the only sustained attempt in twentieth-century American philosophy to locate art in everyday life. On his view, life itself can be, and often is, artistic, and he defends this thesis in terms of a theory of experience that he had already developed in his earlier works. An experience, for Dewey, is a basic unit of life that is characterized by a pervasive quality that unites it into a distinguishable whole. Suffering, grieving, enjoying are all such experiences. They have an immediacy and a consummatory quality that not only unifies the elements of the experience, but brings people to the view that this was indeed "an experience": an unforgettable moment in their lives.[10]

According to Dewey, art derives from such experiences in everyday life. The "sources of art in human experience will be learned by him . . . who notes the delight of the housewife in tending her plants."

The "intelligent mechanic engaged in his job, interested in doing well and finding satisfaction in his handiwork, caring for his materials and tools with genuine affection, is artistically engaged." [11] Indeed, the ability to live life in a way that fosters complete and significant experiences is itself an art. It is "this degree of completeness of living in the experience of making and of perceiving that makes the difference between what is fine or esthetic in art and what is not." [12] The process of creating life experiences is an artistic one; the having of such experiences in everyday life is the subject of aesthetic delight, for, as we are told time and again, the consummatory qualities that infuse, and are characteristic of, all works of art are the very same aesthetic qualities that are to be found in everyday experience, not just the experience of the fine arts. [13]

The artistic process, for Dewey, is one that clearly infuses our lives. This a view which I shall defend, but I will do so in ways that are quite different from Dewey's. His agenda was clearly to develop an account of experience, and while this is not the place to offer a critique of Dewey's theory, his account of art as experience poses difficulties of its own. For it does not seem to be true that fine art always embodies and conveys consummatory experiences in any ordinary sense of these words. A good deal of what we call art—from James Joyce's *Ulysses* and André Gide's *Counterfeiters*, to Salvador Dali's *Apparition of Face and Fruit Dish on a Beach* and Pablo Picasso's *Violin and Grapes*—furnishes us with disjointed, severed, and jarring experiences. Sometimes, as with the writings of André Gide, these are disorganized experiences of a society in disintegration, ones that lack unity or any sense of consummation.

The problem is that Dewey does not adequately characterize our experience of art; nor (as we shall see in Chapter Four) can he adequately characterize aesthetic experience. He has an idealized view of art, one that is largely derived from the very aestheticism that he criticizes. As a result, he displays only a partial understanding of the place of art in life—one that does not do enough to undermine the boundaries of art.

The task of destabilizing these boundaries takes different forms throughout the course of this book. The quite remarkable, yet patently inconsistent, idea that the fine or high arts serve no purpose, are little

more than superfluities in our lives that nonetheless contribute to our culture and our sense of identity, is considered in Chapter Two. This view, I try to show, is responsible for a number of confusions that can be resolved only by acknowledging the place of art in society. This I do by looking very closely at the origins and the function of the distinction between the high and the popular arts; and in so doing, I take to their conclusion some of the arguments and claims that Arthur Danto, George Dickie, Joseph Margolis, and others have developed over the last twenty years.[14] In their own way, each of these theorists insists on seeing art as a social—a "culturally freighted"—phenomenon. But like many contemporary Marxist and Feminist art theorists—all of whom see art as deeply social—these philosophers have not as yet grasped the nettle and explored the full extent to which art is integrated into everyday life.

There is a strong tendency in our society to see art as distinct from life (and from what we sometimes regard as reality)—as commenting on it, reflecting it, imitating it, or else as something that is altogether removed from it. In the third chapter, different versions of this view are explained, explored, and challenged. Francis Sparshott's account of the arts is discussed and used in order to defend the view both that the arts include a good deal more than the fine arts, and that what we call the fine arts have their origin in, and are symbiotically related to, everyday life.

This, however, conflicts with traditional views about the integrity or purity of aesthetic value. According to one theory that has dominated for much of this century, a proper appreciation of art ought always to be untainted by our worldly concerns or by our knowledge of the functions that particular artworks can serve. This is a view that has met with robust opposition in the last twenty years. In Chapter Four, I add to this opposition and show that the attempts made by traditional aestheticians in this century to defend their very restricted view of art by appealing to the notion of a pure aesthetic or artistic value are entirely without foundation. Instead, I argue that our artistic or aesthetic values (I use these expressions interchangeably) are deeply embedded in our practical and everyday concerns. This is not to deny that one can, following Immanuel Kant, hold a work of art in disinterested contemplation. It is, however, to deny that this is the only and the proper attitude to works of art.

If my arguments of Chapter Four are correct, the fact that art is integrated into everyday life can be shown, at least in part, by demonstrating that the values in terms of which we appreciate and evaluate works of art arise out of our everyday interests. It can also be shown by appealing to the fact (of which much is made in Chapter Five) that the language of art applies not just to works of art, but to people and their behavior. People can be beautiful or ugly, unified and balanced. Even more, people have images or pictures of themselves; they tell stories about themselves or about episodes in their lives. We interpret their actions, their narratives, and the images that they project of themselves, and in this way we come to evaluate what they tell us, what they do, and the lives that they lead. Indeed, much of the critical parlance that pertains to art appears to apply, almost without alteration, to persons. I explore this theme by examining the role of narrative in the construction of our sense of self, and argue that the construction of one's sense of self is often achieved with as much skill and imaginative flair as the construction of works of fine art. What is more, just as artists attempt to have their artworks included in the artistic or critical canon, so people try to project their self-image in a way that makes it a part of the canon whereby we judge other human beings. The process is seen as political since it forms part of an attempt to secure one's interests in society. It is at this point in the argument that the close connection between art and politics begins to emerge.

This theme is further explored in Chapter Six. Appearances, I argue, are important; and I explore the role of grooming, of bodily adornment, and of conventional artworks not just in our projection of self, but in the way in which we project our attachments and allegiances, our family image, as well as the impressions that cities, cultures, and nations need to convey in order to achieve acceptance, sometimes dominance, in a world community. Here the discussion ranges freely over art, propaganda, and politics, all of which are united by the common theme of the interest that every individual, group, or society has in being accepted by other individuals, groups, or societies.

The same theme is pursued, although at a micro-level, in Chapter Seven, where I explore the aesthetics of character, arguing that people are often regarded as beautiful or ugly even when their physical appearance does not warrant such attributions. Here, however, my concern is not with the ways in which people, like artists, attempt to

secure particular aesthetic attributions, but rather with the grounds on which we (as "viewers") evaluate others aesthetically. By relying on my earlier account of aesthetic value, I argue that such attributions occur only in certain social contexts—those in which the critics have particular interests and needs. In order to illustrate this, I explore the ways in which we attribute aesthetic concepts to character in the context of the personal relationships of love and friendship, emphasizing the deep needs that enter into these attributions. There is a tendency, I argue, for such attributions to be self-deceptive, but this, I show, is not confined to aesthetic attributions of character but enters as well into our critical assessment of works of art.

One additional way of demonstrating the extent to which art is enmeshed in everyday life is by showing that some art forms have their primary occurrence in everyday social life. So, for instance, we are inclined, in our unreflective moments, to think that drama occurs only on the stage. In Chapter Eight, I argue that its primary occurrence is in everyday life; that it arises whenever there are conflicts between people. At root, drama occurs because people live by, and are committed to, certain narratives: narratives that both define and reflect their interests. Such narratives help create expectations, norms, and worlds, so that whenever they are transgressed or brought into conflict with other narratives, crises are created in which the protagonists enact narratorially determined roles. This, I argue, is social drama at its best, and it is our interest in the course of such real-life events, and, more particularly, our interest in their resolution, that brings us to attend to their representation on the stage or in the cinema—not as a means to any end, but because such resolutions are of interest in themselves. What we find, then, is that a very important art form is deeply embedded in the processes of conflict resolution in everyday life and that the conflicts that we seek to resolve arise because of our commitment to the narratives that govern our lives. Narrative, like drama, finds its origin not in the fine arts but in the arts of everyday living.

Chapter Nine takes this theme further. Works of fine art, I try to show, play an important role both in the development and the resolution of social conflicts. Since conflict between people depends importantly on their commitments, this chapter begins by exploring the

role of commitment in our lives, arguing that it plays an essential part in the sense we make of them, gives a structure to our world and to the ways in which we actually live. Thus it plays an essential part, too, in the political processes that mediate our lives, and in terms of which people achieve or otherwise adjust their various interests. To challenge people's commitments is to challenge them at the very heart of their existence; it is to challenge the deep interest that they have in preserving their way of life and all that their lives subtend. The high and the popular arts, I argue, often provide just such a challenge; and when they do, they are themselves a source of dramatic political conflicts that need to be resolved. What we call art is thus seen to be a powerful source both of instability and stability, for it can and often does subvert or otherwise alter our commitments, and with it, our deeply entrenched ways of seeing and organizing the world. And while this can produce conflicts, it can also resolve them.

If art really does enter into our everyday lives in these ways, it might seem that art and life are one, that our lives and our understanding are both artistic creations. On such a view, art determines absolutely our understanding of the world in which we live; indeed, it determines the character of that world itself. This is a view, I have said, that derives from some postmodernist philosophers, and it is one that is discussed in Chapter Ten, where the close connections between art, seduction, and reason are explored.

It is just a fact, I argue, that cinema, poetry, and drama persuade, and that they often do so not by rational means but through artifice and seduction. The power of art is underestimated only at our peril, but to overestimate it is to embrace a range of seemingly insurmountable difficulties. Richard Rorty's attempt to establish the hegemony of our poetically created "metaphors" or "vocabularies," while in many ways attractive, creates problems that can only be solved if one allows that reason-giving and appeals to truth are not dispensable forms of rhetoric or just another form of seduction. The artwork, text, or "vocabulary" does not have total sway, is not totally powerful, and I argue that, like us, Rorty is forced to appeal to truth and reason in determining the adequacy of our descriptions or artistic renditions.

Truth and reason are the stuff of philosophy, but philosophy must itself be seen as an art: the art of reasoning and explaining. Of course,

when postmodernist philosophers claim that philosophy is just a variety of literature, they mean a good deal more than I do when I claim that philosophy is an art. In Chapter Eleven I explore their claim that philosophy is a variety of literature. I argue that in the middle decades of this century something went seriously wrong with Anglo-American philosophy; that what went wrong with it is not very different from what has gone wrong with the fine arts.

Whatever voice philosophy enjoys in our society derives from the fact that it once successfully addressed, and sometimes still does address, problems of real concern to ordinary people. Over time, however, mainstream philosophy became introverted and formal, and was increasingly concerned with the subtleties of its skills to which it attended, no longer as a means to a social end, but as an end in itself. In this respect, one part of the history of contemporary Anglo-American philosophy directly parallels the history of art in the nineteenth and twentieth centuries. Both undermined their own authority by becoming marginal to the interests of most people in their society. Both, I argue, did so in the same way: they created a mainstream, an orthodoxy, according to which useful skills were no longer put to use but were treated as ends in themselves, simply for the delight and edification that this could afford. In these respects, much philosophy of the period was indeed a variety of literature.

This has not only happened to Anglo-American philosophy; it has happened as well to a range of traditional disciplines in the university. In recent years, of course, Anglo-American philosophy has become much more practical in its outlook. Its skills are no longer pursued merely as ends but are applied in all sorts of ways to substantive problems in the real world. Even so, these observations do tell us something important about the arts. All arts, whether they are the arts of communication or the arts of reasoning, medicine, or design, can be, and sometimes are, treated as ends in themselves. When this happens, and when such treatment becomes an orthodoxy, it signals the removal of the art from the world and the creation of a boundary between it and our everyday concerns. These are the boundaries that I explore and destabilize in the cases of both art and philosophy.

There are, then, at least five interrelated ways in which one can demonstrate the nature and the extent of the connections between

art and everyday life. One is to show that those boundaries that best isolate the fine arts from the broader society serve an important social function and so bring the fine arts, willy-nilly, into the general mael-strom of social life. (This is the approach that I have adopted in the second, and to some extent the third, chapter of this book.) Another is to show that the skills that constitute the arts, and give rise to the fine arts, have their origin in our everyday lives and contribute importantly to them (a strategy that occurs repeatedly throughout the book—most especially in Chapters Three, Eight, and Eleven). The third is to show that the philosophical theories that justify an autonomist and isolation-ist view of art are flawed (in Chapters Four and Eight) and that the values in terms of which we apply aesthetic concepts are importantly determined by our everyday, practical interests. The fourth is to show that the language of art, like the activities that are productive of the arts, is not confined to the fine arts, but enters deeply into our every-day lives (in Chapters Four, Five, and Six). The fifth is to show that the ways in which one gains acceptance for or criticizes the fine arts, and the issues that hang on this, are very much a part of the everyday world of politics (in Chapters Five through Nine).

Art and the Arts

If the boundaries of art are artificial, and if art really is deeply inte-grated into everyday life, what then is art? In a nutshell, I argue, with considerable indebtedness to Francis Sparshott, that an art is a more or less integrated body of skills.[15] These skills are sometimes used to produce artifacts, some of which are regarded as works of fine art on account of the theories, values, and beliefs that prevail in our society at this time. An institutional theory of art such as George Dickie's will help explain how some artifacts come to be admitted to this class and why others are excluded.[16] But the explanation is basically a social one, and it does not tell us very much more than we would expect—namely, that the fine arts are socially demarcated in terms of dominant artistic values, theories, and beliefs. What it rightly does not tell us is what these values, theories, and beliefs are. They will vary from culture to

culture and from period to period within a culture, so that there is no one thing that a work of fine art absolutely must embody that makes it a work of fine art, and there are no special sorts of skills that the fine arts have to employ in order to be fine arts.

This, of course, bears on the now famous debate between Dickie and Morris Weitz, for it seems that there is a sense in which both are right and a further sense in which both are mistaken. Weitz, it is now well known, maintains not just that there are no necessary and sufficient conditions for art, but that any attempt to define art in terms of necessary and sufficient conditions is radically misconceived.[17] Dickie, as we know, contests this, arguing that such conditions can be furnished. However, the conditions that he specifies tell us only about the social mechanism for admitting artifacts (and, by extension, the skills responsible for those artifacts) to a certain social status. As we have just seen, he does not, and of course cannot, tell us what theories, beliefs, and values will *in general* encourage the ascription of this status, for this, of course, must always be specific to a particular artworld, or to a particular period of an artworld, and is invariably open to revision.

Weitz, in his turn, is adamant that any attempt to elevate a particular set of beliefs, theories, and values in a way that generates necessary and sufficient conditions for art is misconceived since it "forecloses on the very conditions of creativity in the arts."[18] Dickie ought really to agree with Weitz about this, for he is similarly loathe to specify the precise conditions—bred of dominant theories, values, and beliefs— for art. Weitz ought reciprocally to allow that one can explain the social mechanism for regarding something as fine art. This, after all, does not threaten his central contention, which is only that one makes particular theories, beliefs, and values definitive of art at the extreme cost of limiting artistic creativity. Weitz and Dickie are talking about different things, so that in certain respects both are right.

Dickie, however, is wrong if he believes that his definition of a work of art contradicts Weitz's central assertion: that one makes certain theories definitive of art at the cost of foreclosing on artistic creativity.[19] It does not. All that it does is explain schematically the social dynamics of the application of the boundaries of art. Weitz, of course, is also wrong if he believes that there is no social mechanism whereby some artifacts

come to be regarded as works of art and that all depends on family resemblances. But in applying and respecting the boundaries of art, and in failing to see the extent to which art is integrated into everyday life, both Weitz and Dickie encourage us to ask the wrong questions and, like most aestheticians of this century, point our theories of art in the wrong direction.

Conclusion

In arguing that the boundaries of art (and philosophy) are artificial, I do not mean to suggest that they do not really exist. In our society at this time, the fine arts are as a matter of fact distinguished from other arts and crafts; high arts are distinguished from popular arts, and life from art. What we do not always understand is why these distinctions are drawn or whether they are well founded. My claim is that the boundaries that they imply are theoretical and social constructions—so that the boundaries of art are not to be found in the substance of the artwork itself or in the nature of artistic creation. But to say that something is theoretically and socially constructed is not, of course, to say that it is artificial. What makes the prevailing boundaries of art artificial, I shall show, is that they mislead us as to the actual role of art in our lives. The actual role that art plays is doubtless, too, a social construction bred of certain theories, but it is one that is hidden by the dominant constructions—the constructions that currently prevail. A closer, more studied, look at the place of art in our lives and the historical accidents and developments that have divorced art from life can bring one to see that art deeply affects, and is reciprocally affected by, ordinary life—despite the boundaries that we misleadingly draw about it. It is in this sense only that the boundaries of art will be found to be artificial.

Many of my arguments within this book make certain important epistemological and metaphysical assumptions as well as assumptions about the role that works of art can play in shaping our view of the world. Some of these are discussed in the present work; others have been discussed, explored, and defended in *Knowledge, Fiction & Imagi-*

nation, which appeared at the end of 1987.[20] From time to time, it has been necessary to refer to that book. While self-citation is not a practice that I favor, it does have the advantages of making this a slimmer volume than it might otherwise have been and of obviating the need to repeat arguments that have appeared elsewhere.

In many respects, this is a companion volume to my earlier work and follows fairly directly from it. Unlike the previous work, I have tried, very deliberately, to avoid technical philosophical arguments. While I hope and believe that the book will contribute to the philosophical debate between modernism and postmodernism, I intend it to be accessible to anyone with an informed interest in the arts—not just to philosophers; and I will judge it successful if it grasps the attention and the imagination of those who are concerned with art. I do not think that the book answers every question that it raises or that it defends all of its central assumptions. To do so is possible, but it is not possible to do so without being dull. Rather than err by being overly cautious, I will err on occasions through a judicious lack of philosophical rigor. In the end, of course, one runs the risk of falling between stools. Since I do not want my readers to fall asleep, this is a risk that I must accept.

There is a further risk to which my subject matter makes me liable. Since I discuss a variety of different ways in which the arts are enmeshed in everyday life, my discussion ranges over what might at first seem to be disconnected aspects of our lives. Hence, I might be thought to have written a series of unrelated essays rather than chapters of a book that make common cause. This impression will, I hope, have been dispelled by the present chapter.

Since I argue that philosophy, like art, emerges from our ordinary, everyday existence with all the accidents and demands that it presents to us, it is scarcely surprising that this philosophical work should have been partly motivated by the personal concerns that, for the past five or more years, have been a part of my life. There is, then, a rather special way of reading this book, which is mildly autobiographical, since many of the issues that are addressed within it reflect the concerns and puzzles that I experienced as my marriage of many years began to disintegrate. My concern with reason and seduction, with the role of narrative in the development of one's sense of self, with knowledge of others, with love, friendship, and their intriguing relation to

art, drama, the aesthetics of groups, propaganda, and artifice stems from this period of my life. I trust that my treatment of these topics has brought the best of my training and education as a philosopher to bear on difficult, sometimes intractable problems and has not been self-indulgent. This I will leave my readers to judge.

HIGH AND POPULAR ART
THE PLACE OF ART IN SOCIETY

In our society we pay lip service to the arts. We speak of their impor-
tance and abiding interest, and yet, after all is said, most of us have
only the slightest concern for the arts. Paintings and sculptures, poems
and plays seem to most people to be in a world removed from ordinary,
everyday living, and are widely thought to maintain a dignified silence
on the really important bread-and-butter issues that confront us.

To make matters worse, we seem, in the western world at least, to
have an ambiguous, almost a schizoid, attitude to the arts. On the one
hand we see them as valuable, on the other as unimportant and irrele-
vant. They have no bearing on our lives, and yet they are the bearers
of our cultural heritage. They are vehicles of our national prestige, but
they are to be found in largely out-of-the-way places—in museums,
libraries, galleries, which we visit on the occasional weekend, often
because of the weather. The broad mass of people in our society re-
gard works of art as rarefied objects which are for the educated, the
cultured, the elite. They are, so the story goes, for those who are sen-
sitive and who have taste, but they are neither entertaining nor even
engaging.

There is, however, another set of arts that enjoys much more at-
tention; a set, I should add, that many would refuse to dignify as
art. Many (although not all) movies, popular romances, television pro-
grams and the advertisements that fund them, as well as comic strips,
magazines, erotica, all-in wrestling, and rock music are both of con-
sequence and profound interest to a broad band of people. They are

entertaining, they are enjoyable, they are sought out and valued, and they have lately come to be known as the popular (sometimes as the "low") arts. These arts are normally distinguished from the so-called high arts, and while I shall have more to say about this distinction later on, it is worth noting that while most people in our society seek out and enjoy the popular arts, they often declare them "lowbrow," "un-refined," or "uncultivated." The popular arts are seldom seen as the bearers of our cultural heritage or our national prestige. If anything, most are denigrated as valueless and crass, but they continue all the while to be sought out as objects worthy of attention. The high arts, by contrast, earn lavish praise but are seldom the object of popular attention.

There is more than an air of paradox about all of this. Professions of regard for the high arts are belied by a widespread lack of interest in them, and while many profess to have little regard for the popular arts, they are consulted rather more readily than their elevated cousins. This is puzzling, and is made all the more so by the fact that those who have attended to the high arts know that they are neither mute nor irrelevant, that they not only delight the senses but also enlighten the mind. When we turn to actual examples of high art—whether it be an Ibsen play or a Brontë novel, a Whistler painting or a Hepworth sculpture—we find that they are not at all useless, that they stimulate our thinking, get us to perceive anew, and are instructive and enjoy-able. And it seems wrong to treat such items (or the skills that produce them) as unimportant or useless.

Not that the position is much better with the popular arts. We tend, I have said, to denigrate them, but some at least have con-siderable merit. Popular cinema often furnishes us with films that are both beautiful and insightful; they bring us to reconsider and recon-ceptualize; and at times they do so with breathtaking economy and elegance. Comic strips, magazine short stories, popular television, and erotica may also, on occasions, be found to have considerable merit. Of course, a good deal of popular art is worthless and even harmful. *CHIPS*, *The Young and the Restless*, *The A-Team*, some pop music, and pornography embody values which, it is arguable, are best avoided. They are often unexplorative works, clumsy and without artistry, which are constructed in accordance with the most banal for-

mulas. I hasten to add, though, that much high art is also without merit. There are bad sculptures, inelegant and clumsy poems, ugly paintings, and trivial choreography. It seems clear that however we distinguish the high from the popular arts, it cannot be in terms of their intrinsic worth.[1]

This said, one could be forgiven for thinking that something has gone wrong with our everyday attitudes toward, and our thinking about, the arts. Why do we think it necessary to distinguish the high from the popular arts? Are there any grounds for this distinction? Why do so many people virtually ignore high art while at the same time professing its worth? And why are they sometimes contemptuous of the popular arts, which they nonetheless seek out and enjoy?

I shall argue that we cannot properly answer any of these questions unless we acknowledge the social dimension of artmaking. How we make or create works of art, what we think of as art, the ways in which we classify the arts, and, of course, what we regard as artistically valuable are all, I shall argue, a function of the social practices and values that help characterize everyday life.

High Art and Popular Art: The Distinction

It would be a good deal easier to distinguish the high from the popular arts if all works of art fitted neatly into one category or the other. But they do not. Most posters, for instance, are thought of as popular art; yet one feels distinctly uneasy about classifying Toulouse-Lautrec's posters in this way. They might have been popular art in his day, one is inclined to say, but hardly in ours. Again, while erotica is a popular art form when it is found in *Playboy*, and high art when manifest in Velázquez's *The Rokeby Venus*, we are often unsure how to classify Aubrey Beardsley's erotic prints and drawings. Are these high art or popular art? How is one to decide?

It was only in the twentieth century that theorists and historians first considered it necessary to distinguish the high from the popular

arts, and there can be no doubt that this distinction was intended to separate the "cream" from the "milk" and to mark off lowbrow art from that which catered to more elevated tastes. It clearly was not a distinction designed to distinguish art from craft; nor was it intended to distinguish folk art from cosmopolitan art, or high art from mass art. These are very different distinctions that are meant respectively to distinguish the useless from the useful arts; regional or group art from a nonregional art that knows no national or group affiliation; and those arts whose production involves the use of a mass technology from those that do not.[2] For the most part, artists and critics agree with Abraham Kaplan that "the kind of taste that the popular arts satisfy . . . is what distinguishes them."[3] And while this observation gives us a clue to the nature of the distinction, it is also potentially misleading since it encourages us to look for formal differences—differences of color, texture, shape, sound, and structure—between the high and the popular arts that will explain the fact that they appeal to different orders of taste.

The trouble is that there are no such formal differences. The popular arts do not enjoy structural features that distinguish them as a group. It is often suggested that formal simplicity is the hallmark of popular art and that it alone is responsible for the lack of sophistication and the blandness that characterizes this kind of art.[4] But only a moment's reflection shows that not all popular art is either simple or bland. Much cinema is unquestionably a popular art form, but very few films enjoy formal simplicity. Most embody very complex forms indeed, and some, moreover, are not just formally sophisticated, but profound. *2001: A Space Odyssey*, *The French Lieutenant's Woman*, and *Out of Africa* are all films that are regarded as popular art. All, however, are not only formally complex, but touch on issues that reach deeply into our lives and that can properly be described as profound.

Of course, formal complexity alone will no more establish the superiority of a work than simplicity establishes its inferiority. For while simplicity may be a mark of the simplistic in a popular romance, in James McNeill Whistler's *Arrangement in Grey and Black* it becomes a mark of elegance and restraint. And while formal complexity in some artworks may indeed indicate subtlety and sophistication, in others it may suggest disorder and vulgarity.

Perhaps the popular arts appeal to a different order of taste not

because they embody specific formal structures, but because they embody, express, or arouse certain sorts of feelings. These arts, it is sometimes said, are no more than amusements designed to divert and entertain us; they are the court jesters of the artworld, which offer neither profundity nor enlightenment. According to Kaplan, popular art "does not arouse new interests but reinforces old ones." It merely dishes up the commonplace, for "its very substance is familiarity."[5] The feelings that it excites in us are familiar ones, and are conjured up merely because we enjoy their old familiar warmth.

There appears, at first sight, to be a good deal of truth in this. Much television drama, popular literature, and cinema are the products of banal formulas designed to resurrect commonplace and tired emotions. These are works that deal in fear, pity, romantic yearning, and sexual arousal, and not the profound and deeply felt serenity or uncertainty or disquiet that is bred of the best works of art. There is little room here for shades and nuances, for subtlety and genuine complexity.

Even so, we must be careful, for not all works of popular art suffer from these defects. Many motion pictures—think of *To Kill a Mockingbird* and *Sophie's Choice*—or television dramas like Frederic Raphael's *Glittering Prizes* are neither banal nor hackneyed; and their subtle complexity suggests that the popular arts are not always the repository of the stale, the tired, and the vulgar. Equally important is the neglected fact that much high art, most especially medieval and Renaissance religious painting, was produced in accordance with well-established, not to say tired, formulas designed principally to stir flagging religious sentiment. And yet it seems wrong to regard medieval icons and Renaissance madonnas as popular art.

It would appear from this that there are neither formal nor affective properties which distinguish the high from the popular in art. While the distinction may well have something to do with taste, this characterization, we have now seen, tends to hinder rather than help. Yet the distinction is often drawn, and our problem at present is to know how to draw it. Perhaps the solution lies in the ways in which these art forms are produced. A work of high art, someone might maintain, is the product of the individual. It arises out of, and conveys, an individual's insights, skills, inspiration, sensitivity, taste, and, sometimes, genius. Where the high arts are concerned, it is the individual alone who shapes the work of art, and there are no corporate or social or

ideological constraints that limit the artist in the pursuit and creation of genuinely high art. By contrast, works of popular art (it is said) are not usually the product of an individual's labors. They are corporate efforts in which the individual's initiative is starkly circumscribed by commercial, ideological, and corporate considerations of one sort or another.

There is, for example, no one artist who is responsible for the production of a film. This is the joint task of actors, directors, producers, writers, sound and lighting technicians, make-up artists, and so on. The ways in which they set about their work depends not just on their shared conception of their project but on a whole range of factors that includes the subtleties of interpersonal relations, the available technology, as well as commercial, ideological, and political concerns of varying dimensions. It is well known, for instance, that specific scenes can be scripted and filmed, and certain effects achieved, only because of the development of color photography and the zoom lens. In addition, the fact that films are made to a budget suggests that their content will be influenced not just by considerations of expense, but also by the profit motive, and, closely allied to it, the political (or at least the material) interests of those who finance the film. For it is clear, I think, that investors are hardly likely to fund and continue funding films that threaten their perceived interests. This is certainly true of film, and it is claimed as well of all other popular arts—whether it be Pop music, comic strips, magazine literature, or soap opera.

Although initially promising, this way of distinguishing the popular from the high arts soon runs into difficulties. A little thought on the matter serves to uncover a startling array of counterexamples. Thus, for instance, opera, dance, and a good deal of theater are usually regarded as high arts, and yet, like the cinema, they too are corporate enterprises with their own technological, economic, and ideological constraints. It is true, though, that serious drama and opera are more easily linked to an individual name (a Mozart opera, a Shakespeare play) than films are with particular directors. But even this is changing, and people often speak of an Eisenstein, a Bergman, or a Stephen E. Levine film. And while some may want to treat an Eisenstein or a Bergman film as high art, most find it difficult to do the same with a Cecil B. de Mille or a Steven Spielberg film.

This, of course, is not to deny that many of the high arts depend

rather more obviously on the efforts of an individual artist than do the popular arts. Even so, we should be wary of exaggerating the role of the individual in the production of the high arts. Prior to the Renaissance most works of art were not attached to any name at all. A good deal of the religious art of this period was produced by monks whose brushes and pens were guided by well-entrenched dogmas. These individuals merely executed the corporate vision, with little scope on their part for inspiration or innovation. The growing emphasis on the individual at the time of the Renaissance did not mean that works of art were always linked to the names of the individuals who painted or sculpted them. Most often, they bore the name of the master of the school within which they were produced. According to Arnold Hauser and Janet Wolff, Michelangelo was the first "modern" artist: the first artist, that is, to be considered fully responsible for his achievements.[6] However, it was only with the rise of romanticism in art some three centuries later, and with the concomitant rise of the cult of individual genius that works of high art became firmly linked to the names of particular artists.

Even those works of art that are properly attributable to a particular artist are never solely the product of that individual's initiative and expertise. According to Wolff, this is true even of "those arts which appear most 'private' and individual. Even writers need materials, need to be literate, benefit from acquaintance with some literary tradition and conventions . . . and need access to publishers and printers."[7] Leonardo's work, like Georges Braque's or Barbara Hepworth's, was possible only because of certain developments in technology: the development of specific pigments, brushes, surfaces, and so on. In this very elemental sense, works of art depend not just on the ideas and the labor of individual artists, but also on the technological innovations of others. They depend, too, on the techniques and conventions of the medium, for artists are always trained in certain traditions and acquire the "vocabularies" that characterize these traditions.[8]

All artists, moreover, depend on the societies in which they live not just for economic support but also for the acceptance of their work. Prevailing theories of art will determine whether or not a work is considered art, and the overall ideological climate will determine whether or not the art is tolerated. It seems unlikely, for instance, that atheistic

or antireligious art could have survived in medieval Europe, given the beliefs and politics of the age. In this century, our ideological commitments have shifted, and we are better able to tolerate an attack on God and the Church. Many of us, however, are a good deal less happy with racist art or with any art that undermines the economic structure of our society.

Which works of art are accepted by a society, and which rejected, must itself affect artistic production since it inevitably influences the individual artist's beliefs about what is worthwhile in art and what a waste of time. Moreover, it is often observed that the process of accepting and rejecting works of art is performed by a whole hierarchy of people who occupy positions of power within what has come to be called the artworld.[9] Not only do art teachers transmit artistic values but they also help determine who will and who will not become a practicing artist. As important are what Wolff calls the "gatekeepers"— the publishers, critics, gallery owners, museum curators, and literary editors who decide what will and what will not be made available to the viewing public. Given their positions of power, such people have considerable influence on what the individual artist produces. For although the individual does from time to time challenge their hegemony, it is a brave artist who does so—and only very few live to tell the tale.

If anything at all is now clear, it is that the popular and the high arts cannot be distinguished from one another in terms of the supposed role that the individual artist plays in the production of high art. The claim, you will recall, was that works of high art are always produced by individuals-in-glorious-isolation whose skill, sensitivity, and expertise are solely responsible for the character of the work. What we have found though, is that high art is never produced in social isolation, and that there are many political, ideological, economic, and technological factors which affect the artist's decisions and thereby the whole process of artistic production.

Appeals to the ways in which works of high and popular art are produced do little to explain the distinction between the two. Nor, as we have seen, can we locate the distinction in the formal or affective properties of either. Rather, if we are to understand the source and the force of this distinction, and if we wish to grasp the reasons for our

currently confused and fragmented thinking about the arts, we will have to look elsewhere.

A Distinction in Context

If what I have said so far is correct, then a work of high art, like a work of popular art, is not a wholly autonomous object produced by the individual in total isolation. On the contrary, works of art are in large measure "socially produced," for, as we have seen, all sorts of social factors—whether technological, economic, religious, or political—both constrain and facilitate the artist's endeavor. This is not to say that the individual artist is somehow redundant; nor yet that individuals have no special contribution to make to the works that they produce. In my view, the artist makes a crucial and indispensable contribution to the work, and this is true of both high and popular works of art.[10] But despite this, the individual is deeply affected by prevailing social influences. E. H. Gombrich captures this insight by arguing that "artists tend to look for motifs for which their style and training equip them." Although we "like to assume, somehow, that where there is a will there is also a way, . . . in matters of art the maxim should read that only where there is a way is there also a will."[11]

Since works of art are to a large extent socially produced, it seems reasonable to suppose that the distinction between the high and the popular arts must itself be socially produced; that it is a distinction that has its origins and rationale within a particular social context. If this is true, the distinction between the two will be based not on the discernible features or origins of artworks, but on socially ascribed properties (or perhaps even on social relations) of one sort or another. I shall now attempt to show that this is indeed the case, that in describing a work as popular or high art, one ascribes a social status to it. The grounds for the distinction between the two, I shall argue, are to be found in certain social relations, and not in the physical features, origins, or causal properties of the works.

I have already observed that it was only the art theorists and art critics of this century who have considered it necessary to make the

distinction between the high and the popular arts. It would be wrong, however, to think that popular art was invented only in the twentieth century. Seventeenth-century and eighteenth-century Europe had seen the mass production of prints, the manufacture of ornaments, the importation from India of calicoes, and the conscious development of fashions of dress. Some of these were what we might now call popular arts, but at that time no one thought it necessary to mark the distinction between the mass-produced objects of popular culture on the one hand and paintings or sculptures on the other.[12] The need for this distinction arose out of the specific social conditions of nineteenth-century Europe.

"The nineteenth century," Monroe C. Beardsley observes, "brought radical changes in the political, economic, and social position of the artist, and posed unprecedented problems, both practical and theoretical, about the artist's relation to his art and to his fellow men."[13] In William Gaunt's words,

> A long and exhausting war was over. The bloody tide of conquest had flowed across Europe, ebbed and left behind the stagnant flats of anti-climax. A ruined dictator had died of cancer of the stomach. . . . When the terror had killed off the aristocracy and Napoleon had continued the work of the guillotine by squandering in battle a very large number of young and vigorous lives, the cream of the nation was twice skimmed. The unfit and the disillusioned remained, together with a middle class, a bourgeoisie, staid, prudent, small-minded, tight-fisted, of traders and peasants who had profited by the catastrophes . . . and become the backbone of society.[14]

It was against this background that the new economic order took shape. If the French Revolution and the wars that followed had taught the surviving middle classes anything, it was that money spoke very loudly indeed, and that in a world deprived of an aristocracy, wealth was the sure road to status and the best available means of security. There thus emerged a new emphasis on economic value as the dominant social value. Utility and exchange value in a supply and demand economy were deemed to be of far greater importance than the moral, religious, and artistic values that had prevailed in an earlier age. The

old aristocracy had valued its wealth, but had seen no need to emphasize economic value. From their point of view, the less attention given to the economy the better, for their hegemony depended very largely on their subjects' uncritical acceptance of the economic status quo. It was in their interests, therefore, to elevate religious, moral, and artistic, but not economic, values.

The new-found emphasis in the nineteenth century on economic and monetary value was not the only effect of the Napoleonic wars. Like all wars, they increased the rate of technological change, so that by the middle of the century machinery was beginning to embody and replace the skills of the artisan. Whatever else it achieved, the industrial revolution that followed meant a gradual decline in the demand for skilled labor with the result that the economy of Europe became increasingly dependent on cheap labor both in industry and in agriculture. Profits accrued to those who owned the factories and the land, so that there now emerged a sizeable and relatively wealthy middle class in which each individual, bolstered and protected by new levels of wealth, no longer depended for everyday services on the cooperation of others. Whereas they may previously have relied on one another for the labor involved in building their homes, in child minding, and in the care of the elderly, the new moneyed class found that it could afford to purchase an increasing number of these services, and that it was no longer obliged to help provide them.

This new-found independence was both attractive and unsettling. It was attractive because it enhanced one's capacity to pursue one's own goals and to fight off the restrictions and constraints of a closed society. It was unsettling because it threatened the networks of cooperative relations which for centuries had formed the backbone of European society. Whereas people, because of their poverty, had previously been forced to cooperate, they could now ignore the needs of others and could purchase what had previously been acquired only through cooperation. The need for reciprocity was on the wane, and with it a range of strong and sustaining social relations.

All of this required some sort of justification. The old order had, in a sense, given rise to the new, but it was by no means clear that the new was morally superior to the old. Attempted justifications were not

long in coming. From G.W.F. Hegel in Germany and John Stuart Mill in Britain came a new emphasis on the freedom of the individual. The individual, Hegel contended, would always strive for freedom; this was an ineliminable part of the human condition, in terms of which world history itself had to be told.[15] And Mill, acknowledging the importance of individual liberty as a condition of human happiness, and hence as a condition of a truly moral society, attempted in his essay *On Liberty* to determine the limits and constraints that could justifiably be placed on individual freedom.[16] Predictably, there were only a few.[17] As a result, the nineteenth century emphasized and elevated the freedom of the individual as never before, and did so in a way that clearly served the interests of the emerging middle classes.[18]

These three features of nineteenth-century Europe—the primacy of economic value, the rise of the machine, and a new emphasis on the freedom of the individual—placed considerable strains on the artist of the day, strains that would eventually lead to a crisis in the artworld. On the one hand, many artists explicitly rebelled against the modern emphasis on monetary and economic value.[19] They hankered after a kinder age in which artistic values were elevated and taken seriously. Many painters and sculptors denounced the view that the successful artist was one whose works could find a buyer in a supply-and-demand market. Artistic achievement, they argued, should not be confused with economic success. In order to be economically successful, an artist would have to pander to what people wanted, and since popular tastes were notoriously staid and unimaginative, appeal to economic values as a measure of artistic merit would inevitably stifle artistic creativity.[20]

It was this fear that led many nineteenth-century artists to reject the economic values paramount in their society. Instead they chose to rebel against, and to emphasize their self-imposed exile from, a materialistic world. Their calling, they said, was art, not money; and they self-consciously ignored the calls of an economically oriented society and refused to provide it with what it wanted.[21] The trouble, of course, was that the Church and the aristocracy had long since ceased to act as patrons of the arts, so that those artists who refused to answer the demands of the market soon became impoverished. In their eyes,

however, poverty was a mark of purity and was the only sure sign of artistic integrity: a living proof, as it were, of the fact that the artist had not become corrupted by the rewards of the marketplace.[22]

The upshot, of course, was that many, although by no means all, artists ceased to attend to their society and its requirements, and they did so, they contended, in order to attend solely to their art.[23] No longer did they see themselves as obliged to meet the needs or cater to the tastes of the society at large, and they resolutely refused to produce art to any social end. Art was not a means of making money; nor was it produced as an entertainment, nor yet as a form of religious, moral, or political instruction. Rather, it was produced simply and solely for its own sake.

In earlier centuries, any such repudiation of the demands of one's society and of one's obligations to it would have reaped a very harsh reward. What was different about the late nineteenth century, however, was the new emphasis on the freedom of the individual. If the middle classes were free to "do their own thing," so too were the artists of the day who could now explore their art, their feelings, and themselves without a mind to the demands of the society that had nurtured them. As a result artworks grew increasingly out of touch with what the broad mass of people expected and wanted from them, and there arose, for the first time in the history of art, a deep and intentionally created rift of understanding. The broad mass of people in European society could no longer understand the work of their artists.

The die was cast. In the years that led to the twentieth century, artworks became increasingly introverted, esoteric, experimental, and incomprehensible. The process, Arthur Danto remarks, was accelerated by the invention of the still and moving camera.[24] Up until then, artists had thought of painting as the art of representing (as realistically as possible) three-dimensional objects on a two-dimensional plane. It is hardly surprising, therefore, that the development of the camera in the late nineteenth century, and the impact of the moving picture in the early twentieth century, threw this view of painting into total disarray. What role, painters now asked, could there possibly be for their art if it could so easily be produced by a machine? Skills that had been painstakingly acquired were now embodied in an inanimate machine that could produce in minutes an "artwork" that would pre-

viously have taken months and years to perfect. It was now incumbent on painters and artists to discover a new raison d'être for their art; and the recent cry of art for art's sake helped furnish them with a new sense of direction.

There followed a profusion of esoteric and introverted artworks that could be understood only by those who had the wealth and leisure with which to pursue an education in the arts. Whereas in previous centuries even the lowly peasant could understand and enjoy most of the paintings that were hung in the manor house, the art of the early twentieth century made little sense to most people in Europe. It is of course true that class barriers and geographical isolation made it difficult for European peasantry of earlier times to consult the great works of art, but they could nonetheless understand them. It took no special skill to see the figure of a man, a tree, or a horse in a painting, or the form of the Virgin in a statue; and the beauty, serenity, and sheer pleasure of recognition were a source of profound enjoyment.

There is, I think, a vast amount of evidence which suggests that up until the nineteenth century, artists painted and sculpted with a mind to what most people wanted and could understand. The Gothic cathedral, with its tall stained-glass windows, its paintings, statues, magnificent spires, and flying buttresses, was expressly designed to capture the imagination of the churchgoer and to force humble peasants to their knees. If the populace of seventeenth-century and eighteenth-century Europe was cut off from the fine arts, this was on account of class and geographical location; it was most certainly not because they could not understand the arts. In this respect, of course, the fine art of the late nineteenth and early twentieth centuries was totally different from that which preceded it. The broad mass of people in these centuries gradually found themselves cut off from painting, sculpture, literature, and music. They were cut off from it because they could not understand it; and since such art neither delighted nor interested them, they came to see it as a mere frippery, a luxury which had floated to the "top" of the society, but which had nothing to say to ordinary people.

In the words of Gerald Graff, art in the early twentieth century had turned against itself; it had marginalized, and so undermined itself.[25] Since art no longer served any worldly purpose, had nothing to say,

and had lost all concern for the society it inhabited, most people found it irrelevant, pretentious, and boring. One of the more effective channels through which individuals and groups could voice their perceptions, their aspirations, and their frustrations in highly imaginative and effective ways was no longer taken seriously. Art had silenced itself.

But the audience that turned away from this art did not enter an artistic void. Its interest was captured by a new band of arts that found its origin in the romanticism and the realism of the nineteenth century. These new art forms self-consciously addressed popular concerns. They strove to entertain, to educate, and, above all, to capture the popular imagination. Chief among these, of course, was the cinema, but magazines, journalism, advertising, the short story, popular romances, the music hall, and eventually television all addressed and nurtured the aspirations, the fears, and the prejudices that found a ready audience. Traditional artists had been displaced, and it was, I would venture, in an effort to recover their waning authority that they came to describe their art as "high art"; the other as merely "popular."

The Politics of High and Popular Art

Taken in context, the distinction between the high and the popular arts begins to make sense. However, the emergence of high art in the late nineteenth century was not the harmless display of artistic integrity that some have taken it to be. Certainly it was an attempt to bring what people thought of as purely artistic rather than economic values to bear on art, but in order to achieve this (rather questionable) aim, artists were forced to ignore what people most wanted from art, and in this way they lost the interest and the attention of the overwhelming majority of people in their society. In this way, too, high art effectively muzzled itself, and lost not just its bite but its bark. This inevitably played into the hands of those who were dominant within the society, for whatever else the cry of art for art's sake achieved, it had the untoward effect of removing much art from the reach of the general public, and so of undermining one of the most accessible platforms from which artists could scrutinize the societies in which they

lived and mobilize popular sentiment. Still worse, the humble artist, often a person of some perceptiveness and moral sensitivity, ceased to control the very art forms that were most likely to receive widespread attention and so shape popular consciousness. These they handed, as if on a platter, to the dominant commercial and political interests in their society.

Since high art was, for the most part, pleasant to look at or listen to, since it was supposed to be an end in itself and had nothing whatsoever to say on political, economic, or moral issues, it is not surprising that the middle classes approved of it. Their material interests were not affected by this art; they could feel comfortable in its presence; and since only a modicum of education—some slight acquaintance with the critics and the manifestos of the day—could unlock the esoteric meanderings of these artists, it was easy to become an initiate, to be able to comment informatively on these artworks, and so acquire a sense of cultural superiority.

It would be wrong to think that the high arts were deliberately favored because they left middle-class interests untouched. In my view, there was nothing conscious about this. It was just that the middle classes felt comfortable with the formalism of the art for art's sake movement in a way that they did not always feel comfortable with the romanticism and realism of Honoré Daumier, Camille Corot, or Gustave Courbet. However, since the middle classes controlled the institutions of learning, the art galleries, and the printing presses, there was relatively little opposition to the inclusion of formalist art in the canon. Scholars were employed who could explore these art forms, and who would discuss and expound the critical principles on which they were founded.

It was soon put about, with general concurrence from the dominant classes, that this art was for those who had taste and sensitivity, and who were in some sense cultured. It was art bred of individual genius; an art, moreover, that was accessible only to those who enjoyed a certain refinement of mind and temper, delicacy of perception, and superior taste. Since the middle classes were in a good position to acquire these attributes (or at least the appearance of them), art for art's sake, and the formalism that was part of it, floated to the "top" of the society, to a cultured elite who saw themselves as a cut above those

who could not comprehend this art and who wallowed in the vulgar, the popular, arts. What begins to emerge is that the distinction between high and popular art does not merely distinguish different types of art, but, much more than this, it actually accentuates and reinforces traditional class divisions within capitalist society.

If this is right, a good deal of traditional aesthetics has a political dimension that its practitioners fail in the round to recognize. Those who attend to high art usually approach it with a very specific and limited set of concerns. They adopt a "distanced," "disinterested," or "contemplative" attitude to it, and attend to shapes, forms, and colors, but not to the content of the work. They emphasize a delicacy of discernment and look for and value the organic unity, balance, originality, and uniqueness of a work. In this way they elevate values that altogether avoid the economic, political, religious, and moral issues of the day.[26] Just to ignore or otherwise avoid these issues has clear political implications since it is just one more of the many obstacles that prevent people from adequately understanding their own lives. And this failure to understand our own lives and the forces operating upon them invariably affects the ways in which our society organizes itself.

The dominant classes, I have said, find high art congenial. Art that raises disturbing political, moral, economic, or religious issues, that questions gender relations, or points a finger at the racism or economic injustices that abound in our society, is sometimes dismissed as mere propaganda, or, at best, as popular or political art. Whatever else it is, it is not the "real" thing: it is not high art. It threatens the social order, entrenched power, and, of course, it promises social chaos. So much better the abstract, formal, and introverted values of art that are seen as pure, entirely gratuitous, and free of the demands of everyday life.

The Fall of High Art
Artistic versus Economic Value

The noble nineteenth-century vision of high art has itself crumbled with time. At first the high arts were those that somehow rose above the widespread obsession with economic value and utility and refused absolutely to "pander" to what people wanted and were prepared to buy. Put more succinctly, the high arts were those that retained their "integrity" by refusing to equate economic with artistic value. The popular arts, by contrast, knew no such scruples, and brazenly furnished people with what they wanted. These were the "corrupt" arts that catered to "vulgar tastes" and were motivated more by the lure of gold than by a delight in art.

But times have changed. We know that many of the nineteenth-century paintings that were produced in a spirit of poverty and for the sake of art alone now change hands for millions of dollars. We know, too, that prominent contemporary artists attach themselves to dealer galleries which do not just exhibit their work, but try to sell it. Although these works still qualify as high art, this cannot be because they are wedded to the ideals of the aesthetic movement. Audiences are no longer expected to view works of high art as ends in themselves, nor are they expected to respond disinterestedly to their formal properties. Both artist and dealer want these works to be admired; they want them to be thought of as artistically valuable, but they also want them to be purchased.

Economic values have gradually intruded. They have moved into the artworld without theoretical discussion, and there is now a clear, although unacknowledged, sense in which the measure of the successful artist has become economic. This is understandable, for by shrouding art in mystery, artistic values themselves became opaque and incomprehensible. The only values that were readily understood and widely subscribed to were economic ones—so that it was simply to be expected that they would make their way into the artworld.[27] This, of course, is not to say that art talk is money talk. Artists, critics, and aestheticians are still expected to keep up their learned discourse, but

in so doing they often do no more than justify—and are themselves justified by—the economic transactions of the artworld.

The exchange value of a work of art in a supply and demand market has become the "bottom line"—the test, as it were, of our critical pronouncements and theoretical insights. Hence, those artists who cannot gain the confidence of a reputable dealer gallery are considered much less worthy than those who can, while the artists whose works "sell" are deemed more talented than those whose works do not. A thriving market has sprung up around exhibitions: a market that not only makes huge profits, but which, in so doing, both creates and entrenches the artistic canon relative to which our critical judgments take shape.

Only those schooled in the aesthetics of the nineteenth century can visit a contemporary art exhibition and believe it nothing more than a treasure house of "pure" artistic values. For despite the rhetoric of the aesthetic movement, I show in Chapter Four that the ideal of pure artistic value—or, as they call it, aesthetic value—is as elusive as the Holy Grail. The pleasure that I take in looking at fine jewelry is unquestionably enhanced by my knowledge that diamonds are rare, gold expensive, and platinum exquisitely precious. When once we know that the jewelry before us does not contain real gold, diamonds, and platinum it ceases to have the same aesthetic impact. Again, but in an altogether different vein, my appreciation of a lithograph is enhanced by my knowledge that Picasso crafted it. The mere fact that it is the work of a famous and celebrated artist makes me attend more closely to it and inclines me to be impressed and to find favor. In just the same way, by knowing that a painting can be sold for three or four million dollars, I find myself willing to treat the painting as a yardstick in terms of which to assess the merit of other paintings.

In the light of considerations such as these, it becomes very difficult to know what a pure artistic or aesthetic value could look like, and it is, of course, notorious that apologists for the aesthetic movement were never able to tell us.[28] This suggests that the ideal of pure artistic value on which the aesthetic movement was based—an ideal, we have seen, that gave rise to the distinction between high and popular art—is one that cannot easily be sustained. What we value in art, I argue in detail later on, would seem to be a function of the many different things that we have been taught to value in the world at large. Those of us who

are religious tend to value the religiosity of medieval painting; those who prize intellectual virtuosity will appreciate M. C. Escher all the more; and those who have been taught in an art school to value shapes, colors, grains, and textures will appreciate these features in the more esoteric arts. Since economic value is of crucial importance to so many people in our society, it, too, affects our assessment of, and attitudes toward, certain works of art.

So it is not entirely surprising that the very kind of art—the formal, esoteric, introverted, and abstract art—that once refused to pander to economic value is now worth vast quantities of money. Nor is it surprising that the economic value of this art is taken by all and sundry to reveal its artistic value. Although still regarded as high art, it is art that caters for and panders to a buying public.

How has this come about? The answer, I think, is to be found in the fact (of which much has already been made) that the high art of the late nineteenth and early twentieth centuries was congenial to the middle classes. It did not ruffle any political or commercial interests; it was comfortably silent and positively pleasing. Since acquaintance with it and, eventually, possession of it, was an indication of status and a mark of being "cultured" and "refined," those who had the most money in the society were also motivated to purchase it.

There were a number of factors that conspired to enliven this fledgling market. Perhaps because they were influenced by the rise of scientific connoisseurship, collectors at once recognized the importance of, and tried to acquire, historical originals.[29] This, taken together with the fact of scarcity and an emerging sentimentality (which led to an increased demand for the work of certain artists), meant that many artworks began to appreciate in value. To the middle classes—those who, since the early nineteenth century, had placed primacy on economic value—the rising price of their artworks was absolute proof not just of artistic merit but of the superiority of their own taste and discernment. And with rising prices came a self-conscious display of wealth—what Thorstein Veblen had referred to as "conspicuous consumption"—which further fueled the art market, leading to an upward spiral of prices whereby members of the middle classes enhanced one another's status.[30]

The distinction between artistic and economic value had effectively

collapsed. The price tag had become intimately enmeshed with the artwork, and this, of course, was a death blow to the nineteenth-century ideal of high art. It was no longer plausible to distinguish the high from the popular arts in terms of pure, economically untainted, artistic values. Even so, the distinction between the high and the popular arts did not disappear. "High art" is still used, for the most part, to refer to the introverted and esoteric work of contemporary artists. But there are no longer any illusions about the artistic "integrity" of such work. No one who is up with the play pretends that such art has nothing to do with economic value.

It is plain that the distinction between the high and the popular arts is no longer based on the ideal of pure artistic value. It is, we have seen, a functional distinction: one that helps establish and sustain certain social differentiations and relations. There is, of course, a considerable body of high art that was not produced in the mold of the aesthetic movement but in reaction to it. The Dadaist movement was plainly anti-aesthetic. So too was Surrealism, Soviet Constructivism, Conceptual Art, and Pop Art. All, however, are now regarded as high art. Quite clearly, then, the distinction between high and popular art, although occasioned by the forces that shaped the aesthetic movement, is not based on the autonomism that the movement proposed.

It nonetheless seems fair to say that until now, most of the works that have been regarded as high art have been "learned" and "difficult"; and that the capacity to understand them has become a mark of being properly cultivated, educated, and refined. But many of these works, we must remind ourselves, help constitute a new "high" art: art undoubtedly tainted by the lure of economic success, but art which holds out the promise of social acceptability in the way that erotica and popular romances simply do not. Of course, the time may come when romances and erotica do hold out such promise, and when the old high art is itself denounced as unworthy of attention. When that happens—and in some circles it seems to be happening—the distinction between the high and the popular arts will either disappear or will be inverted in a way that makes the denigration of high art and the adherence to popular art a mark of social status. None of this should be surprising. The distinction, I have tried to show, is socially grounded. It will sur-

vive only for so long as it is socially required and will take whatever form societies (or certain of their dominant subgroups) dictate.

Conclusion

I have argued that the distinction between the high and the popular arts is a social distinction, one that cannot be wholly located in the intrinsic qualities or the affective dimension of the work itself. It is a distinction, I have tried to show, that makes sense only within a particular cultural context, one moreover whose logic changes with that context.

In exploring this distinction, I have tried to show that art does not merely exist in society, but that it takes its character from that society. Artistic value, I have hinted, is neither pure nor wholly internal to a work of art, but is shaped by what we have been taught to value in ordinary life. And so it should be, for despite the pretensions of the aesthetic movement and the cultural snobbism that followed in its wake, art, as we see in the chapter that follows, is integrally affected by, and in its turn, intimately affects, ordinary life.

Chapter

THREE

ART, LIFE, AND REALITY

The distinction between the high and the popular arts, we have seen, arises out of certain social forces and socially determined interests. In effect, it constitutes a boundary that demarcates the "high" and the "popular" in art. It is a boundary that also helps distinguish those who are considered sensitive, cultured, and refined (because of their interest in the high arts) from those who are considered deficient in taste, refinement, and cultivation (because of their predilection for the popular arts).

Once one grasps the social nature of this distinction, one is bound to ask whether the rigid boundaries that we like to draw around the fine arts—boundaries that distinguish art from life or art from reality—are not similarly the product of our social concerns. Since the distinction between the high and the popular arts encourages the view that genuine art is always remote from everyday life, it does begin to look as if the metaphysical boundaries that we like to draw between art and life, or between art and reality, have a social origin. The problem, then, is to determine whether there are any metaphysical reasons for these distinctions—reasons which are derived from the nature of art and reality itself rather than from social constructs of one sort or another. I maintain that there are no such reasons, that the boundaries that we like to draw between art and life, or art and reality, are much less stable than most of us are inclined to think.

There can be no doubt that people often believe that art is removed from reality or from what they regard as the real issues in their lives.

Whatever their reasons for thinking this, it is plain that for them at least the distinction between art and reality, or between art and real life, is both obvious and uncontroversial. That it is neither, and that the distinction fairly brims with problems, is by now well known.[1] Much more important is the fact that some of these problems are actually instructive, and help reveal the intricate yet subtle ways in which art finds its place in everyday life.

Art and Reality

The distinction between art and reality has a long and uneven history. Its unevenness, and many of the difficulties that attend it, stems from the fact that the distinction finds its origin in several quite disparate and conflicting sources. The fountainhead, of course, was Plato. It is, I think, because of the way in which he opposed art to reality that many people persist in thinking of art as something that comments on reality, that represents it, imitates it, but which for this reason cannot be a part of it. Art, they like to think, is *about* the real world, *refers* to it, and so must be something different from it.

If, on this view, the artwork is to serve its proper function and so qualify as good art, it will do little more than provide a channel through which to apprehend reality. The best art, therefore, is never the focus of our attention. What we attend to are the realities it lays bare. Ideally we should hardly notice, and we certainly should not attend to, the physical features of the artwork, although as Plato acknowledges, art seldom allows us to satisfy this ideal. Instead, through various ploys and embellishments which appeal to the senses and the appetites, artworks draw attention to themselves and distort the reality that they purport to represent. The best art is, in a manner of speaking, transparent, and leads the eager intellect to a direct apprehension of reality.[2] The worst emphasizes appearances, embodies these, and effectively occludes the reality it purports to reveal.

Plato, of course, made no secret of his low regard for artists. On his view, artists were not just weak in will and intellect, but confused by the muses, and confounded by their senses and their appetites, they

simply could not, in their drunken stupor, do the job demanded of them. From a Platonic point of view, the history of art can be seen as the struggle of wayward artists to free themselves from the constraints of reason and reality and to draw attention instead to the succulent and seductive features of their artworks. At first imperceptibly, but after the Middle Ages with ever increasing frequency, embellishment and form came to be emphasized until, in the twentieth century, a good deal of art abandoned altogether the attempt to draw attention to reality, and was satisfied instead to draw attention to the artwork itself.

The rise of formalism and abstract impressionism herald the total rejection of the Platonic ideal of art. Art no longer purports to reveal hidden realities, but presents itself as a real object with real properties that deserve scrutiny. Not only is there a shift in artistic emphasis, but there is an accompanying shift in ontology. No longer is reality to be found in the intellectual and somewhat ghostly realm of imperceptible Forms; rather, following in the wake of eighteenth-century and nineteenth-century scientism, it is to be found in what is perceptible, tangible, and wholly available to the senses. And so, in the twentieth century, works of art parade their reality by inviting their viewers to attend to their physical features and to nothing else. Art ceases to comment on, to refer to, to imitate, and to represent. Instead it presents us with an imaginatively crafted but entirely real object that is to be attended to in its own right.

The rise of this movement plainly signals a second view of the distinction between art and reality. No longer is it the case (as Plato maintained) that unreal art imitates a world of hidden and immutable realities. Rather, the artwork is thought of as real in its own right, so that there is no proper distinction to be drawn between art and reality. Those who defend this view sometimes take it one step further. According to Oscar Wilde, "Art begins with abstract decoration," but this does not entail its unreality, for on his view, "Life becomes fascinated with this new wonder," and, in the end, imitates art more than art imitates life.[3] As if to rub salt into Plato's wounds, art is thought of not just as a part of reality; it becomes a touchstone, a measure, of reality, while life, for the most part, becomes no more than a pale imitation of art.

The uneven history of our distinction does not end here. It is often remarked that the rank and file of Western society have discarded much twentieth-century art, and have refused to treat it as a "reality" in their lives.[4] The popular view seems to be that modern art is "out of touch with reality," does not deal with the bread-and-butter questions of survival, but is abstract, abstruse, and irrelevant. This gives us another, some might say a vulgar, source of the distinction between art and reality. According to it, art is not real because it fails to address real life and refuses to engage with it. On this view, art lacks reality because it fails to imitate, represent, attend to, or comment on real issues which are of concern to real people. Plato, we now know, held precisely the opposite view, namely, that art is unreal because it is about, and so not part of, reality. What begins to emerge is that the terms "real" and "reality" do not always bear a single meaning when they are contrasted with or opposed to the arts.

This difficulty is compounded by the fact that while Marxists generally refuse to speak of art as a reality in our lives—as a material or an economic or a productive force—they nonetheless maintain that art has a social function, and that it often influences what happens in the world. What is real, according to Marxist theory, are the "material conditions of life": anything at all, that is, that directly determines the economic character of a society. So, for instance, the relations into which people enter in order to produce goods within our society, or the technology available to them, are real forces in our lives since they determine the economic character, or the nature of the "infrastructure," of our society. These are the brute material realities that directly affect the capacity of people to meet their most basic needs and desires, and so have a crucial bearing on the quality of all our lives. According to Marxist theory, art holds no such sway; it is a "superstructural" not an "infrastructural" phenomenon—by which is meant that it does not directly determine the economic flavor of the society, but arises very largely because of it.

Hence writers like Leon Trotsky maintain that there is "an objective social dependence and social utility of art."[5] However, Trotsky is also adamant that art cannot be reduced to the forces of production. A work of art, he tells us, "should in the first place be judged by its own law, that is by the law of art."[6] In this respect, Trotsky is not unlike

Lucien Goldmann and Janet Wolff, both of whom insist on the dependence of a work on its social conditions, but who at the same time argue that it stands apart from social and material reality.[7] The mere fact that many, although not all, Marxists generally think of good art as realist—that is, as art that describes or conveys or criticizes social and economic reality, clearly demonstrates that, on their view, art is opposed to, different from, and certainly not reducible to, reality.[8]

There are, of course, many versions of this view that span the spectrum from the least to the most sophisticated Marxisms, but all, I think, agree with Louis Althusser that art merely "*alludes* to reality," that in so doing it makes us see, perceive, and feel, but that it is never a part of reality.[9] Art may, as Wolff has cogently argued, be deeply influenced by real productive forces, but it is never at one with, and cannot be reduced to, them.[10]

Although works of art have no direct bearing on the economic character of a society, and so are not "real productive forces" in the Marxist sense of the term, Marxist theoreticians are generally adamant that art can both reflect and affect these forces. One view is that art, whether it be by sins of omission or comission, invariably conveys certain economic or class interests that arise out of one's situation at the economic "base" of the society. Art, on this view, furnishes a particularly effective way of articulating and conveying one's class interests.[11]

As a result, works of art may come to affect the ways in which people behave, and hence the ways in which they relate to one another and organize production at the economic "base" of the society. For the most part, this happens only gradually, sometimes imperceptibly, but the important point here is that, given the right social conditions, art can and does affect real life. Despite this, art is not itself real, for the artwork remains an ideational phenomenon that merely reflects or conveys the realities hidden within the economic "infrastructure" of the society. On this view, too, even those works of art that are thought to be wholly autonomous, mere art for art's sake, will invariably be found either to serve or convey or reflect certain economic interests.[12] So while Marxists think that art has the potential to affect real life, on their view this does not make art a reality—a real productive force—within our lives.

There is a sense, then, in which Plato agrees with Marx. Both main-

tain that art is about a deeper, sometimes a hidden, reality; and both maintain that art itself is not fully real. They disagree, of course, when it comes to their specification of reality. Marxists are hard-nosed materialists; Platonists are idealists of the most far-reaching variety. Both, however, agree that art normally engages with reality—no matter how reality is specified. However, while Plato seems to think that artists can, through some perversity, fail to attend to reality, Marxists think that art always serves or conveys, and so is in some extended sense about, material and social reality. Neither Marxists nor Platonists see art as an end in itself, and while most Marxists believe that art can affect social reality, they would emphatically deny Oscar Wilde's seemingly bizarre claim that autonomous art is the touchstone of reality which social life merely imitates. The popular view that modern art is not real because it does not comment on, and is unconcerned with, everyday life gives another twist, and a new and somewhat complex flavor, to our distinction. This complexity and the obfuscation to which it gives rise is best resolved by looking more closely at the ways in which people use the words "real" and "reality" when speaking about art.

"Really," "Real," and "Reality"

Let us suppose that I say of some or other unspecified entity in an unspecified context that it is not real. What can one make of this pronouncement? It might be supposed that I think that the entity in question does not exist, but any such construal would in all likelihood be wrong. The context of the utterance, as well as the entity referred to, crucially affect the meaning of my utterance. So, for instance, if the entity spoken of turns out to be a toy telephone—a superlative imitation of the genuine article, but a toy nonetheless—it is not the case that by asserting its unreality I thereby assert its nonexistence. It is much more likely to be the case that I am trying to tell you that it cannot be used to make telephone calls, that it is not a functioning telephone but only a toy one. The toy itself, however, is a real toy telephone, and it is true of the functioning article that it is not a real toy. It follows, I think, that unless you know what is being spoken of,

and what is being contrasted, when I declare an entity real or unreal, you will not be able to make proper sense of my assertion.

No philosopher has done more to deflate the word "real" and its cognates than J. L. Austin, and although his lessons are easily learned, they are forgotten, it would seem, with equal ease. According to Austin, Plato uses the word "real" as a "dimension word": as a word that is designed to privilege a certain class of objects as "authentic," "genuine," or "true," and to contrast these with objects that are "artificial," "fake," or "false." [13] Precisely which objects one privileges in this way will depend, at least in part, on one's prior ontological commitments—that is to say, it will depend in some measure on one's prior beliefs about the kinds of objects that exist and do not exist. However, it is not my purpose at present to disabuse Platonists of their ontological predilections. Suffice it to say that our ordinary ways of using the words "real" and "reality" allow us to convey various ontological preferences so that it can fairly be said that where these words are concerned ordinary usage is neutral as between competing ontologies. It is only in context, as we shall see, that particular ontological preferences begin to emerge, and these always stand in need of rational argument and defense.

To say of something that it is a real painting is not of itself to say that paintings are real. A Platonist could quite conceivably agree that the painting hanging on my wall is a real painting in the sense that it *really is* a painting and not just a print, while at the same time maintaining that paintings are not real since they do not satisfy the conditions laid down by a favored ontological theory. The word "real" does not always function as a dimension word. Sometimes, as Austin has shown, it is "substantive hungry" in the sense that we do not understand its use until we know *what* it is that is said to be real.[14] On this view, when someone says that Pickwick is real, the correct response is not to deny Pickwick's reality, but to ask: "A real what?" For while Pickwick is not a real person, he is a real fiction. The matter is more complicated than this, for until we know what it is for something *not* to be a real fiction, we will not altogether understand what it is for Pickwick to be a real fiction. It is in this sense, Austin maintains, that "real" functions as a "trouser-word." [15] Hence, Austin would have that our knowledge

of the fact that an actual person is an unreal fiction (because he or she is not the product of someone's fanciful imaginings) informs our understanding of what it is for Pickwick to be a real fiction.

There are contexts, too, in which we say of objects that they are not real without implying any particular ontological preferences. Sometimes we merely point to the fact that the object in question does not altogether "fit the bill," that it fails in some way or another to meet the requirements for being a full-blooded member of a certain class. Used thus, Austin tells us, "real" is an "adjuster-word" since it helps compensate for the fact that our language cannot always "meet the innumerable and unforeseeable demands of the world." [16] So, for instance, because the object in front of me is in some respects like, but in other important respects unlike, works of art, I say of it that it is not really art, or that it is not real art. It is clear, I think, that my use of "really" and "real" in this context does not depend on my ontological predilections; rather it depends on my theories and beliefs about art. It is because the object in front of me does not altogether satisfy their requirements that I refuse to treat it—the putative work of art—as real.

Those who dismiss contemporary art on the ground that it does not address the ordinary concerns of everyday life seem to use the words "real" and "really" in just this way. On their view, an abstract painting is not really art, is not "the real thing," because it does not fit their conception of what art ought to be. Although abstract paintings resemble other works of art in important respects, the fact that they are not representational leads some people to the view that they are not really works of art. In a similar way, when one says of a work of popular art—say, a comic book—that it is not really art, one uses the word "really" as an adjuster-word in order to indicate that the comic book does not satisfy favored conditions for genuine or real art.

The case is very different with the Marxist suggestion that works of art are not full-bloodedly real—for in this instance it is their reality (specified in terms of a preferred ontological theory) that seems to be denied, and not their status as works of art. It is because art is a "superstructural," not an "infrastructural," phenomenon that it is not thought of as part of the material conditions of life and so as fully real.

Here the word "real" is used as a "dimension-word" to privilege a certain class of objects, relations, and events that are regarded as primary, elemental, or basic.

By contrast, when formalists of the early twentieth century forced their audiences to attend to the work of art itself and to see it as a real object worthy of attention in its own right, they were not introducing their favorite ontology; nor were they specifically attempting to displace a Platonic ontology. Rather, they were making, albeit indirectly, the perfectly commonplace observation that the painting hanging on the wall before us is the real work of art; a finely worked material object resplendent in the forms and colors that it embodies. At least part of the point in this context of calling it real is to direct attention to *it* rather than something else—just as one does when, in the course of a discussion, one directs a person's attention to a problem by saying, "This is the real issue." "Real," if I may be allowed to add to Austin's list of distinctions, functions here as a "direction-word": it tells us what to attend to, and it does so in the present context not by privileging certain objects in terms of a specific ontology, but by privileging them in terms of a certain set of concerns and values, in this case, artistic concerns and values.

Not that the matter is as simple as this. For although the formalist holds that it is the work of art rather than some transcendent and elusive reality that is "the real issue," just by using the word "real" to describe particular works of art, formalists exploit the fact that "real" is a "substantive-hungry" word. In this respect, their view fairly brims with robust commonsense, for there can be no doubt that the paintings, drawings, and sculptures that we see in galleries are real paintings, drawings, and sculptures. In describing works of art as "real," formalists use this word in two rather different but nonetheless compatible ways. From a particular point of view, something can be both "the real issue" and a "real work of art." It is left to Oscar Wilde to muddy the waters, for, as we have seen, not satisfied with the view that works of art are real objects, he chooses to treat them as the touchstone of all reality, telling us at one point that "Life in fact is the mirror, and Art the reality." [17]

Wilde, so it seems, uses "real" as a "dimension-word." He appeals to a particular, not very well formulated, ontology in order to privilege

certain objects—namely works of art—as genuine or authentic. Life, by contrast, is merely derivative, parasitic upon, and an imitation of art, and so is not properly real. There is, of course, an element of mischief in Wilde, and here, it seems, he is playing fast and loose with a commonsense view of reality: the view, namely, that something is real to the extent that it forms part of, or has some bearing on, our lives. Art, he seems to say, is real because it imparts a certain character to life. It is, however, precisely this view of reality that brings so many people in the West to denigrate the contemporary art that Wilde elevates, for, on their view, many modern works of art have no bearing at all on the day-to-day concerns of everyday life. As a result, art is regarded by them as lacking in substance, as being idle, a luxury, parasitic—and so not part of the real world. It is this view that Wilde turns on its head. Not only is the work of art a real material object, but it is, he thinks, the measure of all reality since it is the yardstick according to which life conducts itself.

It seems clear, then, that the contrast often drawn between art and reality can mean many different things. The word "real" changes its semantic hue with almost every change in context. Consequently, questions as to whether art is real, or is properly contrasted with reality, fail to get a grip until much closer attention is given to the contexts in which these questions and their corresponding claims arise. When once the nuances of context are ferreted out and exposed, such disagreements as remain will not center on the reality or unreality of art, but on the theories, values, and beliefs implied by these nuances. Any attempt to deal with all of these will require not just a complete aesthetic but a comprehensive metaphysic that deals with all possible ontologies. My aim is not quite so elevated. Mine is the more modest task of exposing the confusion that threatens whenever we speak about art and reality, and whenever we try to construct a rigid boundary between the two.

I do not, however, mean to leave matters here. In what remains of this chapter, I want to examine one particular view of the relation of reality to art. It is the view proposed by Oscar Wilde.

Wilde and Wide of the Mark

The claim that art is reality, the measure of all truth, and that life merely imitates it, will strike the seasoned ear as hearty nonsense. Nonetheless, I argue that the claim is not entirely silly, that while unacceptable, it has something to commend it. In arguing this, I probe the boundaries at which art and life intersect, boundaries that are not so settled as we sometimes think.

According to Wilde, "Life imitates Art . . . Life is in fact the mirror, and Art the reality." [18] Here he speaks not just of the lives that people lead, but of nature itself. And so he asks,

> Where, if not from the impressionists do we get those wonderful brown fogs that come creeping down our streets, blurring the gas-lamps and changing the houses into monstrous shadows? To whom if not to them and their master, do we owe the lovely silver mists that brood over our river, and turn to faint forms of fading grace curved bridge and swaying barge? The extraordinary change that has taken place in the climate of London during the last ten years is entirely due to this particular school of Art. [19]

Wilde's argument for this is simple but wrong. "Things are," he writes, "because we see them, and what we see, and how we see it, depends on the Arts that have influenced us." [20] It follows from this that without art nothing can exist because we are not able to look for and see things, and so bring them into existence. Even if we ignore Wilde's phenomenalism, it seems abundantly clear that objects exist even when those people or animals who experience them have little or no experience of art. The ultramodern telephone on my desk exists even though I know of no work of art that portrays it, while my cat in his innocence makes a dash for the chicken liver even though he has no acquaintance with an artistic rendition of it. We need to remind ourselves, and Oscar Wilde too, that his concept of art is culturally and historically specific; that this concept emerged in our history in order to mark a discrete category of skills, performances, and objects only at the time of the Renaissance. Much more obvious is the fact that

there are societies that have no art in Wilde's sense of this term, but for whom the world continues to exist.

Happily, Wilde seems to recognize some of these problems, since it soon becomes apparent that he does not altogether adhere to his theory. Not four sentences later he changes his mind, and tells us that "there may have been fogs for centuries in London. I dare say there were. But no one saw them, and so we do not know anything about them." [21] And so it seems that he is now willing to believe that objects exist whether or not we perceive them. But then, in an immediate reversion to the stronger thesis, he writes: "They [the fogs] did not exist until Art had invented them." [22]

It is tempting to suppose that Wilde must be profoundly confused, but this seems unlikely. An intelligent man, even if he is a poet, must be able to see a contradiction when it waves at him. An alternative and more plausible suggestion is that the rhetorician in Wilde is taking over, and that by moving to the weaker thesis whenever the stronger becomes embarrassing, and to the stronger whenever the weaker becomes uninteresting, he hopes to lure uncritical readers to a particular point of view. This may well be the case, but it is more charitable to suppose that Wilde has chanced on something important, that at the very point at which he wishes to see art as an end in itself, he recognizes the profound influence that it has on the shape of our world, on the hue of our thinking, and on our everyday behavior. He does not just wish to say that "Life imitates Art far more than Art imitates Life," [23] but, more profoundly, that art is a formative influence in our lives, that it actually brings things and states of affairs into being. And yet it seems wild to suggest that art is the origin of all things; that it was not God, nor yet a Big Bang, but Art that created the world and all that is in it.

In what follows, I want to try and defend Wilde's supposed insight in a way that does not require us to embrace the absurd. There is a clear sense, I shall argue, in which art is a deeply formative influence in the human world. This, I will try to show, is why art is inextricably bound up with everyday life—with real practices, actions, artifacts, and institutions. However, there is no reason to suppose that art is the source of everything. The Impressionists may well have brought the

London fogs to our attention, we may not even have noticed them prior to the work of these artists; but it was coal, smoke, and damp, not art, that caused them.

Art and Life

Wilde, it would seem, is unable to divorce his more innocuous epistemological claims about art (namely, that it influences our perception and shapes our behavior) from the bolder, more strident, metaphysical claim that art is the source and causal origin of everything. Art, he believes, must be more than merely influential; it must be formative. But he hopelessly overstates his case by contending that it is causally responsible for everything: that it was the first, the very first, cause. Any such claim, if taken seriously, would require art to exist without artists, and this so changes our concept of art that we can no longer understand the claim, let alone take it seriously.

On my view, Wilde is correct in thinking that art is more than merely influential, that it is also formative. But a more modest case needs to be made for this, and a good place to start is with Francis Sparshott's observation that traditionally an art was conceived of as a practice consisting of an organized package of more or less integrated skills.[24] In this sense, medicine and war are arts, as are plumbing and sheep shearing. All consist of sets of skills often housed within institutional frameworks that perpetuate and regulate them.

It is precisely because doctors, shearers, and soldiers have an interest in doing their job well that they think about, and try to improve, their skills. Consequently, the skills themselves, and not merely the ends that they serve, become objects of attention. It is, according to Sparshott, when an art (an organized body of skills) comes to be treated as an end rather than as a means, that the fine arts begin to emerge.[25]

Oscar Wilde was, for the most part, speaking of the formative influence of the *fine* arts or the arts of beauty; and it becomes possible to explain the formative power of these arts if, following Sparshott, we allow that each fine art has its origin in a body of practical skills. It is

true, of course, that the application of the skills that constitute a fine art usually result in the production of an artifact that is thought of as a work of art. However, we must not allow the work of art to occlude our awareness of the skills responsible for it, for it is here—within this cluster of skills—that art and life properly intersect.

It is difficult to speak in detail or with authority about the origins of all the fine arts. The recorded history of art goes only so far, and there comes a point at which it merely speculates about origins. Even so, theorists and art historians generally locate the source of fine art in the everyday practical concerns of human beings. There is good reason for this. It is all but impossible to look at a painting, a drama, a sculpture, or a dance without being aware, however remotely, of the practical skills exercized in these works of art. E. H. Gombrich's conjecture that representational art takes root in the human desire to control the environment seems plausible only because we can understand why people think that they can use representations (and hence the skills that they presuppose) in this way.[26] They can, of course, use them superstitiously, believing them to have causal or magical powers that they do not have, but pictures and paintings can also be used to draw our attention to objects that are not available for inspection. In this respect the skills of representing have an obvious practical value, for they not only facilitate the communication of attitudes and information but enable us to negotiate situations of which we have no first-hand experience.

Literature provides an even better example. Poets and novelists are normally skilled in the use of language, and while we do not usually assess their work for the practical value of their skills, it would nonetheless be wrong to deny that they have practical value. Facility with language is always useful. However, the skills of the novelist and playwright reach further than this. Each constructs an imaginary world, and does so with considerable expertise. These are worlds inhabited by fictional people who are, of course, the product of an author's imaginings. Needless to say, the author does more than merely invent and populate fictional worlds, for a story is also told in which the characters are made to act out parts of their lives.

Authorial skill, therefore, resides not just in the use of language but also in inventing a world of people and in telling a story about them.

The capacity to invent, to be innovative and original has obvious utility in a world that requires people to respond in new and useful ways to the problems that confront them. Useful solutions to these problems ensure not only the well-being but also the survival of countless human beings. Skills of invention are prized, and are celebrated everywhere in the fine arts of the twentieth century.

The capacity to tell a story, by contrast, is not usually considered to be a useful or an important activity. The fact that in our century stories are often thought of as idle entertainments is beyond dispute and demonstrates, I think, the extent to which literature has marginal-ized itself, and in the process destroyed whatever authority storytelling once enjoyed. In fact, however, stories figure prominently in our lives, and are used not only by the historian to secure an understanding of an otherwise indecipherable and haphazard array of social phenom-ena but also by the politician in an attempt to secure allegiance and popular support. Stories, whether fictional or nonfictional, figure as well in the pub, the education system, the church, and in our most intimate encounters. In every case, they serve both to make sense of the world and to command attention, support, and sometimes, too, affection and regard. Storytelling is profoundly useful, and arises at first in our everyday lives. It is because there was once a time when people recognized the utility and importance of narrative skills, and were fascinated by their power, that they attended to them, explored, and developed them in their own right; and it is this process, I would contend, that led to the emergence of literature as a fine art.

In inventing a story, authors will invariably rely on, and in time imaginatively transform and so add to, the reservoir of narrative skills that exist in their society. People in the actual world may adopt these new skills and, in their turn, imaginatively embellish them so that they become, once again, skills that can be appropriated and transformed by an author.

This reciprocal relationship between art and life extends as well to the representational content both of stories and of dramas.[27] Authors and playwrights do not only invent imaginary worlds but people them with fictional characters who engage in a variety of activities. It is only in the telling or the staging that characters are allowed to act out their lives and to do so with more or less skill. To the reader or viewer

it will seem as if the characters themselves possess certain skills, for they have at their disposal strategies of one sort or another for dealing with morally, intellectually, and physically demanding situations—for solving dilemmas, dealing with intruders, consoling their friends, combating their enemies, and so on. These are representations that take root in the skills of everyday life. It is hardly surprising, then, that the skills exhibited by creatures of fiction should influence the ways in which people act in the real world and the solutions that they adopt for everyday problems.[28]

By the same token, the ways in which people actually act and the skills that they display in the real world inevitably affect the imaginings and inventions of authors and artists. They furnish the artist with hard experience on which to build imaginatively. Nor does the matter end here, for the imaginative transformation of these practices and skills in a work of art at once suggests new ways of acting and behaving to actual people in the real world.

The relation between life and art (or between life skills and the fine arts) is reciprocal or dialectical. So, for instance, the pose that a portrait artist encourages in a subject may influence the ways in which people pose in real life—the ways, that is, in which they choose to present themselves to others. But since people generally have an interest in presenting themselves favorably, they reflect on and develop enhanced skills of "impression management," which, in their turn, might become fuel for an artist's imaginative experiments, and so on.[29]

It is, of course, true that the interactions between art and life which lead to the development of representational skills on the part of a painter will be very different from the interactions that lead to the development of more painterly skills: the skills, for instance, of applying a brush to canvas or of mixing colors. The developments, say, in color photography may suggest painterly skills of one sort or another, while subsequent painterly developments may suggest new techniques to the photographer. Whatever the skills and the dialectical interactions from which they derive, the process of their development is in each case is fundamentally similar. It involves conjuring up and testing possible techniques, rejecting them when they do not work, and inventing in their stead new techniques. This is the creative, fanciful, or originative imagination at work; and on my view it is at work in just this

way whenever one attempts to improve and develop not just artistic skills but any skill whatsoever.[30]

The reason is obvious, for whenever we run out of know-how and are unable to solve a particular problem by recourse either to our own skills, the skills of others, or the skills encoded in instruction manuals, we are forced to "cast around," to imagine, conjure up, or invent new ways of proceeding. There are, of course, no clear guidelines that regulate this activity. It is what Kant would have called an "unruly" activity constrained only by one's past experience—that is, by one's knowledge or beliefs about which techniques are likely and which are unlikely to work. In attending to and devising alternative skills, we project ourselves imaginatively into certain problem situations. We imagine how these techniques would work, and in this way we develop practical hypotheses that we test on the appropriate occasion.

The process, I have said, is fundamentally imaginative, and is the same for all skills—from those involved in writing and bricklaying to those involved in airplane maintenance and statecraft. To the extent that a newly invented technique serves its intended purpose and enables, say, a carpenter to solve a joinery problem, or a portrait painter to capture a subject's mood, it will be adopted and will become part of a body of established skills. But whether these skills are artistic or purely technical, the process whereby one invents and so develops new skills remains precisely the same. It is, as I have said, a process that is fundamentally fanciful; one, moreover, that permeates all walks of life—so that the distinction between art on the one hand, and the practical skills that we live by on the other, becomes rather more tenuous than some have supposed.

Think again of all the many tasks that people perform, and are required to perform, on pain of survival. They do not merely make, cultivate, and tend, but they are required to cooperate with one another in order to produce goods and reproduce people. The skills involved in all of these basic chores are manifestly complex. If, for instance, you wish me to behave in a way that meets your needs, you will have to ensure my cooperation. You could, of course, do so by force, by winning political power, by argument and persuasion, or else by presenting yourself in ways that incline me to cooperate with you. How you do all of this will, of course, depend on your past experience, but

you may, if you feel the matter keenly enough, reflect on what you do and try to do it better. The ways in which you present yourself to me, the ways in which you speak about yourself and relate incidents in your life, the way you dress and wear your hair, your use of body language and bonding signs may (as we will see in Chapter Six) be immaculately and imaginatively crafted. At least as much imaginative effort and skill may go into all of this as an artist lavishes on a painting or a poem. One can craft, model, and shape one's life-narratives, one's appearance, one's behavior, in ways designed to win the approval of, and eventually seduce, an audience. And this, of course, is precisely what the conscientious artist tries to do. Oscar Wilde, but so too Salvador Dali and Pablo Picasso, were cases in point: each crafted himself in ways designed to win approval for his art and respect for his artistry.

If I am right, and if it is true that the fanciful imagination and its exercise are the province not just of the artist but of all people in their everyday lives, then, as I have said, the rigid distinction that we like to draw between art and life becomes somewhat less stable. The creativity of the fine arts is to be found as well in the practical skills, the arts, of everyday living; and we have seen that there is a reciprocal, a dialectical, relationship between these practical skills and the fine arts.

It was, I think, this insight that Wilde was trying to articulate when he maintained that life imitates art more than art imitates life. Wilde, one must suppose, moves freely between that sense of "art" according to which an art is a practice consisting of an organized body of skills, and the sense of "art" in which an art is either a fine art or a work of fine art. What he perhaps saw, however vaguely, was that the skills central to both influence one another, so that life takes its shape both from the arts of living and from the fine arts—although the fine arts, he seems to say, also take some of their substance from life.

Although one cannot draw a hard and fast distinction between art and life, it would be altogether too precipitate to embrace the conclusion (as some are wont to do) that life and art are one: that life does not imitate art, nor art life, since the two are identical. This, I would venture, is a view that has its origins with the romantics and is encouraged by postmodernism, but it is a confused view (I argue in Chapter Ten) that makes the very same mistake I have attributed to Wilde; that is, it fails to distinguish adequately between *an art* and *a work of art*. On

the view that I have so far defended, an art is a practice that consists of an organized body of skills designed to serve a certain end. Following Sparshott, I have suggested that when an art is considered simply for its own sake, it may become a fine art. It is, however, only when the skills that characterize a fine art result in the production of some or other object that the object is properly regarded (in our culture) as a work of art.

With these distinctions to hand, it is possible to agree that there can be no rigid distinction between the arts (meaning *organized bodies of skills*) and the practices that characterize everyday life. The organized bodies of skills that constitute the arts are quite often the skills we live by, so that life skills and the arts merge into one another. In one sense, then, the claim that art and life are identical has something to commend it. But there is another sense in which it is plainly false. For if by "art" is meant *works of art*, it would seem to be abundantly clear that the lives we live or have lived are not art.

Even so, I can imagine someone arguing that we should not dismiss this claim too lightly. Every life, it is argued, is the product of one's life skills. By attending to and carefully applying the skills and practices integral to living, one can mold, shape, and craft one's life in just the way that a sculptor crafts a block of marble to form a statue. The life well lived and properly crafted acquires (on this view) the sort of excellence and perfection—an overall harmony, balance, integration, and unity—characteristic of works of art. Certainly not every life is a work of art, but on this view the life well lived is, and should be, praised and judged accordingly.

Although attractive, this position is problematic. According to it, only excellent lives make works of art—and, of course, they always make good works of art. But if excellent lives are good works of art, why should not bad lives be poor works of art? Indeed, why is not each and every life a work of art irrespective of its merit? The reason is not clear, and yet the thought that every life—from an alcoholic's to Mahatma Gandhi's—should be a work of art is plainly counterintuitive and does much to devalue the currency of art talk. The obvious way of salvaging the view that only some lives are works of art is by arguing that something becomes a work of art only because of its internal structure and its intrinsic excellence—so that unstructured and

indifferent lives cannot be works of art. However, this suggestion fails to take account of the fact that there *are* bad works of art, that it is not merely the skill with which something is executed, nor its intrinsic excellence, nor yet the presence of special properties within it, that makes it a work of art. An excellent tennis match, for instance, although executed with consummate skill, and although in some sense unified, harmonious, and balanced, is not a work of art. In just the same way, the life well lived does not become a work of art just by virtue of its structure or its excellence.

There is a very good reason for this. Not all arts, even when they are attended to in their own right, come to be regarded as fine arts. The arts of leather and metal work, sheep shearing and baking, are often considered as ends in themselves. There are, as everyone knows, baking and sheep-shearing contests whose aim is not primarily to produce cakes or bales of wool but to assess and perfect the skills involved in these activities. Despite this, not one of these arts has come to be regarded as a fine art. By the same token, psychologists often consider life skills not as a means to solving their personal problems but as ends in themselves—and they try to devise ways of perfecting them. But this, of course, is not sufficient to convert the art of living into a fine art.

The culture to which we belong, and, more specifically, the artistic theories and conventions that characterize the prevailing artworld within our culture, determine what will or will not be considered a fine art.[31] For the moment, these do not allow us to include the skills of everyday living under the banner of the fine arts, so that the product that results from the application of these skills—namely, one's life— is not properly a work of art. This may change as our culture grows and changes, and it is, of course, more than possible that the highly contrived lives of Oscar Wilde and Salvador Dali already herald an end to this restriction.

All of this does something to explain the sometimes baffling distinction between the fine arts and sport. Attention in Greek times to the arts of war led not to battle, but to competitions that involved throwing the javelin, sprinting, marathon running, gymnastics, boxing, wrestling, and putting the shot. These early warring skills, when attended to as ends in themselves, resulted then, as now, not in works

of fine art, but in the sport of athletics. The reason of course is that the artworld does not countenance these skills as fine arts. One could go further, and suggest, correctly in my view, that a competitive activity becomes a sport when it is deemed to be so in terms of the theories, beliefs, and values that help constitute what one could call the "sportsworld." And one of these beliefs, undoubtedly, is that the competition should be pursued for its own sake. So while it is possible to take an aesthetic delight in the gracefulness of gymnastics, cricket, or baseball, this will not of itself convert these arts into fine arts.[32]

Conclusion

There clearly is a sense in which art and life are different and distinct. Our lives, no matter how much we praise and revere them, are not works of art. There is, however, another sense in which art and life are not easily distinguished, for the arts are often the skills by which we live. My argument has been that these skills do not differ in kind from the skills that characterize the fine arts. If I am right, they are developed in precisely the same ways—through the good offices of the fanciful or creative imagination. Fancy enters our practical lives at many points, although this does not convert our everyday arts into fine arts. What counts as a fine art and what counts as a work of art must depend on features of our culture, and not on the excellence of our skills or on the properties of the objects that they are used to produce.

It is true, of course, that reality consists of everything that exists—so that in some sense art must be real. But this observation, while both sane and sage, does little to unravel the complexities that beset the many different attempts to distinguish art from reality. My aim was to expose and unravel this complexity. What we found, of course, is that the distinction is congenitally unclear since its meaning differs from context to context. Still more, claims to the effect that art is or is not real can often be assessed only by reference to the metaphysical or aesthetic assumptions that they presuppose. The metaphysical boundaries that are so often imposed on art in order to preserve a robust sense of reality are far from warranted. They still await a reason-

able justification, and begin to look decidedly questionable once one acknowledges the origin of the arts in everyday life.

Oscar Wilde's bold claim that art is reality, that it alone is the measure of truth, and that life merely imitates it, seemed more than questionable; indeed, it seemed manifestly absurd. On a closer and more charitable examination, however, it appeared that Wilde was impressed by the fact that the skills by which we live are themselves arts that are shaped by, and help shape, the fine arts. Life and art, I have tried to show, are intimately and intricately involved—although the precise and sometimes lurid details of their involvement can be exposed only in the chapters that lie ahead.

THE INTEGRITY
OF AESTHETICS

The fine arts, we have seen, are not wholly autonomous. They exist in, and arise out of, our everyday lives. The boundaries that we impose on them—those that distinguish the fine arts from everyday life, and the high arts from their popular cousins—often reflect social interests of one sort or another, and are not nearly so necessary as they are convenient. Much the same seems to be true of the boundaries that we construct between good and bad art, for what we value in art, we saw in both Chapters Two and Three, would seem to be a function not of pure aesthetic values but of our everyday interests and concerns.

If this is right, it poses an enormous problem for traditional aesthetics. For whatever else it is, traditional aesthetics is an unworldly discipline. Bred of artistic and economic integrity, it requires its adherents to contribute to a debate about a singularly elusive value: a value untainted by personal or political interests, by desires, needs, whims, or fancies. If the tradition is correct, aesthetic value has very little to do with what we actually want and prefer; it is an entirely pure value. My aim in this chapter is to show that, in this respect at least, traditional aesthetics is entirely wrong.

One of the major concerns of traditional aesthetics is to characterize aesthetic value and the experience to which it attaches. A secondary concern is the problem of explaining the rational basis of aesthetic evaluation. Immanuel Kant's foray into judgments of taste left twentieth-century critics and theorists with a marvelous theory in terms of which to explain the nature of aesthetic experience and the

objectivity of aesthetic value. Some of the claims and a few of the arguments of the *Critique of Judgement* have been appropriated by contemporary aestheticians who have used them with more or less skill to establish the authority of their discipline.[1]

Partly because of the tendency to judge the worth of anything in terms of its price, the nineteenth-century avant-garde chose, so it said, to produce art not for any material gain but simply and solely for its own sake. It insisted, we learned in Chapter Two, that art should be appreciated not in terms of its economic, heuristic, religious, or intellectual worth but in terms of its intrinsic value alone. It seemed to follow that there must be a pure artistic value, a value entirely different from, and untainted by, economic, intellectual, religious, political, gender, or moral values. It is this supposedly "pure" artistic value that has come in many quarters to be identified with aesthetic value.

This view first received prominence in the work of Clive Bell.[2] Since then, it has been widely defended. Monroe C. Beardsley, Stuart Hampshire, Harold Osborne, F. N. Sibley, and J. O. Urmson are a few of those who defended the principles on which the aesthetic movement of the late nineteenth century was founded, and it was mainly their work which shaped the character of aesthetics in the middle years of this century.[3] Each approached the problem of aesthetic value differently. In most cases, the starting point seems to have been an allegiance to what were taken to be the broad principles of Kant's third *Critique*, but the philosophical trends of the day (rather than any true allegiance to Kant) determined the actual direction taken by these thinkers. I shall consider only two of these attempts to explain the aesthetic: those of Urmson and Sibley. Both are unsuccessful, but an understanding of the reasons for their failure is instructive, and will enable us to develop a more adequate account both of aesthetic value and of aesthetic experience.

In doing this, I am of course contributing to a longstanding debate, and I hope to bring it to a conclusion that art theorists have usually avoided. For although there have been many criticisms of traditional aesthetics, none (I contended in Chapter One) has acknowledged the extent to which aesthetic value is grounded in our everyday concerns. Even though Janet Wolff offers a penetrating critique of some of the central tenets of traditional aesthetics, she nonetheless maintains that

aesthetic value cannot be reduced to, or explained in terms of, socially determined interests.[4] And while Arthur Danto freely acknowledges a social dimension to art, he tends to see art as properly distinct from life and to think of beauty as wholly independent of fashions of taste.[5]

Urmson on Aesthetic Value

J. O. Urmson maintains that only by responding aesthetically to a work of art can we experience its aesthetic value.[6] He is adamant that such a response cannot properly involve attending to the work's intellectual virtuosity, its moral content, its religious message, or its economic value (p. 357). For just as there are distinctive and irreducible economic, moral, intellectual, and religious values, so (on his view) there are and must be wholly discrete and irreducible aesthetic values: values that cannot be explained in terms of any other values and in terms of which we properly respond to works of art.

On Urmson's view, to "say that a satisfaction is wholly aesthetic . . . will be to say that the explanation or grounds of the satisfaction are wholly of one sort, which will necessitate that the satisfaction cannot rest also on moral grounds" (p. 360). One's response to an object may be both aesthetic and moral, but for Urmson aesthetic value is a "pure" value in the sense that it cannot be explained in terms of, and does not consist of, any other kind of value. The same is true of economic, religious, and moral values. They, too, are *sui generis* and hence irreducible to other kinds of value. It follows that the criterion we use to assess the aesthetic value of an object cannot be its price in a market place, nor can it be its moral or religious message, nor its insights or its "philosophy." These considerations lead Urmson to express the view that there "must be general principles of selection of evaluative criteria which determine whether our evaluation is to be counted as aesthetic, moral, intellectual or of some other kind" (pp. 364–365).

Questions about the sort of criteria that govern an aesthetic response are quickly settled. Urmson agrees with A. E. Housman that the aesthetic value of Wordsworth's poetry is to be found not in its message or "philosophy," but in its "thrilling utterance" (p. 363). For "if we

examine . . . some very simple cases of aesthetic evaluation . . .
the grounds given are frequently the way the object appraised looks
(shape and colour), the way it sounds, smells, tastes or feels" (p. 366).
What makes an appreciation aesthetic "is that it is concerned with a
thing's looking somehow without concern for whether it really is like
that" (p. 367). Appearances—without intellectual, moral, religious,
or philosophical content—are what we consider when assessing the
aesthetic value of an object.

Urmson acknowledges that this is not entirely unproblematic, for
whenever we assess a complex work of art, appearances turn out to be
just one of the many factors that we take into account in our evaluation
of it. We may be interested in the theme of a novel, its plot, its moral
message, or the philosophical insights that can be extracted from it. In
the same way, we may be interested in the style, the turn of phrase,
the "thrilling utterance." In view of this, Urmson maintains that our
response to complex works involves the admission "by courtesy" of
certain nonaesthetic criteria, so that to apply these criteria in evalu-
ating a work of art is not really to respond aesthetically to the work
at all.

On Urmson's view, most responses to a work of art are not genu-
ine aesthetic responses. Following a Kantian tradition, Urmson thinks
that we should hold the art in contemplation, attending only to its
sensory features—that is, to its appearances—if we are to respond
appropriately to it and appreciate it *as art*. But at this point, Urmson
misconstrues what is involved in attending to the appearance of an
object. On his view, this can never be an intellectual enterprise: it does
not involve responding in terms of our knowledge or understanding of
the object. Yet we know that the way an object looks or appears to
us, and what value we place on its looks or appearances, depends very
largely on our knowledge and understanding. The mushroom cloud of
a nuclear explosion appears threatening because we know something
about nuclear explosions and understand what such a cloud means.
Again, the soft pink glow on the cheeks of a young child does not look
beautiful when we know that it signifies a fever, but looks youthful,
fresh, and pretty in a healthy child. The skillful artist frequently ex-
ploits this knowledge and understanding in order to achieve specific
aesthetic effects.[7]

That our intellectual capacities play a crucial role in the discern-

ment of appearances is apparent and is admitted, albeit inadvertently, by Urmson. At one point he concedes that we can admire objects for appearances which they do not really possess. "I have in mind," he writes, "occasions when we admire a building not only for its colour and shape but because it looks strong or spacious" (p. 366). Suppose, however, that the building is made of playing cards—all precariously balanced one upon the other. The fact that it *looks* strong certainly furnishes us with a reason for admiring it. However, it is only because we *know* something about strong objects, how they look, and how they are usually constructed, and because we know something about the construction of a house of cards and how flimsy it really is, that we can admire the house of cards for its strong look, its apparent strength. It is our knowledge and understanding that mediates this appearance and our appreciation of it. Since, on Urmson's view, "what makes the appreciation aesthetic is that it is concerned with a thing's looking somehow," it is clear that the intellect (or, if you like, our knowledge and understanding) ought to be allowed a place in his analysis of aesthetic appreciation.

This tells us something important. Aesthetic value, whatever it is, is not nearly so pure as Urmson believes. For if our knowledge and understanding enhance our appreciation of the appearance of the house of cards, then raw, unmediated looks, feels, sounds, smells, and tastes are no longer the sole criteria of aesthetic value. Like so many twentieth-century aestheticians, Urmson makes the mistake of supposing that the art object is meant to be apprehended by the senses alone—without recourse to an intellectual grasp of the work or its appearances. This will not do. If we allow that we can recognize, say, the soft appearance of an object, we have also to allow that knowledge, understanding, and whole sets of expectations play a part in this recognition. After all, what is it to notice the soft look of a face, or a chair, or of the cat's fur unless we have appropriate expectations and beliefs about this quality? How can we notice the brazen look on the face of a young boy or the modest appearance of the Virgin, without bringing systems of moral and religious values to bear? How can we notice the Virgin or the boy in a painting without some beliefs about their social station? Our apprehension of appearances depends not just on our sensory organs but also on an understanding bred of an intricate web of

values and beliefs. We come to artworks clothed in language, knowledge, values, and beliefs, and it is very difficult to shed these in a way that enables us to grasp the raw looks of the artworks themselves.

Traditional aesthetics, I said earlier, has often embraced—uncritically it sometimes seems—a set of doctrines that appear to have their origin in Kant's *Critique of Judgement*. Urmson, we have seen, echoes Kant in thinking that an aesthetic response to an object involves attending to its looks and feels without bringing these under any concepts.[8] Sibley, however, adopts a different Kantian doctrine.[9] Kant had held that the concept of beauty was not rule-governed. This view was embraced by Sibley who applies it not just to the concept of beauty, but to all aesthetic concepts.[10]

Aesthetic Concepts and Aesthetic Value

Works of art are sometimes beautiful, sometimes ugly. They may be elegant, balanced, harmonious, serene, delicate, comely, garish, distorted, dainty, pretty, and so on. F. N. Sibley calls these the aesthetic features of a work. He is concerned with how we come "to *notice* or *see* or *tell*" that art objects can properly be said to possess these features (p. 66).

There is something deeply puzzling about Sibley's enterprise. Although centrally concerned with our aesthetic response to works of art, he is seemingly unconcerned with the fact that we do not just describe but also evaluate works of art by applying aesthetic concepts to them. It is impossible to describe a work of art as elegant, unified, beautiful, or balanced without praising it; and it is similarly impossible to describe a work as ugly, or garish, or bloated without condemning it. Sibley's failure to take aesthetic value into account is both intriguing and instructive.

It is this omission, I will argue, which brings Sibley to the view that "there are no non-aesthetic features which serve in *any* circumstances as logically *sufficient conditions* for applying aesthetic terms" (p. 66). As a result, there are and can be no rule-governed or "mechanical" procedures for applying aesthetic concepts. The application of these

concepts, we are told, is not just a matter of intelligence and eye-sight. Often, Sibley writes, "people with normal intelligence and good eyesight and hearing lack, at least in some measure, the sensitivity required to apply [aesthetic concepts]" (p. 65). A person "need not be stupid or have poor eyesight to fail to see that something is grace-ful. Thus taste or sensitivity is somewhat more rare than certain other human capacities; people who exhibit a sensitivity both wide-ranging and refined are a minority" (p. 65). According to Sibley, we apply aesthetic concepts not by virtue of rules or reasons that can be gener-alized, but in virtue simply of the taste or sensitivity with which we are naturally endowed. If Sibley is right, the application of aesthetic concepts cannot be wholly or even largely explained in terms of the presence in a work of nonaesthetic features. Neither the message of a work nor its style, colors, shapes, sounds or rhythms license the ap-plication of a particular aesthetic concept. The attribution of aesthetic predicates is a matter of aesthetic sensibility alone, and the latter can-not, Sibley seems to think, be explained in terms of anything other than itself. Put differently, Sibley thinks that the process of applying aesthetic concepts is irreducibly a matter of taste or sensitivity.[11]

Since, if Sibley is right, there are no rules according to which aes-thetic terms can be applied, it is difficult to know how these concepts should be used. To make their application wholly whimsical, or a mat-ter simply of personal taste, is to destroy all possibility of rational aes-thetic discourse, and this, of course, is not a move that Sibley favors. Rather, he believes that we learn to apply these concepts by attending to specific works of art and the ways in which critics describe them. Such talk, he tells us, "frequently consists in mentioning or pointing out the features, including easily discernible non-aesthetic ones, upon which the aesthetic features depend" (p. 76). So, for instance, by "merely drawing attention to those easily discernible [nonaesthetic] features which make the painting luminous or warm or dynamic, [crit-ics] often succeed in bringing someone to see these aesthetic quali-ties" (p. 79). Sometimes critics achieve this end by using metaphors. On other occasions, they explicitly mention the aesthetic qualities that they want a viewer to notice while at the same time pointing to certain nonaesthetic features of the painting. They "make use of con-trasts, comparisons, and reminiscences," and when all of this does not

work, "repetition and reiteration play an important role" (p. 80). In the last resort, they "accompany [their] talk with the appropriate tones of voice, expression, nods, looks and gestures. . . . An appropriate gesture may make us see the violence in a painting or the character of a melodic line" (p. 81). This is all, Sibley believes, that there is to the application of an aesthetic concept. There is no point, after you understand this, to the further question, "How is it possible that by doing all of this critics bring people to notice aesthetic qualities?" It is simply a fact, he thinks, that they can and that they do.

It would seem, then, that we can be brought to agree that certain nonaesthetic features in a work of art license particular aesthetic ascriptions only because we are naturally endowed with taste or aesthetic sensitivity. Without this "natural endowment" we would be blind to the aesthetic qualities of an object—although this is not to deny that our taste can be trained, directed, and developed, and that it can vary "in degree from the rudimentary to the refined" (p. 83). The works of art, the artists, and the teachers to which we have been exposed all play a part in the development of our sensitivity or taste. For this reason Sibley is forced to the view that whenever you and I disagree about the aesthetic features of an object, this must be because one or the other of us—and perhaps both—are deficient in taste.

Kant's influence is obvious. Sibley follows him not only in insisting that aesthetic concepts are never applied in virtue of general rules, but also in thinking that we need certain natural "faculties" in order to notice aesthetic qualities. Hence, just as Kant insists on certain faculties as the basis for judgments of taste, so too does Sibley—one major difference being that Sibley insists on a "faculty" of taste—and taste, it turns out, is a wholly mysterious means of perceiving aesthetic qualities. Moreover, whereas for Kant we apply the concept of beauty in virtue of feelings of pleasure; for Sibley, feelings have nothing at all to do with the application of aesthetic concepts.

Sibley's account fairly brims with problems. On his view, disagreements about the aesthetic qualities of a work of art cannot be resolved by appeal to any overarching principles. The uniqueness of a work of art makes this impossible. Any reasons that can be given for the ascription of aesthetic concepts are specific to the artwork and involve pointing with appropriate tones of voice and gestures to some of its

nonaesthetic features. Since Sibley is adamant that these never entail the presence of any particular aesthetic quality, it is difficult to see why they should be thought of as genuine reasons for regarding a work as elegant or serene.

To make matters worse, if, after having had these nonaesthetic features pointed out to us, we still cannot discern the elegance of the painting or its serenity, all that critics can do is repeat themselves— this time, presumably, with more desperate gestures and a more finely modulated tone of voice. If we are still unable to discern the elegance of the painting, there is nothing more to be said. No doubt an unfriendly critic could put this down to a deficiency in our sensitivity or taste. This is the view that Sibley seems to favor. Indeed, if he is right, a viewer might lack this endowment altogether, and might be aesthetically blind. Alternatively, and more democratically, one may simply have failed to develop the "natural endowment" that we all share.

The trouble with this attempt to preserve the rationality of aesthetic discourse is that it is inherently irrationalist. Sensitivity or taste is at root a mysterious endowment: mysterious because it cannot be identified apart from our ability to apply to an artwork the aesthetic concepts that well-seasoned critics think we ought to be able to apply. Whereas a person's intelligence manifests itself in sundry activities, aesthetic sensitivity manifests itself in only one—and it is, of course, the "best critic" who decides whether you possess the endowment in sufficient degree. In the end, if the correct application of aesthetic concepts depends only on someone else's say-so, we may wonder whether there are any grounds at all for the application of aesthetic concepts, whether the whole critical game is not perhaps a charade in which the king stands naked while all and sundry, taking their cue from those who "know best," comment on the magnificence of his robes.

Value and Reason

In this century, the lure of positivism has taken an enormous toll. Almost every academic discipline has come under its sway at one time or another. At root, the emphasis has been on experience—on what

the eye and the ear can discern—for this, it is thought, is the only sure foundation for knowledge and good sense. The physical and social sciences, the study of language and literature, art history, psychology, and philosophy have all been affected by this single simplifying assumption, and by adopting it as a credo, each discipline seems to have claimed for itself the precision and the authority of the empirical sciences.

Like many aestheticians of this century, Urmson and Sibley are also under the sway of positivism. Urmson thinks that to respond aesthetically is to respond to the naked appearances of things. Sibley's view is very different. If he is right, we notice the aesthetic features of objects not with the naked eye but with another "natural endowment," namely taste. And taste functions with respect to the aesthetic qualities of an object rather in the way that our eyes function with respect to colors or our ears to sounds. It turns out that, provided we are sufficiently sensitive, we actually experience aesthetic qualities and that aesthetic concepts are applied in virtue of these experiences. The problem with this attempt to impart a positivistic flavor to critical discourse, is, as we have seen, that the "sense organ" responsible for these judgments remains wholly hidden and mysterious—so that it helps us to preserve the appearance of critical rigor only by introducing new and insoluble mysteries.

I believe that the difficulty of finding a rational basis for aesthetic ascriptions can be put to rest, but this requires that we attend to an aspect of aesthetic concepts that Sibley ignores. Such concepts enjoy an evaluative dimension which he simply does not acknowledge. It is Sibley's allegiance to some of the tenets of logical positivism that best explains his reluctance to account for the aesthetic features of artworks, and hence for the entire discipline of aesthetics, in terms of something as empirically elusive as aesthetic value. The positivist view—at least in Sibley's Britain—was that the linguistic expression of aesthetic values was nothing more than the raw expression of emotion. According to A. J. Ayer, for instance, "such aesthetic words as 'beautiful' and 'hideous' are employed . . . not to make statements of fact, but simply to express certain feelings and to evoke a certain response." [12] If Ayer is right, any account of aesthetics that grounds the discipline in the apprehension of aesthetic *values*, forgoes all claim to

the rigor and respectability characteristic of the empirical sciences. It is this eventuality that Sibley hopes to avoid.

It is simply a fact that aesthetic concepts are applied not just because of an experience of the work of art but also, and more particularly, because of systems of value and bodies of theory that have their own history within the world of art. There are objects, shapes, colors, tastes, smells, sounds, rhythms, messages, and themes that people have come, either through direct experience or through education and socialization, to prize and to value. The presence of any of these features in a work of art, if considered against the background of prevailing systems of value, will incline a critic to praise the work, often by applying certain aesthetic concepts to it.

It is wrong to suppose, as some positivists do, that the expression of these values is the simple, unreasoned effusion of emotion, for one can express the values that prevail within a society at a given time without feeling or expressing any emotions at all. One can, for instance, recognize and say that an act is illegal, a deed courageous, or a speaker eloquent, without feeling or expressing an emotion. One recognizes all of this by applying certain well-established criteria of illegality, courage, and eloquence. Still more, to suppose that the expression of values must always involve the expression of feeling or emotion is to confuse statements like "X is good" with the autobiographical statement "I like X." Whereas the statement "X is good" claims a certain objectivity and so cries out for justificatory reasons, the statement "I like X" does not, and merely expresses my own subjective approval of X. This distinction is crucial. Without it, it would not be possible to like a work of art while at the same time acknowledging that it is not a good work—as we do when we enjoy a B-grade movie or a Harlequin romance even though we allow that they are not good works of art.

Although aesthetic concepts are heavily value laden, the application of these concepts to works of art is not just the expression of one's personal likes and dislikes. Certainly, aesthetic values (like all other values) have their origin in human feelings and preferences, but it is misleading to reduce the expression of aesthetic value to the expression of these. There are reasons that can be given for the ascription of such values, reasons that can be disputed, and that apply (or fail to apply) no matter how one feels. On my view, the ascription of aes-

thetic concepts depends crucially on the availability of such reasons and can be explained in terms of them. Indeed these reasons *are* sufficient for the ascription of aesthetic concepts and provide conditions that govern their application.

What are these reasons? Are they to be found in the work of art itself? Or are they reflected, as Sibley seems to think, in the gestures, tones of voice, and sensitive insights of a proficient critic? How, finally, do they become established within critical discourse as reasons for the ascription of certain concepts?

We know that the reasons for aesthetic ascriptions are not to be found in the naked appearances of works of art. Nor are they derived from what Sibley calls "taste." Sibley does, however, point us in something like the right direction when he emphasizes the tones of voice and emphatic gestures of the critic as a way of getting us to notice the aesthetic qualities of an object. This does occur—perhaps more frequently than we realize—but Sibley sees no need to explain it. On his view, it is something that simply happens.

But there is a need to explain this fact. Why should a critic's gestures and tones of voice enable us to notice qualities in a work that would otherwise pass unnoticed? The explanation that I favor has much to do with the fact that acknowledged critics have a clearly defined social role that carries with it a certain status and authority. Critics earn their status not just through displays of critical virtuosity but also through demonstrations of their erudition. We expect a reputable critic to be acquainted not just with the artistic canon but with the history and theory of art, the established practice of the artworld, and with the artistic values that permeate it.

Just by accepting a critic's authority, an audience will come to value whatever aspects of a work the critic values. In saying (sonorously) of a work that it is elegant, and by pointing to the features that are thought to make it so, the critic enables us to think of these features as elegant and to perceive the elegance in the work. But it is not as if we now see something that was always physically present, although somehow hidden, in the work. Rather, by acknowledging the critic's authority, we defer to her knowledge of the prevailing systems of artistic value, and are prepared to follow her gaze, her expansive or condemnatory gestures, and to see the flow of lines, the detail of color, the message,

or the theme of the work in terms that she prescribes. This is how many of us first become acquainted with the dominant artistic values in our society.

If I am right, aesthetic ascriptions can be more or less well informed so that an aesthetic judgment certainly need not be arbitrary or whimsical. Knowledgeable critics base their remarks on the systems of value and bodies of theory that prevail within the artworld at a particular time. It is because critics know that specific chords, motifs, themes, genres, and the like are preferred by a given society at a certain time that it is possible for them to pronounce on the value of certain works of art. However, critics do not merely reflect and endorse the prevailing artistic values; they often use their authority to add to them. They may tolerate and even praise diversions from the norm, and in this way they help create new values, trends, and expectations within the artworld.

A critic is an officer of the artworld—where the artworld has to be understood as a form of social organization and practice that surrounds the production and dissemination of art. This organization and practice is informed by a particular history and body of theory in terms of which artistic values are both generated and justified. It is, in part, by appealing to aspects of this history and theory, and the values that supervene upon them, that the critic is able to find reasons for the application of aesthetic concepts. Contrary to Sibley's view of the matter, aesthetic concepts *are* condition-governed, although not exclusively by the nonaesthetic features of a work. Their application is governed as well by the artistic values, theories, and beliefs that prevail within a society at a given time. Although the physical properties of works of art must furnish some of the conditions for aesthetic ascriptions, it would be wrong to think that they exhaust these conditions. It is only when critics consider the physical properties of the work against the background of certain conventions, values, and theories that they can have any reason to ascribe aesthetic concepts to them.

It is misleading, then, to suppose that aesthetic properties exist as material properties within the work of art itself. On my view, they are better understood as "culturally emergent" qualities: qualities that, although physically embodied, exist only relative to prevailing artistic conventions and values, and the theories on which these conven-

tions and values depend.[13] We could say that these are properties that emerge only against the background of the cultural values and artistic conventions that form part of the artworld, and in terms of which the artwork is appropriately assessed.

Aesthetic Values and Real Life

If I am right, aesthetic concepts are properly applied only in virtue of certain rules or conditions. These are to be found not just in the work of art itself, but, more particularly, in the conventions, values, and theories that surround it—so that by ascribing an aesthetic property of one sort or another to a work of art, one effectively ascribes a value to it.

Traditional aestheticians think of these values as "pure" or disinterested. On their view, they are neither a function of one's individual preferences, nor of one's political, religious, or economic interests. Urmson clearly assumes this, and although his account of aesthetic judgment is seriously inadequate, this fact does not of itself undermine the traditional view of aesthetic value as disinterested, pure, and untainted. In order to establish the inadequacy of this view, it is necessary to try and understand how systems of artistic value become established within a society.

Let us return for one moment to the notion of pure aesthetic value as expounded by Clive Bell. On his view,

> to appreciate a work of art we need bring with us nothing from life, no knowledge of its ideas and affairs, no familiarity with its emotions. Art transports us from the world of man's activity to a world of aesthetic exaltation. For a moment we are shut off from human interests; our anticipations and memories are arrested; we are lifted above the stream of life.[14]

What is striking about this passage is its sheer perversity. Bell ignores the fact that works of art occur in this life, not some other. Only human

beings who have a rich and reflective mental life, and who have been appropriately socialized, are able to produce and understand works of art. Bell chooses to write as if art somehow transcends our ordinary concerns. On his view it occupies a realm of "aesthetic exaltation" that is altogether "above the stream of life." As a result, aesthetic value is thought of as pure; as untouched by the interests of everyday life.

Despite its rhetorical elegance and initial appeal, the trouble with this view is, as we learned in the last chapter, that—in one sense at least—art is part of everyday life and cannot be separated from it. This observation, we saw, is most cogently made by Francis Sparshott who argues that an art is properly (and traditionally) conceived of as a practice that consists of an organized cluster of more or less well-integrated skills.[15] It is, we saw, precisely because farmers, doctors, and public speakers have an interest in improving their skills that they are inclined to attend to them, not merely as a means to some end, but also as ends in themselves. On Sparshott's view, it is at this very point—the point at which an art comes to be treated as an end in itself—that the fine arts begin to emerge.[16] It is only because the arts of representing, writing, and speaking serve certain practical and valuable purposes in everyday life that people regard them as important and so come to treat them as ends in themselves. The result is the development of the *fine* arts of painting, literature, and drama.

We already know that while any set of skills can be attended to as an end in itself, not all can become fine arts. The reasons for this, I have suggested, are to be found in the cultural traditions, the theories, and values that surround the production of fine art in our society. At present, given the widely held belief in the autonomy of the fine arts, and given their association with the upper classes, any art that seems too closely tied to practical or, still worse, to working-class interests— such as the art of drainlaying—will not be regarded as a fine art even when it is considered as an end in itself.

It is nonetheless the case that whenever we evaluate a painting, a novel, or a play, we effectively evaluate the skills or arts involved in their production. This is as it should be, for works of art are artifacts that have to be produced, and their production can be achieved only by exercising certain skills. In this sense, the artwork is always a testimony to the artist's skills, whether as painter, composer, sculptor, or

writer. It is because these skills are important, and because they derive their perceived importance from the concerns and goals of everyday life, that the values in terms of which they are assessed can be seen to be a part of what Clive Bell calls "life." Thus we *do* need to bring with us something from life in order to appreciate a work of art: we need to share the everyday concerns that incline people to place a premium on a given set of skills.

Which skills one values will be affected not just by fashions and fancies but also by material and social circumstance. At different times and in different circumstances, different sets of skills acquire and lose importance. The skills of the scribe, the swordsman, and the soothsayer, like those of the cobbler, the whaler, and the blacksmith, were once all highly valued; but it is plain that changing beliefs and technology have meant that they no longer enjoy the prominence that they once did. Even so, some skills seem to hold a fairly constant place in our affections. For instance, because we are social animals, we have always valued, and will doubtless continue to value, the skills of communication. Again, we have seen that it is only because most people want to extend their senses in ways that enable them to see, understand, and control remote objects and events that the skills of depicting are considered important. Since most people value diversions and entertainments, they tend to seek out and encourage the development of those skills that best enable them to shed their cares and attend to the lighter side of life.

It is only because we want or need these skills that we value them; and it is because we value them that we attend to, improve, and try to perfect them. Thus, for instance, it was only by attending to, and treating as ends in themselves, the skills of diverting and entertaining people that we were able to develop the fine art of comedy. The same, I said earlier, is true of the skills of linguistic and pictorial communication, with the resultant development of the literary arts and painting. Sparshott contends that it was the emphasis on physical fitness at the time of the Crimean War in the mid-nineteenth century and beyond that encouraged people to attend more closely to the skills of human movement and gymnastics, and this, in turn, led in the present century to a renewed emphasis on the art of dance.[17]

On my view, the values that we attach to works of art in our soci-

ety—what traditional aestheticians call aesthetic value—are invariably married to our everyday concerns. They are derived from everyday life and reflect the human interests that prevail within our society at a given time. No doubt it will be objected that one cannot infer from the fact, if it is one, that the fine arts were originally founded on our everyday interests and values, that our practical interests continue to enter into and govern our assessment of these arts. Could it not be that an entirely different set of values has evolved and that this now governs our evaluation of art? My mistake, it could be argued, has been to suppose that the concerns and values that led to the establishment of the fine arts continue to be invoked in our assessment and evaluation of contemporary art.

It is not difficult to show that our practical interests continue to play a large part in our appreciation of contemporary works of fine art. Thus, for instance, when looking at a competent representational painting, one is aware, however remotely, that the same skills can be used to record not just the scene depicted but other scenes as well. We know that the visual information in pictures can help us to control and negotiate our environment by acquainting us with the appearances of objects and landscapes that are not presently available for inspection. The practical value that we attach to these representational skills is not the only, nor yet the paramount, value in terms of which we normally assess paintings and sculptures. That such practical considerations do nonetheless play an important part in our evaluation of works of art is best illustrated by the fact that the development of the camera in the nineteenth century effectively devalued representational art. Artists could no longer see any point to this art form; after all, cameras could do it better. Certainly there were other social factors that contributed to the eclipse of representational painting, but it seems clear that the move from representational to abstract art cannot properly be explained without pointing to the fact that the representational skills of the artist were no longer regarded as important, and, as a result, no longer enjoyed the esteem that they had once enjoyed. It would take the viewing public a long time to see that there were other, more "painterly," values in terms of which to view the new art—values, I argued in Chapter Two, that were not altogether unrelated to social and political interests.

Poems, like novels, also reveal practical skills—linguistic and narra-

tive skills. Even though we do not always assess a poet's or a novelist's work for the practical value of their communicative skills, it would be a mistake to overlook the fact that these skills do have a practical value and that this cannot easily be divorced from our assessment of the work as a whole. Thus, for instance, the conceptual skills that are manifested in a poem or a novel are valued precisely for the insights they afford, and it is not uncommon to praise a literary work for these insights.[18]

One can go on in this way, to unpack the practical values and concerns that mediate our appreciation of all art forms, but the task is complex and certainly cannot be completed here. The important point to notice at present is that we do have reason to think that the very same interests and values that first led to the development of these fine arts continue to play a role in our evaluation of them. These, however, are not the only values that we bring "from life" when evaluating works of art. Our religious, economic, moral, ecological, and intellectual values can, and often do, intrude. The serene passivity of a Raphael Madonna is valued not just because of the formal correctness of the painting but also because of the religious and gender-related values that we bring to it.[19] By the same token, we often respond aesthetically to, and admire, the architecture and the interior decorations of the Palace of Versailles not merely (as Urmson would have) because of their raw appearances but also because of their uninhibited display of wealth. Indeed, we can speak aesthetically of the magnificence and resplendence of Versailles only because we share, or at least understand, certain economic and political values. We admire both the wealth required to build the palace and the power of a king who could marshal such wealth.

In much the same way, my moral values help shape my response to Jane Austen and Thomas Hardy, while my distaste for the occult affects my appreciation of Hermann Hesse. All of these values are acquired "from life." Some of them may be derived from my experience of works of art; but that, too, is part of the experiences that both constitute and inform my life. The standard assumption that art and our experience of it are removed from life is simply misleading. My life is not, to be sure, a work of art, but art both informs and is informed by our lives.[20]

It is true that people sometimes respond just to the textures and

colors, shapes, and sounds of a work of art, and that they do so without a mind to historical, economic, moral, or intellectual values. This may happen in one of two ways. A sound, a color, or a texture may, for purely physiological reasons, afford pleasure to a viewer. Like a tickle or a caress, the work feels good, and the feeling is entirely personal and subjective. In this case the viewer *likes* the work, but this, as Hume, Kant, Urmson, and Sibley all insist, is a far cry from either understanding the work, from viewing it appropriately, or from making considered and reasoned judgments about its worth.[21]

Most often when people attend to the looks, textures, and sounds of a work of art, however, they do so not because of a desire for sensory gratification but because they are the beneficiaries of an art education that exhorts them to respond to and evaluate a work in terms of its formal appearances. They know that the formal properties of an artwork seldom exhaust what is to be had from it, and they know that the sensory delight that it affords, and the experience of what Clive Bell calls "formal significance," are not the only pleasures that the artwork offers. They view the work in this way only because they have been taught to do so—either in art school or in their local art appreciation group—and the threat of being considered incompetent, insensitive, or ignorant about art gives them a definite interest in attending to textures and grains rather than messages or themes. In such a case, the viewer's artistic (or aesthetic) values are clearly mediated by social considerations. At least part of their reason for subscribing to the prevailing artistic values is that they want to be accepted and acknowledged within a certain social network.

This brings us to another set of interests and related values that affect our responses to, and evaluations of, works of art. These are clearly social in character. Earlier I said that the arts of agriculture and medicine are found in institutional settings that both regulate and perpetuate them. It is obvious that the need for such an institutional framework arises only because people have an interest in perpetuating certain sorts of medical and agricultural skills. Similar institutional arrangements seem to be required for the production of all cultural objects, and the reason for this is that the production of a cultural object—whether it be a television set, an ashtray, or a motor car—will always serve certain interests while threatening or even undermining

others. Conventions and institutionalized procedures serve the purpose not just of regulating these competing interests but of advancing some at the cost of others.

Human interests can both be served and harmed by the production of cultural objects. By producing a television set I adversely affect the interests of a radio manufacturer; and by producing an ashtray I adversely affect the interests of the asthmatic or offend the tastes of an interior decorator. Again, motor cars, although a wonderfully useful means of transport, consume scarce resources, pollute the atmosphere, and injure people. It is in the interests of some people, therefore, to have certain rules and regulations which ensure that motor cars are less dangerous, consume fewer resources, and do less polluting. But this may very well challenge the interests of the car manufacturer. Consequently, what is needed, and what usually evolves, is an institutional structure that will regulate the production of cars, and in so doing adjudicate between conflicting interests, thereby serving some rather than others.

All of this is true of the fine arts as well. They, too, occur in institutional settings that are designed to regulate and perpetuate them, but which, in so doing, advance certain interests and subvert others. There are, for example, schools of fine art, art critics, gallery directors, philosophers of art, artists, and their audiences, all of whom try in one way or another both to advance certain views of art while challenging and even proscribing others. They do this not just because they sincerely subscribe to certain artistic values but also because, as officers of the artworld, they have an interest in perpetuating some views of art and undermining others.

Aesthetic Value and Social Structures: A Conclusion

Far from being untouched by life, the values that attach to art—what traditional aesthetics thinks of as aesthetic values—are bred of our everyday practical concerns and interests. This is not to say that they

just reflect individual preferences. Initially, no doubt, an individual or a group of individuals must have liked a design, an arrangement of colors, or a sequence of sounds, and must, as a result, have had an interest in producing similar objects. It is, however, the agreement among a group of people that certain objects are to be preferred on account of the specific features that they embody that marks the first step toward the establishment of publicly accessible criteria of value that can serve as reasons for the ascription of aesthetic concepts. Still more, such an agreement—whether spoken or unspoken—is inevitably social in character, and it is in this sense that the values to which we appeal in applying aesthetic concepts and in judging the merit of works of art are to be found not in individual preferences but in the society at large.

Societies and the structures that characterize them take their shape around human interests. Different social structures serve different interests, and it is well known that not all interests are served equally. Much the same is true of that cluster of social relations that is called the artworld. It too embodies and reflects (in the form of criteria of value) certain artistic and social interests while subverting or undermining others. This is why it is false to maintain that aesthetic values are pure and totally unmediated by economic, moral, intellectual, religious, or gender interests. For all of these reasons, then, any attempt to explain aesthetic judgements as devoid of, and wholly uninfluenced by, the concerns and interests of everyday life is bound to fail.

Chapter

FIVE

ART, NARRATIVE, AND HUMAN NATURE

The boundaries that distinguish high from popular art, good from bad art, and art from life or reality do not exist independently of the social concerns, interests, aspirations, and values that form part of our everyday lives. If the last three chapters have established anything at all, it is that there is no metaphysical basis for these distinctions. They are all constructions that exist because people want them to exist; constructions, moreover, that do not always reveal existing social practice as it pertains to the arts. It seems to follow from this that the boundaries of art are not so stable as we are sometimes inclined to believe.

There is, though, another way of undermining these boundaries: one that does not appeal directly to their social origins. If talk about art can be shown to be literally applicable to nonart—to objects that are not works of art and to actions that are not involved in the production of art—the distinction between art and nonart becomes much less rigid than we might previously have supposed, and all sorts of similarities between the two begin to emerge. Part of my strategy in this chapter, then, is to subvert the notion that art occupies a domain all of its own by showing that the language of art applies readily and literally to the nonartistic phenomena of everyday life. Following on from this, I show that the processes integral to artistic production play a vital role in the way in which people pursue and satisfy their various interests.

Whenever we speak about ourselves, of the sort of people that we and others are, we lapse, almost inadvertently, into the idiom of both

the visual and the literary arts. It is not just that we have "images," "pictures," and "views" of ourselves which are more or less "balanced," "colorful," or "unified," but that we also have "stories" and "narratives" to tell about our lives which both shape and convey our sense of self.

There is, at first sight, something curious about the fact that the language of art finds such a ready niche in discussions about ourselves. After all, it is not as though we are works of art; and yet it seems that there is no other nonartistic phenomenon which provides such a comfortable haven for the idiom of the literary and the visual arts. It is here, too, that the language of art most obviously enters the arena of political skulduggery. We nod conspiratorially when we learn that there is another and very different "story" to be told about an acquaintance; and we spend much time trying to displace the "images" and "pictures" that some people project of themselves.

The converse also applies, for many of the linguistic expressions that we use in order to assess ourselves apply equally to works of art. We find works "sincere," "honest," "courageous," or "sensitive"; we are "disappointed" in them, "disapprove" of them; we "love" or "hate" them, and so on.

This invites a range of questions, for it suggests that the arts are more intimately connected with one's sense of self, one's individual identity, and one's world of social interaction than we might previously have supposed.[1] It suggests, too, that the arts play a political, perhaps even a subversive, role in our lives. My aim in the present chapter is to explore these claims and in so doing defend the view not just that the visual and literary arts sometimes influence our sense of self, and with it our idea of human nature, but also, and more significantly, that our individual identities and ideals of personhood are constructs produced in much the way that works of art are produced. Furthermore, I shall argue that, like works of art in general, the identities that we assume are politically significant and fall prey to all manner of political intrigue. In this way, I hope further to destabilize the boundaries between art and life.

Looking at Myself

The interest that you and others have in the sort of person I am is, quite often, a moral interest. You want to know, among other things, how I have behaved in the past and how I am likely to behave in the future. If, in your opinion, I am not the sort of person that I ought to be, and if, still worse, I do not appear to see myself for what I am, you may attempt to modify my sense of self. This is what my mother does, when in the Platonic and Christian tradition, she exhorts me to "take a good look at yourself." But such an exhortation is problematic, for it is not at all clear what I could hope to learn about the sort of person that I am just by looking at myself.

What, then, would I see were I to follow my mother's advice and to "take a good look at myself"? This, of course, is not a question that demands recourse to mirrors. Nor is it a question about the size of my neck or my ample girth. It is, as I have said, a question about the sort of person I am, about my character, or my nature as a human being. It does not explicitly invite a general account of human nature, although in discussing the sort of answer that such a question deserves, we will, I believe, learn a good deal about the concept of human nature.

A first and obvious point to make in answering the question is that when I take a good look at myself, I do not *see* very much at all. Nor do I really *look* at myself. The reason is obvious. There is more to my person than the body I stand up in. I am not talking of souls, but I am talking, among other things, of my past actions, aspirations, jealousies, fears, beliefs, expectations, values, knowledge, neuroses, and obsessions. These, we are inclined to say, are just the sorts of considerations that we take into account when we want to know, say, what sort of person Boris Yeltsin is. Presumably, then, they are the sorts of considerations that will have to be taken into account when I want to know what sort of person I am. So, whatever else I do when I take a good look at myself, I will have to consider a goodly number of those actions, passions, aspirations, psychological states, and the rest that can properly be attributed to me.

These are not things that the eye can discern. The vast majority of my actions and passions are long since past; my beliefs, although indirectly visible, have evaporated or else changed with time; my values

have shifted; my neuroses have waxed and waned almost with the phases of the moon. Even if I could capture this with a hypothetical inner eye, through some sort of wide-angle introspection, which gathers together in one broad sweep images of all these items, I should still have to make sense of this bewildering array of bits and pieces of information before I could claim to know what sort of person I am. All that wide-angle introspection would achieve, if such a thing were possible, would be knowledge of a motley collection of disconnected items; and a collection of this sort cannot of itself afford a coherent idea of one's personhood.

But, of course, wide-angle introspection never occurs. It is not as if all of my past is readily found neatly encoded in pictorial form against the back wall of my mind. If I really do look, using the only eyes that I have, I see some of the things in front of me. The ideal, therefore, of discovering the "objective truth" about myself through introspection is simply unattainable. When, in this context, I am described as "introspecting," I do little other than try to remember and recall the sorts of things that I have done and felt. The process is an active one, and not, as empiricists would have, the passive, visual registering of our inner states. What we recall depends in large measure on the sorts of questions we ask, and these, in turn, depend on our purposes in asking them: purposes that do not spring out of thin air, but are, in their turn, shaped by a variety of social influences.

It is clear from this that however else we explain the notion of a self-image, we cannot construe it as a purely visual one: a static "snapshot," passively imprinted on the mind. True enough, my identity as an individual may in part be shaped by certain visual images (including, of course, actual snapshots in the family album), but these do not *tell* me what sort of person I am. Like pictures, visual images have to be used in certain ways if they are to tell us something specific about a subject, for, as I have argued in detail elsewhere, we need to distinguish what a picture depicts or is of, from the communicative acts that it is, or can be, used to perform.[2] On my view, it is only in specific contexts, and only if they are used toward a certain communicative end, that pictures or visual images *tell* us anything specific.

Stories about Myself

The many facts that I recall about myself will have to be organized in one way or another before they can help me understand what sort of person I am. Put differently, one could say that I will have to mold the discrete events of my life into something more pregnant than annals or a chronicle or a list of past events. More specifically, I will need to organize in a sequential, developmental, and meaningful way what I take to be the brute data of my life. To do this is just to construct a narrative or a story about my life; a story that, although nonfictional, is in some measure the product of certain creative or fanciful imaginings. For although my story purports to be about certain real-life events, and so is nonfictional, the way in which I relate and organize my memories of these events, and what I treat as marginal or central to my life, can be more or less imaginative.

The stories that people tell about their lives are of considerable importance to us, for there is an intimate connection between the ways in which people construe themselves and the ways in which they are likely to behave. To take but one example, we all know that it is never enough merely to tell ourselves and others of our lives of kindness and bravery if we do not also contrive to *show* that we are worthy of these epithets. And this must involve behaving in certain ways. Because of this, it is tempting to construe the lives we lead on a dramatic model— as if our life-narratives furnish the scripts that are to be enacted on "the stage of life." This imagery is familiar enough, and has been around since well before Shakespeare. It is to be found in Machiavelli's *Prince*, and much more recently in Freud, G. H. Mead, Erving Goffman, and Richard Wollheim.[3] Although I do not propose to explore these versions of the model here, in one way or another they all suggest that how we view and think of ourselves strongly influences our behavior.[4] It is because of this that we are often concerned enough to challenge the stories that people tell about themselves. We urge them to think again, and in giving them reasons for doing so, we attempt to subvert their sense of self. There is an intricate political process at work here: what I should like to call the politics of narrative identity, whereby we assert and maintain our own interests not just by advancing a particular view of ourselves but by undermining the views that others advance

of themselves. Stories and counter-stories are told; history is written, subverted, and rewritten. And in this game of strategy, those who have the last word also have considerable power over those who do not.

But do we really need to tell stories about ourselves or about episodes in our lives in order to develop a coherent sense of self? It has recently become fashionable to suppose that the self is and has to be a narrative construct, but very little is ever done to argue the case.[5] Why, for instance, shouldn't I develop my sense of self, not by telling a story but by pointing to the causal connections between certain events in my life? The story form, after all, can distort what actually happened, the order and the importance of what happened, so that what we need (someone might argue) is something less imaginative, less fanciful, more descriptive and more accurate, if I am really to know what sort of person I am.

What this sort of objection overlooks is that reports of causal sequences, like annals, lists, and photographs, do not of themselves afford special significance to any of the events in our lives. They fail to tell us which events are central and formative, and which marginal, to the persons we are. Since I can have a coherent, nonfragmented sense of self only if I regard some of the events in, and facts about, my life as more prominent than others, and since reports of causal sequences, like lists or annals, do not afford the requisite prominence to any particular fact or event, they cannot furnish me with a unified sense of self. It is left to narrative to do the job, for it is the only variety of discourse that selectively mentions real or imaginary events and orders them in a developmental or sequential way (the plot) so that the whole discourse (and the sequence of events which it mentions) eventually acquires a significance, usually a moral significance, from the way in which its parts are related to one another (closure). It is because of this that narrative alone gives us the freedom to select and arrange the events of our lives in ways that afford them what we believe to be their proper significance. Without narrative, there simply is no way of emphasizing some events, marginalizing others, and at the same time relating all in a significant whole. Certainly, if one were to chronicle the recalled events of one's life, some would achieve greater significance than others, but because chronicles do not, by definition, achieve closure, it would not be possible to impart significance to one's

life as a whole. In short, it would not be possible to extract from a chronicle, or any variety of discourse other than narrative, a coherent and unified sense of self.

One can, of course, have theories of persons, or theories about oneself, that are not themselves narratives, but which do nonetheless play an important role in the development of one's sense of self. Such theories, however, give us a unified view of self only to the extent that they enable us to select, order, and impart significance to the events in our lives—that is, only to the extent that they enable us to formulate stories about ourselves. Unless they are cast in a narrative form, such theories or explanations are not themselves sufficient to give one a unified sense of self. They do so only to the extent that they help shape the narratives that afford us our self-image. They are not a substitute for narrative.

Part of our fascination with narrative is its flexibility. It can take indefinitely many forms, and so allows its authors considerable scope for their own inventiveness. There are, in consequence, many literary devices that authors invent and introduce into their texts in order to heighten the effect of their stories: devices which make their narratives altogether more plausible, accessible, interesting, and exciting. It is well known, for instance, that a narrative enjoys its own "narrative time," which has to be distinguished from the real time within which the narrative is told. By manipulating narrative time, one can amplify both the affective and the cognitive impact of the story. One can "telescope" time, thereby bringing salient events in the narrative "closer together" and forcing them on the attention of an audience. One can make events appear timeless and universally true, or one can so stretch time that each tiny event within the narrative assumes an importance it would otherwise have lacked. Still more, through flashbacks and what are sometimes called "foreflashes," the manipulation of time allows the narrator an omniscience denied to ordinary mortals.[6] But to say this is only to hint at the powers of narrative. It is not at all to explain how it exercises them. What it does help explain is the attractiveness of the narrative form to those among us who wish to see and present ourselves favorably.

There is another reason why we find life-narrative attractive. It is this: the comprehension of narratives invariably demands the imagi-

native participation of those who attend to them. While I am not sure that David Hume is right when he says that human beings are naturally empathic, it does seem clear that most people desire and need the empathy of others. Stories about ourselves, in which we figure as central subjects, and to which others attend imaginatively, invite the sort of empathy we most desire.[7]

So, despite the objections, there really are good reasons for reverting to life-narratives, to stories about myself, in order to explain the sort of person I am. Chief among these, of course, is the fact that narrative plays an essential role in the development of a unified individual identity. I do not, of course, wish to suggest that we all enjoy such an identity. We do not. Most of us have, at best, a fragmented and changing view of self. We see ourselves successively in different, sometimes incompatible, ways, and we do so, on my view, because we are inclined to tell more than one story about ourselves. This, however, does nothing to affect the fact that narrative is integrally involved in our search for a coherent self-image.

The demand for such coherence seems to me to be historically and culturally specific, and is by no means a feature of all societies. It certainly *is* a feature of the society that we inhabit, and seems to have taken root in the Greek and Christian injunction to "know thyself." The day of judgment, it would seem, looms large in our lives and demands a single, unified view of self: a flawless whole that determines our direction in the afterlife. It is no part of my purpose to discuss the desirability or otherwise of this demand, or of our attempts, in its wake, to develop a unified or coherent view of self. What is clear, however, is that we find it difficult to develop such a view, and that the demand for it may itself be psychologically damaging. For all that, though, it seems plain that the demand for a single and unified view of self is one which is frequently encountered, and it seems plain, too, that in order to develop it, we are forced to rely on plain storytelling: on narrative. For, as we have already seen, the stories that we tell about ourselves impart meaning, purpose, and formal unity to our lives; they give them some or other structure or point (what I have called "closure"). The point might, indeed, be negative. It could turn out, according to the story I tell, that mine is a wasted life; but it could equally well turn out that mine is a life of charity and service.

For the most part, people have little difficulty in constructing and telling stories about themselves. They may be too modest or too shy to do so, but if pressed, most people can tell you, in incipient story form, what they think of themselves. It might simply be a statement of the form "I'm a loser." This, of course, is an abridged version of a much longer story which, if told, would relate recalled events in sad and self-diminishing ways. People seldom spell these stories out at length. The self-absorbed and the articulate do, but for the most part our life-narratives are reduced to pat formulae in terms of which we habitually see ourselves. The important point, though, is that people do seem, in ways yet to be specified, to carry with them a view, most often several incompatible views, of themselves: organizational principles, or, as I shall call them, narrative structures according to which, given the inclination, they can (and sometimes do) construct a full-fledged narrative about themselves. Of course, it is not as if people will normally settle down for an evening and tell you the complete story of their lives. Most often, they tell stories about parts of, or events in, their lives; and they do so in ways that afford insight into their character.

That we all entertain such narratives, and that they shape our view of self, emerges most clearly when we reflect on the phenomenon sometimes referred to as agent regret.[8] As a young student at Oxford, Alfred misphrased a question during a seminar at Merton Street and was guilty of a minor howler. There were ripples of laughter, but the drift of the question was grasped easily enough, and an answer given. Now, some decades later, Alfred still feels profound discomfort when he recalls the event. He regrets the howler, and he continues to regret it even though no harm came of it. Alfred was not thought the worse because of it; nor was he declared unemployable. The people present have long since forgotten his question, the howler, and the laughter it occasioned. In fact, Alfred is now a famous and well-paid philosopher. But the howler still continues to rankle, and he regrets it now almost as much as he did then. Why should this be?

On my view, Alfred regrets it because the error is not part of the story he would like to be able to tell of himself; it sits uneasily with his self-image. Alfred is disposed to think of himself as an articulate, intelligent, and fluent philosopher: a stimulating and penetrating thinker to whom people like to listen. Howlers, no matter how minor,

have no place in this story. His regret, it seems, is not a moral, but an aesthetic response to what he now regards as a blemished image, a sullied narrative.

One could, of course, say that Alfred's pride was bruised, and hope to explain his regret in this way. If so, it is thought, there would be no need to appeal to narrative identity and the like in explaining this instance of agent regret. But appeals to pride explain too little, for it is not clear how we are meant to account for human pride. On my view, pride must itself be explained in terms of the stories we prefer to tell about ourselves—in terms, that is, of the ways in which we select and organize the recalled events of our lives and so think of ourselves. It is the desire to protect and retain a particular view of myself—a view that is bred of the life-narrative or history or story I tell of myself—which best explains the regrets, stubbornness, and arrogance so characteristic of human pride.

It would seem from this that in one form or another we all carry with us narratives which help furnish us with ways of thinking about ourselves. People are disposed to think of themselves as chaste, pious, devout, humble, and all that this implies; and they would prefer to select and organize the events of their past, and so tell the stories either of their lives or of episodes and stages in their lives in terms of these structures.

It is wrong, of course, to treat these ways of thinking about ourselves, these character sketches, as full-blown narratives. They clearly are not. They do, however, express an integral part of narrative. They are narrative structures, for they are the expression of the organizational principles around which detailed narratives can be constructed. They are abstract and truncated narratives. Still more, as I have said, they are narratives of which we are not constantly aware. It is not as if they are perpetually before the mind's eye or ear, bouncing around in one's head, so to speak. Rather, they should be thought of as dispositions to select, relate, and think of the events of one's life in specific ways. This is not to say that we cannot articulate these principles or the detailed stories which they subtend. We can and we do.

The Nature and
Politics of Narrative Identity

Our narrative identities are neither God-given nor innate, but are painstakingly acquired as we grow, develop, and interact with the people around us. Our identities may, of course, be based on past experience, but such experience, we have seen, is too complicated, amorphous, and anomolous (even if accurately recalled) to admit of a coherent self-image. Most often, I have stressed, life-narratives, and the identities to which they give rise, are imaginative constructs that people adopt, and in terms of which they select and order certain events in their lives. However, not all of these constructs are the products of the individual's own imaginings. They may be borrowed from other sources: most obviously, I suppose, from television, the cinema, the theater, and novels. Sometimes, as we shall see, they are not merely borrowed but actively imposed on us by others.

More important for the moment, however, is the fact that the view that we take of ourselves, our narrative identity, is the source of our self-esteem. Those who have reasonably high levels of self-esteem, perhaps because they are disposed to think of themselves as efficient or intelligent, will tend to be guided both in what they attempt and, as a result, in what they achieve, by their sense of self. They are more likely to undertake demanding tasks than those who suffer an impoverished identity. In this important sense, one's self-image or identity is action guiding. As a result, any construal of one's actions that challenges one's sense of self, that suggests, say, that one is less than efficient or intelligent, has the potential to inhibit one's behavior and will be the cause of some consternation. People whose positive self-image is challenged in this way will generally defend themselves against such accusations—either by regarding, say, their inefficiency as momentary and untypical, or else by denying the charge altogether and by attempting to explain it away.

People are generally obliged, for reasons of their own psychological well-being, to defend themselves in this way. For any successful attack on an individual's positive self-image will induce a crisis of confidence, a measure of trauma, depression and, on occasions, neurosis.

It is in order to avoid such crises in our lives, and the dislocations and upheavals that they produce, that we protect ourselves by clinging stubbornly to our identity even at the cost of denying the obvious. Sometimes, moreover, rather than risk this sort of upset, we embrace life-narratives which seriously underestimate our capacities and capabilities, leaving us with very little to live up to. These observations, of course, have more to do with empirical psychology than they have to do with traditional philosophy.

The fact that life-narratives tend to guide and regulate our behavior is of the greatest social significance. They are responsible not only for many of the achievements in our society but also for the many underachievers. The notion of narrative identity also helps explain why people are often immune to reason and rational argument. Individuals are sometimes confronted by sound arguments that tend to undermine important aspects of their self-image and so pose the threat of personal confusion, upheaval, and crisis. Thus, for instance, people who think of themselves as devout, pious, and obedient, and who think favorably of themselves on this account, will not generally be persuaded by an argument—no matter how strong it is—that demonstrates the incoherence of the traditional concept of God. For whatever else our narrative identity does, it helps determine what we consider to be important. Hence a few contradictions and non sequiturs may be considered utterly inconsequential by those who see themselves as primarily devout and obedient theists. On my view, only those people who think of themselves as fundamentally rational will take seriously the accusation of irrationality. To accuse such people of intellectual pride is to attack their individual identity or self-image. It is an attempt to replace it with a self-image more conducive to the interests of those who are embarrassed by rational argument and who regard it as a threat to their identity.

By now it should be clear that narrative identities are of crucial importance not just for the individuals who bear them but also for the societies in which they live. How we see ourselves affects what we regard as important, and this, in turn, must affect how we behave toward others. This, as I said earlier, is why the view that you take of yourself becomes of profound concern to me. I simply cannot afford, for reasons of my own well-being and safety, to allow you to think of yourself

as ruthless, devious, and violent, as powerless or deprived relative to myself, or as belonging to a race, religion, or civilization superior to my own. If you do think of yourself in any of these ways, and if I am sufficiently perturbed by this, I will attempt to subvert your self-image and to replace it with an identity more conducive both to my interests and to what I perceive as the interests of the society as a whole.

The process is quintessentially political, for it involves not just the pursuit but also the regulation and adjustment of various interests within a society. It is a process, moreover, that occurs at a variety of levels. At one level it involves a straightforward interchange between individuals. People try, in ways Goffmanesque, to project particular views or impressions of themselves. They see themselves, and project themselves, as efficient, friendly, and so on; and through a variety of subtle and complex strategies (which involve both *telling* and *showing*) they may successfully impart this view of themselves to others. If, however, one is threatened by a particular narrative identity, the political process takes a different turn, and, as we have just seen, attempts are made to undermine and replace the projected identity. This can occur in different ways. It might involve persuading some third party that a certain person should not be "taken at face value" and that there is a "different story to be told." Alternatively, it could involve persuading certain people that their self-images, their narrative identities, are inaccurate, and that they should see themselves differently. A good deal of our conversation about people consists in just such critical appraisals and reappraisals of the narratives and narrative structures in terms of which they are disposed to see themselves.

There is a second, macroscopic, level at which the politics of identity is pursued. The state invariably assumes a proprietorial interest in our individual identities, and is concerned to see them develop in certain ways rather than others. Schools, the media, and religion are only some of the institutions which are used to convey narrative structures in terms of which we are encouraged to see ourselves. They offer ideals of personhood—whether in history lessons, deportment manuals, *Rugby News*, or *Women's Weekly*. Still more, there are boards of censors appointed by the state which discourage or proscribe certain narratives, which ban films that portray sado-masochism as a virtue or denigrate certain racial or religious groups. They do this precisely

because those who are dominant within the state often wish to pre-
vent people from adopting damaging or potentially dangerous narrative
identities. They neither want people to be cruel, nor (one hopes) do
they want them to feel inferior on account of their race or religion.

Not every state is equally magnanimous, and history tells of those
that have fostered entirely pernicious narrative identities. Germans
and white South Africans have at various times been encouraged to
see themselves as racially superior and to interpret their lives and their
rights accordingly. To challenge such narrative structures is, of course,
to act politically; so that the politics of narrative identity can easily
reach to the core of state politics. It can alter relations of production
within the state by altering the passive acquiescence of those who are
exploited by it. It seems correct to say that the black consciousness
movement of the 1970s recognized a good deal of this, and initiated
its struggle for liberation at the level of narrative identity.

Narrative, Norms, and Human Nature

The message to be taken from all of this is not just that our narrative
identities are intimately involved in the political process but also that
the facts of our personal existence, the brute data of our lives, do not
themselves tell, or compel us to tell, any *one* story about ourselves.
In the process of political self-definition it is often in my interests to
suggest that the facts of my life "speak for themselves"; that what I
say reflects, is shaped, and constrained by what actually happened;
that I am not simply telling a story. As Hayden White points out, the
narrative element of my personal history is an embarrassment, and I
suppress it by pretending that the events of my life cohere in a way
which tells their own story.[9] Alternatively, when the embarrassment is
overwhelming and the narrative element unmistakable, I will explic-
itly acknowledge and so defuse it by saying things like: "Of course,
this is just *my* version of what happened," or "I *think* I'm being accu-
rate," or "This is how *I* see it." The story takes a different twist at
this point, for I now tell it in a way that is designed to demonstrate the
narrator's sincerity.

We have seen, of course, that the views that we take of ourselves are constructs, and are invented rather than discovered. At first sight it would seem that we invent these ourselves. After all, we know that we often dream about the sort of people we would like to be: rich, glamorous, dashing, brave, and so on. But individuals do not simply pluck these visions out of the air. They are suggested to us in many different ways by the societies in which we live. Our parents, teachers, priests, and friends all play a role in our socialization, and in so doing they impart values and instill ideals. It is in the light of these that we prefer to imagine ourselves as ruthless and tough rather than sensitive and caring, fearless rather than circumspect. This process of suggestion is also facilitated by the novels we read and by the films and plays we see. In the light of these we sometimes imagine ourselves in certain ways: as a latter-day Robin Hood, as a sagacious Mr. Knightley, as a soulful and unhappy Maggie Tulliver.[10]

Most often, however, because we already subscribe to certain socially instilled ideals and values, we creatively combine certain aspects of real and fictional people with selected facts about our past, and in so doing create our narrative identities. But this is not always the case. At times our identities are given to us, and we become the beneficiaries, victims, or playthings of the narratives that others create and push in our direction. J. M. Synge's *Playboy of the Western World* provides a fictional example of this phenomenon, but it occurs as well among actual people in the world that we inhabit. People do have greatness thrust upon them. In being treated as folk heroes, they think of themselves as folk heroes, arrange the details of their lives, and begin to act accordingly. They internalize the role of judge, doctor, academic, or priest, and begin to think of themselves in the sometimes sterile ways suggested by the institutions to which they belong.

For the most part, whenever people wish to have their narrative identities praised and taken seriously, they try to project them normatively. In such a case, it is not just that I want you to accept the image that I project of myself as truthful and worthwhile but that I want this image to be accepted as a standard in terms of which to judge others and interpret their behavior. I do not only create a story about myself, but I try to ensure that the story either is, or will become, part of the canon of stories in terms of which to assess other human beings. If, as

happened in the sixties, I were to think of myself as a child of peace, a flower child, and if this turns out to be socially unacceptable, I will try in sundry ways—perhaps by forming group movements and by developing ideological arguments and publishing them—to get others to see my identity as desirable. And this, of course, is precisely what happened not only in the sixties but also among those in the eighties who sought to legitimate a homosexual identity and who formed the gay pride movement.

It seems clear from this that we can change people's ideas about what constitutes a normal, decent, or natural human being by bringing them to accept and respect the stories we tell about ourselves. Consequently, what we think of as natural in human beings becomes highly variable, depending more on social values and the consequent acceptability of certain narrative identities than on the brute facts and physical substance of our lives.

It is not just that we can change one another's ideas about what is natural in human behavior, but that in changing these ideas we can change our behavior. Human beings are notoriously suggestible and can be brought to think of themselves and construe their lives in indefinitely many ways. This is important because, as I have stressed, people will be kind and charitable if they can be brought to think of themselves as kind and charitable. Alternatively, they will be aggressive and competitive if they are made to think of themselves in these ways. In the light of this, it seems that to say of human beings that they are naturally kind, naturally competitive, or naturally heterosexual is to try to lend normative status or "legitimacy" to particular ways of construing our lives, thereby encouraging certain forms of behavior. We do so by appealing (sometimes tacitly, sometimes explicitly) to the authority of science, attempting thereby to reify our narrative constructions not just by calling them "natural" but by trying to locate their source in our biology.

It is not just that we can change people's ideas about what constitutes a proper, decent, normal, and natural human being by "selling" particular narratives about ourselves but it is also true that these narratives (or narrative structures) acquire their legitimacy and normative role from the society that accepts them. For the most part, of course, such acceptance will depend on prevailing notions of what is or is not

true. If the narrative in question is not considered true, it will usually be rejected. But this need not be the case, for there are societies and subcultures in which people are encouraged to adopt narrative identities that are known not to fit the facts of their lives. This suggests that it is often the social acceptability of a narrative identity, and not the truth of the narrative which constitutes it, that determines what we regard as natural, worthy, or excellent in human behavior. What is praised as noble or as natural in one society may be condemned as brutal or unnatural in another. There is nothing new about this; nor, I think, need it introduce a moral relativism.

Although I cannot defend the claim here, I do want to insist that there are facts of the matter, and that nonfictional life-narratives may be shown to be true or false by appeal to them. It is particularly important to see that the facts in terms of which we assess a given life-narrative may be known independently of any specific history or story. It seems plain that I can learn that people desire food, or that there was an earthquake in Chile on 15 July, without believing or inventing a specific story that somehow informs my experience. If I am right, there is no good reason for denying the existence of prenarrative facts, or for insisting (in a way reminiscent of some postmodernists) that all experience and knowledge must be mediated by, or derived from, narrative.[11] Not all explanations are narratives, nor are all theories, descriptions, lists, annals, or chronicles. To suppose that they are, or to suppose that all experience is bred of narrative, is to so stretch the meaning of this word as to render it blunt and all but useless. To inform someone of a causal sequence (that food nourishes or that people deprived of water must die of dehydration) is not to tell a *story* in anything but the most extended sense of this word. Narrative identities, as I have explained them, involve stories in a much fuller, more literary sense, and can be assessed by appeal to the facts of a particular life.

Personhood and Arthood: A Conclusion

At the start of this chapter, I said that it was possible to destabilize the boundaries between art and life by showing how readily the idiom of the visual and literary arts filters into our talk about people—more particularly into our talk about the sorts of people that we and others are and ought to be. This, I said, deserves some sort of explanation, for people are not works of art and it is at first sight curious that the language of art should apply so readily to them. So far, however, I have tried only to show that we do not discover our individual identities through some sort of inner observation, but that they are narrative constructions which are of considerable importance both for the individuals who bear them and for the societies in which they live. I have stressed as well that, having created or adopted narrative structures in terms of which to construe ourselves, we try, through dramatic projection, not just to get others to see ourselves as we would be seen, but to get them to treat our narrative structures and individual identities as norms in terms of which to judge and understand other human beings.

It is time now to explain why the language of art applies so readily and literally to our attempts to develop individual identities and ideals of personhood. The reasons, I believe, are plain enough, for by now it should be clear that there are very strong resemblances between our individual identities—how we come by, foster, and legitimate them; and works of art—how we produce, criticize, and secure acceptance for them. Like narrative identities, works of art are not discovered but invented; they are, of course, the product of an artist's creative efforts in a particular social context. We know, too, that as with our individual identities and ideals of personhood, works of art do not always find acceptance and favor within the community in which they are produced. There are many reasons for this. The most obvious of these is that the works run counter to, and challenge, prevailing artistic standards. But in so doing, of course, they also challenge individual and group interests within the artworld, for the very act of ignoring the established canon and all the standards and artistic myths that it subtends, threatens the status of its advocates and apologists. The criticism of works

of art thus carries with it the same political dynamics and intrigue that we have found in the criticism of people and ideals of personhood that they favor or project. And just as individual identities or ideals of personhood have broader ramifications within the larger society, so too do works of art; so that the state often assumes an interest in, and a measure of control over, the production and dissemination of both the popular and the so-called high arts.

What is more, just as we feel obliged to construct narratives about ourselves or about events in our lives in order to make ourselves acceptable to others, so, Anita Silvers observes, critics, art historians, and artists often attempt to secure acceptance for particular works of art by constructing narratives about them.[12] Such similarities are neither fortuitous nor superficial. What we are describing in both cases is the production of certain cultural objects. Narrative identities, like works of art, are cultural objects produced in a social setting in order to meet specific human needs and desires, but which, through the very fact of their production, may prevent the satisfaction of other needs and desires. Consequently, there is, as we saw in the previous chapter, a perceived need on the part of members of any society to regulate the production of such objects. One might say that they are produced within a certain social framework that attempts always to preserve specific values and interests at the expense of others—although, of course, it will not always be successful in its endeavor to do so. Whenever it fails, new values achieve a degree of prominence and different interests are served.

This, we have seen, is true of the production of all cultural objects from ashtrays to insecticides and works of art. However, the similarity between the production of the literary and visual arts, on the one hand, and our individual identities and ideals of personhood on the other, is especially strong since, as we have seen, both frequently contain an imaginatively produced narrative core. Still more, both works of art and narrative identities are constructed with a possible audience in mind—in the hope, in each case, of achieving broadly similar effects. For just as we want our narrative identities to be acceptable and worthwhile, marking what is decent, normal, and natural in human beings, so, too, we want our works of art to be accepted as important and valuable: as standards of merit in the artworld. We want both to be-

come part of their respective canons and we engage in each case in the same sort of sociopolitical maneuverings to achieve this. Then, too, of course, the construction of narrative identities, like that of works of art, is often highly inventive. Both are usually constructed with immaculate care, often with insight and sensitivity, and in a way, moreover, that must alter and contribute to the sorts of people we are.[13] For in creating either, we are brought to explore a range of human values in a way that tests, teases, and adds to our moral and aesthetic understanding.

It is because of these fundamental similarities between the creation of works of art on the one hand and narrative identities on the other that the language and idiom of the arts applies to each. They are similarities, we have seen, which take root in the fact that both are cultural objects. There is, then, nothing at all surprising about the fact that the same idiom applies to both. One could only find it so if one were to ignore the cultural dimension either of art or of individual identity.

The observations and arguments of this chapter enable us to see that the process which characterizes artistic production is central to the lives we live. This process is not the dispensable luxury that we sometimes take it to be; nor is it something that we are free to take or leave as we please. It is, rather, a primeval process whereby we come to make sense both of ourselves and of the world in which we live: a process at the very heart of our existence and social being.[14] Since this process straddles both art and life, we have a further reason for being skeptical of the view that there are or could be impermeable boundaries that separate art from life.

Chapter
SIX

KEEPING UP APPEARANCES

Appearances, our parents warned us, are not everything. Beauty, they said, is skin deep; and we were further warned (sometimes in somber tones) that there is more to a person than a pretty face. All of this is doubtless true, and for once our parents were right. But they also told us to brush our hair, to use make-up sparingly, and to clean our fingernails. Appearances might not be everything, but in our own lives we soon learned that they were far from trivial and needed to be treated with respect.

Most of us are encouraged to attend to and to cultivate our own appearances, but, at the same time, to be mildly skeptical of the appearances of others. This schizoid attitude does not, in my view, reflect confusion. It reflects an intuitive grasp of the importance and power of the appearances that individuals, couples, families, cities, and nations cultivate and project. A beautiful face can launch a thousand ships; the beauty of the fatherland can summon people to war.

The problem, of course, is to get people to recognize this beauty, and this problem is central to the questions that I want to explore in the present chapter. In doing this, I shall show that the very same problems that confront artists in their enterprise enter into personal, economic, and political relations in the actual world. We do much more than tell stories about ourselves in order to make our way in the world. We also attend to and develop our appearances in ways that play an important social and political role, and influence crucially the lives of people and of nations.

In this chapter, then, I take my argument one step further by attempting to uncover yet another respect in which the boundaries of art are permeable. My aim is to show that the processes whereby an individual, a family, or a nation develops appearances and parades them at large differ only in social location from the processes of creating and displaying works of art. When these processes occur in everyday life, we may see them as daring, as wily, or as political; when they occur in the artworld, they are an essential part of the creation of art. What we usually fail to recognize, I shall argue, are the many strands that ordinary political processes have in common with the processes of producing, and securing recognition for, our artworks.

Good Looks and Grooming

People groom themselves. They spend time and often vast quantities of money in an effort to mold their bodies, tame their hair, and improve their complexions. Even those who form part of the "deliberately ugly brigade,"[1] who dress in dull blacks and greys, wear torn and tired jeans, dirty hair, and threadbare overcoats, often expend considerable care on their "careless" appearance, and do so not just because they "feel good" when dressed that way but because this often is their only way of identifying with, and finding acceptance within, a particular community or group.

Our appearance is not the trivial matter that we sometimes think it is. It not only identifies us as having certain attitudes and values, and hence as belonging to specific (sometimes vaguely defined) groups within the community but it also serves to exclude us in important ways from other groups, ideals, and values. An individual can, of course, be more or less reflective about this, and it seems plain from what people say and do that they are often perfectly unreflective about their appearance; that if they grasp the social significance of their dress and grooming at all, they do so only at an intuitive level.

Nonetheless, since my appearance does have important social ramifications, your judgment of it will invariably be based on certain

socially acquired values that reflect interests and attitudes of one sort or another. To think of a woman as demure, well-groomed, slim, fat, dumpy, homely, ugly, petite, or graceful; a man as rugged, handsome, well-dressed, good-looking, or manly; a minister as doleful, insipid, and colorless; a schoolchild as sprightly, gay, shabby, or skinny is of course to judge their appearances. Such judgments, even when couched in aesthetic terms, are never the application of "pure" or "disinterested" aesthetic values. On the contrary, it seems plain that in these cases certain social values are being brought to bear. In our society at this time, only women are said to be demure; only men are thought of as rugged. And here gender-related values clearly govern our aesthetic ascriptions. Women are said to be demure only if they fit a certain social image and play a particular role that is sanctioned by expectations based on gender, and the same is true of the man who is said to be rugged. Again, to speak of the shabbiness of the schoolchild, the colorlessness of the clergyman, the homeliness or comeliness of the housewife, is to judge their appearances in terms of prevailing cultural values. What counts as a shabby schoolchild has a lot to do with the current economic climate, with standards of dress, and, of course, with attitudes to children and to childhood. Again, what counts as colorlessness in a clergyman depends crucially on contemporary attitudes to religion, the church, and the clergy. And we cannot separate comeliness or homeliness in housewives from dominant fashions of physical beauty or the role in any given society that housewives are meant to play.

A person's looks are plainly important, and in some sense serve as a "ticket" to acceptance by the group or by the community at large. Aestheticians have had very little to say about grooming and personal appearance, and this is surprising, not just because there is a copious aesthetic vocabulary that is used to assess one's personal appearance, but also because works of art of various kinds are often used to enhance and project our appearances. These include photographs, sculptures, and painted portraits. But they also include jewelry, tattoos, clothing, hairdos, and the use of body paint and cosmetics.

According to E. H. Gombrich, it "is certain that one of the earliest forms of pattern-making is the decoration of the human body. It

modifies the human body by cosmetic devices, by paint, tattooing, jewellery, headgear, or clothing, in a variety of combinations and with spectacular effect."[2] And he goes on to tell us that

> the dressmaker's power to conjure with the figure and thus to contradict biblical authority, which tells us that we cannot add a cubit to our stature, is only one of the many ways in which the body can be manipulated in its appearance. Even body painting or tattooing, which may be the oldest form of decorative art, must have been practised with this aim consciously or unconsciously in mind. . . . We all know how easily the look of the eye can be transformed by make-up . . . and what difference a change in hairstyle may make to the appearance of the face.
>
> Perhaps no one went further in this use of costume than Queen Elizabeth I of England, particularly later in life when she may have felt that her ageing features stood in need of such enhancement through a surrounding "field of force." We must isolate her face to discover the human being behind the made-up mask, encircled by an awe-inspiring halo composed of spreading circles moving outwards till they reach the final fringe of the lacework.[3]

But bodily adornment is not the only way in which one enhances one's appearance. The portrait painter can do the same. For not only could portrait artists of the eighteenth and nineteenth centuries bring people to see an aristocrat differently—as beautiful, handsome, and statuesque, as dapper, bold, or devout—but they could also flatter their subjects and gain their favor by creating an overly good likeness. Today the camera often serves this purpose, but so, too, do sculptures of leaders and statesmen. All conspire in one way or another to convey a particular look or appearance that is designed to bring us to see their subjects in a certain way: a look or appearance which may dignify or vilify, enhance or diminish, their subjects.[4]

Our power—that is, the control that we have over other people and their minds—is greatly affected by the appearances that we project. It was not without purpose that Adolf Hitler wore shoes with stacked soles, and Gandhi a sheet, sandals, and occasionally a loin-cloth. The splendiferous costumes of Henry VIII and Idi Amin were plainly designed to impress and overawe their audiences. They were intended

to make these leaders unassailable, to force the allegiance of their followers, and to gain new acolytes. The hairdo that you and I cultivate, the beards that we trim, the eyebrows that we pluck, and the gait that we affect may not always enhance our political power and prestige but may nonetheless make us more acceptable to others. Such devices may facilitate, even legitimate, our membership in a group, and, depending on the vulnerabilities of those who assess us, they may make us attractive (or unattractive) to people, facilitate friendships and sexual liaisons. Sometimes, too, they are contrived to enhance the attractiveness of politicians who are instructed by professional image makers to remove moustaches, alter hairdos, spectacles, manners of speech, and styles of dress in order to win the approval of voters.[5]

People do think about, and often plan, the way they look, although this is not to say that they always attend to their appearance with a mind to their power, prestige, or acceptance in a group.[6] Sometimes they are concerned with their looks as ends in themselves. Magazine advertisements, television actors, our cousins, and our friends furnish us with models that help determine how we would prefer to look, and we aspire to these appearances for no reason other than the delight that we take in our appearances. Although our appearances on these occasions may serve certain functions, it is not because of these functions that we groom ourselves in the way that we do. Rather, we wear the clothes, cosmetics, and hair styles that make us feel most comfortable—although, of course, our "comfort" in these instances is not entirely nonfunctional but often depends on the belief that our appearances make us acceptable (or unacceptable) to a chosen group of people. The way in which I dress and do my hair is indeed a personal matter, but it is never purely so. My appearance always has social, even political, implications that go far beyond the personal.

Thus, for instance, in perpetuating a certain type of appearance, I may also perpetuate particular attitudes toward a group of people. Certainly, it is up to me as a woman whether or not to dye and tease my hair, wear rouge, bright red lips, pearls, twinsets, a tight skirt, and high heels. The trouble, though, is that in dressing in this way I not only identify myself as belonging to a certain group of women but I encourage a particular view of women as decorative, relatively immobile, and hence vulnerable persons who, in the last resort, depend on

men for their living and their protection. That this view of women is often found to be constraining and oppressive is now widely accepted, but it is entirely overlooked by Janet Radcliffe Richards when she defends the right of each woman to decide for herself how she should look.[7] According to Richards,

> If it is worthwhile to go to the trouble of putting up Christmas decorations, it is equally worthwhile to go to the trouble of making oneself pretty for a party. People disagree about how much effort these things are worth, of course, but that depends on their own personal priorities. . . . Feminism is concerned with sexual justice, and not with the ultimate worthwhileness of one kind of preference over another.[8]

But Richards seems unaware of the fact that by assuming an appearance that has traditionally contributed to the oppression of one's group, one may well perpetuate that oppression.

If I am right, one's appearance has important social consequences, not just for oneself, but for others as well; and it is this that makes decisions about our personal appearance more than a matter of personal preference. Certainly one has the right to make decisions about one's appearance, but like all rights, this one is defeasible, and becomes forfeit, I think, in those situations where its exercise creates more harm than good. Whether there actually are such circumstances is not an issue that I will pursue at present. What is obvious is that there could be. Think, for instance, of footbinding, and of those Chinese women—if there were any—who insisted on their right to dress their feet in the traditional manner, thus encouraging the expectation that all women's feet should be similarly treated.

On my view, it is our explicit or intuitive awareness of the social implications of our dress and hairdos that incline us to attend with care and deliberation to our physical appearance. People often sculpt and craft their appearance with all the thought and care of an artist. Just as there are minimalists among artists, so there are the equivalent of minimalists when it comes to grooming: those who very deliberately put minimal effort into their appearance, but do so in order to create a particular effect. Similarly, there are baroque groomers, naturalist

groomers, and, when one considers punk, even Cubist and Dadaist groomers. The careful groomer often hopes for the same rewards as the artist—that is, for acknowledgment, approval, and acceptance within a social group. Still more, just as artists strive to have their works admitted to the canon, so, too, do those individuals who do not wish to conform to certain standards of dress and grooming but to shape it.

Nowadays, however, the deliberate manipulation of fashion by commercial interests makes it increasingly difficult for individuals to set new standards of grooming and dress. Boy George and the few individuals who helped shape the punk and gothic movements seem to be exceptions, although their entry into the "canon" was assured only because the standards of dress that they created were sanctioned in one way or another by commercial interests. This, however, should not be allowed to detract from the fact that individuals often develop considerable skill at honing and refining their appearance; that in some ways, their acquired skills resemble those of the artist since they require the same sort of imaginative endeavor, risk taking, and perseverance. Just as artists may be allowed or denied entry to a chosen social group on the basis of their art, so ordinary individuals are allowed or denied entry to their chosen groups on the basis of their appearance.

Impressions of a Group

It is not just the lonely individual who cultivates an appearance. Groups do as well. Couples, families, cities, and nations often nurture a specific image which they then project for popular consumption. This may be a deliberate and reflective process—a bold effort at impression management; but it can also occur without much reflection by merely following the practices and forms of behavior that are deemed socially appropriate. The images of a unified nation, a resplendent city, a prosperous business, or a harmonious family invite confidence and admiration. Each is something to be treasured, for when once these images are accepted by the public at large, people will respect and place their trust in the nations, cities, business enterprises, and families who are thought to embody these admirable qualities.

Groups sometimes have a clear interest in creating a particular appearance. Hitler's SS tried with the help of severe black and silver uniforms, fearful insignia, ostentatious styles of marching, crisp and noisy salutes, and clipped, impersonal speech to create the image of a ruthlessly efficient paramilitary machine. Less apparent and less deliberate are the sometimes subtle ways in which couples create and project various appearances. Such appearances are cultivated not only for the sake of acceptance and admiration within a community but in order to warn off intruders, and, less obviously, in order to reinforce and strengthen the relationship by enhancing the attachment of each for the other.

Couples often demonstrate their affection for one another and their commitment to each other by means of what we could call "bonding signs."[9] They hold hands, publicly caress, kiss, or nuzzle, engage in noticeable and sustained forms of eye contact, walk arm in arm, and (more recently) slip their hands into the back pockets of one another's jeans. They adopt special tones of voice, special gestures, and affectionate forms of address. But they do more than this. They use jewelry, most especially rings, but also watches, bracelets, necklaces, and a variety of heirlooms in order both to establish and announce their union. Gifts of jewelry, perfume, and flowers not only help cement an attachment, revealing, as it were, a certain depth of commitment, but they also help lovers to announce their intentions and connections to the rest of the world.

In addition, couples (like families, cities, business houses, and nations) use artworks—photographs, portraits, sculptures, music, song, dance, poetry, and the humble narrative—to celebrate, reinforce, and sometimes declare their attachment. The photograph in the family album, it is true, is more a record than a work of art—or this, at least, is the intuition that I derive from the current state of art theory. The photograph carried in a wallet, a purse, or a locket, like the photograph pinned to the bulletin board in the kitchen, does more than merely record. It can be used to inform people of an attachment and its seriousness.[10] Some photographs of the couple are produced by artists, framed, and displayed as one might a work of fine art. In so doing, of course, the picture acquires a status similar to a work of art, and this, by its place of honor on a mantelpiece or a wall, helps

establish and eventually normalize and legitimate the relationship in the eyes of others.

Not only this, but couples who are also lovers create and frequently recount stories of their first meeting and of the early years of their attachment. They do this not just for their family and friends but for one another, and they take endless delight in the telling and retelling of their magical union and the coincidences and sheer good luck that brought it into being. Eventually it will become a piece of family lore that not only celebrates and reinforces the relationship but helps bind the family. It may be a story of hardship, of the triumph of love in adversity, of fortunate coincidences, and of rivals that fell along the way; and in each case, whatever its content, it is told with a good deal of sentiment.

Like all narratives, those that help bind a couple can also become the object of criticism and can be praised for their beauty or their dramatic and poetic qualities. Conversely, they can be criticized for their maudlin sentimentality or for their simplistic rendition of complex facts. Negative criticism of this sort, we all know, usually indicates dissatisfaction not just with the narrative but with the relationship that the narrative portrays. This comes as no surprise, for we already know from the argument offered in Chapter Four that our critical or aesthetic response to a narrative or photograph is bound to be influenced by our attitudes to its function and subject matter.

Dance is another art form that helps establish, reinforce, and announce a relationship. The mere fact that one dances repeatedly with the same person is itself significant, but, in addition, couples (and individuals) can be highly reflective about their dancing behavior— the remoteness or intimacy of it—and some spend hours perfecting certain moves and styles, sometimes just in order to manage the public impression that they create.

There are, however, very definite limits on the extent to which dancing can convey information. Like all art forms, dance is bound by conventions and traditions. When once a dance becomes too stylized and the movements too tightly bound by convention or tradition, it cannot be used to communicate the status either of one's relationship or of one's feelings. We know from information theory that the amount of information conveyed by a word, a sound, a gesture, or

a bodily movement is inversely proportional to the likelihood of its occurrence in a particular context.[11] Since square dancing, ballroom dancing, and the ballet are all highly stylized art forms, almost every step and gesture can be anticipated, with the result that, although formally interesting, they cannot easily be used to convey information. It follows from this that even a small departure from these conventions may be replete with information. This, I think, is why, in any formal dance, notions of propriety are easily violated.

It was a dissatisfaction with the formal and restrictive nature of ballroom dancing, as well as with its inability to reflect the spirit of the new music, that brought generations of teenagers to adopt the much less constraining dance forms of jive, rock 'n' roll, the twist, and eventually disco dancing. With the help of these relatively unstructured forms, it became possible at first to express a greater range of emotions, attitudes, and facts that were not a part of the more staid fox trot or waltz. Disco dancing, for instance, requires only that one attempt to keep some sort of bodily time to the music. What movements, gestures, grimaces, and sounds one includes in the dance are largely a matter of personal preference, and the sheer unpredictability of some of these movements made them sometimes highly suggestive, sometimes highly informative.

However, as soon as jive, rock 'n' roll, and disco became entrenched, their apparent unpredictability became entirely predictable and so ceased to convey information about dancers and their attachments. As a form of self-expression, dance is always curtailed by tradition; a fact which in this century has led to a succession of dance forms, including, most recently, the notorious lambada whose purely formal eroticism effectively prevents its participants from communicating any erotic thoughts or intentions to one another.

The dance, then, is an art form that can be used, in a tightly circumscribed way, both to announce and to entrench one's status as a couple. There are, of course, other ways in which we use art forms to signal our status as a contented couple or family. One way involves acting out certain roles that are scripted for us by the society in which we live. There are, if you like, fashions of group appearance: ways in which husbands are supposed to relate to their wives in public, wives to their husbands, children to their parents, or lovers to one another.

That these are culturally and historically specific is a lesson that we have learned from feminist scholarship, but even so, a failure to abide by them can have profound social consequences that can easily lead to the dismantling of families and attachments. The wife who, after eighteen years of marriage, removes her engagement ring is not just telling her husband something about their marriage but is telling her social circle something about it as well. By departing from the conventional marriage script, and so dismantling the appearance of a sound relationship, she begins to dislodge the confidence that others have in the relationship and to undermine its public status.

The script is a social one, and the appearance of unity, harmony, and strength that result from adhering to it are the very qualities that may make us want to describe the relationship as beautiful. These appearances, however, can be retained only to the extent that one enacts the behavioral role that society expects of members of a couple or a family. Here information theory helps us once again. We learn very little about the marriage that adheres strictly to public convention. The least deviation, however, is highly significant. This, of course, was the message brought to us by Giovanni Morelli's art of scientific connoisseurship. On his view, it is only by ceasing to attend to the conventions that characterize the school in which a painting is produced, and by attending instead to the seemingly trivial details of the work which escape the attention of the dominant stylistic conventions, that one can discern the individual style of the artist, and so learn something about the origin of the work.[12] In just this way, it is the deviation from convention, and hence the deviation from what we expect in group relationships, that carries with it fresh insights, information, and understanding. Conformity to convention, one could say, shrouds the individual or the group in a cloak of obscurity and prevents both from conveying any information about themselves other than the hackneyed information embodied in the conventions that mold their appearance.

It is our tacit knowledge of this fact that inclines us to observe the gestures of couples in whom we have an interest; and it is their tacit knowledge of the same fact that inclines them to deviate from, and in this sense manipulate, existing conventions in order to convey particular impressions of their relationship. Like all scripts, the script that prescribes the behavior of couples is indeterminate in many respects,

leaving room, as it were, for the creative contribution of the players. No one needs to succumb to the obscurity of conventional appearance, and whether or not one does must depend on one's interests in the matter.

It seems clear from all of this that groups go to a lot of trouble to foster and nurture particular appearances and images. They do so because, as social animals, their psychological and physical survival depends on their ability to enter into, and sustain, human relationships of one sort or another. As a result, they try to preserve those social groups that are important to them, and it is often the case that the survival of a group is facilitated by the image that it projects. This is why people frequently engage, as Goffman might say, in group impression management, and expend at least as much effort in grooming the appearance of their families, businesses, and nations as they do on their personal appearance.

Appearance across Cultures

In traditional aesthetics and empiricist epistemology, how I eat, sleep, walk, and blow my nose all present certain sensory impressions and are therefore a part of my appearance. This presents us with a problem. It is the problem of knowing what is to count as the appearance of a person or a group.

According to the empiricist, the fact that I have two arms, two legs, a neck, and a head is inevitably a part of the way in which I appear to others. This, however, seems wrong, for if it is pretty well standard for people in our society to have four limbs, a head, and a neck, and if this is what most people expect not just of me but of all the people in their society, then there is a clear sense in which these aspects of my person will not be considered to be a part of the appearance that I present. Rather they become what Kendall Walton has called the standard features that form the background relative to which my appearance as a person is discerned and judged.[13] And this clearly suggests that not all perceptible or sensory features of an object will be considered a part of its appearance.

My use so far of the word "appearance" is vastly richer than the traditional use made of it by empiricists and aestheticians, and it extends beyond mere sensory appearances to the overall impression that a person or a group creates. As I am using the word, wholly invisible aspects of a person—properties that cannot directly be apprehended by the senses—may form part of that person's appearance. Thus, for instance, we all know that the meanings of my words on a particular occasion are very much a part of the impression that I create, and so shape my appearance in what I take to be the standard sense of this term. Indeed, it is arguable, and I have argued the case in Chapter Four, that it is a mistake to suppose, as the aesthetic movement did, that the aesthetically significant appearances of artworks or people consist in raw and unmediated sounds, tastes, colors, shapes, smells, and tactile sensations.

Certainly people use the word "appearance" in this narrow way, but it clearly gives us a very impoverished view of what it is for a person or a family to convey a particular appearance and so create a specific impression. For how wealthy a person appears to be, how circumspect, wise, or kind, depends only in part on the perceptible qualities of that person. It also depends on the significance that we attach to his or her words, gestures, dress, hairdos, cosmetics, jewelry, and the like. It seems correct to say, therefore, that the appearance of a person, a family, a culture, or a nation depends crucially on the knowledge, beliefs, and values of those who view or assess them.

Appearances in the sense that I favor are always appearances *of* something or other. There are no appearances simpliciter. Rather, one appears to be (or has the appearance *of* being) smooth, mean, or kind; one appears handsome, ugly, or gorgeous; and it is plain that these appearances can be discerned only because one has some beliefs about kind, mean, gorgeous, or smooth individuals that are themselves a function of one's socially acquired values. As values change, therefore, so too will the appearances of others. What was once fresh and beautiful becomes quaint and old-fashioned—and this is determined not by the raw sensations that we apprehend but by the knowledge, the systems of belief, and the values that help constitute our culture. Moreover, if these are in a state of flux, so too are the impressions that I create. It is true, of course, that any person or any community that

takes a modicum of care about the image that it projects, will respond to changes in values. It will attempt not to run foul of the prevailing ideas of dress, deportment, speech, and behavior, and at times it may even exploit them in order to preserve its image and to keep up appearances.

These observations enable us to address an important and well-known problem over which wars are sometimes fought. For if it is true that appearances (in my sense) are apprehended, and impressions created, in terms of prevailing cultural values, then it is all but certain that there will not always be cross-cultural consensus about the impressions that different cultures or nations create. This should come as no surprise. Westerners have considerable difficulty in seeing contemporary Iran as a beautiful society. To them, Iran (and Muslim culture generally) appears to be lacking in unity, to be discordant, and, in many respects, ugly. Iranians in their turn, tend to see the United States as an evil, ugly, and distorted society. The same sorts of judgments are applied by those who live in New Zealand and America to Afrikaner culture in South Africa, and this certainly is not the view that Afrikaners take of their culture.

It follows, then, that what we loosely call cross-cultural understanding requires close acquaintance (in a sense to be specified) with the values in terms of which other cultures judge their own appearances. To share the Iranian view of Iranian culture, actually to *believe* that it is an integrated, devout, dignified, and harmonious society, one must not just have knowledge of, but must also subscribe to, the values in terms of which these judgments are made. In this respect, coming to understand and appreciate another society or culture is very like coming to understand and appreciate a work of art. For if one thinks, as I do, of works of art as culturally emergent entities, then it must be the case that they emerge only against the background of certain cultural conventions.[14] If this is right, it would seem that one cannot properly understand and appreciate a work of art unless one is acquainted with at least some of the salient conventions and values that characterize the culture from which it has emerged.[15]

Understanding a work of art requires only that we have some knowledge of the salient conventions that it embodies and presupposes. *Appreciating* it—where appreciating involves *finding* it valuable—re-

quires, in addition to knowing these values, that one should also sub-
scribe to, adopt, or agree with them. In just the same way, we can
understand Iranian or Afrikaner culture just by knowing something
about the conventions, values, and practices that are central to those
cultures. However, we will find Iran or Afrikanerdom attractive in the
way that Iranians and Afrikaners do, only if we subscribe to the very
values which bring them to the view that their culture is attractive.

At its best, what we call cross-cultural understanding requires more
than a knowledge of the values and conventions that infuse another
culture. It requires, in addition, that one actually subscribe to at least
some of the beliefs and attitudes that form part of that culture. For it
is this alone that gives one the capacity to experience different aspects
of another culture in the same way as its members do: to find the same
rituals and states of affairs beautiful or ugly, attractive or unattractive.
The job of the propagandist, therefore, is not just that of imparting
knowledge. It is also the job of bringing people to subscribe to a set of
values that will encourage a particular view and feeling for a country
and its culture.

In this respect, artist and political propagandist may be seen to
have a good deal in common. Both wish to seduce their audiences.[16]
They want them to understand, but more than this, they want them
to embrace and submit to certain values. This, of course, is one of the
main aims of the propagandist; and I can imagine someone objecting
that if it is any part at all of an artist's aims, it is at best incidental
to the artistic enterprise. But such an objection, were it forthcoming,
would do no more than perpetuate the myth of artistic integrity. For
it is simply a fact that artists desire, and unquestionably attempt to
secure, approval for their works of art, and that they do so by trying to
bring their viewers to embrace the values that mediate their artworks.
This should come as no surprise. People from all walks of life desire
approval, and many hope to secure it through their work.

The difference between artist and propagandist, we sometimes like
to think, is that while artists want approval for their work, and through
it, approval for themselves, conscientious propagandists want approval
not primarily for themselves or their work but for the doctrines and
values that they propagate and hence for some or other political cause.
However, even a brief glance at the history of art shows that artists

have often concerned themselves with specific causes and that they have tried with all their skill to seduce their audiences and to instill certain values and ideals. At times, artists have found themselves at the vanguard of social movements, crafting the insights and rallying cries for those who followed. (Think of Voltaire, Leo Tolstoy, Émile Zola, Jean-Paul Sartre, Alexander Solzhenitsyn, André Brink, and Nadine Gordimer.) It was only in the wake of the nineteenth-century aesthetic movement that the artworld came to the view that the artist should not propagandize, proselytize, or instruct. The religious art of the Middle Ages knew no such scruples; nor did the political or official art of Hitler's Germany and Stalin's Soviet Union. Nor, of course, does much revolutionary and political art today.

Music stars like Bob Geldhof or Paul Simon, and political figures like Nelson Mandela, have come to use popular music and rock concerts as forums for political action. Not only have such forums been used to combat famine but they have been used with resounding success to further the anti-apartheid cause at meetings that have attracted audiences much larger (if one counts television viewers) than anything Hitler or Stalin ever managed. It was John Lennon who first recognized the power of the rock star when he claimed on behalf of the Beatles a following much larger than that of Jesus Christ. The resultant censorship of Beatle music in some countries around the world suggested not just that politicians agreed with him but that some envied him.

It will not do to insist that art of this sort is not art at all. Much of it might not be good art, but it is difficult, without begging the question, to find any reason at all to deny its status as art. Tracy Chapman's songs, while unquestionably political, are nonetheless works of art. Nor will it do to insist that the message of a work is only incidental to its artistic value. Experience suggests that this is far from being the case. The content of William Blake's engravings and poems, of Tolstoy's novels and fairy tales, of Wordsworth's and Yeats's poetry is in large measure responsible for the artistic merit of these works of art and cannot be treated as incidental to it.

There are, then, no conceptual or a priori reasons for thinking that works of art cannot be propagandistic, instructive, didactic, and moralistic *qua* works of art. It follows, too, that the processes of artmaking are much more deeply embedded in everyday life than we might pre-

viously have thought. For, as we have now seen, the task of cultural impression management undertaken by the political propagandist is in many respects the task of an artist. Both try, often with painstaking care, to produce something that is intended to seduce its audience into embracing certain values.

The Beauty of the Group

It was Hitler in *Mein Kampf* who described the propaganda of his social movement as an "indefatigable attempt to make the new thought processes clear to others."[17] The simple repetition involved in such a task frequently persuades, and it was a recognition of this that eventually led Josef Goebbels to the cynical pronouncement that if one tells a lie often enough, it becomes the truth. But although cynical, his view has something to commend it. We all mistake what is familiar for what is natural, and it is difficult to believe that our well-entrenched commonplaces can be false. Exposure and re-exposure to a lie, like to a piece of furniture, helps breed familiarity, and we are, for reasons of comfort and security, much more inclined to accept the familiar than the strange and the new.

Repetition, however, is the weapon not just of the propagandist but of the advertiser too. Both believe, or at least hope, that by repeating their message they will bring people to a set of different, sometimes outrageously different, values and beliefs. This they do by challenging our existing ideas and values. There is, I think, no better way of doing this than by shocking, alarming, frightening, teasing, or arousing an audience. These are the techniques that "awaken" people and prompt them to look at and scrutinize not just the new values and ideas that are being proposed but also their own values and beliefs. It is the desire to come to terms with what is challenging and difficult, to accommodate it, accept it, and in so doing defuse it by rendering it less shocking or disturbing that the propagandist exploits. As we will see in Chapter Ten, studies in cognitive dissonance show that people do not want to be at war with new ideas. The resultant emotional and psychological turmoil breeds fatigue, and, in the end, it is the desire

for stability and calm, as well as the deeply felt need to be approved of and accepted by a community, that sends many of us scurrying to accept the otherwise unacceptable.

There is a sense, then, in which a propagandist, like an advertiser, attempts to secure, perhaps even to precipitate, what Hans-Georg Gadamer has called a "fusion of horizons."[18] Normally, of course, people are shy of the new and the unfamiliar. They are inclined, I think, to rest secure with the ideas, beliefs, and values that they already have and to dismiss those that are foreign or strange. However, when snared in a crisis of beliefs and values, people attempt unabashedly to understand, assimilate, and adopt new ideas and different values. However, we can become properly familiar with new beliefs and standards only when we engage with them, relate them to other beliefs, and try to adjust our existing ideas and values in ways that accommodate the new and the unfamiliar. This "play"—what Gadamer calls a to-and-fro movement between the fresh ideas and our existing "prejudices"—may eventually bring an accommodation that results in the acceptance or adoption of certain values and beliefs.

Most would agree that the "fusion of horizons" is something brought about, at least in part, by the inquiring subject—by the person, that is, who actually wishes to understand. Both propagandist and advertiser rely on this desire, but they also fuel and prompt it. Hitler, for instance, seemed to believe that constant exposure to an idea was not enough, that it needed to be coupled with threats and promises, and that this would expedite the process of acceptance and assimilation since it would force people to engage with and respond to his ideas. While latter-day propagandists are not as free with their threats and promises, they, like the commercial artists who design our advertisements, believe that inducements play an important role in facilitating acceptance. The process may well be nondiscursive, and may involve the use of juxtapository metaphors as, for instance, in Coca-Cola® advertisements where a brown, fizzy, sugary sweet liquid is skillfully juxtaposed with beautiful and youthful people, thereby transferring ideas associated with the latter to the former.[19]

There are ways, then, of expediting the "fusion of horizons," of getting people to accommodate, assimilate, and eventually accept the values in terms of which individuals and countries would prefer to have

their appearance judged. Much the same sort of thing happens with works of art. Artists or members of a particular school of art try passionately to be exhibited, correctly believing that only through more or less constant exposure will their work come to be accepted. They often support their own endeavors with manifestos and rely on critics who sometimes act as propagandists for a particular school of art. Here the aim is to present certain older art forms as passé; the current art form as in vogue, sophisticated, insightful, cultured, the preserve of initiates, the sensitive, and so on. Here, too, there are lures and incentives that help expedite the "fusion of horizons."

Not that this always involves simple repetition. Quite often a new understanding is secured, or a new set of values and priorities imparted, by exploiting values and beliefs to which people already subscribe. Thus, for instance, a country such as France readily exploits its rich artistic tradition in order to make itself not just acceptable but attractive to the international community. Paris fairly brims with art museums; it was the home of Picasso, Degas, Matisse, Cézanne, Renoir—these, and many more. It was the cultural and spiritual center of the twentieth-century avant-garde, and helped nurture and sustain the Bohemian spirit. This, at least, is the popular view. And because we admire French art and the happy individualism of the Left Bank, we are inclined to regard French culture as beautiful.

So it would seem that just as tasteful and desirable jewelry and clothing can be used to enhance the appearance of an individual, so the artworks that help characterize a culture, as well as the received history or image of that culture, can be used to enhance its appearance. It is because people value the artworks of Cézanne and Renoir, the novels of Zola and Dumas, or the literary tracts of Voltaire and Rousseau that the French state can, in a sense, hide behind the façade that these works create. We forget about French atrocities in Algeria and Vietnam, French nuclear testing and possible nuclear pollution at Murorua Atoll in the Pacific, or the sinking of the Greenpeace ship, *The Rainbow Warrior*, in New Zealand. Our attention is diverted from the anti-Semitism and racism that are part and parcel of French daily life, and we come instead to see French culture in terms of the values that we already place on its artworks and history.

It is the presentation of French culture and daily life in terms of

values that we already admire that brings the uncritical among us to admire the culture as a whole. We tend, in consequence, to marginalize and to regard as aberrant those aspects of the culture of which we disapprove, and to see it instead as clustering around, and being driven by, those properties, institutions, or values of which we already approve. The tendency, in other words, is to collect the various phenomena that constitute French cultural life and French nationhood under a principle of cultural demarcation that reflects only certain values, and it is the job of the propagandist to appeal to and exploit these values in order to bring us to view the culture in the preferred way.[20]

As we have seen, however, the management of impressions and appearances is not always a matter of adjusting what people look at; it is not, that is, invariably a matter of redirecting their gaze and bringing them to attend to what they already value in our culture. It is sometimes, and quite often, a matter of adjusting the values in terms of which they look at us. It is, for example, absurdly difficult for a country like Iran or South Africa to alter culturally determined forms of behavior and the appearances that these create. What has to be altered, propagandists think, are the values and beliefs in terms of which others apprehend these cultures. And this, of course, is true of individuals as well. I cannot easily alter the shape of my mouth or my nose, but I can furnish you with beliefs and values in terms of which I would prefer to have you look at me. And in so doing, I actually alter the way in which you see me: I alter my appearance.

Getting It Wrong

At times what looks beautiful turns out to be ugly; what seems attractive is on closer inspection repulsive, and we have no difficulty in declaring it so and in treating our original judgment as mistaken. This could be considered puzzling, for if it is true, as I have said, that appearances are apprehended in terms of one's values, and that one can alter appearances just by altering these, then the appearance of any object would seem to depend entirely on the beholder. From this the inference is drawn that we cannot ever misperceive the appearances

of persons and of groups. The appearance is as we see it, and there is no possibility of our ever getting it wrong.

This puzzle is easily resolved. It is important to remind ourselves that aesthetic perception does not depend just on our values and beliefs. It depends in addition on the actual properties of the object observed. Hence, it is easy to misjudge the appearance of an object—if only because one has not seen all of it. On closer acquaintance and while employing precisely the same values, one might very well revise one's judgment about its appearance and decide that one's earlier judgment was mistaken.

It might seem, though, that if aesthetic perception is dependent on values in the way that I have just suggested, an incurable subjectivism is introduced into the judgment of appearances. What I find beautiful you might find ugly, but since we perceive merely in terms of our respective values, there can be no way of showing that either one of us is right or wrong. Those who argue in this way assume, of course, that the values that we use in aesthetic judgments are merely personal. However, we saw in Chapter Four that the values that govern our aesthetic judgments do not just reflect our personal preferences but are, in the broadest sense, cultural values that are shared by a wide community of people. The extent to which various people possess these values, one could say, is a measure of their common culture. Hence, an ability to judge works, persons, and groups aesthetically will require recourse *not* to one's personal preferences but to the values and standards that prevail in the appropriate culture. Nor need this introduce a radical relativism, for merely by acquainting oneself with the culture one can come to understand the values and apply them correctly or incorrectly in aesthetic judgments. It is only if knowledge of other cultures is not possible that aesthetic judgments become incurably relativized. But this is a position that has been widely contested and decisively refuted.[21]

It follows that one can misperceive the appearance of an art object, a person, a family, or a nation, and that one can do so not just, if at all, because aspects of it are hidden but also because one looks at these entities through the wrong spectacles. Which spectacles are the right ones depends on what one wants to know—whether one wishes to know how Iranians perceive American culture or how middle-class

Americans perceive their own culture. In each case, one approaches the topic with a different range of values and beliefs at the ready, and if one adopts the wrong ones, one can be shown to have made a mistake.

Conclusion

The world of art enters deeply into our lives. People, I have shown, expend the same imaginative energy, the same skill and effort as artists do, in grooming not just their own but also their group's appearance. The politics of appearance is everywhere apparent and enjoys a social dynamic that is in some ways similar to the politics of the artworld. It is not just that artists and critics vie for favor by presenting their immaculately crafted artworks and critical tracts to the public. It is also that they sometimes try to alter the beliefs and values in terms of which all works of art are assessed. This is not just, if at all, a matter of educating their public. It is a political process: one that, if successful, will ensure their success as artists and critics, and with it, their status in the artworld.

This is precisely the game that individuals and nations play when they attempt to manicure the impressions that they create. They try not just to exploit the values to which we already subscribe by drawing attention to the more attractive aspects of themselves or their culture, but they try as well to alter the values and the beliefs in terms of which we view people and their cultures. To this end, we have seen that the artifacts that find their place in the artworld—paintings, decorations, sculptures, poems, songs, and dances—and that accord prestige to those who produce and comment on them, are enlisted in order to enhance the appearance, and with it the prestige, of individuals, families, and nations.

Throughout, I have stressed the political importance of our appearance, for, in the case of individuals, it not only marks our affiliations within a community, but adds to, and on occasions, detracts from our prestige and our power. Dress is an obvious example of this, and it is because of the conventional attitudes that attach to dress that there is a sense in which our attire reciprocally molds our behavior. A person

who dresses in a certain way is expected to behave accordingly—so that the very device that we use to enhance our appearance and sometimes our power also constrains our behavior and helps regulate the lives that we lead.

All of this gives us only a partial insight into the scope of art and artistry in our ordinary lives. Whenever people or nations deliberately manage their appearances, craft or mold them, they do so for a purpose. Broadly characterized, it is the purpose of achieving certain of their interests often at the expense of the interests of others. This is a political process that helps demonstrate the place of art, artistry, and artifice in our lives.

Chapter
SEVEN

LOVE, FRIENDSHIP, AND THE AESTHETICS OF CHARACTER

Adolf Hitler was an ugly and distorted man—not because of his face but because of his nature and the life that he led. Even though it is difficult to look at Hitler's face and think it handsome, his features were more regular, his nose neater, his smile more formally correct than the older Gandhi's. And yet, people often look at Gandhi's toothless smile (or at photographs of it) and think it beautiful. No doubt they think this because they like and admire him. We can safely assume that, just as disillusioned lovers no longer find their partners beautiful, so too with Gandhi and Hitler. Those who admired them found their faces striking, gracious, elegant; those who detested them found their every look menacing and ugly.

It would seem from this that there is a very intricate aesthetic in terms of which we respond not just to works of art but to the people whom we know: what I call the aesthetics of character. My aim in this chapter is to explore this aesthetic and, in so doing, to pursue further the themes of the last two chapters by demonstrating the ways in which, and the extent to which, art critical discourse is integrated into everyday life.

Aesthetic ascriptions are always marks of approval or disapproval. Hence the ascription of aesthetic properties to particular people will depend crucially on the relations in which we stand to them. We are most likely, for instance, to find our friends and lovers aesthetically pleasing, our enemies aesthetically repulsive. Hence one can treat of the aesthetics of character only by venturing into the social context of these ascriptions—in this case, the field of human relationships. This

should not surprise us, for we found in Chapter Four that we can explain aesthetic ascriptions to works of art only by considering them in the social context within which they occur.[1] In this chapter, I attend to the aesthetics of character in the context of love and friendship, for these relationships do much to capture the intricacy of aesthetic ascriptions to characters, persons, and their lives.

Preliminaries

We speak of a person as balanced, ebullient, effervescent, scintillating, lively, dull, dazzling, distorted, ungainly, tortured, serene, dynamic, bold, colorless, beautiful, or ugly. And whenever we respond to people in this way, we are responding in part to the ways in which they project themselves, to the appearances that they somehow convey. Our response is not directly moral, but is explicitly critical, and is reminiscent of our response to a work of art.

It is through their behavior that people best show us what they are like. What they do, and how they do it, enables us to say of them that they are beautiful or ugly, balanced or distorted. Sometimes, people do not actually show us, but merely tell us, what they are like; and we learn about them from what they say rather than from what they do. They speak about their lives (or of episodes in them) and in so doing, we saw in Chapter Five, they contrive to tell a story about the sort of person that they are. And the listener or observer reifies these revelations by speaking in turn of a person's character—for a character is nothing other than that cluster of mental or moral dispositional properties that we generally attribute to a person.

It was Freud who first remarked on the human need not just for acceptance but for approval: a drive that all but compels people to present themselves in ways that will secure the favor and admiration of others. It seems fair to say that we judge people in terms of the ways in which they present themselves, and that this involves both the interpretation and the evaluation of their sayings and doings. Such judgments, as we shall see, can be more or less rational, and are themselves based on certain standards and norms.

In describing a person as loud or garish, as gracious or elegant,

one appears at first sight to use traditional aesthetic concepts in order to express one's approval or disapproval of a person's character. On my view—one that I defended in Chapter Four—it is only by tacitly appealing to certain cultural (including moral) values, clusters of theories, and bodies of belief that the concepts in terms of which we make aesthetic ascriptions find any application at all. It is because in our society at this time we value certain forms of dress, movement, and behavior, certain virtues, hair styles, and manicures, that we describe someone as elegant or ill-kempt, as rough or smooth.

Constructing a "Safety Net"

Let us suppose that Freud is right and that any normal human being requires both approval and acceptance: that our physical and psychological well-being depends on this. It is apparent, I think, that we can earn the approval of others only if we say and do what people regard as appropriate or correct. It is this that earns the most flattering aesthetic ascriptions. Our task, it would seem, is that of monitoring and controlling what we say and do, for failing this, we are bound to follow our more intemperate urges, with perfectly offensive results.

The trouble, though, is that we say and do too much, and simply cannot monitor all of our behavior. There is a clear sense in which we need a "safety net": some way of earning and retaining the regard of others irrespective of our various lapses. Some parents try to provide such a safeguard, and they do so in much the way that schools and military academies do, by instilling certain habits. Habituation, Aristotle thought, was essential to the inculcation of the virtues; and it seems plain that if one habitually acts in ways that others find appropriate, there will be no need to monitor one's behavior since there will be no behavioral lapses.[2] It will all be a matter of habit. The trouble with this, as Aristotle himself observed, is that our behavior is only properly praiseworthy if we choose to do it.[3] If all of a person's behavior is the product of habits bred of inculcation and training, that person will be little more than an automaton and not someone whose character can properly be admired.

Equally obvious is the fact that, although we are trained and encouraged to behave in certain ways, such training does not have a cast-iron grip on our behavior. No matter the efforts of our parents and teachers, we invariably err, and our errors sometimes bring us into disrepute. But all is not lost. The guest who deliberately empties his wine glass over the wedding cake will lose the regard of all but his closest and dearest friends. Friendship, the love of a parent for its child, or the tender regard that lovers have for one another can all perform this function: they furnish what we regard as the only genuine safeguard against the worst consequences of our various indiscretions.

There is a sense in which we are forced to rely on the love and friendship of others if we are to retain the regard of at least some people throughout the long years of our lives. It is this, we think, that prevents the rejection and disapproval that would otherwise accompany our unguarded behavior. And so one seeks love and friendship with a tragic urgency, believing sometimes that one's survival, one's identity, and one's wholeness as a person depends on this.

It would be wrong, though, to suppose that people set about finding friends and lovers only because of their conscious need for a "safety net."[4] Most often, we seek the friendship and regard of others because we like them. We attempt to know them more closely, and, if successful, eventually come to care for their happiness and well-being. Aristotle is correct when he maintains that we may befriend and love people because of their utility to us, or because of the fun and the pleasure that they afford. But this, he thinks, is not a genuine friendship; nor is it really love. People genuinely befriend and love one another only when they treat each other noninstrumentally, and so care for each other in themselves: as ends rather than as means.[5] That people often believe themselves to be in such relationships, and that their actions toward their friends and lovers are often moral and selfless, is beyond question. Even so, it may well be that such relationships serve the unacknowledged function of ensuring, or at least promoting, one's emotional and hence one's psychological well-being. There is much that suggests that this is actually the case and that it affects profoundly our perception of other people and hence our attribution of aesthetic properties to them.[6]

On Knowing One's Friends

We normally believe that we know, indeed, that we have to know, the people that we befriend and love and think of as delightful and beautiful. It is, we prefer to believe, only because we have become acquainted with them over a period of time that we have also come to love them. It is manifestly odd to claim people as friends, to claim to love them, and to know that they are beautiful, balanced, "neat," or "together" if one also acknowledges that one does not know anything at all about them. One can, of course, be infatuated, obsessed, and in this sense *in* love with another while acknowledging that one knows very little about them. But, as we shall see, friendships based on love are quite different from obsessions and from the state of being *in* love.

This at once presents us with a problem. For what is it to know a person? Normally, of course, if I want to know what sort of person you are, I will try to discover what it is that you are disposed to say and do—and this must involve looking at your past thoughts and actions. But it seems quite clear that you are just too complex and inaccessible for me to know *all* of this.

We cannot observe every action performed by a person during the course of a life, and because we forget so many of those that we do observe, the knowledge that we take ourselves to have about another's life is invariably partial and notoriously selective. We select from a person's behavior the actions and speeches that we take to be significant and we regard them as significant only because we subscribe to certain normative ideals of human behavior and human nature. If we think that kindness, charity, and honesty are important, we may—depending always on our motives—look for and remember those actions that exemplify these qualities. Conversely, if we think of certain actions and dispositions, and the qualities that they manifest as unimportant, we will not harp on, or even bother to remember them. The way people chew their food or blow their noses might very well be the sort of action that we notice only to forget. Their sexual predilections and their manner of speech may be regarded as significant by some and as wholly trivial by others. And how they are regarded will depend on the values and ideals to which we subscribe.

If this is right, we come to know a person only partially, and we

do so by selecting certain of their actions and inferred dispositions in terms of our interests, our values, and ideals. These are the actions and dispositions that we see as central to the person, and it follows from this, I think, that we tend to speak of their lives and construe their behavior in terms primarily of our own values and ideals which become the "narrative structures" in terms of which we tell the stories of other lives.[7] Hence, what often passes as knowledge of other people is no more than the story I choose to tell about them: a story that is based on my view of what is desirable (or undesirable) in human beings. It is a story in the sense that it both selects and sequentially organizes the details of another's life (the plot), so that the whole discourse, as well as the life in question, eventually acquires a particular, usually a moral, significance (closure). Any discourse that is selective and contains both a plot and closure is a narrative, and it is in this sense that what I take myself to know about you need be nothing other than a narrative construct.[8]

In brief, then, we usually take ourselves to know another person in circumstances where we have only a partial and highly selective view of that person: one that involves constructing narratives about lives (or episodes within lives) in ways that promote the view that the lives embody certain desirable or undesirable qualities. This need not mean that one's beliefs about other people are always inaccurate. My belief that Mary is kind and gentle may very well be true, and my tendency to ignore as aberrant her angry behavior may turn out to be well justified. But this does not affect the fact that my knowledge of Mary is highly selective and is based on the merest sample of her expressed thoughts and her behavior. And it is in terms of this knowledge that I will either befriend or reject Mary and perhaps ascribe aesthetic properties to her.

Structures of Affirmation

The sort of person who best affirms me is not just a person who accepts, or who likes, or who loves me. We all know how irksome it can be to be admired by the unadmired admirer. Rather, I am best af-

firmed, and my self-image most enhanced, when I am selflessly loved, admired, or befriended by one who appears to embody those qualities I most value in human beings. Structures of personal affirmation are essentially bilateral and are never finally secured until one admires one's admirer. This is why the beloved may wish, and even try, to love her suitor, and will do so with varying degrees of success.

Often, when one admires another person, considerable effort is made to earn her (or his) good opinion. This quest for unqualified acceptance, approval, and affirmation is what I shall call the state of being *in* love. Should the desired affirmation be secured, one might eventually come to *love* the person in question—where this involves caring for them as ends in themselves, and not merely as a means to acceptance and unqualified approval. Alternatively, of course, one may tire of the other's approval, grow weary of the relationship, and seek the company and affirmation of someone else.

When those that we love begin to behave in ways that are not altogether admirable we strive to keep our view of them intact. We have to do so, for (as I have said) there is no joy and little beauty in being loved by those one dislikes. It is in order to avoid this that people often try to ensure that their "knowledge" of others—the image that they have of them, the stories that they prefer to tell about them—remains intact. The woman who refuses to grasp the significance of her beloved's dishonesty or drunkenness, and the man who refuses to believe that his friend has stolen from him are both attempting to protect their structures of affirmation. For to come to dislike or hate one's friends and lovers is to forgo the value of their admiration.

Hence it is not just the case that one's knowledge of others is always partial and selective but it is also the case that lovers and friends seem to have a mutual interest in keeping it so. They reciprocally emphasize the virtues and ignore the vices of their friends and partners. A similar partiality prevails among those who despise and hate one another—except that in this case they ignore one another's virtues in favor of their vices; and, of course, they use these vices as narrative structures around which to construe one another's lives.

Whether we love or hate a man, our image of him and hence our aesthetic attributions concerning him are invariably shaped by our particular interests. A predominant interest, I have suggested, is the

desire to preserve our sense of personal worth, so that it seems fair to say that our perception of our friends, our lovers, and our enemies is deeply influenced by our own psychological needs and vulnerabilities. But our material interests figure as well. It is easy, for instance, to admire and even love the political leader who satisfies our material needs and desires. Closer to home, the wife who is economically dependent on her husband has little interest in dwelling on his faults and may very well see him as all things virtuous. By contrast, the wife who is no longer dependent in this way, no longer has the same inhibitions, and may come, when it suits her, to dwell on his faults and, indeed, to construct new narratives that tell the story of his life in new and unflattering ways.

Love and the Aesthetics of Self-Deception

If I am right, we always wish to preserve our structures of personal affirmation and this strongly inclines us to a partial view of our friends, our enemies, and our lovers. It follows, I think, that the judgments—more specifically the aesthetic judgments—of character that we make about those whom we befriend or love are often based on a highly selective, perhaps a distorted, picture: one governed by a range of psychological needs and vulnerabilities of which we are usually unaware.

In this respect, aesthetic judgments of character appear to be motivated in ways that ordinary aesthetic judgments are not. But this appearance is misleading. It is true that in judging a landscape aesthetically my personal interests need not intrude, but it is clear nonetheless that they often do. Whether I find an agricultural landscape aesthetically more satisfying than unspoiled native bush may very well depend on whether I am a farmer or a hiker. Again, when I respond aesthetically to a painting, my personal and social interests often play a role. We have already seen that many of my "painterly" values are intimately related to my allegiance to a certain school, tradition, or canon, and that if the canon is undermined through critical practice this could well affect my interests within the artworld.[9]

Even so, the interests and values that figure in "ordinary" aesthetic

judgments do appear, at least at first sight, to be different from those that enter into aesthetic judgments of character. For it is, as we have seen, our psychological vulnerabilities and needs that direct our perceptions of, and our judgments about, the characters of others. The usual view is that one's judgments about a painting ought never to depend in this way on one's psychology and that any judgment that does is wholly idiosyncratic. But this view is mistaken, for it is not difficult to see that an artist's or a critic's desire for status and acceptance within the artworld is, at least in part, a psychological need—one, moreover, that is all too likely to influence his or her aesthetic judgments.

Despite this, there does seem to be one important difference between an aesthetic response to a work of art and an aesthetic response to character. It is much easier to detect a bias in our responses to paintings and sculptures than it is to detect a bias in our responses to people. Human beings, as we know, are complex and remote: they are not always available for close inspection. As a result, their past actions and thoughts are more easily denied and more easily reconstrued under alternative descriptions and explanations than are the brute features (words, colors, sounds) of a work of art. This is why critics who are confronted by features of a work that embarrass their judgments and interpretations cannot simply deny the existence of these features. All that they can do is attempt to downplay their significance, but even this is difficult in the face of critical arguments that establish the contrary.

It is true, of course, that the bias that infects judgments of character has to pass unremarked, for when once one admits that one's "knowledge" of a loved one is skewed, this not only threatens the worth of the beloved but threatens as well the affirmation of self that one's relationship affords. Also clear is the fact that aesthetic judgments of character incline us to self-deception, and do so to a far greater extent than "ordinary" aesthetic judgments. In order to understand why this is so, we need to remind ourselves that character judgments are offered only of those people of whom we either approve or disapprove. We may be angry with them, bored by them, irritated by them, or hate them. Alternatively we may be *in* love with them, or we may love them. Let us turn once again to the question of friendship and love in order to see more precisely how these affect the attribution of aesthetic properties to persons.

Initially, when people fall in love, they imagine the affection, the warmth, and regard of the other, and the thought of this acceptance by one who is so attractive promises such a powerful boost to their self-esteem that they will believe themselves unable to do without it. It is because of this that a person who has fallen in love will attempt by fair means or foul to secure the approval and dependency of the beloved.[10] In effect, as I have shown, this constitutes a quest for self-affirmation: a quest for the acceptance and affection of the other.[11]

The case of a close friendship is very different. Here there is no explicit quest for acceptance. There is a growing appreciation of, and caring for, the other; an enjoyment of the other's company for its own sake, and a trust in, and appreciation of, one's acceptability to the other. Still more, in the case of a developing friendship the desire for approval and affection is not so strong as it is in the case of people who are in love. One's equilibrium and sense of self do not depend on it—at least not to so great an extent.

It seems to follow from this that people have a much greater interest in deceiving themselves about those with whom they are in love than they have in deceiving themselves about their friends or loved ones. It is when one's desire for self-affirmation and support is urgent and depends on the approval of the person with whom one is in love that self-deception of one sort or another becomes almost inevitable. By contrast, one can continue to love one's friends and family even when one recognizes their faults. This is why we feel safe and supported in the company of those who befriend and love us, and why a genuinely caring love, which treats us as persons who are worthy of consideration and respect, is thought to provide a "safety net" that protects us from the worst consequences of our indiscretions. Nonetheless, the bilateral structures of affirmation that govern our friendships and our loving relationships effectively ensure that we do have some motive for deceiving ourselves about our friends and loved ones. The mother who will not countenance the fact that her son is a thief tries to protect not just her son but also the self-worth that the love of an honest, prospering son affords her.

I have dwelled on loving relationships and the state of being in love because both involve certain states that call forth aesthetic judgments of character. It is, as I have said, the state of being in love rather than

the settled state of being in a loving relationship that tends for the most part to breed self-deception—although, as we have just seen, it is true that an ordinary friendship can also incline one to self-deception.[12] In both cases, the beauty and perfection of the beloved is derived from failing to attend or to give full due to his (or her) flaws. Such a failure would seem to be motivated, for, as should now be obvious, to fixate on the beloved's selfishness, vanity, or ruthlessness is to destroy not just one's feeling for her, but it is in some measure to destroy one's own self-esteem. That self-deception of this sort actually occurs is beyond question. A husband having an affair will typically behave in uncaring and selfish ways that ruthlessly disregard his children's and wife's well-being. This information is directly available to his mistress, and yet she continues not only to love him but to consider him a beautiful, perhaps an elegant, but certainly a warm and an altogether remarkable person.

Why is this? Only, I would venture, because of a capacity that all people have: the capacity to ignore or else fail properly to process available, but inconvenient, information. *Akrasia*, understood as the lack of proper rational control that leads, among other things, to self-deception, seems to be a capacity that all human beings share.

What is not often recognized is the important role that self-deception plays in aesthetic judgments of character. It goes without saying that self-deception cannot ever consist in a decision to deceive oneself. Any such decision, unless promptly forgotten, must be self-defeating, and will of course preclude deception. The phenomenon of self-deception is better thought of as a variety of motivated irrationality;[13] and there will be occasions when the motivation consists in a wish or desire for acceptance and approval.[14] It is because the lover's desire for acceptance and approval is so strong that he or she fails to give adequate attention to the shortcomings of the beloved. Self-deception of this sort plays a prominent role in aesthetic judgments of character. If the beloved is considered beautiful, gentle, and warm, this is often because her lover fails to attend to the sharp, the hard, the distorted edges of her character. It would be wrong, though, to think that self-deception does not play a role in other aesthetic judgments. It does. Artists who produce paintings, sculptures, or novels may be unable to detect flaws in their own works; flaws that they would have no hesitation in pointing to

when dealing with the works of others. Here their strong interest in success both as artist and as critic blinds them to the obvious. And this is a problem with all creative work. Philosophers, historians, and classicists may all be blind to the defects in their research and arguments and allow them to pass unremarked while condemning the same errors in others.

Self-deception of this sort would be a singularly baffling phenomenon were it true that persons necessarily consist of a unified self, and always have before the mind's eye a unified and coherent view of self. If this were so, people could deceive themselves only by knowingly deciding to do so, and this, of course, makes deception impossible. However, I have already suggested that even though we are encouraged to develop a unified view of self and to act according to it, in point of fact people tell a range of different stories about themselves and see themselves differently in different situations.[15] It is this that makes them unaware of some of the inconsistencies on which they trade; and it is this that inclines us to accuse them of self-deception. It is my strong desire to be both a good artist and a sound critic (and a commitment, in different situations, to both of these views of self) that inclines me to overlook the flaws in my own work (as artist) that I would unquestionably notice in the work of others (as critic). Here my self-deception is motivated. It is motivated by the different views of self that I have and wish to preserve: views that are brought to the fore and eclipse one another in different social situations.[16]

It is important to observe that those artists who deceive themselves about the aesthetic qualities of their artworks (and who believe their artworks to be better than they are) are likely to fail as artists. By contrast, the lover who deceives herself about the virtues of her beloved's character is more likely to succeed in bringing him to care for her. And in this way she will enhance her sense of self by creating a socially affirming "safety net." Here self-deception appears to pay off, for it now turns out that there are at least some occasions on which self-deception (explained in terms of *akrasia*, that is, as a lack of proper rational control) is the correct or rational method to adopt in order to achieve a desired end. Put differently, it seems that there are occasions when it is rational to be irrational.

The appearance of paradox is easily dispelled, for it is plain that

two very different senses of "rational" are here combined to produce the oddity. In one perfectly ordinary sense, any efficient means to a desired end is a rational means to that end. There is, however, another sense in which to be rational is always to take the available evidence properly into account. That these two senses of the word are different and exclusive of each other is clear from the fact that one can efficiently achieve a specific end by refusing to countenance, attend to, or recognize the importance of a given body of information. Politicians, so it seems, do this all the time. So the claim that it is sometimes rational to be irrational, or, conversely, that it is sometimes irrational to be rational, does make sense.

On Truth and Beauty

There are occasions when it clearly is rational for politicians to ignore information that does not serve their interests. Less obvious is the claim that it really is goal serving, and in this sense rational, to deceive oneself about the aesthetic qualities of another's character.

If, without a trace of irony in my voice, I were to tell you that Stalin was a beautiful person, that Mother Theresa has led an ugly life, or that Vincent van Gogh was a balanced personality, you would not hesitate to declare me wrong. Such aesthetic predicates, you would say, do not apply to these people. What is more, to apply them, and to believe that they do apply, would be misleading and even dangerous.

Suppose that I were to fall in love with the recently resurrected Vincent van Gogh. He adores my brilliant blue eyes and my wit; I admire his dedication, his painterly skills, and his balanced personality. I simply refuse to attend to the fact that he has lost an ear, has deeply scarred hands, and is often depressed. These I think of as incidentals, and I am convinced of the power of my love to heal the minor defects that others point to in his character. As a result, of course, our relationship thrives. I feel great, and so does Vince. But unless my beliefs about Vincent are wholly self-fulfilling, there will come a time when I will have to admit that his behavior (evidenced perhaps by an alarming shortage of ears) is unbalanced. Still worse, his tantrums, his dark

moods, and his increasingly bizarre paintings all come as a surprise to me. At this point, shocked into a realization that I do not really know Vincent at all, I can no longer be sure that I love him. My "safety net" and, with it, an important source of personal affirmation, has started to fall away. To me it seems as if my world is falling apart, and of course, the pain and the grief that all of this occasions could have been avoided if I had not deceived myself and had attended properly to the available evidence.

This suggests that self-deceptive aesthetic responses to another's life and character do not serve the "deep" interests that one has in forming personal relationships. A large part of that interest, we have seen, resides in the creation of a stable and reaffirming "safety net." The pain of psychological upheaval is precisely what stable personal relationships are meant to offset, and it seems obvious that self-deceptive aesthetic ascriptions will not normally achieve this goal.

This does of course suggest that there are facts of the matter concerning people that can be discovered quite independently of our interests and ideals of personhood, and quite independently too of the narratives that we construct in order to realize our interests. It is not as if we create others by telling stories about them, for no matter how often I ascribe stability and balance to Vincent van Gogh in my various stories about him, the plain fact of the matter is that, given the values and theories that circumscribe psychological stability, he is far from stable—indeed, he is manifestly unbalanced.

But this view, we learned earlier, is often considered naive.[17] It assumes settled and fixed properties in individuals, properties that are unaffected by the stories that we tell of them. And yet, we also know that people attempt to live up (or down) to our narratives, for, as I have already remarked, people are extremely suggestible.[18] They will be fearless if we tell them that they are, and they will be gentle if we describe them as gentle. If this is right, then it really does seem that we create not just the self-image of others by telling stories about them but that we also create their personal qualities. The facts (or "prenarrative material") to which we appeal in verifying or falsifying a given ascription are themselves narratorially constituted—perhaps in other or earlier narratives. Whatever the "prenarrative material" to which we appeal in order to verify our aesthetic ascriptions of charac-

ter, the claim is that these have themselves to be interpreted and so are narratorially constituted.[19]

This argument leaves a good deal to be desired. Let us consider an example. I assert yet again that Van Gogh is a balanced personality. As if to show me up, Van Gogh promptly cuts off another ear and, for good measure, cuts his tongue out as well. Now, it is true that this behavior can falsify my claim only if it is construed as unbalanced behavior. But in *construing* Van Gogh's behavior as unbalanced, no story is told, for not every construal or interpretation is a narrative. Narratives, we saw earlier, consist of descriptions of selected events, arranged according to a plot so that the whole acquires a certain significance. However, to construe Van Gogh's removal of his ear and tongue as unstable behavior does not constitute a narrative in this sense of the word. For a start, it is not as if one selects the facts of Van Gogh's behavior. They are so unusual, so out of the ordinary, that they force themselves on one's attention. Second, it is not as if one has to order one's descriptions of these events to form a plot. They can assume whatever order one likes and they will still present themselves as signs of a personality in disequilibrium, and they will do so because of the values and theories to which we subscribe at this point of time and in this culture. And since there is no plot, it follows that there is no narrative.

It follows, I think, that events in the real world, as well as our descriptions and construals of them, can serve as touchstones in terms of which to verify our narrative construals as well as the aesthetic ascriptions of character that are based upon them.[20] It is to these facts rather than to her own narrative construals that the sage lover looks when she wants to verify her assessment of her beloved. Of course it is possible for her to become caught up in the charm of her narratives in a way that renders her unable to observe her beloved's behavior except in terms of them. This is the same difficulty that devoted theists and political ideologues have: the difficulty of never allowing oneself the "epistemological space" in which to falsify the theories and creeds to which they subscribe.

One frequent response, both of ideologue and lover, is to construct ad hoc hypotheses in order to explain away evidence that embarrasses. Here one's commitment to a cause prevents beauty from being dissipated by truth. The lover (like the theist, the politician, or the

ideologue) very often has a strong personal interest in not coming to know the truth about her beloved (God, the political party, or the creed). Her *akrasia* is not just motivated, but is, in a sense, politically motivated. Here the politics of knowledge are at play; so that when a woman is presented with evidence of the fact that her lover is guilty of sexual harrassment she prefers to see this behavior as a momentary lapse, as a version of the truth, as hearsay, and so on. In each case, an ad hoc hypothesis is offered that helps protect her interests, and a new story is told in terms of it.

There is a clear sense, then, in which our hapless woman confuses truth with beauty, and does so in a manner reminiscent of the great romantics. It was, of course, John Keats, in his "Ode on a Grecian Urn" who first declared

> "Beauty is truth, truth beauty,"—that is all
> Ye know on earth, and all ye need to know.

That Keats actually subscribed to this doctrine is well known. In a letter to Benjamin Bailey on 22 November 1817, Keats wrote:

> I am certain of nothing but the Holiness of the Heart's affections, and the truth of Imagination. What the imagination seizes as Beauty must be Truth—whether it existed before or not—for I have the same idea of all our passions as of Love; and they are all, in their sublime, creative of essential Beauty.[21]

The beauty that love creates is always truly attributed to the beloved. On this view, the truth of the aesthetic attribution is determined by nothing other than the strength of one's passions. Hence, if Keats is correct, there can be no possibility of counter-evidence that could ever displace one's aesthetic judgments of character, for it is not evidence but one's passions that determine the truth of our aesthetic ascriptions. These are essentially subjective, and it is, on Keats's view, their intensity that carries with them not just our belief in their correctness but their correctness itself.

This poses a peculiar problem. For how, on Keats's view, can one learn, as one unquestionably does, that my lover is not the beautiful or

the balanced or the polished person that I once took her to be? What is it that shakes my conviction in my earlier, very passionate judgment? Normally we would appeal to evidence of one sort or another: behavior or utterances that constitute reasons for abandoning a particular judgment. Keats, however, cannot allow this. Since it is the strength of the passion that proves the truth of any aesthetic ascription, he is committed to the view that my judgment that Vincent is a beautiful person can be displaced only by another and stronger passion. The "falsity" of the earlier judgment is entirely a function, then, of the strength of the new passion.

The problem with this answer, as one might expect, is that our passions do not usually spring from nowhere. Indeed, the fact that we can and do distinguish appropriate from inappropriate passions suggests that we expect our passions to be based on some or other reason, or where there is none, on an answering cause. Psychoanalysis teaches us that we might not know the reason or the cause of a particular passion, but also that such causes and reasons are in principle recoverable, and that by coming to know them, one can learn to adjust the passion.

Titania's belief in Bottom's beauty arises from a set of causes—in this case Puck's magic—which if known to her might bring her to reassess her judgment and the passion that it reveals. In the same way, my belief in the beauty, freshness, crispness, and vigor of my beloved may be considered by all and sundry to be part of a lover's madness and to be based on reasons that do not license these aesthetic ascriptions. Here beauty is not truth; nor need the truth be beautiful, for it may of course serve to reveal the ugliness of the person with whom I am in love. All too often, as we now know, the reason that I have for seeing beauty where there is none has more to do with my need for acceptance and approval, for an enduring "safety net" in a significant relationship, than it has to do with the facts of the matter.

Conclusion

That there are grounds for the ascription of aesthetic qualities to people and their characters is now plain enough. These, we have seen,

are to be found not just in the behavior and the appearance of an individual but also in the systems of value, the ideals of personhood, the theories and the bodies of belief that form part of our culture, and in terms of which human behavior and human beings are characteristically assessed. It is these, I have suggested, that help furnish the narrative structures in terms of which we both construct our view of others, come to "know" them, and so justify (or contest) the ascription of aesthetic properties to them.

For the most part, we apply aesthetic concepts to characters and lives of which we either approve or disapprove. Indifferent lives may well call forth aesthetic ascriptions, but we describe the mediocre person as dull only because we disapprove of her mediocrity. Most often, it is in the context of love, friendship, and enmity that aesthetic judgments are made of people and their lives. It is this, I have tried to show, that most strongly influences, and in some sense skews, our aesthetic ascriptions and makes them much less than reliable.

It was in order to explain the bias that enters unavoidably into the aesthetics of character that I offered an account of the relationships of friendship and love and distinguished these from the state of being in love. At root, I argued, friendship and love are relationships of dependency that enable us to satisfy our very deep, usually unknown and unacknowledged psychological need for approval and acceptance. It is, I contended, the personal interest that we have in earning or retaining the regard and support of other people that prevents us from noticing their flaws and encourages us to dwell on their virtues. Hence self-deception plays an important, some might say a vital, role in the aesthetics of character.

This is important, for as I have tried to show, it is not just the aesthetics of character that is beset by problems of self-deception. The same problems occur in ordinary aesthetic judgments where aesthetic properties are ascribed to works of art. So far as I am aware, this is an aspect of critical practice that has been ignored by aestheticians, and it is one that fairly cries out for attention, for it reveals the extent to which the concerns of ordinary life intrude on the fine arts.

Chapter

EIGHT

OF DRAMA, THE DRAMATIC, AND EVERYDAY LIFE

In our unreflective moments, we believe that genuine drama occurs only on the stage. If this belief can be shown to be false; if, in fact, drama has a place in, and emanates from, everyday life, then what Hegel has described as the highest of all art forms will be seen to be integrally involved in the processes of ordinary life.[1] In showing this to be the case, I will explore the role that drama plays in our lives and will develop a theory of drama (and of our response to it) that best explains this role.

The Place of Drama in Everyday Life

Occasionally a parent will say of an ostentatious child that she is being dramatic. The comment is usually dismissive in tone and is meant to convey the fact that the child is exaggerating her hurt, her indignation, her joy, or her anger. In such a case, bold gestures, larger than life, are the substance of the dramatic: gestures which, if they do not actually tell a story, tell part of one. And one way to stop the offending behavior is for a parent to tell the child that she is acting—where this suggests that her behavior is not genuine.

But dramatic behavior is not always artificial and insincere. To suppose that it is, is to confuse the dramatic with the theatrical, and although drama is an integral part of theater, it also forms an important

part of everyday life. To say of an action or an event that it is dramatic may be to say one of two things. It may be to say that the action or event is dramalike, that it resembles actions that are typical of the dramas performed on the stage. Alternatively, it may be to say that the action is part of a drama and belongs to it.

But what is drama? It is important to notice right away that the concept of drama cannot be explained except in terms of everyday life, for whatever else it does, drama represents or imitates the actions and events of everyday social existence. According to Aristotle, drama begins at the point at which we do not merely tell a story about everyday life but represent or imitate the actions which constitute that story.[2] He speaks of the actors in a drama as representing a "story dramatically, as though they were actually doing the things described."[3] And he adds that "imitation is natural to man," and, indeed, is distinctive of human beings since the human animal "is the most imitative creature in the world [who] learns at first by imitation." Even more important, Aristotle maintains that "it is also natural for all to delight in works of imitation" not just because of the pleasure of recognizing the familiar but "because one is at the same time learning—gathering the meaning of things."[4]

When it comes to a discussion of what we learn from drama or narrative, Aristotle's examples are impoverished. We learn much more than "that the man there is so and so."[5] Art, on his view, imitates life; but everyday life is enormously complicated and consists of many different objects, events, actions, and processes. One way of making sense of the bewildering array that we call life, we saw in Chapter Five, is by telling stories about our lives, the lives of others, or the "life" of our society—whether in autobiographies, biographies, or histories. In telling such stories, we of course select and organize the details of everyday life, and we do so in a way that gives these details some point. It is by focusing on some events and making them central, and by confining others to the margin, that we describe a sequence of events (the plot) in a way that lends significance to the whole (closure). In this way, dramas and the narratives they enact enable us to impose order on, and to make sense of, our lives. Still more, the stories that we choose to tell often reflect our preferences and values, and we usually assume in the telling that others embrace these same values and pref-

erences. Our stories, we have also learned, are normative: they reflect or otherwise imply the proper order of things, and we always hope that they will become part of the canon of stories whereby other human beings, their actions, projects, or activities are judged.[6]

It would be surprising if activities that serve these ends were to be entirely divorced from the transactions of daily life. It is quite clear, for instance, that stories are written and told not just as an art form but as ways of communicating with our friends and acquaintances and of bringing them to grasp the significance that we attach to certain events. We write and tell stories about our neighbors, about what happened at the school meeting, and about our lives; and in all of these instances we do not just convey information about the events in question but at the same time help others and ourselves to make sense of and evaluate them.

One can convey a story of this sort dramatically, and one can do so by imitating the actions that it describes. To do this is to perform a drama in the most minimal (or formal) sense of this term: a sense that Aristotle seems initially to favor. When telling a story of the fight at the pub or the police action at the soccer match, I may imitate the actions that my story describes. Alternatively, I may imitate only a part of the action, in which case we have an elliptical or truncated drama: one where the audience merely imagines the remainder of the action and does so in the light of the exchanges that the actor imitates.

It seems clear that dramatic presentations of this sort do form part of everyday life. My examples so far, however, give us a wholly misleading impression of social drama. They portray it as the representation or imitation of actions mentioned by the casual stories that we choose to tell about our daily lives—usually during coffee breaks or in the pub. There is, however, a much more important class of social narratives: narratives that bear some of the structural weight of our social existence. These, I now wish to argue, may also form the basis of what is a much more important, indeed a socially fundamental, form of everyday drama that pervades our lives, and is, I shall argue, a condition of serious or "high" stage drama.

Social Scripting and Social Drama

Most people experience certain upheavals and crises in the course of their lives. Love, birth, marriage, divorce, illness, but also injury, insult, blackmail, robbery, and rape occur, usually as crises, in people's lives. For the most part they occur only infrequently, and in this respect they are manifestly different from the actions that we perform or the events that occur on a daily basis like feeding the cat, making beds, traffic jams, and post office queues.

Upheavals in our lives are distinguished by their unfamiliarity. We marvel to find ourselves doing the very things and being in the very spaces that we had always thought foreign—perhaps marvelous, perhaps hostile and dangerous. Much worse, we are required to act in these situations, even though we have no first-hand knowledge of how to act in them. What knowledge we do have is usually derived from our experience of how other people have behaved in similar situations, and we imitate their behavior in order to cope with the crisis at hand. We observe the grieving behavior of the widow, the triumphant behavior of the sportsman, the elegant behavior of the bride and groom, the angry behavior of a wronged spouse, and this becomes the behavior that we sometimes imitate when we are required to negotiate the upheavals and crises in our own lives. We may also imitate fictional models, for novels and stage drama often treat of such crises, and we watch any number of heroes and antiheroes responding to the demands of the situations that they must confront.

It could well be argued that the mere imitation of the behavior suggested by these fictional and real-life models is not itself drama. Aristotle, you will recall, thinks that drama begins when we represent or imitate the actions that constitute *a narrative*. If he is right, then just by imitating the grief of a widow or the anger of a wronged wife, I do not engage in, or in some way create, a drama—even though my actions may be dramatic in the sense that they resemble those of stage drama. At most I act out a role, and this, it would seem, is not sufficient for drama in any full-fledged sense of this term.

But the matter is not so simple as this. To respond to a crisis without understanding it is almost invariably to respond inappropriately to it. In such a case, one may be said to have panicked—not just because of

one's fright but because, in acting without an adequate understanding, one fails to deal with, and perhaps aggravates, the crisis. If, however, one sees one's actions as being of a piece with, as somehow following in a sequence from, the actions of others, and if one thinks of them not just as leading to an end but as imparting significance to the entire sequence of actions, then, given the account of narrative that I have offered, one is acting out, or imitating the actions of, a story.

Telling stories, I have said, is one important and everyday way of making sense of the crises that beset us. We could equally advance psychological or sociological theories, and these may, but certainly need not, take a narrative form. However, it just is a fact about people that they revert more easily to storytelling, perhaps because it does not require an education in psychology or sociology. The wife faced with the disintegration of her marriage does not usually see her situation in psychological or sociological terms but reviews the events that have led to this end: she tells the history of her partner's disaffection, a history which may treat the situation as comic or tragic, as ridiculous or deeply serious, as ironic, inevitable, or perverse. More important, she will act in the light of the story she tells, the understanding that it breeds, and the behavior that it suggests to her.

One could say that narratives and the roles they subtend often guide one's actions in a crisis. More accurately, they suggest forms of behavior that we may imitate in order to negotiate the crisis. Sometimes people respond to a crisis by acting out or imitating a certain role that is quite foreign to them, and they do so in the belief that their behavior forms part of a story or a history. A woman can respond to her husband's infidelity or desertion by acting out the role of a wronged wife, but she can do this only if she also subscribes to a particular marriage-narrative that delineates the roles of husband and wife and which inclines her to view her marriage in a certain way.

Life crises are not the only situations in which we act in terms of chosen or imposed narratives. There are many stories that we live by: stories that script our daily lives. Some of these we furnish ourselves, but most are socially received. Take again the case of marriage. For some celebrants marriage is a wholly new experience which requires them to live in a way that is quite different from their former way of life. For many people, this is undoubtedly an upheaval with

which they will have to cope. The temptation to panic is always there. Those who have been properly socialized, however, will act in terms of a received marriage-narrative: perhaps a "happily-ever-after" or "until-death-do-us-part" story (or what I earlier called a "narrative structure"), according to which the events of a marriage take their significance, and in accordance with which the course of the marriage is anticipated. It is this story and the roles that it subtends that often guide the actions of those who are new to marriage. However, it may continue to guide their actions long after the unfamiliarity of the married state has waned. It then becomes internalized and is regarded as "the proper way," the received way, and some would think the natural way, for a husband or wife to behave.

Such narratives are socially constructed. To the extent that they mediate, guide, and direct our actions they can properly be regarded as socially produced scripts: scripts, moreover, that furnish subsidiary or subordinate texts in terms of which to deal with the disasters, crises, and upheavals that occur in our lives. If, for instance, one subscribes to the conventional marriage script, one will tend to see the desertion of a marriage by a spouse as destructive, selfish, as a waste of many good years, and one will act toward the spouse accordingly. Again, the parenting narrative that one prefers to tell, and the accompanying scripts that guide one's behavior, will furnish models in terms of which to deal with (and think about) a delinquent child or a childhood illness.

It is not as if one has a clear choice of narratives and scripts. Rather, it would seem that such stories—the story of a "normal" or an "ideal" career, childhood, or marriage—help structure our world, and so earn our unthinking commitment over time. As a result, it takes an alternative set of powerfully seductive ideas to displace them. Our social scripts, one could say, can be rescripted, and often are by political or social movements of one sort or another, or by the process of counseling which often seeks to displace maladaptive narratives with "more suitable" ones. The feminist movement, for instance, has done much to rescript the traditional marriage narrative, and many feminists now tell the story of marriage in terms of the oppression and exploitation of women. This furnishes a new narrative structure in terms of which certain events are treated as central to the marriage, others as peripheral, and in terms of which the significance and value of the entire

sequence of events is gauged. Should this story ever come to guide the behavior of a person in a conventional marriage, the scene is set not just for tension, but for conflict.

It would be wrong to infer from this that just by acting out the role suggested by a socially received narrative, one engages in social drama. After all, nothing seems further from a drama than my day-to-day behavior as a very staid and conventional husband—even when it accurately reflects a widely held marriage-narrative. The reason is that I have internalized this role and the narrative it assumes and act unreflectingly in terms of it. I emphatically do not imitate or represent the actions of a husband; I simply perform them.

One could say that it is only when I do not know how to behave in a particular situation and adopt a role fashioned for me by a particular social narrative that I am imitating or acting out the role, and so satisfy the formal conditions for engaging in, or performing, a drama. When I become familiar with the role, it becomes a part of my everyday behavior, and a part, too, of the person that I am, so that I no longer imitate the role but actually perform it. It is at this point that drama ceases and everyday behavior begins. Consequently, if my preference is to be a philanderer, but I nonetheless adhere to the socially constructed marriage script by conscientiously imitating the behavior that attends the role of husband, I am engaging in a form of drama. When this happens in everyday life, we have what I have called a social drama.

But this still seems unsatisfactory. Why, it will be asked, should we call the resultant social behavior a drama? Doesn't drama require something loftier than this? The short answer is that much drama does, but that just by imitating or representing the actions described, mentioned, or insinuated by a narrative, one satisfies the formal conditions for drama. There is, though, another, more basic, reason for refusing to regard my imitations as drama. It could be argued that everyday social behavior, even when it involves imitating the actions mentioned in some or other narrative script, can never properly be regarded as a drama. Certainly it can resemble a stage drama, and, in this sense, can properly be thought dramatic; but, following George Dickie's definition of art, it is argued that something can be a drama only if it is located in the artworld.[7] It is for this reason that social behavior which conforms to a narratorially constructed role is not, and cannot

be, a drama except in some or other extended or metaphorical sense of this word.

This view is wrong. While there is no disputing the fact that drama is paradigmatically an art form, not all drama need be a work of art. The objection overlooks the fact that the fine arts have their origin in everyday arts or skills. There is, I argued in Chapter Three, a perfectly ordinary sense of "art" in which any organized body of skills that is designed to achieve a certain end can be said to be an art. In this sense, I said, both medicine and agriculture are arts, but so too are the skills that allow us to imitate or represent the actions of a narrative, for such skills, we have seen, enable us to negotiate the social world in which we live and so serve a specific end. Following Francis Sparshott, I contended that it is only when an art of this sort comes to be considered as an end in itself rather than as a means to some or other end, that it comes to be treated as a fine art.[8]

My claim is that long before there was anything that counted either as an artworld or as the fine art of drama, people found it advantageous to act out received narratives.[9] The exercise of these skills earned them both social acceptance and approval, so that the more they adhered to social scripts, the more approval and social support they could expect to earn. Partly because people are social animals who need favor and advantage, they seek to do better. This, I have already contended, forces them to attend to and develop the skills involved in enacting social narratives—the skills, that is, that are involved in their everyday social lives. It is at this point that the *fine* art of drama begins to emerge. It is not as if social drama presupposes the existence of stage drama. Quite the contrary, stage drama presupposes, and depends for its existence on, its social counterpart.

The Content of Social Drama

In one perfectly ordinary sense of the word, social drama is not always dramatic. It is often routine, banal, and hackneyed. There is a sense of "dramatic," I said earlier, in which to say of a sequence of actions, or indeed, of an action itself, that it is dramatic is to say that it resembles

actions that are typical of stage dramas. Such resemblances are normally asserted in certain respects: in respect of intensity, heightened emotion, and tension, but also in respect of gesture, tone of voice, and turn of phrase. Enacting the conventional marriage-narrative, the traditional parenting script, or career story need not of course be dramatic in any of these respects.

This gives rise to an important question, for if it is true that stage drama is parasitic on social drama, why is our concept of the dramatic derived from stage and not from social drama? In order to answer this, something more needs to be said about the nature of drama. I have been careful up until now to explain drama not in terms of content but in terms, rather, of a set of formal conditions. Drama, I have said, is the imitation or representation of the actions that are mentioned or insinuated in a narrative. But this, we have seen, leaves something important out of account, for just by satisfying these conditions we may be left with what is admittedly a drama, but a drama in a minimal and uninteresting sense of this term. The best way to explain precisely what is left out of account is to look, yet again, at social drama—this time at its content.

Part of what binds us together in a society is a shared history. To fail to share this history, and hence the narrative that relates it, is to hold a different view of the society, and there are occasions when this will lead to tension and conflict. Our everyday social lives contain many narratives. These include stories about one's family, one's neighbors, and oneself, and all, I have suggested, convey ideals of human behavior. They may tell us, in one way or another, what it is to be a brave soldier, a good mother, husband, or doctor, a "real" woman, man, and so on.

Such narratives are not purely descriptive. While they do select and order past events, they also function normatively and furnish instructions for future actions. The role of father or friend, for instance, is socially scripted, and what these roles require depends crucially on an assumed narrative that tells us something about the end or goal, and hence about the significance, of these roles. Each narrative sees a certain sequence of actions (a plot) as essential to the performance of that role, and in tacitly advocating these actions, it becomes a social script.

Such scripts and the narratives they presuppose are formulated in only the broadest terms. They are little more than narrative structures and are indeterminate in many respects. Nevertheless, they do specify certain roles in society, and they instruct the actor in these roles while at the same time permitting a degree of individual initiative and spontaneity. However, just as there often are different histories told of the same society, so people will adopt different social scripts. They will conceive of the role of mother, doctor, or good citizen differently and they will often do so on the basis of their perceived interests. The capitalist's story about rational behavior in society may be quite different from the worker's story, and when each subscribes to a different story about the same issue in the workplace, understanding differs and conflicts of one sort or another will very likely arise. In much the same way, the woman who, in the context of a conventional career and marriage, adopts and enacts the feminist career and marriage script is likely to come into conflict with those who adhere to the conventional narrative.

We usually believe it up to the individual to decide whether or not to act out conventional social roles—whether it be the role of husband, worshiper, or soldier. An individual may, of course, decide not to do so—not to do the "conventional thing"; and the reasons for such a decision will vary greatly. It may be unbridled selfishness, a heightened sense of morality, or sheer stubbornness; but it could also be that a widely held social narrative conflicts with a person's self-image—that is, with the story that one chooses to tell about oneself. When people choose to act out their "own" stories and reject traditional narratives they invariably give cause for offense; tensions usually result, and conflicts and schisms may ensue.

From the very earliest times, social reality has simmered with such conflicts. My story of self, and the self-image to which it gives rise, may easily breach the received narrative of the good teacher, citizen, or what have you. It is at this point that social tensions and conflicts arise. According to the anthropologist Victor Turner, they are everywhere apparent, not just in complex industrial societies, but in very simple societies as well.[10] Similar conflicts arose with Watergate, the breach between Henry II of England and Archbishop Thomas Becket, between Caesar and Antony, between Pontius Pilate and Jesus Christ,

between Mr. Profumo and the British government, and continue to arise in struggles for political power, or in the competition between rival lovers, the world over, endlessly. According to Turner,

> Social drama first manifests itself as the breach of a norm, the infraction of a rule of morality, law, custom, or etiquette, in some public arena. This breach is seen as the expression of a deeper division of interests and loyalties than appears on the surface. The incident of breach may be deliberately . . . contrived by a person or party disposed to . . . challenge entrenched authority—for example the Boston Tea Party. . . . Once visible, it can hardly be revoked. Whatever may be the case, a mounting crisis follows.[11]

What Turner fails to acknowledge is the extent to which such breaches result from different social narratives. It was the monarch-story to which Henry subscribed and the bishop-story that Becket had adopted that led to tension, conflict, and martyrdom. And of course, the narratives that the protagonists adopted furnished subsidiary texts in terms of which they could act out the detail of their conflict. This is abundantly clear in accounts of the conflict between Becket and Henry, for, if the historians are to be believed, Becket as chancellor showed no great reverence for, or love of, the Church prior to becoming archbishop, but once enthroned seems to have acted and then to have internalized the appropriate role (as specified by a culturally produced archbishop-narrative).[12] It is was his adoption of, and commitment to, this narrative, I would venture, that prompted him to resist Henry's demands and enabled him not only to act as Archbishop but also as an archbishop would in the heat of a conflict with the monarchy. The archbishop-narrative, one could say, was Becket's guide in wholly unfamiliar terrain.

Every schism is a crisis or an upheaval, and we can now see that the narratives or social scripts to which we subscribe, and which are often the cause of the schism, help direct the ways in which we act out and manage the conflict. Put differently, they furnish roles for us to perform and suggest behavior that we imitate in order to negotiate the crisis. This conforms, I believe, to our subjective experience of crises or upheavals, for quite often those involved in a crisis find

themselves saying and doing things that are foreign to them, and that seem to be forced on them by the stories to which they subscribe. Their commitment to, and inability to think past, a certain narrative or set of narratives forces them to adopt roles that are strange, foreign, even uncomfortable; and yet, they adhere to them as the only guide and security in what has become an unknown world. This conflict of narratives results in social drama that is filled with the full range of human passions and flaws: a drama that is vastly more interesting and absorbing than the minimal drama involved in enacting a socially scripted role.

For the most part, the stage drama that we find absorbing does not just enact a narrative, but enacts the narrative of a conflict between social narratives. Such stage drama becomes a meta-narrative: it tells and enacts the story of narrative conflicts in the actual world. It is this that imparts the interest, the passionate intensity, and the profundity that we think of as characteristic of serious stage drama. But such profundity and interest derive in the first instance from everyday life. It is here that the stage acquires its intensity.

We should not privilege the stage unduly, for social dramas are not just re-enacted in front of the footlights. Those dramas in history that grip the popular imagination and are thought to mark major changes in the course of society—the drama, for example, of Christ on the Cross, Muharram, Passover, and the dramatization of the *Ramayana*—are regularly re-enacted, and become rituals around which religious observance takes it shape.[13] Again, those pageants that represent political dramas, such as the Boston Tea Party, the Fall of the Bastille, and the Great Trek, become with time secular rituals that celebrate particular forms of state. Social drama, then, is represented in church ritual and in the pageantry of state, and is not just to be found in the theater. This notwithstanding, it is convenient, and for my purposes sufficient, to refer to any representation of a social drama as stage drama.

Earlier I asked why, if it is true that stage drama is parasitic on social drama, our concept of the dramatic derives from stage and not from social drama? The answer, I think, is that with the advent of stage drama—a drama that represents, in all its relevant detail, stories about the conflicts of everyday life—the broad mass of people acquired a model in terms of which to see the world in which we live, if not as a

stage, at least as the locus of narrative conflicts. The stage emphasizes and highlights the conflictual nature of drama and its attendant emotions and behavior. And we use the stage as a measure of the dramatic precisely because it has brought us to see aspects of our world in a way that, for most people at least, might otherwise have gone unremarked.

So while we can see that the heightened emotions and the exaggerated gestures that characterize stage drama are derived in the first instance from everyday social life, it is their occurrence on the stage that gives us a model in terms of which to describe our everyday actions and reactions as dramatic. Moreover, and quite apart from this, we need to remember that the stage has an institutional life of its own—what we call the theater—and that many of the theatrical conventions that mediate stage drama do not find their origin in everyday life. They are often the product of fashions and styles that have evolved for purely institutional reasons within the theater itself. Nonetheless these conventions—whether they be the stylized conventions of Noh theater or the Theater of the Absurd—do affect how people behave in the actual world, and this reciprocally affects what happens on the stage.[14] The relationship between stage drama and everyday life is reciprocal or dialectical so that it is in point of fact difficult to find stable and fixed boundaries between the world and the stage.

The World and Katharsis

The world, of course, is not simply the physical environment in which we live. It is also the sense that we make of that environment. My world, one could say, consists of the organizational principles that I impose on, and in terms of which I order, my surroundings and render them both habitable and supportive. The disruption of any of these principles must throw my world into chaos, and I might then speak of my world as collapsing, as falling about my ears—even though the physical environment that forms part of it remains perfectly intact.

The sense that we make of the events and happenings that surround us is largely, although by no means entirely, a product of a network of socially received stories. Commitment to these narratives lends sig-

nificance not just to our acts but, as we have seen, to our lives and shapes intimately the ways in which we see ourselves, others, and our physical environment. This is what it is to have a world. Hence, to challenge the narratives by which other people live and to which they are committed is to challenge them at the heart of their social existence: it is to threaten the structure of their worlds. This helps explain the enormous tensions and heightened emotions generated by narrative conflicts. An unwelcome narrative, and more especially the commitment of others to it, may at times threaten one's whole world, and with it one's sense of security, by transforming the familiar and the comfortable into what is foreign, unpredictable, and hostile.

The destruction of one's world, then, is the loss of the familiar and the secure and of one's orientation in, and understanding of, one's surroundings. The pain, fear, and grief that this occasions is what the protagonists in a drama seek desperately and pitifully to avoid. Their assurance, their pride, and eventually their self-respect are put to one side as they attempt, often inappropriately, to avoid what is both fearful and unavoidable.

The struggle to preserve and maintain one's world is not simply the invention of stage drama. It is an important part of everyday life. Indeed, it is the audience's intuitive grasp of the importance that it attaches to its own world that allows it to apprehend in a flash the significance to Othello of Iago's story about Desdemona; and from that point onward the audience is inevitably drawn into the tensions of the play. The presentation of such a conflict on stage is deeply interesting and allows us to attend to its resolution not, I think, because of the practical value of a particular denouement but because the proffered resolution is of profound human interest in and of itself. It contains, as Aristotle observes, "incidents arousing pity and fear," and this transports us into the life of the drama.[15] Indeed, I have argued elsewhere that this is necessary if the audience is properly to understand the work; and it is necessary, too, if one is to acquire moral insights from it.[16]

Drama of this sort—call it high drama—does not just arouse certain emotions, but, if Aristotle is right, it either purges the audience of these emotions or otherwise purifies them. However, even as he introduces the notion of *katharsis* in the *Poetics*, Aristotle declines not

just to explain but even to discuss it, despite his earlier promise in the *Politics* to do so when discussing tragedy.[17] However, the theory of stage and social drama that I have advanced so far points us in the direction of what I believe to be a satisfactory account of *katharsis*: a satisfactory account, that is, of the way in which drama seems to rid or purge the audience of certain emotions.

Perhaps the best way to explain this is by looking to its occurrence in everyday life. Consider the traumatic divorce of one's friends. If one cares for them at all, their trauma must be upsetting. One will pity them and even fear for them, and this will invariably give cause for reflection. One will think about and consider the different accounts that the unhappy couple give of their predicament, the stories that they tell, and this will give one some insight into their situation and situations like theirs. In the light of this, one may come to reconsider one's own view of their marriage and of the story that one prefers to tell about it. As a result, one may place a different construction on it and so shed the tensions and the range of emotions in terms of which one views the couple. One's new, perhaps improved, understanding alters, even purges, one's emotional states. It may do more than this. It may enable one to reconsider one's own view of marriage and the story one prefers to tell about it. In reconsidering, one may be brought to disengage from the conflicts within one's own marriage and so shed the tensions and the emotions that accompany them. In the end, it may enable one to recommit oneself to a revised marriage-narrative, and in this way, re-establish the integrity of one's world.

There are, as one would expect, other ways in which everyday life rids us of our emotions. My anger at my government may be dissipated when I learn what has become of a friend who dared express a similar anger. Here a recognition of the futility of my feelings, or, on occasion, a prudential regard for my own well-being, diverts the emotion—and I find, perhaps to my surprise, that I have shed it. In this case, narratives, albeit of a cautionary sort, are at play. I tell myself the story of what has happened to my friend. I do not like its outcome since, presumably, it does not coincide with the stories that I would like to have told of my own life. My desire to preserve my life, my world, and everything that depends on them effectively banishes the emotion: it ceases to function as a motivating force in my life and gradually dissipates.[18]

There is nothing mysterious about this when it occurs in everyday life; nor is it mysterious when it occurs in stage drama. In both cases one's emotional attitude to an event is tempered, even dissipated, by an understanding bred of certain narratives. The tragedy performed on a stage, as we know, represents a narrative conflict. The pity and fear that the representation occasions may bring us to notice the demands of the portrayed situation and to consider how we would respond to such a situation in our own lives. By doing this, we are in effect forced to test the adequacy of our own narrative ideals. In other words, we are forced to test our beliefs about how the protagonists ought to behave and live out their lives.

It is in this way that we come to revise the narratives that we have favored and the ideals that they embody. Should this happen, many of the emotions that previously accompanied the narrative, or our assessment of situations in the world, will no longer find any application. My emotional attitude to, say marital infidelity depends on a particular marriage-narrative, but Ibsen's *Doll's House* encourages me to consider a story which could very well alter my commitment to the view that I have so far preferred. As a result, the anger or indignation that might once have accompanied a breach of my preferred narrative, and that may have been part of my initial response to Nora's decision to leave her marriage, no longer has any ground in which to take root. Assuming always that I am rational, these emotional attitudes will simply atrophy and disappear.

I do not wish to suggest that this explains every dimension of what Aristotle refers to as *katharsis*. The explanation that I have given is cognitive and requires an audience to entertain certain narratives, but it seems plain that some cathartic effects cannot be accounted for in this way. In certain circumstances it seems more appropriate to posit a causal or a neurophysiological response to the drama.[19] Exposure to certain intense emotions over a period of time has the neurophysiological effect of making one unable to experience, with similar intensity, the same emotions within a certain timespan. This is very obviously the case with great fear, anger, sadness, and hilarity.

An explanation of this phenomenon requires an advanced knowledge of neurophysiology. If some psychotherapists are correct, this experience does have therapeutic value and can be exploited in order to rid people of certain emotions.[20] Increasingly, though, psychothera-

pists have come to the view that an emotional discharge which is not mediated by insight or understanding will not have any sustained therapeutic value.[21] Psychodrama, of course, is itself the enactment of narratives which do not just produce emotional responses but which promote a narrative understanding of the situation of those patients whose stories are enacted. It is this understanding which eventually produces a cathartic effect and removes the reasons that we might otherwise have for certain emotions.

A large part of the problem with discussions of *katharsis* is that two quite distinct processes seem to fall under its aegis. The one, I have argued, involves the dissipation of emotion through an understanding bred of a narrative or a narrative conflict. The other is a neurophysiological process that, it would seem, can bring no lasting relief from a particular emotional attitude. This, perhaps, is why Aristotle seems to speak of *katharsis* both as moral purification and as medical purgation.[22] Purification amounts to something like clarification bred of understanding, and has, it would seem, a moral dimension, while purgation amounts to little more than neurophysiological exhaustion.

According to Martha Nussbaum, there is considerable evidence in Plato and Aristotle to suggest that *katharsis* was traditionally linked to learning and understanding: that it was cognitive rather than physiological. On her view, we find that

> *katharsis* and related words, especially in the middle dialogues, have a strong connection with learning: namely, they occur in connection with the unimpeded or "clear" rational state of the soul when it is freed from the troubling influences of sense and emotion. The intellect achieves "purification"—or, better, "clarification," since the word obviously has a cognitive force.[23]

And she goes on to argue that Aristotle favored a wholly cognitive account of *katharsis*. It is not, Nussbaum thinks, that he sees tragedy either as purifying or purging the emotions. Rather, he believes that "the function of a tragedy is to accomplish, through pity and fear, a clarification (or illumination) concerning experiences of the pitiable and fearful kind."[24] And this, she at once points out, would be profoundly shocking to "a middle-period Platonist," for on Plato's view the emotions confound and do not clarify the intellect.

Whether or not Nussbaum adequately explains Aristotle's view of *katharsis* need not concern us here. What is clear, though, is that her explanation is fully compatible with the account of *katharsis* that I favor. It seems plain in any event that a wholly noncognitive (or a purgative) account of *katharsis* is problematic, because it forces us to ask how an audience can become emotionally engaged in the action of a tragedy without responding cognitively to it. We must at the very least understand the significance of the event portrayed in the drama before we can become emotionally affected by it; and this, I have argued elsewhere, requires our imaginative involvement in the drama.[25] What one understands is a story of conflicts between people who are committed to certain narratives. It is a story, one might say, of worlds under threat and worlds in collision. It is the audience's imaginative involvement in all this that breeds its pity and its fear and forces it to reflect on the adequacy of particular narratives, and of a character's commitment to one or another of them.

What emerges, then, is that *katharsis* requires human understanding. We should not think of it as confined to the stage, for, as we have seen, it occurs in everyday life as well—often when the narratives that help constitute our world come into conflict with other narratives. It is our understanding of this conflict that breeds our pity and fear: emotions which, in their turn, encourage us to reflect on and reconstrue the events in question. By telling new and different stories about old events we not only alter our understanding but we sometimes remove the reasons which were previously the occasion of our emotional response.

Speaking Theoretically: A Conclusion

Drama occurs in everyday life. It occurs, we have seen, because people live by and are committed to certain narratives which create expectations, norms, and ways of understanding. Whenever these narratives are seriously transgressed—perhaps by being brought into conflict with other narratives—crises arise in which the protagonists enact narratorially determined roles. This is social drama at its best, and it is our interest in the course of such real-life events, and, more particu-

larly, our interest in their resolution, that brings us to attend to their representation on the stage or in the cinema, not as a means to any end, but because such resolutions are of interest in themselves.

So much I have argued. In so doing, I have inevitably contributed to the theory of drama, and have added yet another theory to the growing list. It is necessary now to speak briefly of the relation in which my theory stands to others in the tradition. In some measure, the theory that I have defended is Aristotelian in character since it treats drama as the imitation of those actions that constitute a narrative. This, I have tried to show, need not confine drama to the stage, but allows scope for the notion of social drama.[26] For all that, though, the theory that I have offered is compatible with the mimetic views of Aristotle, for it is plain that on my view stage drama imitates the social drama of everyday life; and social drama imitates the actions that help constitute our socially received narratives.

To say, as I am inclined to do, that stage drama takes root in and contributes to our social life is not to endorse the views of Bertolt Brecht. For although Brecht believes that theater ought to relate to our social existence, he believes that conventional stage drama removes us from the realities of everyday life since it exploits the audience's feelings and so prevents "reason" from bringing people to reconsider their social lives. On his view, theater ought not to rely on empathy, for "feelings are private and limited" and have the effect of preventing a critical reassessment of our everyday lives.[27] Rather than exploit our feelings, true theater—what he calls epic theater—should convey theories and argument since "reason is fairly comprehensible and can be relied on."[28]

It is important to realize, though, that like most theories of drama and the theater—whether we look at Aristotle's *Poetics*, Sir Walter Scott's "Essay on Drama" (1814), or the contemporary work of Antonin Artaud, Bernard Shaw, or Eugene Ionesco—Brecht's theories are normative in character. They try, for the most part, to tell us what theater or drama ought to be like and, unlike the theory that I have developed, say little about the conditions that are necessary and sufficient for describing something as drama.

Eugene Ionesco's reaction to Brecht is similarly normative. In his diary for 10 April 1951, he speaks of pure drama as "anti-thematic,

anti-ideological, anti-social-realist, anti-philosophic, anti-boulevard-psychology, anti-bourgeois"—where this is not intended as a description of drama, but as a prescription for good drama.[29] On his view, the dramatist should not seek to advance theories. Rather, and contrary to Brecht, the worthy dramatist seeks to involve us emotionally, for it is this involvement and the excitement that it generates which are the most important aspects of a drama and will be remembered long after its reasoned arguments and theories are forgotten.[30] Insights and understanding are furnished not through reason but through the creation of intense feelings, and to this end "nothing is barred from the theater."[31]

The casual theatergoer is bound to remark that both Brecht and Ionesco offer what is, at best, a partial picture of drama. Drama, it will be said, can do both: it can present theories *and* involve the emotions. However, to object to Ionesco or Brecht on these grounds is to miss the normative point of their various pronouncements. Neither theorist purports to tell us what drama is actually like; rather, as I have said, each tells us what the theater should be like.

It is possible, I think, to show that some of these prescriptions are unattainable.[32] Of more interest to my argument, however, is the fact that in offering his prescriptions for epic theater, Brecht supposes that it will enable members of an audience to apprehend the strangeness of their own lives—what he calls "alienation"; and it is this, he believes, that will bring people to the realization that their way of life is not fixed but can be altered. This seems true enough, but it is never clear why Brecht believes that drama cannot achieve this end. Without anything approaching an argument, he asserts that the dramatic form exhausts the capacity of people to act; that it does so through the exploitation of their emotions, and through the medium of a linear plot which suggests that social reality is unalterable.

If my arguments are correct, all of this is false. Most of what we call drama—whether it be a Greek or an Elizabethan tragedy, Ibsen's *Hedda Gabler* or Chekhov's *Three Sisters*—has the capacity to make us reflect on the social narratives that shape our lives and to which we are sometimes deeply committed. It has the capacity, as well, to alter these narratives, our commitments, and thereby the behavior which they prescribe. Stage drama does this, we have seen, by engaging us

emotionally in a narrative conflict, and by bringing us to explore the consequences of adhering to one or another of these narratives.

Brecht's approach overlooks the fact that reason, political theory, and argument are meager weapons when it comes to dislodging the commitment that pervades many of our social actions and interactions. On my view, such commitment is often challenged, and "alienation" best secured, by our emotional involvement in dramatic fiction. It is our emotional involvement that leads to *katharsis*, and so to the clarification, the alteration, and even the abandonment of those social narratives and scripts to which we were once committed.

It begins to be apparent that *commitment* to various narratives lies at the heart of everyday life and that it is the very stuff of social and stage drama. It infuses not just the world of politics but also the world of art, so that any satisfactory account of the place of drama and, indeed, of the place of art in everyday life, will have to say a good deal more than I have so far said about commitment and its role in the conduct of our lives.

Chapter

NINE

ART, CONFLICT, AND COMMITMENT

Conflicts, we have now seen, are the stuff of high drama and arise very largely because of the different narratives to which people are committed. There is, of course, no shortage of conflicts. Whenever we examine relationships between people or explore the dynamics of our own or other societies, we stumble upon conflicts which differ only in their scope and intensity.

Indeed, the history of most societies can properly be told as a story of conflict: often a conflict between the indigenous and the imported. Participants in these conflicts always wish to resolve them, although the envisaged resolutions take different forms depending on particular attitudes and the interests from which they derive. In this chapter, I want to explore the role of art in both the development and the resolution of social conflicts. Art, I shall argue, is well placed to foment and perpetuate conflict and the unreason that conflict sometimes requires. It is also well placed to resolve these conflicts; and in each case, I shall argue, it does so by unsettling or otherwise altering our commitments.

In doing all of this, I shall demonstrate—from yet another perspective—the extent to which art is integrated into the processes of everyday life. Here, however, I do not appeal, as I did in earlier chapters, to the fact that the language of art and the techniques of artistic production reach deeply into everyday life. Nor do I appeal, as I did in the last chapter, to the origins of the fine arts in the techniques and processes of day-to-day living. Rather, my strategy is to look at the role that works of art actually play in the creation and resolution of

conflicts. In order to do this, however, it is necessary to provide a more detailed account of the concept of conflict than has so far been given.

What Is a Conflict?

Only a moment's reflection shows that not every disagreement, spat, or squabble is a conflict; nor is every violent act. We can disagree about the merits of a painting or about the likely outcome of next year's election without being in conflict with one another. Again, while a mugging or a brawl is invariably violent and for that reason serious, we will hardly regard these incidents as conflicts if the mugger, like the victim, agrees that theft and violence are wrong, and if the brawlers concede their own stupidity. For whatever else conflicts involve, they require enduring disagreements between people not just over ideas, beliefs, and attitudes, but also over the adequacy of the narratives that govern their lives and to which they subscribe. Without this or something like it, there can be no genuine conflict.

If this is correct, it follows that we can disagree about the accuracy and adequacy, say, of William L. Shirer's history of the Third Reich and still not be in conflict with one another. If, however, we know that we are each *committed* to different and incompatible stories about the Reich, which, given our commitment, we wish to perpetuate, then we are in conflict with one another. Suppose, by way of an example, that I am committed to a history according to which the Third Reich was responsible for the senseless murder of six million Jews, while you favor and are committed to the view that the Reich deservedly eradicated parasitic elements in European society. In such a case, we do more than disagree. For assuming that we recognize and acknowledge the disagreement, and provided, too, that our commitment to our respective stories is genuine—so that we wish, in consequence, to achieve, and actually do strive to achieve, different and incompatible goals—then we are in conflict with one another. Since I want people to accept my version of the events, and since you do not want this, we will try to thwart one another's goals by advancing our respective accounts. And this is just what a conflict is: it requires an acknowledged

disagreement that is brought about through commitment to incompat-
ible narratives, beliefs, and attitudes—where this results in an attempt
to achieve incompatible and exclusive ends by thwarting the goals of
one's protagonist.

What form our conflict takes must, of course, depend on our indi-
vidual temperaments. We could be very low key about all of this and
choose wherever possible to avoid one another. Alternatively, we may
revert to gossip or slander, or straightforward physical violence. This
aside, a moment's reflection will show that conflicts are bred not so
much of the incompatibility of our ideologies, narratives, and the atti-
tudes and beliefs to which they give rise, but of our commitment to
them. It is our commitment that is the "deep" source of human con-
flict. It is also the "deep" source of social and stage drama. For it is
only because people are committed to incompatible stories, say, about
their countries, that they are prepared to fight one another for the sake
not just of their country but also of their country's story. It is their
commitment, in other words, that inclines them to thwart the goals
that others have so as to secure the ends to which they are committed.
This is, of course, a social drama of proportions that might one day
incline us to portray it on the stage.

It is an important fact about human beings that they are capable
of commitment not just to propositions and values but also to one
another, to practices, goals, movements, and the societies in which
they live. I try to show that an adequate understanding of the place of
commitment in our lives helps not only to destabilize the boundaries
of art but also to explain how art can help foment and resolve social
conflicts. In order to do this, we need to know what commitment is,
and what role it plays both in art and in everyday life.

Commitment and Reason

To be committed to a set of beliefs is to be bound to them and is, as
a result, to be inclined to treat them as unassailable, incontrovertible,
and certain. To be committed to a cause is to attempt to serve its inter-
ests unfailingly and at every turn. To be committed to the performance

of a certain role or to the achievement of a certain end is generally to refuse to be diverted from that role or from one's pursuit of that end. Commitment to persons, causes, ideologies, social roles, and specific ends is always based on empirical beliefs that one declines, for the most part, to treat as such, and that one has more or less locked into place and now regards as all but incontrovertible. To be committed in this sense is to be inclined to treat these statements as nonfalsifiable: it is to be in a psychological state that does not allow one (what I earlier called) the "epistemological space" in which to respond critically to these beliefs by properly assessing the evidence regarding them. Of course, the beliefs may turn out to be true, but to be committed to them is often to refuse to allow that they could be otherwise.

Although people often respond derisively to commitment of this sort, it does offer certain benefits. It is a major source of social cohesion. If everyone in a society is committed to the same beliefs, narratives, practices, and institutions, social cohesion is assured. So too is an eternal reluctance to assess critically the dominant ideas in one's society. This is the hegemonic goal of almost every political and social movement.[1] It is a goal, though, that is seldom, if ever, achieved, and as long as people are committed, as they unquestionably are, to different and incompatible narratives, goals, or ideologies, some or other degree of social disruption is assured.

We speak both approvingly and disapprovingly of commitment. One wants one's compatriots to be committed to the cause, and when they are, one praises their commitment. But in almost the same breath, one may criticize as disaffected the local Marxists who condemn capitalism, and here one speaks disapprovingly of their commitment to certain ideas. In this case commitment is thought to involve irrationality; more especially, it is said to involve an uncritical adherence to certain ideas that makes them impervious to evidence and argument.

In point of fact, though, commitment need not always be uncritical. I am as a matter of fact committed to the belief that race is not a determinant of intelligence, but I am nonetheless prepared to seek out evidence and argument in terms of which to defend, criticize, and refine this belief. In addition, I am prepared to allow the possibility of evidence which will disprove it. For all that, though—and until the day comes—I remain committed to the truth of this belief—where

this means only that I am bound to it, will attempt to defend it against criticism, and will not abandon it lightly.

Even so, the trouble is that commitment tends to blind us to evidence and argument. Those who are strongly committed to a belief often seem unable to attend to and assess the evidence and arguments that count against it. This tendency is undeniable, but it does not afflict all cases of commitment equally. We draw a distinction between absolute commitment to a belief or a cause, which we think of as irrational, and partial commitment, which can be more or less rational. We are absolutely committed, and manifestly unreasonable, when we refuse to question or abandon a belief despite the obvious strength of the available counter-evidence. In such a case, we try resolutely—perhaps for all of our adult lives—to defend our beliefs by constructing makeshift hypotheses in terms of which to explain away awkward evidence.

Such beliefs enjoy our total commitment, but there are many others to which we are only partially committed and which, even though they are relied upon with deep psychological conviction, are eventually abandoned in the face of recalcitrant experience. So, for instance, I believe and rely profoundly upon the honesty of my business partner. At first, the evidence that conflicts with this belief is ignored or explained away, but as his dealings become more obvious, and as the balance sheets begin to reveal discrepancies, I am led, through force of evidence, to abandon my belief. It seems fair to say that my commitment to this belief, although substantial and real, was not absolute. I was able adequately to process the evidence that eventually undermined the belief.

Some may argue that in cases where deeply held beliefs come to be altered through experience and argument, there never was a genuine commitment to these beliefs, just a deep reliance upon them. But this view is wrong. It is simply a fact, and one familiar to most of us, that our commitments can and do alter throughout the course of our lives, and that they are sometimes altered through force of argument and appeals to evidence. Nowhere is this more apparent than in the case of religious belief, although it is only when believers are committed to the canons of rationality that they will be persuaded to abandon their religious commitments by appeals to reason and truth. Certainly

an altered or abandoned commitment could not have been absolute or total—in the sense of being impervious to rational criticism—but this, we can now see, is no reason for refusing to treat it as a commitment. It is essential to the concept of commitment that our commitments can be altered—even by, but not only by, reason and evidence. Why otherwise do we try to disabuse people of their religious or political views by appeal to arguments and evidence? And when that fails, we often revert to a range of different techniques and play on the emotions and psychological vulnerabilities of people in order to displace their commitments.

It follows from all of this that not every belief to which we are committed is an irrationally held belief. On the contrary, one can have good reasons for believing a proposition while at the same time allowing that, despite one's commitment to it, the belief may be false. It is only in the case of absolute, rather than relative or partial, commitment that the belief cannot be rationally held; for such commitment, I have said, involves an inability to process evidence and arguments that count against it. And in one perfectly ordinary sense of "irrational," this is always a mark of irrationality.

There is another, and very different, sense in which some commitments—whether partial or absolute—are not rational. In many cases, the process of becoming committed to a belief, a person, or a cause falls beyond our rational control and is not the result of informed decision making. We are on occasions surprised to discover the extent of our commitment to a belief or a cause. In retrospect, we can see how our lives or worlds have taken shape around a particular set of beliefs, and, given our need for security and stability, it is hardly surprising that we should wish to defend or protect it. But the act or process of becoming committed, of becoming bound to a belief, a narrative, or an ideology, need not be something of which we are aware; still less, something that we resolve to do on the basis of a reasoned assessment. In these cases, if our commitment is not actually irrational, it is at the very least nonrational.

It would be wrong, though, to think that commitment is invariably beyond our rational control. There are many occasions when people recognize the importance to themselves, their family, or their society of treating some doctrines, narratives, beliefs, ideologies, and mass

movements as unassailably justified or correct. And here commitment is very much a matter of the will and amounts to no more than loyalty. One forces or demands commitment of oneself, and with effort and habituation one finds oneself increasingly able to live up to this demand. While belief, as David Hume observed, is not itself subject to the will, he failed to see that commitment to a belief, and all that it entails, can be.[2] Hence when religious believers blame others for abandoning their belief in God or the bodily resurrection of Christ, they blame them not for the beliefs that they have or do not have but for their lack of commitment: that is, for their unwillingness to defend the belief (and hence the cause or the movement) no matter the evidence against it.

In much the same way, one can hardly blame people for becoming disenchanted with the political ideology to which they were once committed, but one may very well blame them for their lack of commitment to the cause when, in due course, they walk away from it and into the arms some rival movement. Whether or not one's blame is justified is a very different issue and must depend on the moral worth of whatever it is that demands one's commitment. It is possible, I believe, to give reasons which show either that commitment is or is not morally justified, but this is an issue that I will not pursue here.

The Scope of Commitment

Commitment is a psychological state that tends to irrationality since it interferes with the proper assessment of evidence and argument. However, I have shown that not all commitment is irrational in this way: that absolute commitment unquestionably is, while partial commitment to a belief or a cause need not be.

It is a deep psychological need for security and stability in an uncertain world that brings us to treat some propositions as fixed and assured. Our need to make sense of our environment, to find our way about it, and to negotiate its various snares and pitfalls requires us not just to take some propositions for granted but to treat them as secure in the scheme of things. They become for us the linchpins on which

everything else turns, and we are inclined, in the absence of better, more fruitful beliefs, to protect them against upheaval and displacement by making them impervious to reason and evidence. According to Karl Popper, it is when we refuse to treat a proposition as falsifiable that we effectively treat it as a metaphysical proposition.[3] This, I think, allows us to see the whole of traditional metaphysics as an attempt to justify propositions that are impervious to evidence and reason, and which are held with conviction not just because of the arguments and evidence in their favor, but because of the vital role that these propositions play in the sense that we make of our environment. Observation of what others say and do, and a certain degree of instruction, may implant these beliefs, and they will come to be held with the utmost certainty only because other beliefs and practices, some of profound value to the individual, depend on them.

Many of our commitments in later life share the same psychology and logic as our commitments in early childhood. A child will often believe unswervingly, and without ever deciding to do so, that there are objects that exist independently of it, that there are regularities in nature, that people communicate, that its parents can be trusted, that despite what they say and do, they really are kind and mean them well. They will believe that men "go out to work," and that women "stay at home," and, again, without deciding to do so and without ever assessing the evidence, they will see this as fixed, proper, natural, and unchanging. Here the beliefs—and the narratives that some of them presuppose—are held uncritically and with utter conviction. The child is committed to these views, and will be dislodged from them only with the greatest emotional difficulty. These become the basic, and the relatively unassailable, assumptions in terms of which the child constructs its world.

It is the myth of childhood innocence that inclines us to think of adults, but not of children, as committed to beliefs, narratives, and ideologies. In a manner reminiscent of Wordsworth, we prefer to believe that children, still trailing clouds of glory, are innocent of such irrationalist excesses. But this, we can now see, is wrong. There *are* commitments of early childhood. It seems true to say that human beings always treat some beliefs as fundamental and unassailable, that they do so from the very moment at which they begin to make sense of their surroundings. People of all ages and in all cultures and times

have to rely on, and treat as certain, specific beliefs and narratives, and they have to do so in order to make sense of their experiences and their social life. These are what Hans-Georg Gadamer calls our "prejudices," our "forestructures of understanding," or our "horizons."[4] Insofar as we are committed to them, they become for us the fixed points, the foundations, in terms of which we construe our experience, shape our worlds, and our lives. They are not, it is true, particularly secure foundations, for we have seen that our commitments can and do change. For all that, though, our commitments are enormously formative and are the foundations upon which we build our lives and our worlds. Little wonder, then, that the broader society takes so great an interest in them and that it attempts, through socialization, to proscribe some and encourage others.

All of this is starkly reminiscent of Friedrich Nietzsche. On his view, it is the Apollinian impulse in all of us that helps us to constrain a universe of fundamentally unstable experiences and forces us to impose an imagined order upon it.[5] This we treat as "fixed, canonic and binding," and we do so as part of an attempt to impose control on what is basically uncontrollable.[6] It is part of what Nietzsche elsewhere calls the "will to power"; and it is an attempt to deny the Dionysian or unruly elements that are so much a part of our basic natures and experience. Instead, we opt for an order and a safety of our own making. And it is this that we dignify with epithets like "rational" and "true." If Nietzsche is right, then something like commitment is necessary for all of what we call "rationality," and yet, paradoxically, we have seen that commitment tends, in two rather different ways, to irrationality.

The tension is easily dispelled, for to the extent that our commitments facilitate understanding they also limit it; and in limiting it, they make us the sort of people that we are, with the sorts of lives that we lead and worlds we construct.[7] We are, Kant said, finitely or imperfectly rational beings, and it is, I would venture, our foundational commitments that determine the scope and the limitations of our rationality.[8] They also determine the ways in which we live, and are, one could say, the foundations, the more or less fixed presuppositions ("prejudices," "horizons"), that permit us to organize, relate to, and understand our surroundings. In the end, they furnish us with a world and with lives that we can lead.

Ludwig Wittgenstein takes up this very point and insists that we

treat such beliefs as certainties in our lives because "something must be taught us as a foundation."[9] Indeed, we can enter into a form of life or a language game only if "one trusts something" (para. 509). These are the "hinges" on which our experience and our world depend, and without them we would lack a life in both a biological and an autobiographical sense. So, for instance, unless I believe as a certainty that the earth will support my weight, or that bread will nourish me, and water quench my thirst I will not easily be able to survive. Nor will I have any sense of self if I cannot believe with certainty and assurance that there are people other than myself, that they speak to me, admire or chastise me. And without a sense of self I cannot have an autobiographical life. Hence Wittgenstein writes "my *life* consists in my being content to accept many things" (para. 344).

There are innumerable, apparently empirical, propositions and narratives to which we are committed. These, according to Wittgenstein, are the propositions that "stand fast for me" (para. 151). He writes: "It might be imagined that some propositions . . . were hardened and functioned as channels for such empirical propositions which were not hardened but fluid; and that this relation altered with time, in that fluid propositions hardened, and hard ones became fluid" (para. 96). This, of course, prompts us to ask why certain empirical beliefs and narratives harden; why others remain fluid. And the answer by now is plain enough. The worlds we inhabit invariably depend on our construals or understanding of our environment, and the way in which we understand depends in part on certain set assumptions. Still more, our sense of self and our lives depend on these assumptions, and it is in order to preserve our worlds, and with it the lives that we lead, that we treat certain structures of ideas as inviolable.

Any attempt on your part to deny my commitments, by contending, say, that there are not other minds, or that nothing exists independently of my mind, is bound to be met with incredulity and a profound desire on my part to defend my commitments. I may never previously have entertained the proposition that there are other minds, and may be surprised to find that I both assent to it and am willing (at some cost) to defend it against your infuriating skepticism. But in defending this and other propositions, I am in effect defending the structure of my world. To abandon these beliefs would require a radical revision

of all my previous construals and understandings. It would allow my world and my way of life to collapse. Hence, whenever one strives to protect the beliefs and narratives to which one is committed, one is, in effect, attempting to preserve one's world and one's place within it. And people will go to extraordinary, sometimes frightening, lengths to do so.

Art in a Changing World

Conflicts, I have said, involve enduring ideational disagreements, and arise only when the ideas, beliefs, narratives, or ideologies to which we are committed are threatened by opposing beliefs, narratives, or ideologies to which others are committed.

Since our commitment to these ideas helps shape our worlds, our lives, and our sense of self, to allow them to be undermined is to lose not just our sense of security and stability but, with it, the ways in which we normally make sense of ourselves and our environment. It is a desire to protect all of this, I have argued, that is the "deep" source of human conflict.

How one conducts such a conflict must depend on one's temperament and character. It is here, though, that commitment, conflict, and art come together in ways that often preclude prudent reasoning. Indeed, it is here that people come up against the limits of their rationality, for what is at stake are the very principles in terms of which they normally make sense of themselves and their environment. Their standards of rationality are under scrutiny and duress, and as a result a heightened and a charged response seems often to be the only one available to them.

It was emotionally charged thinking of this sort—thinking that is clearly encouraged by some works of art (especially drama)—that most frightened Plato. On his view, such thought is incapable of ever discovering the truth. It is hardly surprising, then, that Plato should have wanted to cure drama of its "flaws" and perhaps even banish it as a public spectacle, for, he thought, it could serve only to perpetuate unreason and turmoil. Since, drama inevitably plays on our emotions and

appetites, Plato believed that it would seduce and subvert our commitments, and so eventually destabilize and dismantle our social world.

It is well known that Plato's fear of the emotions—and his belief that they invariably confound rationality and occlude the truth—is needlessly exaggerated. Although emotionally charged, and although remarkably seductive, the challenge posed to our commitments by dramas and other works of art is often of the greatest value. It may shake away our blinkers and help us to understand, to see, and to think differently. Plato certainly is correct if he thinks that works of art have the capacity to challenge and undermine our commitments, but this sometimes leads not to confusion but to a more adequate understanding of the situations in which we find ourselves.

Every stage drama works toward a denouement: a way, often an unsatisfactory way, of ending (rather than resolving) a conflict. Elsewhere I have argued that in the process of doing this it suggests new ways of looking at and understanding certain conflicts and both teases and tests some of the values, the beliefs, and the social narratives to which we are committed in our everyday lives.[10] Subtly, and without ever directly confronting our commitments, good drama suggests alternative ways of evaluating, construing, and eventually understanding everyday life, and it does so by playing on our emotions. Think of what *King Lear* does to one's understanding of parental love; of what *Hamlet* does to one's understanding of filial duty; of what *A Doll's House* does to one's view of marriage; of what *Dead Poets Society* does to one's beliefs about pedagogy and parental authority; of what *Catch-22* does to one's understanding of patriotism. None of these works suggest definitive resolutions to the conflicts that they portray, but all challenge, on an emotional and an intellectual level, certain deeply held views of the world and our place within it.

While Plato's fears about the effects of drama on people are not without justice, they are one-sided. It is true that drama can dislodge the unreflective from desirable—some might say rational—commitments. But drama, we have seen, is double-edged, and it can and does do a good deal more than this. For in bringing an audience to reconsider, to think again, and to discover anew, drama occasionally dislodges people from irrational commitments and from the hostility and turmoil that they breed. To dispense with drama because of the harm that it can

do is to forego its ability to afford useful insights and, sometimes too, a profound understanding. It is to become firmly lodged, frozen, one could say, in one's ways of thinking and understanding, closeted in a rigid world that will not countenance change.

Art and Anaesthesia

Normally, any public challenge to widely held commitments within a society is met with outrage. In some societies, a challenge to democracy, or capitalism, or religion will be met with nothing but public hostility. Interestingly enough, this does not usually happen to what is thought of as good literature or drama in our society when it teases, or threatens to subvert, widely held beliefs and commitments. An audience challenged in this way by Nadine Gordimer or Maurice Gee does not usually respond with the same outrage and defensiveness as people do in their daily lives.

This suggests a new dimension to the time-worn observation that works of art—most particularly literature, the cinema, and theater, but also, I think, painting, sculpture, photography, architecture, and music—play a political role in our lives. For it now appears that drama and literature do not just have the capacity to destabilize our commitments at a very basic attitudinal and cognitive level but that they are able to do so in a way that prevents the customary defensive response. They not only make us suggestible, and with it susceptible to new narratives, values, beliefs, and even ideologies, but they also anaesthetize us against the pain that normally attends such upheavals. Because of this, literary and dramatic works of art may come to undermine prevailing sets of ideas and foster what Nietzsche has called our Dionysian tendencies by allowing us to conceive of new ways of understanding that undermine the established order and, with it, current conceptions of rational thought and behavior.

Of course, literary and dramatic works of art, music, sculpture, and painting may also serve, as official art does, to reinforce and entrench prevailing attitudes and ideas. Such works encourage the Apollinian in us by reaffirming our sense of order and our ideals of rationality.

Ironically, they may do so while at the same time flattering us into the belief that it is the Bohemian, the daredevil, the Dionysis in us, that allows us to appreciate, understand, and agree with this art.

The political importance of these observations cannot be overestimated. If they are correct, art may be considered an instrument of policy that can succeed where tanks and guns fail. However, the philosophically interesting issue here is to try and discover how this is possible: why it is that people who would normally react with hostility to any challenge to their basic beliefs and attitudes find themselves able to tolerate this in literature, drama, or the cinema.

At least part of the answer, but only one part of it, is to be found in the observation that the theater, cinema, and literature allow us to identify emotionally with creatures of fiction. It is by imagining the details of Anna Karenina's situation that we, as readers, are able to understand her situation, not from our own point of view, but from hers—and in this sense imaginatively and emotionally identify with her.[11] Our sympathies are enlarged; we are brought (always through the medium of our own commitments or "horizons") to understand, and eventually inhabit, a new world, and in this way we become susceptible to new ways of thinking and feeling, different moral standards, religious values, and so on. Since these different and new ways of thinking and feeling are arrived at through our own imaginative endeavor, we are not threatened by them—even though they do much to destabilize our world, our sense of self, and our lives. On my view, it is our imaginative participation in the fiction, and our consequent efforts to understand both Anna's behavior and the adequacy of our response to it, that prevents us from fixating on the consequences to ourselves of our changed attitudes and opinions. For as long as we fail to dwell on these consequences, and are absorbed instead by the plight of our heroine and her attempts to resolve the problems that beset her, we will not be threatened by the novel and so encouraged to protect our earlier commitments.

In this way, we find that people who might previously have been deeply opposed to adultery are gradually able to understand and sympathize with aspects of Anna Karenina's adulterous behavior. Readers of *The Color Purple* may find that their attitudes to lesbianism have imperceptibly altered, so that they are no longer hostile to sexual love

between women, and have even become accepting of it. All these attitudinal changes, moreover, can be achieved without our being made aware of them, so that as time passes we may discover that our commitments have shifted, and, on reflection, we may trace these shifts back to our exposure to certain literary or dramatic works of art.

Sometimes, though, good theater, like good literature and cinema, is deeply and consciously unsettling: it is, as Edgar Wind puts it, "an uncomfortable business." [12] Socrates certainly thought as much, and it was partly because of this that he owned to a deep mistrust of the dramatic arts. [13] As we know, he endorses (but certainly does not approve of) the view, given above, that it is an audience's emotional involvement in drama that explains the subversion of its understanding. And one can, of course, hold this view without subscribing to the Socratic claim that the play of the emotions is always bad or that it invariably subverts rationality. Leaving this to one side, it is important to see that even though our capacity to identify imaginatively and emotionally with fictional characters unquestionably opens us to new ideas, emotions, and perspectives, this is not the only device that artists rely on in order to destabilize our world views and commitments.

Indeed, something more than imaginative and emotional involvement in the dramatic arts seems to be required if our commitments are to be altered. This is clear from the fact that we often identify imaginatively and emotionally with the plight of other living human beings, but that this does not normally subvert our established ways of thinking and understanding. I may, for instance, empathize with, and feel desperately sorry for, starving people in Ethiopia, but this emotional identification does not itself encourage me to alter the fundamental ideas, beliefs, narratives, or ideologies in terms of which I see myself, my life, and my world. This can happen, but when it does, it is often because I have become committed to a particular view of the person (or the cause) concerned—as happens whenever one falls in love with a person or enlists in a political movement. More specifically, it is only if I am convinced that the people who are the object of my concern mean me well, are kind, worthy, beautiful, and so on— that I am likely to adopt their views and some of their commitments without a struggle. If this is right, then it seems likely that part of the reason why our commitments are peculiarly vulnerable to works

of art is that we are committed to the view that art is itself harmless and ineffective. It is this view that inclines us to ignore the challenge that works of art present to our commitments, our way of life, and our interests.

In order better to understand this, imagine someone who expresses an abhorrence of William Faulkner's writing because of its racist overtones. It is customary in some literary circles to regard this sort of response to a work of art as little more than an elementary mistake. The view is that Faulkner's racism ought not to affect one's appreciation of the artistic or literary value of his work. To those who are not very sophisticated in these matters, this response seems odd, for one can hardly deny that racism in art often fosters racism in the broader community: more particularly, that it can and does alter, or else that it reinforces, prevailing commitments. The claim that the racism in Faulkner's writing is irrelevant to its merit suggests that we should simply ignore the political, social, and moral implications of the work in favor of other—so-called genuinely artistic or literary—considerations.

This view of art is neither rare nor idiosyncratic. Many who consider themselves people of taste and artistic refinement subscribe to it, believing that the content of a work, its bearing on real life and the everyday world, is of no artistic consequence. This is the view, we learned in Chapter Two, that has long been dominant and whose influence is only now beginning to fade. According to it, the text or the work has an integrity of its own and should be considered for its own sake and the aesthetic pleasure it affords rather than for an elusive message. It is this view to which many art lovers and sophisticates in our society are committed. To challenge it, as I did in Chapter Four, evokes from some professors of literature all the defensiveness and anger that one expects of people whose basic orientations are being challenged. And it is this deep-seated commitment to a view of art— one that has its origins in the aesthetic movement of the late nineteenth century—that often inclines an audience to the belief that art cannot really affect our lives. This, in part, is why audiences abandon any attempt to defend their basic beliefs and world views when they are challenged by works of art.

The art historian, Edgar Wind, complained in *Art and Anarchy* that people in the West fail to take works of art seriously; that they treat works which have blatantly contradictory messages as being of equal importance and interest. On his view, the general public has acquired a certain ease "in touching the surface of many different arts without getting seriously entangled in any."[14] This, he thinks, is due to a cult of instant gratification that has invaded the West: a cult that forbids us to think about the implications of what we are doing, saying, looking at, or consuming as long as it provides us with instant pleasure. The entire tendency, Wind argues, is to derive pleasure as quickly and with as little intellectual effort as possible, and without "making contact with [the work of art's] imaginative forces."[15]

This cult of gratification is itself just an extension of the message that was forged in the fiery excesses of the aesthetic movement, for long before the advent of tea bags, television, and instant coffee audiences were being exhorted to attend to works of art as ends in themselves.[16] It is an approach to art, we saw earlier, that has deep roots in the economic and political developments of nineteenth-century Europe. It is an approach, moreover, to which some people are politically committed since, as we learned in Chapter Two, it is thought to assure them of a place in an intellectual, cultural, and class elite.

Over the years, though, mass technology has been used to deliver the high arts to more and more people. Mozart, for instance, has moved into almost every home and is played and replayed on countless stereos, while Rembrandt and Picasso prints find their way into bedrooms and living rooms all over the world. In this situation, one's membership in the upper classes can be retained through art only if the cultural elite demonstrates a willingness to appreciate increasingly exclusive works: works that exclude because they are wayward and difficult to understand—whether it be the work of Mark Rothko, Robert Rauschenberg, Jackson Pollock, or Francis Bacon.

The result in the second half of this century is a profusion of esoteric artworks, each offering different insights and messages, and all crying out for attention. It is a state of affairs, I would venture, that has been brought about both by the desire of the dominant classes to use art as a mark of its cultural superiority and by the desire on the

part of others to use art as a means of upward social mobility. The resultant diffusion of art in this century has produced so many artistic contradictions and contradictory messages that it has become very difficult to take art seriously. And this further encourages the deep-seated view that while works of art are interesting, suggestive, and engaging, they are ultimately trifling and can have no lasting import.[17] It is this attitude to art which, precisely because it prevents us from taking art seriously, makes us more, rather than less, vulnerable to the cognitive effects of art. It is because we think of the best works of art as a "splendid superfluity," "a glorious irrelevance," that we lower our guard, and allow our commitments to be challenged and destabilized by them.[18]

From time to time, of course, people do react with hostility to works of art that challenge their commitments. If what I have said so far is correct, they do so for one of two reasons. First, they may react with outrage because they have not been socialized into the view that art is a harmless superfluity. This, I think, helps explain the reaction of Shi'ite Muslims in Iran and elsewhere to Salman Rushdie's *Satanic Verses* and of some Christians around the world to *The Life of Brian*. Alternatively, people who have been brought up to accept the Western view of art as an end in itself and as a mark of high culture may be outraged by any work that challenges this view of art. Marcel Duchamp's Dadaist works, like later conceptual, minimalist, and eventually excremental art, challenged deep-seated views of what art ought to be, and was met with considerable hostility. This, of course, is hardly surprising. What is surprising is that so much of the art that does challenge world views and deeply held commitments is allowed to pass unchallenged—usually with a nod and smile.

Art and Instability

Art may be an uncomfortable business and may at times be deeply unsettling, but the plain fact of the matter is that only some of us ever have our basic commitments altered by a work of art.

Edgar Wind recalls an incident, when, as a young man, he visited a German expressionist exhibition:

> The walls were filled with apocalyptic pictures painted in violent colours and incongruous shapes. I found this aggressive art singularly exciting and consumed it with the fresh appetite and strong stomach of youth. In the midst of this I was struck with a thought that troubled me greatly; and it might still trouble me now, were it not that I have become less serious. It occurred to me that if all these intense pictures, one after the other, had been experienced by me with the intensity they demanded, I ought to be out of my mind, but I clearly was not. And, extending this thought to the numerous visitors who had been exposed with me to the same exhibition, I came to the conclusion that something was wrong.[19]

But what, if anything, was wrong? Wind, it should be noted, eventually changed his mind, and concluded that "there is nothing wrong with an illusion of intensity."[20] And while it is of course true that one can hardly criticize German expressionism for failing to produce madness in its viewers, Wind is mistaken if he thinks that the paintings of this school merely provide "an illusion of intensity." They are genuinely intense and unsettling, but even so, they do not force us into insanity.

Although I have raised the specter of art as a subversive political weapon that can introduce us to new ways of understanding and new standards of rationality, it seems plain from our own and Wind's experience that art does not always shift our beliefs, attitudes, and notions of rationality. This prompts a range of questions, for we now want to know under what conditions, if any, a work of art is capable of unsettling our basic commitments and so producing or resolving a conflict.

The first point to notice is that some parts of our world may be more dispensable than others. I am convinced, for instance, that mountains, people, and lakes exist independently of my thoughts about them, and I cannot abandon this belief without at the same time radically upsetting the way in which I make sense of my environment. Chances are, therefore, that, like me, most people will be unable to abandon

such a belief and still be considered sane. The belief plays too great a role—indeed, it plays a pivotal role—not just in the way in which particular people construe their surroundings, but in the way in which their communities understand and make sense of the environment.

However, there are other less pivotal beliefs to which we are also committed, and these are more easily abandoned. My belief in God may be one such; but also my belief in the goodness of humankind, the correctness of capitalism, the bounty and wisdom of my leader, the democratic nature of my society, and so on. Each one of these may be a belief that I take for granted and rely upon at present; but because they are not absolutely vital to my world, because my world will not disintegrate without one or the other of them, I can allow them to shift with comparative ease. True enough, they are the principles in terms of which I construct my world at present, and they are altered only with difficulty; but like all such principles, they can shift. For, as I argued at the outset of this chapter, what we treat as an inviolable commitment can change. If it could not, there would be no point to the many conflicts in which people try to alter one another's commitments. Nor would there be any point to psychotherapy; and it would never be possible to shift our Gadamerian "horizons." At root, it is the belief that commitments can change that permits us to take issue with the commitments of others, and feel threatened about the security of our own commitments.

This notwithstanding, the important point is that some commitments shift more easily than others, and they do so only when this does not result in massive psychological and social disorientation. Not everyone will be disoriented in the same way by the same changes of belief and attitude. One person may be able to chuckle at the discovery that a spouse has been unfaithful; for another, it is the dissolution of an entire world and life story, a total loss of direction and orientation. There are, as we have seen, many other beliefs to which we are all committed and can abandon only at the cost of our sanity. These are the most common and pervasive of beliefs: a belief in causal regularities, in the independent existence of material objects and other people, and, of course, a belief in our capacity to communicate. It is possible for these beliefs to alter, but the consequences are profound, and anyone who does not believe that there are causal regularities,

or material objects, or other minds, and who acts accordingly will be regarded as insane.

This suggests that the ideas in literature or drama that we find attractive will initially displace only small and dispensable parts of our world. Their displacement will of course be facilitated if these same ideas are also challenged in other works. There are, of course, fashions of thought and value that sweep across the intellectual landscape, and are embodied not just in one or two works of art but in the many works that help characterize a period. Here repetition as well as peer pressure help destabilize the commitments not of one or two conscientious readers but of entire populations.[21] For my purposes, though, it matters little whether such displacements occur in individual works or as a part of major cultural movements. In either case, seemingly small adjustments to our commitments may eventually come to displace kernel ideas—either through explicit attack, or, more likely, through a gradual displacement bred of preferences and interests. The process is reminiscent of the hermeneutic circle: the gradual modification of the sense that we make of the parts inclines us, through a process of adjustment, to modify the sense we make of the whole, which reciprocally leads us to modify our conception of the parts. This process can continue, dialectically, until we find ourselves thinking differently, interpreting and classifying anew: until, that is, we find ourselves in a new and different world.

But, as I have already said, this does not often happen. Some of the reasons for this are obvious. If, for instance, a new way of conceptualizing and understanding does not enable us to cope with our environment, we will simply discard it. Again, we find it more comfortable and less disruptive to remain closeted within existing ways of thinking and understanding. As a result, most people tend to resist new ideas in the interests of stability and order—even when they are manifestly useful. It is this that protects us from the madness of the German expressionists and allows us only a cursory glimpse into its world of enormous upheaval. Our inclination always is to allow our Apollinian tendencies to prevail and to withdraw into our own familiar world with its warmth and security.

It follows that those artists who want their insights to affect our lives, and to infiltrate our thought processes and our understanding, have the

job not just of presenting their ideas with imaginative flair but of cajoling and even seducing a naturally reluctant audience into accepting new beliefs and new ways of understanding. Artifice and seduction are very much a part of the artist's armory; but they are a part, too, of that bag of tricks that serves the lover, the politician, and the propagandist. It is at this point, I think, that art merges most fully with the rough and tumble of everyday life, and if we hope ever to have an adequate grasp of the place of art in our daily lives, it here that we must look.

Chapter
TEN

SEDUCTION, ART, AND REASON

There is no denying the impact that art can have on our minds and our lives. Not only can works of art unsettle strongly held commitments but we have seen that they are also capable of altering the fabric of our society. This gives us another reason for rejecting any theoretical tradition that thinks of art as removed from, and in some way opposed to, life and that fails to acknowledge the power that art has in our lives.

Artists do try to affect their audiences. Those who succeed often do so through artifice and seduction; and it is at this point that art merges most fully with everyday life. In maintaining this, however, I do not wish to suggest that art wholly determines our lives—or that there are no independent, extra-artistic ways of assessing the views and attitudes engendered by works of art. While some works can deeply affect our beliefs and values, I shall argue that there are limits to these effects; more specifically, that it is possible to assess rationally the visions encouraged by certain works and, if need be, to reject them on the grounds of reason and of truth.

It is precisely this that Richard Rorty denies in *Contingency, Irony, and Solidarity*.[1] Rorty, like Jean Baudrillard before him, believes that there is no distinction to be drawn between rational persuasion and seduction; that in the end our rational persuasions, like our seductive utterances, are nothing more than "redescriptions."[2] On his view, no one redescription can lay claim to greater authority than any other, so that the power of art is never constrained or subverted by our experiences, by brute facts, or by what we take to be true and literal descriptions.

My task in this chapter is twofold. It is, first of all, to explain what is involved in seduction and artifice, to show that it differs from rational persuasion, and that it does actually play a role, not just in politics and advertising, but in novels, the cinema, and drama. My second aim is to disabuse Jean Baudrillard and Richard Rorty of some of the claims that they make regarding the seductive powers of art. Art does sometimes seduce, but, I shall argue in line with my view of narrative in Chapter Five, that it does not and cannot determine entirely the sense that we make of our environment. This might be thought to beg the question against Rorty, Baudrillard, Jacques Derrida, and other postmodernists, for all are adamant that there are no experiences or structures that can help us to adjudicate between competing systems of signs. At least part of my aim in what follows is to show that they are wrong and to do so without begging any questions of substance.[3]

In doing this, of course, I hope to show that there are, after all, some important discontinuities between art and life. The postmodernist assault on the boundaries of art has been radical and thoroughgoing, and has tended to see all human activity, including philosophy, as art. My arguments up until now have enabled us to see why this view is tempting; my arguments in this and the next chapter will enable us to see why it is wrong.

Seduction, Artifice, and Reason

William Blake was just too honest. Much of his art was a direct assault on the social and religious beliefs of his age. His work shocked his contemporaries, and it did so by urging on them a new vision: a new way of looking at, and understanding, their social environment. The result was that his peers thought him mad, and it was left to later generations to appreciate the acuteness and power of his art.

What Blake hoped to achieve required not just art but artifice as well. He needed to persuade his audience that his vision should be adopted, but he could not very well hope to do so as long as his peers remained committed to preserving their privilege and their way of life. What he had to do was lure his audience away from a perception of

their own interests and persuade them, perhaps falsely, that it was in their greater interests to look elsewhere—perhaps to the needs of others. An element of deception was needed; and in this, it is well known, Blake was largely deficient. Indeed, the very deceptions, lies, and artifice that he denounced in his art were what he needed most in order to be effective.

Blake's plight is shared by every artist who wishes to be taken seriously. For each has the task of shifting sometimes deeply held beliefs and attitudes where rational persuasion will not do service. A similar task falls to propagandists, politicians, advertising agencies, and occasionally ardent lovers when each wishes to secure a person's abiding support or custom. At times this involves disturbing the equanimity of people by subverting their more basic commitments while persuading them, often falsely, that it is in their best interests that this be done. Alternatively, it may be achieved, as we saw in the previous chapter, by diverting an audience's attention away from its own interests.

Artists, I wish to argue, are often very skilled in achieving these ends. The skills that they use, though, are not confined to the fine arts but find their place in almost every aspect of the media, and are brought into the service of all those who would shift our allegiances and change our values. The artist, the propagandist, the politician, and the lover often share the common aim not just of mobilizing the attention of their audience but of gaining their loyalty, their commitment, and sometimes their affection. It is not as if they can always do this rationally. Part of the problem, we have seen, is that people will be persuaded by reasons and reason-giving only if they are already committed to rational procedures, and it is notorious that their religious, their economic, or their political commitments may take precedence.[4] In his *Songs of Innocence and Experience*, Blake depicts a world that furnishes us with reasons for changing the social order, and he does so by appealing to certain truths derived from human experience.[5] But his audience, we must assume, was not about to listen to reason. It was committed to a particular social order and chose instead to think of Blake as out of step.

It would seem, then, that those artists who wish to affect the thinking and the commitments of others, where appeals to reason and truth are bound to fail, have the job of seducing their audiences. Seduction,

in this context, is best thought of as an act of enticement that plays—sometimes openly and honestly, sometimes subtly and deceptively—on people's hopes, desires, and psychological vulnerabilities; and does not appeal, in the way that reason giving does, to their intellectual assessment of a particular situation. Hence, as I am using the term, "seduction," is a nonthreatening form of persuasion that does not involve an appeal to reasons, but works by enticing people to certain actions or points of view.

Rational persuasion, by contrast, involves offering reasons that are designed to demonstrate the appropriateness of one's beliefs, actions, or goals, and it does so by placing oneself or others in an epistemically stronger position regarding them.[6] The process of rational persuasion is always one in which one is made aware of reasons for doing or believing something or other. Those who are rationally persuaded, therefore, are always in a position to know why they have reached a particular conclusion or adopted a specific belief. In this respect, seductive persuasion differs starkly from its rational counterpart, for to have been seduced is quite often not to know, and is at times to wonder, how one has come to hold specific beliefs and perform particular actions.

Politicians, like artists and lovers, stand a better chance of seducing an audience and shifting its commitments if they can persuade it that they share its interests—or, at the very least, that their actions or attentions are not inimical to its interests.[7] In this they are often sincere, for the act of seduction does not always involve deception. If, for instance, I fall in love with you, I will attend to your interests, take them to heart, act on them, and in this way, by playing sincerely and openly on your hopes and desires, I may bring you to accept and eventually love me, believe something of what I believe, and adopt certain of my commitments. And all of this, although a complex act of seduction and manifestly nonrational, is performed with complete sincerity. But of course, seduction need not be sincere; in which case I will bring you to share my interests, beliefs, and commitments only by pretending that I share yours.

Whether sincere or not, there is, I think, no better way of seducing you than by maintaining steadfastly, and bringing you to believe, that I share your interests, and that it is in all other respects a matter of indifference to me whether or not you adopt my views and do my

bidding.[8] I am, in other words, most likely to bend you to my will if I can convince you of the harmlessness of my attentions as lover, or politician, or artist. I need to bring you to the view that my kindness and attention are not to my advantage (except, of course, insofar as I have made your interests my own); still more that they have no real effect on your autonomy, but serve merely to enable you and to meet your needs.[9]

These are the sorts of claims for which lovers and politicians are famous. Less obvious, perhaps, is the fact, discussed in the previous chapter, that markedly similar claims are often made about the high arts in our society. Many believe that the great dramas, paintings, and literary works of our age are for our delight and pleasure; that they are interesting, engaging, and entertaining, but have no lasting effect, and cannot ever serve the political end of destabilizing our commitments and allegiances. A similar claim is made on behalf of the popular arts. Movies are frivolous and idle entertainments; so are magazines, comic books, television dramas, and romances. They are harmless fun. It matters little whether those who claim this are sincere in their belief; for the most part, I think that they are. The crucial matter is that if we subscribe to this view of art—and many of us do—we are more (rather than less) likely to be seduced by it.

The cultivation of the belief in a person that one's overtures and attentions are selfless and in the interests only of that person is a classical persuasive maneuver. It is achieved, though, not by exposing the other to a set of reasoned arguments, but by exposing her or him to a set of causes. It is, we saw in Chapter Six, the impression that we create by means of our tone of voice, songs, deportment, soft looks, gifts, kind words, fresh breath, intimate gestures, dress, narratives, muted smiles, and careful grooming that helps displace old, and helps to create new, commitments. While it is true that seduction need not always be insincere, it is never fully articulate: people who are seduced do not really know *why* they have come to hold the views that they now hold. Direct and reasoned attempts at persuasion often fail to achieve their end because they are not tailored to suit the psychological needs and vulnerabilities of the beloved. Consequently, we find that the art of the seducer is often laced with artifice. Here the dishonesty of the lover finds its parallel in the behavior of unscrupulous politicians, faith

healers, and gurus, all of whom pretend to take their followers' interests to heart, but try to alter commitments in ways that suit not the followers' but their own interests.

In this, of course, the seducer is aided by the deep needs and psychological vulnerabilities of those whom they address. Flattery and attention will take root and blossom, we learned in Chapter Seven, only if they fall on the right psychological terrain, so that we can correctly say that seduction only occurs when there is a coincidence of needs or desires on the part of seducer and seducee. Hence, it is not sufficient for seduction that I must appear to make your interests my own. In addition, my professions must seem plausible to you and my attentions (of whatever sort) acceptable to you on account of my personal qualities and your needs. It is this that makes me attractive to you; and attractiveness, as every commercial artist knows, is an important persuasive device.[10] People, commodities, political and commercial messages, but also works of art, strive to create the right appearance, and they do so because those who create them know that appearances are important, and can help bend people to their will.

Even when seduction does not involve any obvious deceptions, it may nonetheless involve subtle and hidden forms of coercion of which the seducer is not even properly aware. Anyone who is skilled in the art of seduction will play repeatedly on an audience's deep need for stability, security, and approval. In this way, the skillful artist, like the skillful propagandist (discussed in Chapter Six), sets up a conflict of desires and needs within us—what psychologists have come to call "cognitive dissonance." Our equanimity is disturbed; we are taunted with incompatible narratives, beliefs, and ideologies, and the conflicting desires and goals to which they give rise. Still more, it is made increasingly clear to the victim that certain benefits await specific outcomes—whether it be moral approval, corporal gratification, or political favors. When once disturbed, moreover, people reach out for stability, and constant bombardment and upheaval make the search for order more urgent—so that, when once it becomes clear that consent is the road to order and stability, consent will very likely be given.[11]

Whenever these forms of coercion are tacit rather than explicit, it seems correct to say that seduction and compliance are secured through artifice—where artifice is to be understood as any skill or contrivance

that is designed to trick or deceive. Traditionally, of course, there are close conceptual connections between all the fine arts and artifice. Whatever else Pliny's story of Zeuxis and Parrhasios tells us, it clearly illustrates the Greek belief that the painting that best deceives is the painting most to be admired. Zeuxis, E. H. Gombrich recounts, "had painted grapes so deceptively that birds came to peck at them. [Parrhasios invited Zeuxis] to his studio to show him his own work, and when Zeuxis eagerly tried to lift the curtain from the panel, he found it was not real but painted, after which he had to concede the palm to Parrhasios, who had deceived not only irrational birds but an artist." [12] Nor does the ideal of deception end with the Greeks. In Roman times we find *trompe l'oeil* floor mosaics and murals, and the rediscovery of perspectival projection in the fifteenth century led to a profusion not just of paintings but of architectural designs and sculptures designed to deceive; and this extends into the present century. [13] The same desire to deceive and delude is found in literature. In the opening pages of *Robinson Crusoe*, Daniel Defoe deliberately conveys the impression that his is a history, not a fiction; while contemporary novelists as diverse as Doris Lessing, John Le Carré, Hammond Innes, and Robert Ludlum use the same wealth of detail to create the illusion of a factual report which tends to disguise the fictional status of their work.

The author's, the artist's, the playwright's, and the producer's attempts at verisimilitude are often an attempt to create a plethora of lifelike detail that will lure an audience into the uncritical adoption of certain beliefs, and this, it is well known, is the artifice in art of which Socrates was most frightened. As we already know, he wrote respectfully of the powers of the artist, admitting to a "sacred fear" of their abilities, infected as they were with a divine madness of inspiration. This, he thought, enabled them to play on the emotions (rather than the intellect) of an audience, thereby inducing it to mistake appearance for reality. [14] Nowadays, of course, the inspiration of artists is no longer considered divine. In the wake of romanticism, it has been located somewhat more justly in the imaginative genius of the individual. Hence, deception in and through art, if it occurs, is now thought of not as a product of divine madness but of the artist's own wizardry and genius.

Seduction, the Individual, and Rorty

Seduction and artifice are often intended to achieve and retain power, sometimes over individuals, sometimes over whole communities and nations. Most of us, however, are inclined to think that genuine art never serves such blatantly political ends and that the artifice that we associate with the fine arts is always an empty trick designed solely to deceive the eye and to delight the viewer. But this is untrue. Certainly *trompe l'oeil* paintings are often no more than a formal exercise produced for the delight of those whose eyes are momentarily led astray. However, we know that there are also works of art that encourage us to think differently, to reconsider our own values and commitments; and we have seen that in destabilizing or unsettling these commitments, the artist often reverts to artifice precisely in order to alter our values and realign our loyalties.

It is just a fact, then, that the fine arts do not always rise above the cut and thrust of everyday politics. Nadine Gordimer, Mandla Emmanuel Sibanda, and André Brink in contemporary South Africa, but also (in less troubled times) Charles Dickens, Henrik Ibsen, Émile Zola, Ernest Hemingway, George Orwell, and Pablo Picasso all used their artistic ability to bring us to certain, arguably political, points of view. Their capacity to do this was unquestionably enhanced by their ability to manipulate the desires and hopes of their audience, and in this sense seduce them.

Take, for instance, André Brink's novel, *States of Emergency*, in which the narrator asks whether an author can ever justify writing a love story in the midst of the suffering and upheaval of contemporary South Africa. At one level, the question seems to be dealt with in a scholarly way: reasons and arguments are given, history cited, footnotes subtended to the text. At another level, love stories are told; but the social conditions that form the backdrop to these stories—conditions that shape the lives of the characters and simultaneously subvert and encourage their love—are not foregrounded, and their moral dimension is never explicitly discussed. But the reader comes, nonetheless, to have a moral view of the state of emergency, and comes to it through the ploys of the author. It is because we are made to sympathize with the characters in the novel (in ways described in Chapter Nine), and

because we feel for them in their suffering that we loathe the situation that so afflicts them. Brink triggers certain responses in his readers, but not by giving reasons and arguments or by offering a discourse on the evils of apartheid. Rather, he exploits the readers' vulnerabilities and psychological needs, and by playing on their desire for equanimity and happiness, brings them, they know not how, to the view that the state of emergency is an evil. Surprising though it may seem, it is, in the end, this very process of seduction that lends moral weight to the author's decision to write a love story, even as South Africa burns.

Seduction plainly integrates the fine arts into the political mêlée of everyday life, and brings politics and art much closer together than the apologists for the aesthetic movement were ever prepared to allow. For some people in our society, the skills of seduction are little more than basic survival skills; for others, notably artists and propagandists, they are to be developed, nurtured, and painstakingly applied; while for the majority, seduction—although frequently employed—is thought of as morally questionable and is often denounced.

The moral problems that surround the skills of seduction are legion, and yet, whatever our scruples, it would seem that, without seduction and the artifice it sometimes involves, one is unlikely to achieve the social cohesion and stability that results from shared commitments. To a very large extent, though, our moral scruples regarding seduction and artifice derive from the fact they are not always used in the service of the broader community. People are frequently committed only to themselves, and they will use all sorts of contrivances to secure their individual advantage. Indeed, it is impossible to write about seduction as an instrument of persuasion without returning, time and again, to the fact that individuals often seek their exclusive salvation, and do so at considerable cost to others and to the community. Widespread commitment to self, it is often held, must result in a fractured society: in nothing other than a discordant individualism and the gradual disintegration of the community. And it is very largely because of this that seduction is frequently met with a chorus of moral disapproval.

Earlier I argued that one way in which individuals advance themselves and their interests is by imaginatively crafting their own life-narratives which they then convey to others in an attempt to manage the impressions that they create. Their aim, I have argued, is not just

to bring others to affirm their value as individuals but is sometimes to make their own life-narratives the norm: part of the canon, as it were, in terms of which other people and other lives are to be judged.[15] The activity, we have seen, is sometimes riddled with artifice, and the aim plainly is to seduce others in a way that privileges the individual and advances his or her interests, often at a profound cost to those who do not fit the ideals of personhood that they advocate. The only antidote, I have argued, is to constrain the storyteller by showing that the life-narrative that she or he favors contradicts itself, is an unfair representation, or is not at one with our experience. In the last resort, it is an appeal to experience, truth, justice, and reason that constrains the seducer, subverts the text or the artwork, and shows it to be less than adequate.

This, however, is precisely what Richard Rorty denies. He is an "ironist," and ironists, he tells us, are people who refuse to adopt, or else have profound doubts about, the idiom of the age, the "vocabularies," the metaphors, and doubtlessly, too, the life-narratives that others construct for us and expect us to adopt. As a result, ironists construct their own points of view and their own life-narratives, refusing all the while to concede the authority of the justifications that are standardly offered in support of "official" ways of valuing, understanding, organizing, and perceiving (pp. 96–97). On this view, reason, justice, and truth are justifications that belong to someone else's "final vocabulary"—to someone else's measure of what is and is not justified; and, in this way, justice, truth, and reason are rejected as empty authorities that cannot be used to foil the seducer, the artist, the guru, or the politician (p. 73).

Like all ironists, Rorty seeks to construct himself—in his case by imaginatively redescribing the ideas of other thinkers. His aim, it sometimes seems, is for his views to become a part of the canon by which all theorists and their thoughts are judged. But if truth, reason, and justice play no part in his enterprise, he will be able to lure and seduce his readers into accepting his "redescriptions" at a cost—some might say an "injustice"—to the philosophers whom he redescribes.

Rorty's solution to this problem is simple, yet paradoxical. On his view, the ironist's poetic self-realization must be seen as an individual or a private undertaking—one that should not be inflicted on the

broader community or strive to become part of a canon in terms of which to judge others (p. 65). What we need, he thinks, is a liberal society in which such private undertakings are not made public, and certainly not imposed on anyone else. To do the latter, he rightly observes, may be to act cruelly, and following Judith Shklar, he believes that the criterion of a liberal is "somebody who believes that cruelty is the worst thing we do" (p. 146).

The paradox is obvious enough. Rorty has published—made *public*—a book that reveals his private irony, and like it or not, he inevitably makes claims, sincere claims (he tells us) about his philosophical and literary predecessors that are bred of being knowledgeable, or, at any rate, of *not* being what he calls a "know-nothing" (p. 82). Inevitably, and unless we doubt his sincerity, the redescriptions that he offers of his intellectual forebears and contemporaries have to be taken seriously: they are at least tentatively regarded as authoritative. If truth, justice, and reason play no part in this enterprise, those about whom he writes may well come to feel badly, even cruelly treated by Rorty's representation of them.

Rorty's attempt to privatize our narrative constructions of self and the world—his attempts, that is, to privatize irony—must fail if he insists, as he does, on publicizing his vision under the imprint of Cambridge University Press. Had he passed his manuscripts around in blue and brown manila folders to curious friends, or if his fantasizing had been posthumously published, he might perhaps have escaped my charge of inconsistency, but one suspects that, like most of us, Rorty feels compelled to do what he does. After all, if Freud is right, people cannot help seeking public approval and the acceptance that it signifies. A Darwinian would tell us that such urges have obvious survival value, and seem deeply, although perhaps not inviolably, a part of what it is to be a human being. Then, too, it is simply a fact that most human behavior takes place in public. Since our life-narratives (which are a subset, I think, of what Rorty calls our poetic "self-creations") not only affect our self-image and self-esteem, but also (as I have argued) our behavior, it is ineliminably a part of our "poetic self-realization" that we should enact our view of self in *public*.

It would seem, then, that Rorty is still encumbered with the problem that his book was designed to solve: the problem, that is, of rec-

onciling "private fulfilment" with "human solidarity" (p. xiii). It is all
but impossible for human social animals to keep their life-narratives or
poetic self-creations private in a way that will avoid confrontations with
the community. The obvious resolution to conflicts between the self-
creating individual (the artist, the poet, the ideologue, the guru) and
the broader society is to admit truth, evidence, and justice—the usual
Enlightenment canons of reason—as ways of adjudicating between
competing narratives, and as ways of combating mindless seduction.
But this option is closed to the "ironist," although, as I shall show later
on, it can be denied only on pain of inconsistency.

The Art of Politics and the Politics of Art

The tension, not to say conflict, between individual aspirations on the
one hand and communal obligations on the other, is a perennial, per-
haps the central, problem of statecraft. If my arguments so far are cor-
rect, it is our commitment to particular narratives—narratives in terms
of which we see ourselves and in terms of which we live our lives—
that is largely responsible for this tension.[16] Consider, for example, the
many different and sometimes incompatible narratives that we have
come to accept and to which individuals in our culture are more or
less committed. We are brought up with good samaritan stories; stories
of the heroes of the French and Dutch Resistance during the Sec-
ond World War; stories of Florence Nightingale, Mother Teresa, and
Mahatma Gandhi—all of which urge communal obligations, compas-
sion, and human solidarity on us. But we are also reared with stories of
the wild West, with "man-alone" novels, with contemporary feminist
or "women-alone" novels, autobiographies, and the rest, which intro-
duce us to a rugged individualism, a sense of autonomy, and a clear
understanding of what is due to us as individuals.

At least some of these stories will have to be discredited if the ten-
sions between them, and the conflicts that they create in the broader
society, are to be avoided. Hence, certain of the narratives that guide
our beliefs and actions in our society will not only have to be rewritten
but our allegiance to old narratives will need to be altered in favor of

the new. Whatever else this requires, it clearly does require compe-
tent storytellers: people who can so construct and relate narratives as
to bring their audience to a new set of commitments. In short, what
it requires of politicians and propagandists are some of the skills that
are characteristic of the artist. This perhaps is why Plato thought of
statecraft as the highest and most compendious art form of all, for it
demands not just the ability of our leaders to spin a story and keep us
spellbound but the ability as well to secure our commitment to their
finely crafted view of things.[17]

The same skills, and the same tensions between individuals and
their broader community, infuse the politics of the artworld. Here
the belief in individual genius and a desire for individual fulfillment
and fame encourage an individualism that is often in conflict with a
stable artworld. This, we have already learned, was not always the
case. Until Michelangelo, the role of the individual in the creation of
a work of art was not highly prized. Indeed, the cult of the individual
and the emphasis on individual genius took root and really flourished
only in nineteenth-century Europe, and was responsible for enormous
tensions within the artworld.[18]

The twentieth-century artworld has taken shape around a narrative
according to which genuine artists enjoy a bountiful reservoir of tal-
ent—what some call "genius"—that demands its own development
and fulfillment. On this view, artists have both the right and, it seems,
the sacred obligation to follow their genius wherever it may lead. In
the end, it is the originality of an individual's vision which allows
him or her to earn the highest accolade of all: that of being an artistic
genius. The fact that so many artists are committed to this narrative
constantly threatens the stability of the artworld. Positions of authority
and canons of criticism within it are always under threat, and are repeat-
edly assailed by those who would be geniuses. In all of these cases,
the creation of one's artistic persona plainly is not the private affair that
Rorty thinks it should be in an ideally liberal society. It impacts on
others who are forced to protect their status and their authority within
the artworld.

So although originality is expected, even demanded, by artists and
critics who see it as a mark of genius, it is not always welcomed by
them. Departures from the canon, the school, or the tradition often

undermine the authority of established artists, critics, and curators who frequently resist the destabilization of their world either by creating or entrenching a canon beyond which, it is suggested, no self-respecting artist ought to venture.

This process, however, is fraught with risk. When Georges Braque and Pablo Picasso founded Cubism they thought of it as the ultimate refinement of painterly techniques, and soon began to gather acolytes. Critics, like Kenyon Cox, who condemned the movement as "nothing less than the total destruction of the art of painting" set themselves in conflict with it, and, to their chagrin, eventually fell by the wayside.[19] Given the gradual rise of formalism, and the emergence of apologists who defended it competently, the old guard soon found themselves without authority within the artworld. For a while, loyalty to Cubism was the order of the day; the artworld stabilized, and the hegemony of the formalists was assured. It was only after Braque's injuries in the Great War and the gradual development of Picasso's reputation as an artistic genius that Picasso found himself in a position to break ranks with Cubism and to seek his fortunes on the basis of his own, now acknowledged, genius.

Those of us who follow the vicissitudes of the artworld see Picasso as entirely justified in this act of faithlessness. In much the same way, we tend to forget about Gauguin's family, abandoned in Europe, while the primitivist genius cavorted on the sands of Tahiti. True to the narrative of the successful artist, we encourage an unbridled individualism in our artists, and the entire artworld pays lip service to it. But the officers of the artworld also have to cope with it, and in order for gallery directors, art teachers, critics, and art theorists to retain their authority and protect their interests from the constant threat of upheaval and displacement, they have to dissimulate. On the one hand they have to appear to encourage the selfish individualism that accompanies genius, and they have to pretend that genius will always have its due reward, no matter what. On the other hand, they have to try as hard as they can to retain the social order that legitimates their own judgment and gives them whatever status and power they command. This they try to ensure by perpetuating certain schools of art and condemning in the very best journals those who transgress certain limits. As gatekeepers, rewards are offered to those artists who instantiate their values, while a judicious attempt is made to banish from view

those who do not. All of this, however, is possible only for as long as people can be brought to accept the narrative of the successful artist—a narrative which usually implies that originality and genius are invariably encouraged and always receive the recognition that is due to them.

Politics in the artworld strongly resembles the politics of state. Both require subterfuge and artifice; both work to seduce the populace by instilling in them values that will guarantee the hegemony of a few. In the cultural West, both elevate the ideal of the individual, of individual freedom, enterprise, genius; and both promulgate the notion that enterprise and genius are virtues and ought always to be rewarded. A body of arts or skills is required in order to perpetuate this view; the same sort of arts, I would venture, that Plato called statecraft. The art of politics, it seems, is not far removed from the politics of art, and both rely on the skills of the fine arts. Each is in the service of the other; the two, I have tried to show, are intimately enmeshed.

Power and Art

Much has been written about the cognitive and affective power of the arts and the impact that they have on our lives.[20] While we should not, of course, underestimate this power, we should beware, I said earlier, of the recent tendency to exaggerate it. Jean Baudrillard, for instance, tells us that in "America cinema is true because it is the whole of space, the whole way of life that are cinematic. The break between the two . . . does not exist: life is cinema."[21]

One is tempted to deflate this claim: life in America, one wants to say, is not cinema; the brick on which I stub my toe in Kansas City does not derive from, or find its way into, the movies. Nor does the agony of a bruised and twisted toe. Speaking from his experience, Denis Dutton remarks that a "week's visit with relatives—anybody's relatives—in Des Moines, sleeping on a sofa bed, might have cured such delusions, but he [Baudrillard] seems to have spent most of his time either on the freeways or in such 'paradisiacal' haunts as Santa Barbara."[22]

It is arguable that these rejoinders overlook the scope and force of

Baudrillard's claim. There are at least two ways of construing the contention that the cinema (and other art forms) shape reality. The first is to say that the cinema shapes our beliefs about reality, but that from time to time the way things really are subverts these beliefs and gives the cinema the lie. On this view, there is some way in which things actually are—independently of our descriptions, idioms, and images; and what we say in our artworks can be undermined by appeals to the way the world is. Hence the cinema is thought to represent reality, sometimes truthfully, sometimes not.

The second way of construing the claim that the cinema shapes American life is to say, after Richard Rorty, that the idiom of our "poeticized culture" (to which the cinema undoubtedly contributes), goes "all the way down"—that there is no truth beyond the metaphors, cinematic or not, that we imbibe. On this account, there is nothing that we can point to "out there"—no extratextual, extrametaphorical, extracinematic reality that impinges on our consciousness, guides or constrains our descriptions and redescriptions, and makes them true (pp. 3–22). On this view, our language—the language game that we play and hence the "vocabulary" that we use—is contingent (p. 5), and certainly is not the product of reason-giving and of truth. It has evolved through countlessly many fortuities rather than because of some settled way in which things are that shapes or molds our discourse. Hence, it will be the most seductive texts or "metaphors"— rather than reasoned arguments and truth—that will push us into new ways of looking and understanding, and will shape our language games and our world.

On this view, lifelike, finely crafted, and suggestive art forms—and here one must include the cinema—will have considerable impact on one's world because, in the end, there is nothing "out there" that can tame these "metaphors." When once they gain currency, they will form what Rorty calls the "vocabularies" (p. 5), in terms of which we think and in terms of which we displace as outmoded our older "vocabularies" and so establish new relationships of power, new orders, new regimes.

If one is persuaded by Rorty, then one will believe that the cinema can be every bit as powerful as Baudrillard suggests: powerful in the sense that it molds, shapes, controls the thinking of others, and deter-

mines what we think of as reality. The only surprising thing, then, would be that the postmodernist Baudrillard should ever have thought, if in fact he did, that cinema and life in America *ought* to be separate. If, on the other hand, one disagrees with Rorty and allows that there is an independent touchstone of truth relative to which the pronouncements of the cinema can rationally be assessed, then the idiom of the cinema, like any other "vocabulary," can be subverted by reason and truth.

On Rorty's view, like Baudrillard's, it is only through seduction that a particular cinematic "vocabulary" weaves its way into our thinking, destabilizes our entrenched view of the world, and determines our notion of reality. Rorty, however, also believes that what we, as heirs to the Enlightenment, call reason and argument is itself just a form of seduction and rhetoric; that there is no clear distinction to be drawn between reasons and causes except within a "vocabulary" or language game that countenances the distinction (p. 48). This, he believes, is why one cannot "rationally" subvert a given "vocabulary": all that one can do is lure a person away from it through artifice, guile, and cunning. At root, there are no reasons to be given; that is, there are no statements that can actually establish or demonstrate the appropriateness of a given way of looking and describing. The cinema, therefore, has the power (like any other "vocabulary" or language game) to determine absolutely our sense of reality. On Rorty's view, there is nothing beyond it (other than alternative "vocabularies" or "redescriptions") to which we can appeal in trying to displace it.

Rorty, Reason, and Truth

Those of us who stub our toes, break strings in our tennis rackets, suffer from toothaches, and bump into objects in the dark might be tempted to think that there are facts of the matter—some way in which things actually are independently of our descriptions of them or the movies that we make of them. We might further be inclined to believe that the way things are can very well subvert or confirm

received descriptions or cinematic images, can show them to be false or, alternatively, can establish them as true.

Rorty resists this. The mistake, he thinks, arises when we become fixated with individual propositions, with

> single sentences as opposed to vocabularies. For we often let the world decide the competition between alternative sentences. . . . In such cases it is easy to run together the fact that the world contains the causes of our being justified in holding a belief with the claim that some non-linguistic state of the world is itself an example of truth, or that some such state "makes a belief true" by "corresponding" to it. But it is not so easy when we turn from individual sentences to vocabularies as wholes. When we consider alternative language games . . . it is difficult to think of the world as making one of these better than another, of the world as deciding between them. (p. 5)

If the entire "vocabulary" of the cinema is to be given the lie, it is not (he would contend) by appeal to an independent, "neutral" reality; it is by appeal, rather, to a set of alternative "metaphors," "vocabularies," language games, or descriptions (p. 39).

Rorty is prepared to allow that there is something "out there," an environment, if you like, that is not the product of the human mind and exists independently of it (pp. 4–5). He is not, however, prepared to allow that this something can make our descriptions true. This is more than a little puzzling, for he straightaway tells us that whatever is out there—the rock on which I stubbed my toe, the broken string in my tennis racket—*can* justify my belief that my racket has a broken string or that I stubbed my toe on a rock. It cannot, however, make the sentence in question true. And this is odd, for normally when we say that an empirical statement is true, we mean nothing other than that "the world contains the causes of our being justified in holding [the] belief" (p. 5) expressed by the statement. But Rorty denies this because, on his view, truth is a property of descriptions, not of the world (p. 5). Later on, he tells us that "since truth is a property of sentences, since sentences are dependent for their existence upon vocabularies, and since vocabularies are made by human beings, so are truths" (p. 21). It seems, then, that on Rorty's view, my statement that it is raining is not true because of my experience of falling rain

drops. My experience of falling rain drops merely "furnishes the cause of [my] being justified" in holding the belief that my statement expresses. If my statement is true at all, it is true because of the language game or "vocabulary" that it inhabits, and this is something that people have invented. Truth, on this view, has nothing to do with our experience of what is "out there"; rather truth is "whatever the outcome of undistorted communication happens to be, whatever view wins in a free and open encounter" (p. 84).

There is, I have said, something very strange about all of this. Rorty is of course correct when he says that truth is a property of descriptions and that it is not a property of whatever is "out there" (cf. p. 27). But it certainly does not follow from the fact that truth is a property of descriptions that what is "out there" cannot justify my descriptions and in so doing *establish* their truth. To say that a physical state of affairs— say, the broken string in my tennis racket—makes my statement, "The tennis racket has a broken string," true is not to suggest that truth is extralinguistic. It is, rather, to agree with Rorty that whatever is "out there" does not depend on our minds but is the effect "of causes which do not include human mental states" (p. 5), *and* can be used to justify the sentences that we believe.[23] But to say this is just what we normally mean when we say that these sentences are true.[24]

All of this might seem merely to quibble with Rorty's substantive thesis. His view, after all, is that whatever is "out there" will not be able to help us decide between competing "vocabularies." A "vocabulary," for Rorty, should not be thought of as the words that characterize and help distinguish a natural language. Rather, a "vocabulary" is a particular internally consistent way of describing one's life and one's world, and, if I understand him correctly, one's life and world do not exist apart from one's favored "vocabularies," for people are nothing other than "incarnate vocabularies" (p. 88). Any one natural language can generate indefinitely many "vocabularies" in Rorty's sense of this word. Each "vocabulary" is no more than a privileged set of "metaphors" that jolt us into seeing our surroundings in different ways. They are "metaphors" that furnish us with sets of alternative descriptions—so-called redescriptions for which no reasons can be advanced (pp. 18–19), but which are designed to make other descriptions and "vocabularies" look bad (p. 44).

The quick way with Rorty is to ask whether his view of the contin-

gency of language, community, and self is itself correct, right, or true. If it is, then it seems that he has, after all, pointed to the way things actually are. If it is not, there is no need to take him seriously. But Rorty is determined to avoid this sort of criticism. He writes:

> The difficulty faced by a philosopher who, like myself . . . thinks of himself as auxiliary to the poet rather than to the physicist—is to avoid hinting that this suggestion gets something right, that my sort of philosophy corresponds to the way things really are. For this talk of correspondence brings back just the idea that my sort of philosopher wants to get rid of, the idea that the world or the self has an intrinsic nature. (Pp. 8–9)

So it would seem, then, that Rorty believes that his redescriptions are also contingent; that they are just another "vocabulary" that has evolved through accident and whim, and certainly are not constrained by our experience of an extratextual reality. Any arguments that he may offer in favor of his redescriptions "are always parasitic upon, and abbreviations for, claims that a better vocabulary is available" (p. 9). But this, of course, leaves those of us who maintain that there are reasons (extratextual reasons) for believing the "vocabulary" of the Enlightenment, with the insurmountable difficulty of knowing why we should take Rorty seriously. What, we want to know, could convince us that his views are worthy of adoption?[25]

To ask this question is, of course, to ask for reasons, and this is just what Rorty wants to disallow. He believes that the "redescriptions," language games, and "vocabularies" suggested by works of art, by the cinema, and of course by his text, cannot be supported or subverted by an appeal to reasons external to these redescriptions: that the best that one can do is try to show that the idiom they advance looks good or bad. By contrast, my view is that reasons can be advanced, and can help entrench or undermine a particular "vocabulary," but that, of course, people may not always respond reasonably to the reasons advanced. And they will fail to respond reasonably, I have so far contended, when their commitment to particular doctrines or causes overrides their commitment to reason. In such cases they will be dislodged from their "vocabularies" only through seduction and the artifice that seduction sometimes involves.

If Rorty is to be believed, artists and lovers may very well seduce, but so too do philosophers and scientists. The only difference between them is the "vocabulary" that they employ. If he is right, the distinction between seduction and rational argument is just an Enlightenment hangover that pretends to objectivity and extratextual truth where there is none. It follows, Rorty believes, that the idiom of art is every bit as powerful as the idiom of reason and rational argument, and that neither are ever constrained by the way things are.

Redescriptions Redeemed
The End of the Textual Laager

How can one show that Rorty is wrong without begging the very question that is in dispute? One way is to look at how Rorty advances his own views and to show that he cannot escape the idiom of reasons and reason-giving in the way that he purports to do. The other is to resist the hard and fast distinction that he advocates between individual sentences on the one hand and what he calls "whole vocabularies" on the other.

When one looks at how Rorty advances his own views, we find, surprisingly in the light of what he has said, that he often appeals to the facts of the matter as *reasons* for his position. So, for instance, in defending his particular liberal "vocabulary," he tells us that his "is a conviction based on nothing more profound than *the historical facts* which suggest that without the protection of something like the institutions of bourgeois liberal society, people will be less able to work out their private salvations." (pp. 84–85; italics mine). Elsewhere he tells us that it is the manifest failure of the correspondence theory of truth (historical fact) that constitutes a reason for his version of pragmatism.[26] Even for Rorty, there are historical and social facts to which one can appeal in deciding whether or not a particular view of society is correct and a particular "vocabulary" attractive or adequate.

Appeals to facts—to what actually happened (p. 55), to what exists, and to what is right and wrong, correct or incorrect—occur repeatedly

throughout Rorty's book. According to him, there actually are people, communities, and cultures (p. 14); people have bodies and fantasy lives (p. 37) through which they can create themselves (p. 43). Human beings can and do feel pain, can be humiliated, and treated cruelly (p. 89). There is conversation among people (p. 67); there are religions and poets (pp. 68–69) and societies that "depend on the existence of" certain scenarios (p. 86). And Rorty insists that the French Revolution of the late eighteenth century taught Hegel and the future Romantics the power of redescription (p. 7); and it is this power which serves as Rorty's main *reason* for the view that there is nothing other than successive redescriptions which vie for authority in our social world.

Whether or not these supposed facts are true matters not at all. What is important here is that Rorty sees each as a *reason* for adopting a particular point of view, and many seem to rely on his experience of whatever is "out there" (people, conversations, religions, revolutions, the Romantic movement, and so on). Rorty is locked into what he calls the "vocabulary" or language game of Enlightenment reason-giving, and uses reasons time and again in order, ironically, to disabuse his readers of reason-giving and appeals to truth. He does, however, attempt to excuse this apparent inconsistency, and tells us that

> The trouble with arguments against the use of a familiar and time-honored vocabulary is that they are expected to be phrased in that very vocabulary. They are expected to show that central elements in that vocabulary are "inconsistent in their own terms" or that they "deconstruct themselves." But this can *never* be shown. Any argument to the effect that our familiar use of a familiar term is incoherent, or empty, or confused, or vague, or "merely metaphorical" is bound to be inconclusive and question-begging. For such use is, after all, the paradigm of coherent, meaningful, literal, speech. (Pp. 8–9)

This attempt on Rorty's part to salvage his position will strike most readers as enigmatic. The history of philosophy is crowded with attempts to show that familiar, everyday terms are incoherent, but none of these "are expected to be phrased in that very vocabulary." Gilbert Ryle's critique of the Cartesian soul is a case in point, and the many criticisms of the traditional concept of God are another.[27] In each case these criticisms are stated without overtly or covertly demonstrating

any allegiance to the soul or to God; still less to Platonic and Christian "vocabularies." In much the same way, traditional mimetic views of art have been shown to be incoherent; so, too, some of our familiar beliefs about science. Whether or not one agrees with these criticisms does not matter. What is important is that it is possible to state them without doing anything more than mentioning the terms that are in dispute.

Contrary to what Rorty says, then, it is difficult to see why anyone should expect his views to be phrased in the very "vocabulary" that he criticizes. On the contrary, if his criticisms are genuine, he ought to be able to escape that "vocabulary." After all, it is possible to criticize the old and widely held denotation theory of meaning without reverting to it and the Christian concept of God without demonstrating a covert allegiance to the language game of theism. But this is exactly what Rorty seems unable to do. He finds himself forced to use the "vocabulary" of reason-giving and facts in order to establish the inadequacy of this way of proceeding. And this would seem to suggest that he cannot avoid the so-called Enlightenment "vocabulary," which, he persists in telling us, is merely accidental and altogether dispensable.

Rorty can respond by saying that he could, if he wished, forgo the rhetoric of reason-giving and simply revert to other "vocabularies" in order to bring us to his point of view. After all, there is more than one way of seducing an audience, and reason-giving is just one among many forms of seduction. Hence Rorty might contend that the only thing that prevents him from abandoning reason-giving is the fact that his audience is locked into the "vocabulary" of the Enlightenment and will not budge until reasons are given for dispensing with it. So even though he frequently reverts to the "vocabulary" of the Enlightenment, this is not because *he* cannot avoid it, but because his *readers* will not allow him to do so.

It is futile to argue against Rorty at this point by adducing reasons in favor of reason-giving. Any appeal to the appropriateness of this form of behavior, and the inappropriateness of seduction, is just taken as further evidence of our inviolable commitment to the "vocabulary" of the Enlightenment and of our inability or unwillingness to see it as a form of seduction. But there is one move, I think, that we can make against Rorty with some hope of success.

We have already seen that seduction is quite different from rational

persuasion. Rational persuasion, I suggested earlier in this chapter, involves offering statements that express beliefs about the appropriateness of a course of action or a point of view and so place one in an epistemically stronger position regarding them. In other words, if, as a result of rational persuasion, one assents to a proposition or a course of action, one knows why one has assented. Seduction, by contrast, often begins when such procedures fail to persuade, usually on account of a person's prior commitments. Paradigmatically, we saw, seduction involves adopting, or pretending to adopt, another person's interests in a way that has the effect of bringing that person to believe that what you advocate will be good for her or him. This is a causal process that plays intentionally on a person's psychological vulnerabilities, and sometimes reverts to deception and subtle, usually hidden, forms of coercion. To treat rational persuasion as nothing more than a form of seduction is to adopt a "redescription" that ignores important differences between the two: differences that are readily apparent to anyone who has experienced both.

It is, I would contend, an audience's acquaintance with the differences between reason-giving and seduction that prevents Rorty from abandoning what he calls the "vocabulary" of the Enlightenment and reverting instead to nonrational forms of persuasion. It is not so much that the audience is locked into the "vocabulary" of reason-giving; it is, rather, that the audience's experience makes it aware of the difference between seduction and rational persuasion, and that anyone who is aware of the difference will not tolerate nonrational forms of persuasion when reasons are required. In the end, it is the reader's experience of the difference, and not a contingent "vocabulary," that forces Rorty to adopt the idiom of reason-giving that he wishes to dismantle. Nothing else will do.

Rorty, we have seen, is prepared to accept that facts bred of experience can serve as reasons that count in favor of the "vocabulary" that he advocates. In the light of this, it is at first blush surprising that he will not allow facts and experience to count against "vocabularies." Experience, it would seem, can falsify sentences, but can do nothing at all to undermine entire "vocabularies" (p. 5). Even if we ignore the appearance of inconsistency, and it is one that will not easily go away, we can show that Rorty's approach at this point is mistaken by looking

at the rigid distinction that he tries to draw between "vocabularies" on the one hand, and the individual sentences that they generate on the other.

Sentences and "Vocabularies"

The examples of alternative "vocabularies" that Rorty offers are "the vocabulary of ancient Athenian politics versus Jefferson's, the moral vocabulary of Saint Paul versus Freud's, the jargon of Newton versus that of Aristotle, the idiom of Blake versus that of Dryden" (p. 5). And later on he mentions the idiom of Romantic poetry, socialist politics, and Galilean mechanics as further examples of "vocabularies" that, at one time or another, have come to dominate.

Now, one thing at least seems abundantly clear about any two competing "vocabularies": it is that people entrenched in one of them are nonetheless able to understand the other. This is not something that Rorty explicitly denies, although I am unsure how he could affirm it since he explicitly relativizes what will count as a reason and a truth to particular "vocabularies." However, it is necessary to understand any two "vocabularies" if one is to be in a position to know that they are different and exclusive of each other. It is, after all, only because I understand the jargon and the claims both of Newtonian and Aristotelian physics that I also understand that they differ from, and exclude, one another.

Now, the only way in which I can understand both Aristotelian and Newtonian physics is by having a grasp of the conditions under which the assertions made in that "vocabulary" or "idiom" would be true. Still more, we can only know that the "vocabularies" compete with one another because their central assertions, given in individual sentences, differ from, and compete with, each other. We can know this, however, only because the truth conditions of their respective assertions can be seen to differ. If this not very original insight is correct, it follows that competing "vocabularies" covertly appeal to precisely the same concept of truth and that, contrary to all of Rorty's denials, the concept of truth is neutral as between the two. Unless it were, there

could be no apprehension at all of the fact that the "vocabularies" compete and are exclusive of each other.

However one looks at it, this is an embarrassing consequence for Rorty, for it now turns out that competing "vocabularies" must have at least one concept in common: one, moreover, to whose instantiation we can now appeal as a reason for discarding certain "vocabularies." Of course, philosophers can still have different theories of truth; this is not in question. The crucial point, though, is that however we explain the concept of truth, we must all have it in order to understand that two sentences are in competition with each other.

Rorty, however, seeks to avoid this consequence. He does so by treating "vocabularies" not as a medium in terms of which people make assertions about reality but as metaphors that, following Donald Davidson, push and pull us into noticing certain things, but lack a (metaphorical) meaning and so a truth-value. Metaphors, it seems, are not to be thought of as assertions; they do not enjoy a truth-value, and so lack truth conditions in terms of which to decipher their content. What is more, if Rorty is to be believed, new "vocabularies" are nothing other than what Mary Hesse has called "metaphoric redescriptions" (p. 16); and these either invite us to notice, or otherwise jolt us into noticing, what was previously unnoticed. As these metaphoric structures solidify into established language games, we begin to speak of truth; but truth, it now turns out, is, in the words of Friedrich Nietzsche, no more than "a mobile army of metaphors" (p. 17).

If Rorty is correct, "vocabularies" compete only in the way that metaphors compete: by nudging us into noticing different aspects of the same thing. And since metaphors lack a message or a cognitive content, we do not come to recognize that different metaphors are in competition with each other by appealing, as I have suggested, to meaning or to truth conditions. Hence Rorty would no doubt conclude that we do not need a neutral concept of truth in order to recognize that "vocabularies" are different or in competition with one another. He seems to have answered all objections from that quarter.

But has he? Let us accept for the moment that new "vocabularies" really are just clusters of metaphors. Let us assume, falsely I think, that Rorty is right about metaphor, and that, in just the way that Davidson has argued, metaphors have no metaphorical meaning

or corresponding truth-conditions.[28] It still does not follow from this that the sentences or assertions about the nature and behavior of matter that derive from competing "vocabularies" do not make competing truth claims. They plainly do. Aristotelian and Newtonian theories of gravity purport to explain one and the same set of phenomena; so too do their respective theories of motion. But Aristotelian assertions about these matters can sometimes be shown to be misleading, and are often inadequate to our experience. This is what people mean when they say that certain claims based on Aristotelian physics are false; and it is of course their falsity—their inability to account for our experience—that inclines us to adopt theories (and "vocabularies") that are more adequate, that account for our experience, and are deemed to be true.

In every case we work with the same notion of truth and falsehood. However one explicates these concepts, and whatever one thinks of the correspondence theory of truth and the metaphysic that it presupposes, it does seem to be the case that competing assertions bred of alternative "vocabularies" both appeal to, and are understood in terms of, the same concept of truth. Rorty has so far said nothing that is capable of undermining this, for, of course, if there is no neutral concept of truth we will not be able to tell whether the sentences that different "vocabularies" generate really do compete with each other.

It is when a "vocabulary" is inadequate to our experience that we begin to look to other "vocabularies," or to develop them ourselves. One sure motivation for abandoning a "vocabulary" is that it is found to be misleading: that it generates individual assertions which, if followed, lead to inadequate predictions and mishaps. This is what we mean when we say that its assertions are false. Again, one sure motivation for adopting a "vocabulary," a language game, a theory, or a Kuhnian paradigm, is that the assertions that it generates are found to be adequate to our experience, have predictive utility, do not lead us into minefields, or make us mistake cyanide for candy. Such assertions we think of as true. And it is abundantly clear that the truth and falsity of the individual sentences generated by particular "vocabularies" or language games help us to decide whether or not to accept not just these sentences but, eventually, the "vocabularies" or language games themselves. Contrary to what Rorty says (p. 5), truth *is* an im-

portant consideration when deciding which of two or more competing "vocabularies" to adopt.[29]

If all this is correct, we are able at last to show that Rorty has it wrong, or, if he prefers, that (for very good reasons) his "vocabulary" is by and large unattractive: it does not do justice to our experiences or to our desire for consistency. We do decide between competing "vocabularies" by appealing to reasons and truth, and this is *not* one among many options that we have. It is not just that each assertion or sentence generated by a particular "vocabulary" will be accepted or rejected in virtue of how well it accords with our experience—that is, in accordance with its truth-value; but it is also the case that competing assertions, and the "vocabularies" that encourage them, covertly appeal, and have to appeal, to the very same notion of truth in order for us to compare and understand them. Rorty, we have now seen, cannot avoid this consequence by treating competing "vocabularies" as Davidsonian metaphors, for insofar as they eventually generate literal assertions—and they do—they also make competing truth-claims.

The way we speak, our idiom, our chosen metaphors, and our "vocabularies" greatly influence our world and our sense of reality. The same is true of the artworks—the paintings, novels, cinema—that bring us to think differently, to adopt new values, and to assess situations afresh. In this, Rorty and I are in profound agreement. We disagree, though, about the unbridled power of "vocabularies" to roam unconstrained by reason and truth. The cinema is indeed powerful, but not nearly so powerful, I think, as Rorty's anti-metaphysic would lead us to believe.

Conclusion

Artists often seduce; good philosophers do not. They argue the case, and give reasons which establish the appropriateness of the positions and paradigms that they adopt. Early in this chapter, I tried to explain the structure, and to some small extent the phenomenology, of seduction, and showed that there is a clear distinction to be drawn between seduction on the one hand, and the processes of reason-giving and

rational persuasion on the other. Artists, I said, often need to seduce their audiences if their messages are to be adopted. Even so, it is possible for an audience to discover that it has been seduced, and, on reflection, to find reasons for rejecting (or accepting) a particular way of thinking, looking, and evaluating.

It is, I said, the capacity of art to seduce and deceive that makes it a potentially powerful political weapon. However, the politics of art does not end with the artwork itself. While seduction and artifice are very much a part of the artist's armory, we have seen that they enter deeply, and at many levels, into the world of politics. In this respect, the boundaries that we like to draw between art and everyday life are found, yet again, to be more tenuous, and much less stable than we might have imagined, for the skills of the artist can be seen to play an integral part in the political process.

Among these skills, I have argued, are those which enable us to create our sense of self and to spread it abroad in an attempt to cultivate and maintain the good opinion of others. Rorty takes up this point, believing as he does, that most people create themselves in terms of certain fashionable "vocabularies" that have no rational basis, but are either attractive or unattractive to us and adopted or rejected in consequence of this. On his view, like mine, the "vocabulary" of American cinema—the images, the values, the metaphors, the narratives that it encourages—is extremely powerful. Rorty, however, contends that these cannot be constrained by appeals to truth, reason, evidence, and argument. In Rorty's opinion, the artwork, like the metaphors, the idiom, and the "vocabularies" that it encourages, helps shape our thinking and our world without being grounded in, or regulated by, truth or reason.

A large part of my aim in this chapter has been to show that Rorty is wrong; that we can, and often do, adjudicate between competing descriptions, idioms, metaphors, or "vocabularies." And we do so, I have argued, by appeals to reason and to truth. This is important, for it tells us yet again that reason need not be divorced from art; that, as Plato insisted, there are constraints on the artifice of artists and on the power of art: constraints that are neutral as between our different "vocabularies" and world views.

Chapter

ELEVEN

ART AND PHILOSOPHY

There are, we have seen, many different points at which art and life intersect. The processes of artistic production, the language of art, the values that we attach to art, and the various art forms themselves all play (or are capable of playing) important roles in the way that we live our lives. This, we saw in Chapter Ten, does not entail that art is ubiquitous. It is simply misleading to maintain that art is life or that it determines our entire sense of reality. For all that, though, we have now seen that the arts form an integral part of our lives, and that it is quite wrong to think of them as occupying a separate, rarefied realm.

The tendency to see art as distinct from life dates back to the Greeks and was undoubtedly encouraged in medieval and Renaissance Europe by the tendency of the Church to align religious art with the sacred rather than the secular. This tendency was further fueled by the crisis that artists faced at the time of the Industrial Revolution in nineteenth-century Europe. For, as we learned in Chapter Two, it was a widespread emphasis on economic value in the period after the Napoleonic wars that encouraged artists to rebel against the philistinism that this emphasis encouraged and to attend only to what they thought of as pure artistic values. As a result, many refused to meet the demands of the marketplace, and in doing this they self-consciously turned away from what their audiences wanted of art and could understand. Art for art's sake, and the formal abstraction that followed it, gave rise not just to the distinction between the high and the popular arts but also to a body of critical discourse that regarded esoteric,

introverted, and abstract art as "mainstream." And it was in relation to the "mainstream" that popular art was seen as merely derivative, as markedly inferior.

Even so, and despite all the critical acclaim that they received, the high arts soon lost the attention of the rank and file of society. As a result, painting, literature, sculpture, music, and drama lost whatever authority they had once enjoyed. Instead, as we have seen, the mantle of authority came to be worn, without fanfare and with unrivaled modesty, by the popular arts. These became the arts that were to affect most lives and would, in time, furnish people with popular wisdom, with values, and with role models in terms of which to cast their own behavior. But despite their obvious success, the popular arts continue (we saw earlier) to be denigrated as low-brow and tasteless, while the so-called high arts earn lavish praise even though relatively few people attend to them.

The arguments of this book have been intended to serve as an antidote to these attitudes and the artificial distinctions that they encourage. They are attitudes, however, that are not confined to the fine arts. Philosophy has suffered a similar fate, and it is interesting to observe that the recent history of the fine arts finds a parallel with the history of Anglo-American philosophy. While it is of course fitting in a book such as this to end by looking at the connections between art and philosophy, my aim in doing so is not just to establish connections between apparently disparate activities. What I also hope to show is that, despite the discontinuities between the fine arts and philosophy discussed in the previous chapter, recent developments in the fine arts are not peculiar to fine art. They can happen to the other arts—and happened earlier in this century to the arts of reasoning: to philosophy. It is this, I think, that encourages some theorists to maintain that philosophy is just a variety of literature.

Philosophy as Literature

In his introduction to the *Treatise*, Hume tells us that quite often among philosophers, "It is not reason which carries the prize, but elo-

quence." And he deplores the fact that "no man need ever despair of gaining proselytes to the most extravagant hypothesis, who has art enough to represent it in any favourable colours."[1] It is reason, Hume thinks, that is and ought to be the stuff of philosophy, and, following in a tradition which starts with the Greeks, he clearly believes that the fruits of reason are of profound value to all who come within reach of them.

Philosophers in the Anglo-American tradition have remained convinced that reason and truth are the substance and core of their subject. It is a view, we know well enough, that has not always found acceptance. Nietzsche delivered the first major broadside when he declared truth no more than "a mobile army of metaphors."[2] And in this century, the attack has been renewed in the works of Jacques Derrida and Richard Rorty—both of whom prefer to see philosophy as a form of rhetorical persuasion or "eloquence": in short, as a variety of literature.[3] In Hume's words, they think it inevitable that "victory" should be gained not "by the men at arms who manage the pike and the sword, but by the trumpeters, drummers and musicians of the army."[4]

Hume, of course, thinks of art as a dishonest means of persuasion; Rorty believes that philosophers merely flatter themselves when they think of rational persuasion as superior to the less explicit, sometimes seductive, persuasion of art. On his view, when philosophy persuades, it does so in just the way that poetry and novels do. By and large, of course, philosophers in the Anglo-American tradition have not taken kindly to this view and see it as an attack on the authority of philosophy; as undermining its claims to the truth, and as assimilating it to a kind of discourse that is more akin to game playing than to serious inquiry.[5] Literary works of art, they are inclined to argue, are largely gratuitous. They address (or ought to address) no problems other than the purely formal artistic problems that are of their own making. Philosophy, by contrast, addresses actual problems and is concerned with rational solutions to them. The view is that whereas literature deals with the rhetorical, the figurative, and the fictional, the currency of philosophy is hard, unadorned, literal truth.

The claim that philosophy is no more than a kind of literature derives part of its "sting" from a rather special and impoverished view of the literary.[6] Many who rise to the bait and indignantly deny that

philosophy is, or could ever be, a variety of literature have in mind this same, very narrow conception of literature. It is a conception that took root in the aesthetic movement of the nineteenth century and has blossomed in this century with the growth of the New Criticism. If my arguments so far are correct, it is an inadequate view of literature— although I do not propose to challenge it here.[7]

What does seem true is that philosophical arguments and discourses are not devoid of figurative language, and certainly are not "plain, unadorned literal truths." An increasing number of philosophers in the analytic (Anglo-American) tradition are nowadays prepared to acknowledge the role of metaphor in their texts.[8] Some, like myself, even acknowledge the role of rhetoric and fiction. On my view, metaphor, rhetoric, and fiction contribute importantly to philosophical discussion, and can do so without affecting the fact that philosophy contains, and relies upon, rational arguments. Consequently, if fiction, metaphor, and rhetoric really are the stuff of literature, then philosophy is indeed a variety of literature—although this, as we saw in the previous chapter, need not mean that literature and philosophy are incapable of conveying truths about our world.

Nonetheless, I want to insist that there are important continuities between philosophy and literature, and that some of these have to do with the fact that, in this century at least, philosophy and literature have enjoyed a similar history. Both managed for a certain time to trivialize themselves; each lost its audience and its voice, and came to be regarded by most people as of marginal interest and of little concern to the world in which we live. This, I argue, was the result not of the artistic content of literature or the literary content of philosophy. It was the result, rather, of the social organization and practice of these skills. For as practiced up until very recently, one could be forgiven for thinking that philosophy was a variety of literature in the narrowest and most trivial sense of this term. But, of course, I do not propose to leave the matter here. I argue as well that philosophy, like the fine arts, need not be practiced in this way: a way that undermines its insights, its status, and its authority to pronounce on matters of substance.

Decision Making in Philosophy

Most professional philosophers find some time each week in which to read the work of their philosophical colleagues. The time available is, of course, limited, and as a result all philosophers are forced, as a matter of everyday practice, to choose between different authors and titles. The choice is usually made without fanfare or public discussion, and little is ever said about it.

And yet the problem of deciding which philosophical works to read, which to study and teach, is both important and pressing. Philosophers cannot possibly read and seriously consider all the tracts that come their way, and they can have no sound, nonarbitrary, reasons for ignoring a work unless they are already acquainted with it. Of course, the idea that decisions that are integral to the everyday practice of philosophy are themselves arbitrary is abhorrent to those who take the claims of their discipline seriously. And yet philosophers never attend to, discuss, or even acknowledge the problem.

Exactly the same problem confronts artists and critics. They too have to decide which artworks are worthy of their attention and which unworthy. And, like philosophers, they seem to think the solution obvious—although very little is ever said in its defense. Sometimes philosophers contend that they choose what to read on the basis of their interests, and that this, of course, eliminates those titles in which they have no interest. But this answer will not do, for even a seemingly narrow interest may be met with an abundance of titles, and choices have to be made. The question thus remains: what nonarbitrary reasons can philosophers have for choosing to read one thinker rather than another?

The best reason, of course, is that they are already acquainted with the earlier works of these philosophers and have found one to be an outstanding thinker, the other somewhat deficient. This would give inductive plausibility to the decision on this occasion to read the one philosopher and to ignore the other. But things do not often work this way. Most often we ignore philosophers because we have not "heard" of them. Their lack of prominence and fame is somehow treated as indicative of their philosophical ability.

The belief that "merit will out" and that we are bound to have

"heard" of an author if he or she is "any good"—a belief that is exactly paralleled in the artworld—seems seriously deficient. For it is a fact well known that there are always philosophers who are new to the scene, who have not been widely published, and whose work may nonetheless be worthy of serious attention. We also know of the existence of modest philosophers who do not choose to print every stray idea that comes their way, but who, although previously unheard of, may develop outstanding arguments in their first and only published article. There is, in any event, something perfectly outrageous about supposing that *my* ignorance of the existence of certain philosophers is or could be a mark of *their* incompetence.

It might be contended that, in philosophy at least, reputations are bred of ability, so that to have "heard" of a philosopher—in the right way of course—is to have prima facie grounds for supposing that he or she is reasonably able. But this answer is only a small part of a much larger story, and in order to tell it all, we need to return to the point with which I began; namely, that the sheer bulk of philosophical thought and publications requires us to read and to study selectively. Limitations of time, as well as the need to create a semblance of order and progress within the discipline, force all philosophers to acknowledge and pay serious attention to a somewhat restricted body of philosophical works and their authors. These are treated, if not always as the seminal, at least as the central and, for the moment, as the most important texts: texts that are more or less crucial to, and that help characterize, the tradition. Any person who is acquainted with the tradition or who is correctly regarded as a member of the "school," must know these texts and be able to expound and discuss them.

It is this body of works and accompanying authors that I shall call the philosophical canon, and the general, albeit unacknowledged, presumption seems to be that any work of genuine merit will find its way into the canon. It follows from this that any philosopher who has been educated in a particular tradition or school will know the works of all the "really important" and "worthwhile" contributors to that tradition. Not to have "heard" of certain philosophers, therefore, is either to know that they are not "of the first rank," or to concede one's ignorance of the canon that characterizes the tradition in question. This, I think, is why the fact that we have not "heard" of certain philosophers

is taken to say something both about their standing and their worth in the philosophical world.

This applies in very much the same way to artists and critics. If there is to be any order and consistency within art criticism only some works and styles can be regarded as of the first importance; and it will be necessary for an art critic and a properly "qualified" artist or author to be acquainted with the canon, to allude to it, and to depend on it, if they are to be accepted as fully fledged practitioners. Here, too, the belief is abroad that only those works that are genuinely meritorious—works of genius—will be admitted to the canon—a belief that we will return to presently.

Both literary critics and philosophers, however, are confronted by an obvious problem: one that does more damage to the pretensions of philosophy than it does to literary criticism. The problem is this: the sheer volume of philosophical and literary works forces both philosophers and critics to seek and acknowledge a canon that is meant, among other things, to guide them in their choice of what to read and, *a fortiori*, in their assessment of what they have read. If, however, it is true that the criteria of literary and philosophical adequacy are derived from the canon within which one is reared, it is not clear that one can ever adjudicate between competing canons, schools, or traditions. Literary critics seem willing to bite this bullet, and are often happy to relativize their judgments.[9] The problem, however, becomes particularly embarrassing for philosophers, for the tendency is to privilege one's own philosophical tradition; but it is not clear that one can have neutral reasons for doing so. As a result, it seems difficult to avoid the unpalatable conclusion that what is true in one philosophical tradition need not be true in another.

We are left with the problem of justifying the philosophical canon. It is a problem, of course, that resolves itself into the old debate about rationality and relativism, and even though I think the debate an important one, it is not my purpose to address it here.[10] Suffice it to say that unless we can discover some neutral way of justifying the canon, philosophy must lose its authority to pronounce on matters of truth and falsehood. Were this to happen, the discipline of philosophy would come to be regarded as no more than a variety of nonrational, per-

haps literary, persuasion, and academic philosophers would all have to adjust to a new life in Rorty's postphilosophical culture.[11]

In the previous chapter, however, I argued that it is possible to assess a canon ("vocabulary") rationally, and that we can do so by appealing to criteria of adequacy that transcend it and are neutral as between competing canons. For all that, though, I now argue that our philosophical canon has evolved in ways that have little to do with critical reasoning and truth and much more to do with social convenience—so that many of the philosophical decisions based upon it turn out in the end to be arbitrary.

Forging the Canon

How do philosophical and literary canons evolve? The view most flattering to philosophy and literature contends that works become part of the canon because of their intrinsic worth. Philosophical merit, like artistic merit, is thought to "speak for itself," and the assumption is that any work of genuine merit will eventually be acknowledged and canonized. This is the narrative that many professional philosophers adopt—partly, one suspects, in order to preserve the integrity of their discipline.

If historians of philosophy are to be believed, gifted individuals sometimes offer arguments that, because of their intrinsic interest and worth, become part of the canon. These arguments affect other individuals who produce their own doctrines, which, if they are good enough, will either replace or coexist with their forerunners in the canon. And so the story goes.[12] What often remains unexplained, however, is why certain philosophical topics assume the importance that they do at any given time. Nor are we usually told why new and competing doctrines, which clearly threaten the philosophical status quo, receive any sympathetic attention at all. Why was it decided to publish, advocate, or teach these ideas? Were the reasons always intellectual ones? Or were they sometimes based on religious, economic, or political considerations?

Such questions and issues are sometimes regarded as entirely irrelevant to an adequate history of the philosophical canon. Any competent history, we are told, should attend only to the arguments of philosophy, to their strengths and weaknesses, and certainly not to their social origins. Failing this, we run the risk of politicizing our subject, destroying its neutrality, and undermining its capacity to pronounce on the truth. Just as it was once thought that genuine art could not be political and would have to confine itself to artistic problems alone, so it is often thought that philosophy must retain its integrity by concerning itself solely with argument, truth, and reason. Nor should we think it simply fortuitous that the same claims were made on behalf of fine art as were made, earlier in this century, on behalf of philosophy. On the view that I have thus far defended, the skills of artists and philosophers are useful, and the desire to improve them can lead to their being treated as ends in themselves.[13] It is because both are arts in the sense specified by Francis Sparshott that their history is similar.[14]

Even a cursory glance at the evidence suggests that considerations of a social nature are by no means irrelevant to an adequate history of philosophy. It is not as if philosophers function in a void, depending simply on their brilliance and a biro for the impact that they make on the world. They function in a social context, and their work, like the very existence of their profession, is crucially dependent on all sorts of social relations. So, for instance, a climate of tolerance toward philosophy, the existence of adequately funded institutions of higher learning, the availability of printing presses, libraries, and willing students are all required if philosophy is to survive in anything like its present form. The emergence of philosophical ideas, therefore, depends not just on their intrinsic brilliance but also on all sorts of social conditions. Individual genius will manifest itself only if the social conditions are right—from which it follows that philosophical merit will not always live to see the light of day and will not always make its way into the canon. Consequently, any adequate history of philosophy and the philosophical canon must look beyond the arguments of the day to the social context in which they arise. In these respects, then, philosophy is very like literature, for, as we saw in Chapter Two, literature and the other fine arts are also, in a large measure, socially produced.

The importance of what I have broadly termed social considerations in the practice of philosophy becomes even more obvious when we reflect on the fact that some philosophers have much more influence than others over the life of their profession. They may control journals or printing presses and they may hold sway over appointments to teaching positions. In effect, of course, these philosophers have the power to perpetuate some arguments and ideas at the expense of others, and their reasons for doing so need not always be based on considerations of philosophical merit. In the discipline of philosophy, like any other discipline or practice intent on the production of cultural objects, certain interests are always served and others are undermined by the publication and dissemination of certain arguments and ideas.[15] A philosophical argument that is devastatingly critical of my work threatens not only my prestige in the world of philosophy but also the prestige of all those philosophers who have cited my work approvingly or who have relied on it. For this reason alone, it is always in a philosopher's interests to be able to control what is published and, of course, what is taught.

Those who exercise this sort of control are the "gatekeepers" within the discipline.[16] They have the power to keep certain philosophers and ideas out of circulation and to admit others to the circle of the elect, and they exactly parallel the critics, publishers, and gallery directors of the artworld. It is obvious, I suppose, that a good reputation as a philosopher (or artist, critic, teacher) will help people to occupy these positions, but it is equally obvious that great skill as a philosopher (or artist, critic, teacher) is neither a necessary nor a sufficient qualification for becoming a "gatekeeper." What most probably is necessary in philosophy is that one should be able to do philosophy; after all, one is hardly likely to rise in the profession without some basic levels of attainment. All that is required in addition to this is the good fortune to know, be friendly with, and to have gained the trust of those who are in a position to bestow the status of "gatekeeper" on others.

The powers of the "gatekeeper" are often informal, although they are not insignificant. Informality is itself a source of power, for in the absence of formal rules, the authority of the "gatekeeper" can take many subtle and uncodified forms. Theirs, one might say, is a power that works in the shadows, away from the scrutiny of those who are

most affected by it, and against which there is little, if any, appeal. As a result, it is much more difficult to control than the formal constitutional powers characteristic of the well-defined institutions that political scientists study. Still worse, it is capable of abuse in the way that formal power, with all its constitutional checks and balances, is not.

This suggests that the philosophical canon is, in part at least, a social construct whose shape and content is not always determined by considerations of reason and truth alone.[17] In this respect it clearly parallels the literary canon, for, as we saw in Chapters Two and Four, what is included in the literary canon does not and cannot depend on genius alone or on pure artistic value. It follows, then, that any philosophical decision based on the canon lacks the rigor that most philosophers suppose it to have.

In saying this, I do not wish to maintain that considerations of philosophical merit have no role at all to play in shaping the canon. They do have an important role to play. We need to remind ourselves, however, that the criteria of philosophical adequacy and merit in terms of which works are admitted to, or barred from, the canon are themselves a part of that canon. In other words, the canon tends always to reinforce and entrench itself, for it judges every new philosophical work in terms which are integral to and definitive of it. This, I urged earlier, does not entail that philosophical arguments are correct only within, or relative to, a particular tradition. According to my argument in Chapter Ten, there certainly are criteria of philosophical adequacy—in particular, truth and consistency—that do not only transcend but *have to* transcend particular canons, traditions, and (what Rorty calls) "vocabularies."

However, it is simply a fact—obvious in the case of art—that not all criteria of adequacy can rightly claim this universality. Some criteria are mainly concerned with passing fashions of style and often elicit uncritically harsh responses. So, for instance, any philosopher who writes too directly and who fails to formalize central arguments will be looked on with suspicion by many analytic philosophers, while those who write of Being, *différance*, *Geist*, or *archi-écriture* will be excluded from the Anglo-American canon simply in virtue of their terminology and style, no matter the strengths of their arguments. It follows, then, that at least some of the criteria of merit that help constitute a particular philosophical canon are specific to it and are bred of particular

interests and concerns internal to the tradition. It is this fact, I think, that lends initial credibility to those who wish to relativize truth and rationality. What is clear from the arguments of Chapter Ten, though, is that some criteria of philosophical merit—most especially truth and consistency—do transcend particular traditions. Other criteria, however, are clearly specific to particular canons, and these, it seems, are often bred of social interests and convenience.

If the content of the canon were simply the product of truth and reason, and in no way the product of social convenience, we would expect philosophically superior arguments to supplant inferior ones. Indeed, if some historians of philosophy are to be believed, this is precisely what happens. The evidence, however, shows that nothing of the sort occurs. The Cartesian theory of mind is just one case in point. It is known to be philosophically deficient in almost every important respect, and it is plainly inconsistent with those theories of mind that currently secure our qualified approval. Despite this, the theory still has a secure place within the canon. It is one of those theories, so most of us believe, with which every student of the philosophy of mind needs to be acquainted. Certainly, it does not now have the prominence that it once enjoyed, but no matter its philosophical weaknesses, its status as an important theory worthy of our attention is assured. On my view, its importance cannot be derived from its philosophical insights and strengths, but must be derived rather from a range of social considerations. Chief among these is the desire to preserve a particular philosophical tradition. We know, for instance, that a good deal of contemporary work in the philosophy of mind requires the Cartesian theory to give it point. It is only in the context of the failure of Cartesian dualism that we can explain the development of later accounts of mind. Hence it is in the interests of all those engaged with the topic to ensure that Descartes' theory retains a place in the canon; and it retains this place because the philosophical enterprise must lose its sense of progress and direction if it does not.

In a sense, this is as it ought to be. Every social practice, including the practice of philosophy, is suffused with its own history and can make proper sense only when taken against the background of that history. For this reason alone, Cartesian dualism is properly a part of the canon, although this entails that the canon is not the product of philo-

sophical correctness alone. We need to remember, though, that the way in which scholars tell the story of a philosophical tradition—the connections that they emphasize and the fountainheads that they acknowledge—frequently reflects shared professional interests. On my view, it is because philosophers want their writings to have some point and substance, to indicate progress and growth, that they include the Cartesian theory of mind in the canon, and hence in the history of philosophy. In much the same way, what art historians encompass in or exclude from their histories, and the ways in which they explain the periods they discuss, will of course reflect, entrench, and advance their own theoretical perspectives, their own specialties, interests, and obsessions. The canon is a construct, not just of artistic merit, but, as I hope I have shown, of social interests and social pressures as well.

Mainstream Philosophy

Philosophers, we now know, are required to make decisions not just about what they will teach and read but also about what problems deserve attention and research. These decisions are based on the philosophical canon, but the canon is not the pure and undiluted product of critical philosophical reasoning that some believe it to be. As often as not, it takes the form that it does for reasons of social convenience. This is an embarrassment to Anglo-American philosophy, for it turns out that when it comes to their own profession, philosophers fail to practice what they preach. Nor does the embarrassment end here. The philosophical canon is organized in a way that makes some aspects of philosophy more central, important and, as we sometimes say, more "mainstream" than others. For reasons that are not always readily apparent, epistemology, metaphysics, logic, and semantics are all firmly a part of the Anglo-American mainstream. These have become the branches of philosophy in which it is believed that students should receive their primary training. Thereafter follow the less central, the "softer," "popular," and derivative aspects of the discipline, which, for a long while in the middle years of this century were considered (and in many universities still are considered) marginal to, and parasitic upon, the mainstream.

Very few philosophers ever question the appropriateness of a mainstream in philosophy. There is considerable agreement in our tradition about what the mainstream is and ought to be, and even though other traditions have different opinions on the matter, I know of no sustained debate about the proper way of deciding the issue. If one thing is clear, it is that the conception of mainstream philosophy that prevailed during the middle years of this century has done much to undermine the authority and status of philosophy in the Anglo-American world. To borrow from Gerald Graff, it has turned philosophy "against itself," so that philosophy came for a while in the twentieth century to suffer the same fate as literature and the other fine arts.[18] All were regarded as mute, as having nothing of importance to say, and as having no bearing on the central problems of our lives. They were seen as introverted exercises in intellectual virtuosity—the preserve of an educated and cultured elite—that had nothing to offer to a society beset with problems.

It is strange that philosophy should have earned this reputation, for we know that, for a very long period in our history, philosophical problems and speculation arose, and were taken to arise, out of pressing everyday concerns. The problems of statecraft and the good life that occupied Greek philosophy, like the preoccupation with human nature and knowledge in the seventeenth and eighteenth centuries, were bred of actual human concerns of the time and were designed to answer questions of abiding interest to real people. Philosophers in the Anglo-American tradition have tended on occasion to forget that philosophy first took root in, and only got going because of, quandaries and puzzles that arose in their everyday, nonphilosophical lives. Moral philosophy, for instance, arose in part because people were puzzled by, and chose to question, the moral demands made on them. In much the same way, the epistemological theories of the Enlightenment can be seen as both a defense of a growing belief in science and a response to the questionable power that kings and bishops, astrologers and soothsayers derived from specious claims to knowledge. Political and religious philosophy, aesthetics, hermeneutics, and even metaphysics have similar origins in day-to-day human concerns.

Despite this, mainstream Anglo-American philosophy was for many years only remotely concerned with what it called applied philosophy. In some ways, this is puzzling. Why did the highly abstract and

abstruse become central to British and American philosophy? What caused this philosophical tradition to go off at a tangent, developing arguments about arguments, and building edifices of rarefied abstractions that failed to address the sorts of philosophical problems which confronted people in their workaday lives?

The answer, I hinted earlier, has to do with the fact that philosophy, no less than literature, is an art. An art, I argued in Chapter Three, is traditionally conceived of as a practice consisting of an organized package of more or less integrated skills. In this sense, medicine and war are arts, but so too are philosophy and literature. All consist of sets of skills often housed within institutional frameworks that perpetuate and regulate them.[19] Useful skills, I said, demand their own perfection. All plumbers, for instance, enjoy a wide range of plumbing skills, but there is all the difference in the world between being a passable plumber and being a good one. Since there are social and economic advantages that attach to being a good plumber, there is every incentive for plumbers (like tailors, engineers, or bakers) to perfect the skills that characterize their trade. As a result, these skills are often attended to in their own right. All practical skills, we saw, can be treated in this way—as ends rather than means; and the same, of course, is true of the skills of philosophy. As we have seen, they too are primarily intended to serve useful ends, but (for reasons that can easily be reconstructed) they have come to be treated as ends in themselves—as skills worthy of attention in their own right.[20]

Take the case of epistemology. Earlier I said that one reason for its renewed vigor in the seventeenth and eighteenth centuries was not just the rise of science but also the desire to undermine the power of those who claimed to know God's will. Any attempt to challenge such power would have to begin by undermining these claims to knowledge. And, of course, it would not be possible to do this without developing and defending certain epistemological theories.

These theories, and the arguments for them, were themselves of philosophical interest. In order to respond rationally to them, one would have to attend to them, and one would have to do so without a mind to the ends that they were meant to serve. Both the perfection and the rejection of philosophical arguments and theories require that they be attended to in their own right. However, it is a far cry from

this unexceptionable claim to the tendency, dominant in mainstream Anglo-American philosophy, to attend to philosophical arguments as if their bearing on social issues is and ought to be of no concern whatsoever. What happened, of course, was that as eighteenth-century political concerns receded into the past, philosophers began to attend to the philosophical arguments of that century, not out of any social interest, but in order to sharpen their own philosophical skills and understanding. Arguments were adduced either in support of or against these epistemologies, and then, in increasing levels of abstraction and erudition, there were arguments about these arguments, and so on, until mainstream philosophy began to attend only to the perfection of its own skills, and hence to its own artificially generated and largely gratuitous problems.

In this way, mainstream Anglo-American philosophy of the 1950s, 1960s, and 1970s turned away from, and ceased to engage with, the society that nurtured it. It tended to see itself as politically neutral and as having nothing much to do with the world in which we live. It enjoined, and continues regularly to enjoin, philosophers to attend to the argument, and has been known to look with suspicion at anyone who attempts to apply philosophy to matters of social concern. Since the rise of the Vienna Circle, emphasis in the mainstream has been formal and abstract; and the mark of philosophical merit became (and in many circles still remains) skill in abstraction. The ability to generate subtle, formal distinctions, and to make abstract and clever points of argument are still very important.

There is, I would contend, a clear sense in which mainstream philosophy "aestheticized" itself. Just as artists of the late nineteenth century began to attend to art as an end in itself, exploring the formal dimensions of their media and moving toward increasing abstraction, so mainstream Anglo-American philosophers of this century came to attend to philosophy not as a means to some social end but as an end in itself. And the effect in both cases was precisely the same: the broad mass of people in our society came to think of philosophy and the "high" arts as abstract and erudite, the preserve of a refined elite which was of no concern to ordinary people in their everyday lives. Philosophy, like the fine arts, had turned against itself.

It was a short step from the central arguments and preoccupations of

mainstream Anglo-American philosophy to the view that philosophy was not properly concerned with the world; that its primary concern should be with arguments, ideas, concepts, meanings, and texts, but not with matters of fact or substantive truths. This, I think, is the inevitable consequence of any attempt to treat formal argument and philosophical abstraction as ends in themselves. On this view, it matters nothing that philosophy has no bearing on the world, and those, such as Richard Rorty, who follow the mainstream to this conclusion, are happy to write of "The World Well Lost." [21] What matters to them is coherence as well as the capacity of philosophy to function as a kind of cultural criticism that enables us to understand how various doctrines, ideas, and systems of belief "hang together."

It is at this point, that so-called modern philosophy (the philosophy that started with Descartes and the philosophers of the Enlightenment) is thought by Rorty and Derrida to have reached its end. For, we are told, it has at last recognized that it does not relate to a world "out there," and is concerned only with arguments about arguments, with texts about texts. [22] Here postmodernism takes the stage; and on the view that I have advanced, it can do so only because of the tendency in this century of authors, artists, philosophers, and others to attend to their practical skills as ends in themselves. In this way, by destroying the function of the arts that they practice, many philosophers, authors, painters, dramatists, and sculptors have constructed rigid boundaries between their work and the everyday world. The effect, of course, is that their texts can no longer refer to the world, and are not concerned with, or constrained by, it and its problems. [23]

It was, I think, Gerald Graff who pointed most eloquently to the dilemma that we face. On his view, either we must refuse to treat literature as an end in itself and so violate a central orthodoxy of the New Criticism; or we must treat literature as wholly autonomous and as having nothing whatsoever to do with the world—but in so doing we effectively commit ourselves to the central tenets of postmodernism. [24] The point may be generalized. If we attend to the practical skills of communication, of reasoning, of trading, and producing only as ends in themselves, and if, as has happened in the artworld and to some extent the world of philosophy, this becomes the norm, then our works, texts, and activities can no longer engage with an independently exist-

ing environment. Each is an end in itself and does not refer beyond itself except to comment on other works, texts, and arguments.

Of course, not every philosopher who is uncritical of a formal and abstract mainstream is also uncritical of the view of philosophy that it encourages. Most philosophers in the Anglo-American tradition dismiss Rorty's views about the end of philosophy with a shrug. They are adamant that philosophy is useful, that it does have a role to play in informing us about and helping us to negotiate the real world. Such philosophers have no desire to undermine the authority that philosophy has traditionally claimed for itself: the authority to uncover and pronounce on matters of substance and truth. What they fail to see is that, if they accept the central tenets of the mainstream, they are committed to treating philosophy as an end in itself, having nothing to do with, or to say about, the real world.

In recent years some philosophers have found themselves disturbed by the fact that Anglo-American philosophy tends to take refuge from the world. Increasingly, they have attempted to re-establish philosophy in the lives and concerns of ordinary people. Journals like *Philosophy and Public Affairs*, *The Journal of Applied Philosophy*, *Biomedical Ethics*, and *Philosophy and Literature* try, with a good deal of public acclaim, to apply the skills of mainstream philosophy to actual problems that arise in our daily lives. Book-length philosophical studies have appeared on AIDS, on love, war, gender, business ethics, the environment, animals, and famine; on lying, human nature, secrecy, literature, medical ethics, and homosexuality. The list is growing, and it is beginning to have an effect on what people regard as mainstream philosophy. Despite this, the tendency is to see these areas merely as applications of mainstream philosophy: as "applied" or "popular" philosophy, while the other is "hard," "pure," and rigorous.

There is a sense, then, in which applied philosophy serves to reinforce the distinction between genuine ("mainstream," "hard," "pure") philosophy, and its ("popular," "applied," "soft") derivatives. It is a distinction that carries with it shadows of the boundaries drawn earlier in this century between high and popular art. If my arguments are correct, exclusive attention to mainstream philosophy will inevitably trivialize the discipline and consign it (together with much fine art) to the dustbin of the "elegantly useless." However, applied phi-

losophy does furnish an antidote to the strictures of the mainstream, for even as it applies the mainstream to everyday problems, it tacitly criticizes it for its reluctance to venture into the world.

There have, however, been a number of explicit attacks on the Anglo-American mainstream. These have come very largely from the continent, and have their origin in the Romantic reaction to the philosophy of the Enlightenment.[25] In recent years, however, a similar attack has come from some philosophers who have been reared in the analytic tradition as well as from feminist philosophers.[26] Some of these critiques are valuable; others, such as Rorty's, seem deeply flawed. None has as yet left its mark on the mainstream. The reasons for this are complex, and it is beyond the scope of this chapter to pursue them here.

Conclusion

The claim that philosophy is no more than a variety of literature gets some of its sting, I have said, from the very narrow conception of literature on which it might be thought to trade. It is a conception, we have seen, that has its origins in the aesthetic movement, and was taken over in this century by the New Criticism—according to which literature cannot impart truths about our world, does not refer to it, and has nothing at all to say about it.

On this view, what is important about a literary work of art is not its didactic function, but its formal properties. Still more, according to this conception, there can be no question of our literary decisions about what to read, teach, praise, and blame being based on reason, argument, and truth. Rather, such decisions are governed by the literary canon which is ultimately shaped by what people want: by fashions of taste and the social considerations that attend them.

The analogies with Anglo-American mainstream philosophy are everywhere apparent. It is these analogies (rather than the fact that philosophical works embody metaphors, rhetoric, and fiction) that lend plausibility to the view that (mainstream) philosophy is a variety of literature in the narrowest and most trivial sense of this word. While

it is true, of course, that some literary works conform to these narrow specifications, not all, I have argued elsewhere, need be of this sort.[27] In just the same way, we have seen that not all Anglo-American philosophy conforms to its mainstream, although whenever it does not, the mainstream persists in regarding these "new" developments with suspicion and frequently treats them as no more than soft options which merely apply the hard work that it does.

Rather like the artistic canon, we have seen that the mainstream in Anglo-American philosophy embodies its own, sometimes very narrow, criteria of philosophical merit. As a result, whatever it considers philosophically sound need not be so regarded in another tradition. This raises once more the specter of an untenable relativism: one that effectively undermines the authority of philosophy. For unless there are overarching criteria of adequacy that are neutral as between different traditions, philosophical truth will always be relative to a particular conception of the mainstream, and philosophy will not, after all, be able to convey universal truths. Understandably enough, Anglo-American mainstream rhetoric rejects this possibility. According to it, those philosophers who occupy the mainstream are best equipped to uncover universal truths and to encourage clear thinking.

Despite the rhetoric, there are times when an insidious relativism does emerge. The eager undergraduate who asks why Derrida, Heidegger, or Foucault has no place in a particular curriculum is likely to be told that in *this* university a different tradition is taught. And the suggestion is that these philosophers are not without value, but that they have their value in some other tradition. This rejoinder encourages the view that there are discrete categories of philosophy, a view that encourages a relativism about the findings of philosophy. For rather than tackle the argument itself, there is a tendency to speak of it as "good of a kind"—as "a good existentialist argument," "a sound piece of phenomenology," "a penetrating hermeneutic analysis"—implying always that although good of a sort, these arguments are not properly a part of "our" tradition.

What has happened, of course, is that categories of philosophy have come to play the very same role in the criticism of philosophical arguments as literary genres play in the criticism and assessment of literary works of art.[28] We all know that a good ode is not a good sonnet, that

a compelling and elegant Elizabethan drama will not be a compelling or elegant comedy of manners. Literary merit is always perceived relative to particular genres, so that there is no point in discussing the comparative merits of Shakespeare's *Hamlet* and Joyce's *Ulysses*. The question "which is better?" makes little sense since, insofar as they belong to different genres, the two are not strictly comparable. The temptation of late is to treat philosophical texts in the same way. Sometimes philosophers exempt themselves from rational discussion by assessing philosophical arguments relative to particular categories. A good phenomenological argument, they seem to think, will not be strictly comparable to a good rationalist or analytic argument, so that there is not much point in asking which is the better or which is correct. To the extent that this occurs, the quest for philosophical truth is relativized, and the subject as a whole is not just "aestheticized" but trivialized.

Studies in the history of philosophy can, and sometimes do, take the same form. Often, when philosophers study Plato or Spinoza or Leibniz, they do so not because of the truths or insights that these philosophers afford but as an interesting and stimulating intellectual exercise. The job of reconstructing their thoughts, of seeing how they cohere, and of gauging their significance within their own cultural and historical setting is regarded as a worthy end in itself, and little if any attention is given to the current utility of the arguments and preoccupations of these philosophers. Sometimes teachers of philosophy do no more than introduce their students to a particular philosophical genre—to rationalism, empiricism, idealism, or what have you— so as to trace and locate historical influences, but they do so without seriously attending to the adequacy of the positions involved. The fact that this occurs suggests that, in some circles at least, Anglo-American philosophy is practiced more as a kind of cultural diversion and entertainment than as an attempt to engage with the world and its problems.

Little wonder, then, that Anglo-American philosophy lost its audience and its voice for a while in this century, and that the broad mass of people in our culture now consider mainstream analytic philosophy, just as they do much fine art, irrelevant to the world in which they live. They consider it irrelevant because much of it has become ir-

relevant, and it has done so because of an exclusive attention to its skills and techniques. Although it is in the nature of any art—whether it be plumbing, painting, or philosophy—to attend exclusively to its skills, there is, of course, nothing inevitable about this. Like artists and critics in the cultural West, philosophers of the Anglo-American tradition have shown themselves unwilling to acknowledge the social origins of their decisions and the social dynamics of their profession. If we have learned anything from the argument of this chapter, and some of the chapters that have preceded it, closer and more critical attention to the social forces that rule the practice of philosophy and the fine arts will have the welcome effect of bringing both back into the lives of ordinary people.

NOTES

The State of the Arts

1. A brief look at titles in *The British Journal of Aesthetics* during the 1960s and the early years of the 1970s suggests that it was concerned very largely with such an apologetic.

2. Peter Kivy and George Dickie furnish excellent examples of this phenomenon. Kivy did much in his *Speaking of Art* (Nijhoff, The Hague, 1973) and subsequent articles to dismantle some traditional doctrines of the aesthetic movement, but continues nonetheless in *The Corded Shell: Reflections on Musical Experience* (Princeton University Press, Princeton, N.J., 1980) and in other publications, to speak of music and the experience of music as removed from everyday social interactions. Much the same could be said of Dickie whose well known definition(s) of art furnish an implicit critique of the aesthetic movement. However, in *Evaluating Art* (Temple University Press, Philadelphia, 1988), he assumes, uncritically, that works of art occupy their own realm and that properties of them can be valuable in isolation (p. 158). See, as well, Arthur C. Danto, *The Transfiguration of the Commonplace* (Harvard University Press, Cambridge, Mass., 1981), who seeks throughout to explain how it is possible to have two objects, both exactly alike, only one of which is a work of art. Danto is exclusively concerned with discontinuities between art and life, and fixates on them to so great an extent that he pays no attention at all to the ways in which art permeates, and is continuous with, everyday life.

3. It is a view, of course, that was partly stated by Friedrich Nietzsche, *The Birth of Tragedy and the Case of Wagner*, translated by Walter Kaufmann (Random House, New York, 1967). It has found a more recent voice in Richard Rorty, *Contingency, Irony, and Solidarity* (Cambridge University Press, Cambridge, Eng., 1989).

4. See, for example, Friedrich Nietzsche, "On Truth and Falsity in Their Ultramoral Sense," in Oscar Levy, ed., translated by Maximilian A. Mügge, *The Complete Works of Friedrich Nietzsche*, 18 vols. (Allen & Unwin, London, 1911), vol. 2; and Rorty, *Contingency, Irony, and Solidarity*.

5. Jacques Derrida, *Of Grammatology*, translated by Gayatri Chakravorty Spivak (Johns Hopkins University Press, Baltimore, 1974); Jean Baudrillard, *Selected Writings*, edited and introduced by Mark Poster (Stanford University Press, Stanford, Calif. 1988); Rorty, *Contingency, Irony, and Solidarity*.

6. On this, see Jürgen Habermas, *The Philosophical Discourse of Modernity*, translated by Frederick Lawrence (MIT Press, Cambridge, Mass., 1990), ch. 7.

7. Rorty, *Contingency, Irony, and Solidarity*, p. 48.

8. Aristotle, *Nicomachean Ethics*, translated by Terence Irwin (Hackett, Indianapolis, Ind., 1985), Book VI.4.

9. John Dewey, *Art as Experience* (1934); reprinted in *John Dewey: The Later Works, 1925–1953*, edited by Jo Ann Boydston, 17 vols. (Southern Illinois University Press, Carbondale, 1987), vol. 10, p. 9.

10. *Ibid.*, ch. 3, as well as pp. 297–298.

11. *Ibid.*, p. 11.

12. *Ibid.*, p. 33. See as well, pp. 31–34.

13. *Ibid.*, pp. 19–25.

14. See, for example, Danto, *The Transfiguration of the Commonplace*; Joseph Margolis, *Art and Philosophy: Conceptual Issues in Aesthetics* (Humanities Press, Atlantic Highlands, N.J., 1980), pp. 27–50; George Dickie, *Art and the Aesthetic: An Institutional Analysis* (Cornell University Press, Ithaca, N.Y., 1974).

15. Francis Sparshott, *The Theory of the Arts* (Princeton University Press, Princeton, N.J., 1982), ch. 2. This would seem to introduce an important ambiguity into my use of the term "art." It will be clear from the context whether the terms "the arts" or "art" are being made to refer to skills in general, or to those *works* of art that constitute the fine arts, the popular arts, or the high arts.

16. See Dickie, *Art and the Aesthetic*, ch. 1; as well as George Dickie, *The Art Circle* (Haven, New York, 1984).

17. Morris Weitz, "The Role of Theory in Aesthetics" (1956), reprinted in Joseph Margolis, ed., *Philosophy Looks at the Arts*, 3rd ed. (Temple University Press, Philadelphia, 1987), pp. 143–153; and Morris Weitz, *The Opening Mind* (University of Chicago Press, Chicago, 1977).

18. Weitz, "The Role of Theory in Aesthetics," p. 149.

19. It is not clear whether Dickie does believe this. See George Dickie, "The Institutional Conception of Art," in Benjamin R. Tilghman, ed., *Language and Aesthetics: Contributions to the Philosophy of Art* (University of Kansas Press, Lawrence, 1973), p. 22. What is clear, of course, is that Dickie does contradict Weitz insofar as he agrees with Maurice Mandelbaum that observable

resemblances are not sufficient for classifying something as a work of art. See Maurice Mandelbaum, "Family Resemblances and Generalization Concerning the Arts," *American Philosophical Quarterly* 2 (1965): 219–228.

20. David Novitz, *Knowledge, Fiction & Imagination* (Temple University Press, Philadelphia, 1987).

CHAPTER TWO
High and Popular Art

1. Cf. Abraham Kaplan, "The Aesthetics of the Popular Arts," in James B. Hall and Barry Ulanov, eds., *Modern Culture and the Arts*, 2nd ed. (McGraw-Hill, New York, 1972), pp. 48–62. Kaplan thinks that this distinction has to be drawn in terms of aesthetic value.

2. Mass art is not always popular; nor is popular art invariably mass. The schoolboy limerick is a popular art form that is not on any account a mass art; so, too, perhaps, the erotic drawings of the said schoolboy. Nineteenth-century naive art, musical hall, and, of course, dances like the can-can and the fox-trot were all popular art forms, but none of them can plausibly be regarded as mass arts. Much high art in this decade of the twentieth century is mass produced with the aim of reaching as large an audience as possible. The recorded performances of the music of Mozart, Bartók, and Stravinsky are all obvious examples. On the view that I favor, but cannot defend here, they have become mass, but not popular, arts. They are, and remain, high arts that have been distributed to a mass audience with the help of a mass technology. For more on the relation of mass art to popular art, see Noël Carroll, "The Nature of Mass Art," *Philosophic Exchange* (forthcoming, 1992). See, as well, my "Noël Carroll's Theory of Mass Art" (forthcoming, 1992).

3. Kaplan, "The Aesthetics of the Popular Arts," p. 49.

4. *Ibid.*, pp. 50–54. See, as well, Pierre Bourdieu, *Distinction: A Social Critique of the Judgement of Taste* (Harvard University Press, Cambridge, Mass., 1984), p. 386, where he tells us that the "simple and repetitive structures" of popular art "invite a passive, absent participation." See, as well, pp. 33–35.

5. Kaplan, "The Aesthetics of the Popular Arts," p. 55.

6. Arnold Hauser, *The Social History of Art*, 4 vols. (Routledge and Kegan Paul, London, 1968), vol. 2; Arnold Hauser, *The Sociology of Art* (University of Chicago Press, Chicago, 1982), ch. 5, esp. pp. 284ff.; and Janet Wolff, *The Social Production of Art* (Macmillan, London, 1981), p. 26.

7. Wolff, *Social Production of Art*, p. 33.

8. For more on this, see E. H. Gombrich, *Art and Illusion: A Study in the Psychology of Pictorial Representation*, 3rd ed. (Phaidon, London, 1968), esp. ch. 5.

9. The notion of the artworld was first introduced into philosophical aesthetics by Arthur Danto, "The Artworld," *Journal of Philosophy* 61 (1964): 571–584. It was popularized by George Dickie in *Art and the Aesthetic: An Institutional Analysis* (Cornell University Press, Ithaca, N.Y., 1974). Ironically, the term "artworld" was not used as Danto had recommended. For him, the artworld is constituted by "a certain history, an atmosphere of theory" (p. 580), and is inhabited not by officers of a social institution, but by works of art. It is in terms of theory and history, not as a social institution, that Danto explains the artworld.

10. Lest there be any doubt about the applicability of this observation to the popular arts, we would do well to think of artists like Billy Joel or Marilyn Monroe—both of whom are in large measure responsible for the production of popular works of art.

11. See Gombrich, *Art and Illusion*, p. 75. Gombrich, it should be stressed, confines this remark to the conventions and techniques available to the artist. He does not explicitly state that it applies to social conditions in the round, although he clearly assumes this. For more on this, see *Art and Illusion*, pp. 55–78.

12. See Chandra Mukerji, *From Graven Images: Patterns of Modern Materialism* (Columbia University Press, New York, 1983), especially chs. 2 and 5. Mukerji details the growth of "commodity fetishism" from Dürer's time onward. Dürer's commercial aims do not lead to a distinction between high and popular art. Indeed, at this time his commercialism did not detract in any way at all from the status or value of his prints. See p. 62.

13. Monroe C. Beardsley, *Aesthetics from Classical Greece to the Present: A Short History* (University of Alabama Press, University, 1977), p. 283.

14. William Gaunt, *The Aesthetic Adventure* (Penguin, Harmondsworth, Eng., 1957), p. 11.

15. The seminal work was, of course, Georg Wilhelm Friedrich Hegel, *The Phenomenology of Mind*, translated by J. B. Baillie, 2 vols. (Allen and Unwin, London, 1910). A very lucid account of Hegel on freedom is to be found in Peter Singer, *Hegel*, Past Masters Series (Oxford University Press, Oxford, 1983), chs. 2–4. It is worth emphasizing, though, that Hegel's conception of freedom was very different from Mill's.

16. John Stuart Mill, *On Liberty* in *Utilitarianism, Liberty and Representative Government*, introduced by A. D. Lindsay (J.M. Dent & Sons, London, 1910).

17. "Self-protection" is the only ground cited by Mill for curbing the individual liberties of others. Opinions and discussion, he believed, should most certainly be free, and while actions should not be as unregulated as these, people should in general be free to put their beliefs into practice. Nor, of course, should society interfere with "purely personal conduct" except where it breaches the principle of freedom.

18. This is not to suggest that the emphasis on individual freedom was mis-

placed, nor that it was a device designed to entrench middle-class interests. That it had this effect is true enough, but it would be entirely mistaken, I believe, to think that Mill's primary purpose was to support middle-class economic interests.

19. They rebelled more obviously in their work than in their writing. See, however, Théophile Gautier's preface to *Mademoiselle de Maupin* (1835) (Garnier, Paris, 1966).

20. These views are well represented in James McNeill Whistler's *Ten O'Clock Lecture* (Chatto and Windus, London, 1888), where he tells us, disapprovingly, that "Beauty is confounded with virtue, and before a work of art, it is asked 'What good shall it do?' . . . and thus the people have acquired the habit of looking . . . not *at* a picture, but *through* it, at some human fact, that shall or shall not, from a social point of view, better their mental and moral state" (p. 19). See, as well, T. R. Way and G. R. Dennis, *The Art of James McNeill Whistler* (George Bell, London, 1903), p. 103; Denys Sutton, *Nocturne: The Art of James McNeill Whistler* (Country Life, London, 1963), pp. 113–120. See, in addition, Oscar Wilde, "The English Renaissance of Art," in Oscar Wilde, *Miscellanies* (Methuen, London, 1908), pp. 241–277. Wilde tells us at one point that "Into the true and sacred house of Beauty the true artist will admit nothing that is harsh or disturbing, nothing that gives pain, nothing that is debatable, nothing about which men argue" (p. 257). And he goes on to say that "to the poet all times and places are one . . . for him there is but one time, the artistic moment; but one law, the law of form; but one land, the land of Beauty—a land removed indeed from the real world" (p. 258).

21. This is well documented by Robin Spencer, *The Aesthetic Movement* (Studio Vista, London, 1972), esp. pp. 78–113. See, as well, Harry Levin, "The Ivory Gate," *Yale French Studies* 12 (1954): 17–29.

22. On this, see Beardsley, *Aesthetics from Classical Greece to the Present*, pp. 284–290.

23. The exceptions, of course, were those artists who were wedded to realism and romanticism such as Gustave Courbet, Honoré Daumier, and Camille Corot. On this, see Beardsley, *Aesthetics from Classical Greece to the Present*, pp. 290–313.

24. Arthur Danto, *The Philosophical Disenfranchisement of Art* (Columbia University Press, New York, 1986), ch. 5.

25. Gerald Graff, *Literature against Itself: Literary Ideas in Modern Society* (University of Chicago Press, Chicago, 1979).

26. Perhaps the most famous philosophical defense of this account of art appreciation was offered by Stuart Hampshire, "Logic and Appreciation," in William Elton, ed., *Aesthetics and Language* (Blackwell, Oxford, 1959). Here Hampshire elevates disinterested perception (p. 166), and refuses altogether (although for reasons that are not plain) to countenance the view that works of art can properly serve a practical, e.g., a didactic purpose. On his view,

"A work of art is gratuitous." And this is seen from the fact that the "canons of success and failure, of perfection and imperfection, are . . . internal to the work itself" (p. 162).

27. I am indebted to Rosemary Du Plessis Novitz for this observation.

28. I refer, of course, to Clive Bell's well-known but wholly inadequate attempt in *Art* (1914) (Arrow Books, London, 1961). Subsequent aestheticians did a better, but never a satisfactory, job. See, for example, Monroe C. Beardsley, "The Aesthetic Point of View," in Monroe C. Beardsley, *The Aesthetic Point of View: Selected Essays*, edited by Michael J. Wreen and Donald M. Callen (Cornell University Press, Ithaca, N.Y., 1982). Cogent criticisms of this position are many. See, for example, Timothy Binkley, "Piece: Contra Aesthetics" (1977), and George Dickie, "The Myth of the Aesthetic Attitude" (1964), both reprinted in Joseph Margolis, ed., *Philosophy Looks at the Arts: Contemporary Readings in Aesthetics*, 3rd ed. (Temple University Press, Philadelphia, 1987).

29. For more on the rise of scientific connoisseurship, read Edgar Wind, *Art and Anarchy* (Faber and Faber, London, 1963), ch. 3; and Richard Wollheim, *On Art and the Mind: Essays and Lectures* (Allen Lane, London, 1973), ch. 9.

30. For more on Veblen's theory of conspicuous consumption, read J. A. Hobson, *Veblen* (Chapman & Hall, London, 1936), ch. 8. According to Veblen, the acquisition of expensive art was just one of the many ways in which the middle classes could express their excellence. On his view, "conspicuous waste and conspicuous leisure are reputable because they are evidence of pecuniary strength; pecuniary strength is reputable or honorific because, in the last analysis, it argues success and superior force" (p. 165).

CHAPTER THREE
Art, Life, and Reality

1. See, for example, John Hospers, "Art and Reality," in Sidney Hook, ed., *Art and Philosophy* (New York University Press, New York, 1966), as well as the various responses to Hospers's article in Part III of the volume.

2. Here I am indebted to Arthur Danto, *The Philosophical Disenfranchisement of Art* (Columbia University Press, New York, 1986), ch. 2.

3. Oscar Wilde, "The Decay of Lying," in James B. Hall and Barry Ulanov, eds., *Modern Culture and the Arts*, 2nd ed. (McGraw-Hill, New York, 1972), p. 7.

4. See, for example, Gerald Graff, *Literature against Itself: Literary Ideas in Modern Society* (University of Chicago Press, Chicago, 1979). There is, of course, a good deal of confusion about the notion of "reality" and the relation of reality to life. What happens in our lives will not be regarded by every

metaphysician as real. I tackle some of these difficulties in the next section. For the moment, however, I wish merely to capture widespread beliefs about the relation of art to life and reality.

5. See Paul N. Siegel, ed., *Leon Trotsky on Literature and Art* (Pathfinder, New York, 1970), p. 33.

6. *Ibid.*, p. 13.

7. See Lucien Goldmann, "Interdependencies between Industrial Society and New Forms of Literary Creation," in Lucien Goldmann, *Cultural Creation in Modern Society* (Blackwell, Oxford, 1976); and Janet Wolff, *Aesthetics and the Sociology of Art* (Allen & Unwin, London, 1983).

8. The exceptions, of course, are to be found in the Russian Formalist and the Frankfurt Schools. For more on this, see Terry Lovell, *Pictures of Reality: Aesthetics, Politics, and Pleasure* (BFI Publishing, London, 1973), chs. 4 and 5.

9. Louis Althusser, *Lenin and Philosophy and Other Essays* (New Left, London, 1977), p. 204.

10. Janet Wolff, *The Social Production of Art* (Macmillan, London, 1981), chs. 2, 3, and 4.

11. See Siegel, ed., *Trotsky on Literature and Art*, p. 31, where Trotsky maintains that "each class has its own policy on art."

12. See Leon Trotsky, "Proletarian Culture and Proletarian Art," in Beryl Lang and Forrest Williams, eds., *Marxism and Art* (McKay, New York, 1972), esp. pp. 69ff.

13. J. L. Austin, *Sense and Sensibilia* (Oxford University Press, Oxford, 1962), pp. 71–73.

14. *Ibid.*, pp. 68–70.

15. *Ibid.*, pp. 70–71.

16. *Ibid.*, pp. 73–76.

17. Wilde, "Decay of Lying," p. 10.

18. *Ibid.*, p. 11.

19. *Ibid.*

20. *Ibid.*

21. *Ibid.*

22. *Ibid.*

23. *Ibid.*, p. 14.

24. Francis Sparshott, *The Theory of the Arts* (Princeton University Press, Princeton, N. J., 1982), pp. 25–26.

25. *Ibid.*, p. 30. It is important to recognize that treating such skills as ends rather than as means is necessary but not sufficient for fine art. I shall return to this point presently.

26. E. H. Gombrich, *Art and Illusion: A Study in the Psychology of Pictorial Representation*, 3rd ed. (Phaidon, London, 1968), pp. 93–96.

27. I deal with this in Chapter Eight.

28. On the ways in which we acquire skills from fiction, see my *Knowledge, Fiction & Imagination* (Temple University Press, Philadelphia, 1987), Chapter Six.

29. I have borrowed the term "impression management" from Erving Goffman, *The Presentation of Self in Everyday Life* (Allen Lane, London, 1969).

30. For an account of the role that fanciful imagination plays in everyday life, see Novitz, *Knowledge, Fiction & Imagination*, Chapters Two, Five, Six, and Ten.

31. Here I am, of course, indebted to Arthur Danto, *The Transfiguration of the Commonplace: A Philosophy of Art* (Harvard University Press, Cambridge, Mass., 1981), and to Stephen Davies, *Definitions of Art* (Cornell University Press, Ithaca, N.Y., 1991).

32. The emergence of theater sports in the late 1980s furnishes one clear example of a sport that is also a fine art. Although the women's floor routine in gymnastics would count as dancing in the appropriate social context, it still is not regarded as a fine art.

CHAPTER FOUR
The Integrity of Aesthetics

1. Immanuel Kant, *The Critique of Judgement*, translated by James Creed Meredith (Clarendon Press, Oxford, 1978).

2. Clive Bell, *Art* (1914) (Arrow Books, London, 1961).

3. See Stuart Hampshire, "Logic and Appreciation," in William Elton, ed., *Aesthetics and Language* (Blackwell, Oxford, 1959); F. N. Sibley, "Aesthetic Concepts" (1959), reprinted in Joseph Margolis, ed., *Philosophy Looks at the Arts: Contemporary Readings in Aesthetics*, rev. ed. (Temple University Press, Philadelphia, 1978); J. O. Urmson, "What Makes a Situation Aesthetic?" (1957), reprinted in Francis J. Coleman, ed., *Aesthetics: Contemporary Studies in Aesthetics* (McGraw-Hill, New York, 1968); Harold Osborne, *The Art of Appreciation* (Oxford University Press, Oxford, 1970); Monroe C. Beardsley, *Aesthetics: Problems in the Philosophy of Criticism* (Harcourt Brace & World, New York, 1958).

4. See Janet Wolff, *The Social Production of Art* (Macmillan, London, 1981), which strongly criticizes the idea of the uniqueness of art and of individual genius and explains artmaking (and to some extent art criticism) as a social, not an individual, enterprise; and Janet Wolff, *Aesthetics and the Sociology of Art* (Allen & Unwin, London, 1983) in which, while insisting on the relevance of sociology for aesthetics, Wolff defends aesthetic value from sociological reductionism. Again, although George Dickie has written cogently of "The Myth of the Aesthetic Attitude," *American Philosophical Quarterly* 1 (1964):

55–65, he nonetheless insists in *Evaluating Art* (Temple University Press, Philadelphia, 1988), p. 160, that properties of artworks can be valuable in isolation. Ted Cohen criticizes Sibley's account of the application of aesthetic concepts in "Aesthetic/Non-Aesthetic and the Concept of Taste: A Critique of Sibley's Position," *Theoria* 39 (1973): 113–152, but does not himself explore (or concede) a social basis for the application of such concepts.

5. See Arthur Danto, *The Philosophical Disenfranchisement of Art* (Columbia University Press, New York, 1986), ch. 6, where he argues for the view that art which attempts to disturb the boundaries between art and life is futile. See pp. 121ff. In other words, on Danto's view, the boundaries of art are right and proper—and art should not be seen as deeply integrated into everyday life. Danto's views on beauty are hinted at in *The Transfiguration of the Commonplace: A Philosophy of Art* (Harvard University Press, Cambridge, Mass., 1981), pp. 105–106, and were more explicitly conveyed to me in a conversation at Columbia in October 1990.

6. See Urmson, "What Makes a Situation Aesthetic," p. 357, where he informs us that the "philosophical task to be tackled in this paper is therefore this: to make explicit what it is that distinguishes aesthetic thrills, satisfactions, tolerations, disgust, etc., from thrills, satisfactions etc., that would properly be called moral, intellectual, economic, etc." Further page references to Urmson's article will be given in the text.

7. For more on how the artist exploits an audience's knowledge, understanding, and expectations, see my *Knowledge, Fiction & Imagination* (Temple University Press, Philadelphia, 1987), Chapter Nine.

8. See, for example, Kant, *The Critique of Judgement*, p. 67. It is "what pleases by its form that is the fundamental prerequisite for taste." Kant's emphasis on the disinterested nature of aesthetic apprehension and judgments of taste is frequently stated, most especially on pp. 42–44. On p. 49, Kant writes that "taste in the beautiful may be said to be the one and only disinterested and *free* delight." It is not the case, of course, that Urmson adequately represents Kant's doctrines. He seems merely to have imbibed a popular version of them: a version that was popularized, I think, by the aesthetic movement.

9. Sibley, "Aesthetic Concepts," pp. 64–87. All further references to this article will be given in the text.

10. Kant, *Critique of Judgement*, p. 75. Kant writes: "There can be no objective rule of taste by which what is beautiful may be defined by means of concepts. . . . It is only throwing away labour to look for a principle of taste that affords a universal criterion of the beautiful by definite concepts." This is translated rather differently and, I think, more accessibly by Werner S. Pluhar, in Immanuel Kant, *Critique of Judgment*, translated by Werner S. Pluhar (Hackett, Indianapolis, Ind., 1987), p. 79, thus: "There can be no objective rule of taste, no rule of taste that determines by concepts what is beautiful. . . . If we search for a principle of taste that states the universal criterion of the

beautiful by means of determinate concepts, then we engage in a fruitless endeavour."

11. See Stein Haugom Olsen, "Literary Aesthetics and Literary Practice," in *The End of Literary Theory* (Cambridge University Press, Cambridge, Eng., 1987), esp. pp. 7–14.

12. A. J. Ayer, *Language, Truth and Logic* (1936) (Pelican, Harmondsworth, Eng., 1971), p. 150.

13. Here I follow Joseph Margolis, *Art and Philosophy: Conceptual Issues in Aesthetics* (Humanities Press, Atlantic Highlands, N.J., 1980), pp. 48–49. I take this up in *Knowledge, Fiction & Imagination*, pp. 100–105.

14. Bell, *Art*, p. 36.

15. Francis Sparshott, *The Theory of the Arts* (Princeton University Press, Princeton, N.J., 1982), pp. 25–26.

16. *Ibid.*, p. 30. On Sparshott's view, this condition is necessary rather than sufficient for fine art.

17. Personal communication.

18. See my *Knowledge, Fiction & Imagination*, pp. 132–139.

19. For more on this, see Mary Devereaux, "Oppressive Texts, Resisting Readers and the Gendered Spectator: The NEW Aesthetics," *Journal of Aesthetics and Art Criticism* 48 (1990): 337–348.

20. The assumption that art can properly be distinguished "from life" is found not only in Clive Bell, but, as we saw in the previous chapter, in Oscar Wilde's "The Decay of Lying," reprinted in James B. Hall and Barry Ulanov, eds., *Modern Culture and the Arts*, 2nd ed. (McGraw-Hill, New York, 1972), pp. 3–14, and in a good deal of Marxist aesthetics.

21. See Immanuel Kant, *The Critique of Judgement*, Part 1, Section I, Book I (Analytic of the Beautiful); and David Hume, "Of the Standard of Taste," in John W. Lenz, ed., *Of the Standard of Taste and Other Essays* (Bobbs-Merrill, Indianapolis, Ind., 1975), pp. 3–24.

CHAPTER FIVE
Art, Narrative, and Human Nature

1. Throughout this chapter, I use the word "identity" in its epistemological, not its metaphysical, sense to mean the view or sense or beliefs that one has of oneself.

2. See my *Pictures and Their Use in Communication: A Philosophical Essay* (Nijhoff, The Hague, 1977), chs. 1, 4, and 5. Cf. Nelson Goodman, "Twisted Tales: Or Story, Study, and Symphony," in W.J.T. Mitchell, ed., *On Narrative* (University of Chicago Press, Chicago, 1981), pp. 100–101. Goodman clearly

believes that pictures can tell stories without being used in a specific context to do so. He does not appear to have an argument for this view.

3. See, for example, Sigmund Freud, "The Relation of the Poet to Daydreaming," in Sigmund Freud, *Collected Papers*, translated by I. F. Grant Duff (Basic Books, New York, 1959), vol. 4, pp. 173–183; George Herbert Mead, *Mind, Self and Society*, edited by Charles W. Morris (University of Chicago Press, Chicago, 1934); Erving Goffman, *The Presentation of Self in Everyday Life* (Doubleday, Garden City, N.Y., 1959); Richard Wollheim, *The Thread of Life* (Cambridge University Press, London, 1984), lecture 3.

4. See Stanford Lyman and Marvin B. Scott, *The Drama of Social Reality* (Oxford University Press, New York, 1975), ch. 5, for a discussion of some versions of the dramatistic model.

5. See, for example, Roy Schafer, "Narration in the Psychoanalytic Dialogue," in Mitchell, ed., *On Narrative*, p. 26, where it is merely submitted that it "makes sense, and it may be a useful project, to present psychoanalysis in narrational terms." Although Paul Ricouer is adamant in "The Questions of Proof in Freud's Psychoanalytic Writing," in Paul Ricouer, *Hermeneutics and the Human Sciences* (Cambridge University Press, Cambridge, Eng., 1983), that the self is a narrative construct, he merely asserts, but does not argue for the view. For more on this, see Anthony Paul Kerby, "The Language of Self," *Philosophy Today* 30 (1986): 210–223; and his "The Adequacy of Self-Narration: A Hermeneutical Approach," *Philosophy and Literature* 12 (1988): 232–244.

6. Goodman, "Twisted Tales," p. 106.

7. For a full account of the way in which we empathize with subjects in a story, see my "Fiction and the Growth of Knowledge," *Grazer Philosophische Studien* 19 (1983): 47–68.

8. I am indebted to the late Flint Schier not just for my use of this term, but for drawing my attention to the phenomenon.

9. See Hayden White, "The Value of Narrativity in the Representation of Reality," in Mitchell, ed., *On Narrative*, pp. 1–23, esp. pp. 18–20.

10. The precise dynamics of this process are explained in my *Knowledge, Fiction & Imagination* (Temple University Press, Philadelphia, 1987), Chapters Three and Five.

11. Cf. Kerby, "The Adequacy of Self-Narration." I take this point up again in Chapter Seven.

12. Anita Silver, "Politics and the Production of Narrative Identities," *Philosophy and Literature* 14 (1990): 99–107. For more on this theme, see David Carrier, *Artwriting* (University of Massachusetts Press, Amherst, 1987).

13. This same point is made in more detail by Michael Krausz, "Art and Its Mythologies," in Richard Burian, Michael Krausz, and Joseph Margolis, eds., *Rationality, Relativism and the Human Sciences* (Nijhoff, The Hague, 1987).

14. The nature and scope of this process, its epistemological role and meta-

physical implications are extensively discussed in my *Knowledge, Fiction & Imagination*, Chapters Two and Three.

CHAPTER SIX
Keeping Up Appearances

1. I am indebted to Bianca Candlish for this expression.
2. E. H. Gombrich, *The Sense of Order: A Study in the Psychology of Decorative Art* (Cornell University Press, Ithaca, N.Y., 1979), p. 65.
3. *Ibid.*, pp. 169–170.
4. How this is possible is discussed in my *Pictures and Their Use in Communication: A Philosophical Essay* (Nijhoff, The Hague, 1977), esp. ch. 6.
5. Recently, a professional image maker recommended that New Zealand's minister of finance remove his moustache. The moustache—a very public and rather endearing appendage—was duly removed, causing some public comment. In defending his recommendation on radio, the Australian image maker did so in aesthetic terms, appealing repeatedly to the "aesthetic impact" of moustaches, which, as my comments in Chapter Four would lead us to expect, was gauged in terms of the more practical values that attach to effective communication, honesty, and trustworthiness. Radio New Zealand, *Morning Report*, 19 April 1990.
6. Here I am indebted to C. J. Crawford.
7. Janet Radcliffe Richards, *The Sceptical Feminist: A Philosophical Enquiry* (Routledge & Kegan Paul, London, 1980), pp. 188–197.
8. *Ibid.*, p. 197.
9. For more on this, see Desmond Morris, *Manwatching* (Jonathan Cape, London, 1977).
10. For more on the ways in which pictures can be used to convey information, see my *Pictures and Their Use in Communication*, chs. 4 and 5.
11. See R. A. Sharpe, "Music: Information-Theoretic Approach," *British Journal of Aesthetics* 11 (1971): 385–401.
12. For more on this, see Edgar Wind, *Art and Anarchy* (Faber and Faber, London, 1963), ch. 3. See, as well, Richard Wollheim, *On Art and the Mind* (Allen Lane, London, 1973), ch. 9.
13. See Kendall Walton, "Categories of Art" (1970), reprinted in Joseph Margolis, ed., *Philosophy Looks at the Arts: Contemporary Readings in Aesthetics*, 3rd ed. (Temple University Press, Philadelphia, 1987), esp. pp. 55–67.
14. See Joseph Margolis, "Works of Art as Physically Embodied and Culturally Emergent Entities," *British Journal of Aesthetics* 14 (1974): 187–196.
15. I argue for this in *Knowledge, Fiction & Imagination* (Temple University Press, Philadelphia, 1987), Chapter Five.

16. The problem of seduction is discussed in Chapter Ten.

17. Adolf Hitler, *Mein Kampf*, translated by Ralph Mannheim (Hutchinson, London, 1969), p. 531.

18. Hans-Georg Gadamer, *Truth and Method* (1960) (Crossroads, New York, 1975), pp. 273ff. This claim might be considered controversial since it could be argued that Gadamer is trying to explain how we come to understand, not how we come to adopt, other ideas and values. But this is not what he says. On his view, our horizons consist of beliefs *and* values, and although we are aware of our own horizons in coming to understand another culture, our own horizons may be altered or lost in the process of fusion. He writes: "In the process of understanding there takes place a real fusing of horizons, which means that as the historical horizon is projected, it is simultaneously removed" (p. 273). His reason for thinking this seems to be that one can only apply one's understanding if one adopts the beliefs and values that are understood (p. 274).

19. For more on the notion of a juxtrepository metaphor, see my *Knowledge, Fiction & Imagination*, Chapter Nine.

20. For more on how we demarcate cultures, see *ibid.*, Chapter Ten.

21. *Ibid.*, Chapter Five, pp. 109–113.

CHAPTER SEVEN

Love, Friendship, and the Aesthetics of Character

1. A similar position has been defended by Timothy Binkley, "Piece: Contra Aesthetics"; and Joseph Margolis, "Robust Relativism," both reprinted in Joseph Margolis, ed., *Philosophy Looks at the Arts: Contemporary Readings in Aesthetics*, 3rd ed. (Temple University Press, Philadelphia, 1987).

2. Aristotle, *Nicomachean Ethics*, translated by Richard McKeon, *The Basic Works of Aristotle* (Random House, New York, 1968), Book II, ch. 1, 1103a–b, p. 952.

3. *Ibid.*, 1106, p. 957.

4. Here I am indebted to C. J. Crawford.

5. Aristotle, *Nicomachean Ethics*, Book VIII, ch. 3, 1156a, 1157b, p. 1060–3.

6. See Sigmund Freud, "The Question of Lay-Analysis," in Sigmund Freud, *The Standard Edition of the Complete Psychological Works of Sigmund Freud*, James Strachey, ed. (Hogarth Press, London, 1953–74), vol. 20.

7. The concept of a narrative structure is explained and discussed in Chapter Five.

8. *Ibid.* See, as well, Hayden White, "The Value of Narrativity in the Representation of Reality," in W.J.T. Mitchell, ed., *On Narrative* (University of Chicago Press, Chicago, 1981).

9. Chapters Two and Five. This point is developed further in Chapter Ten.

10. I leave open the question whether the state of being in love is itself a social construct peculiar to specific cultures and periods of our history. I happen to believe that it is, but any attempt to establish this will take me too far from my main argument. For more on this, see Robert C. Solomon, *Love: Emotion, Myth, and Metaphor* (Prometheus Books, Buffalo, N.Y., 1990), ch. 6.

11. I am aware that a very different account of what it is to be in love has been offered by J.F.M. Hunter, *Thinking about Sex and Love* (St. Martin's Press, New York, 1983), esp. pp. 70–71, where he suggests at first that no conditions can be specified that are sufficient for being in love. Later on he seems to change his mind, for he maintains that, generally, if one "gives ungrudgingly" and if one treats "the loved one's interests as if they were our own," we would be in love (p. 75). On my view, Hunter confuses the relationship of loving with the state of being in love, but I cannot pursue the matter here. See as well, Robert Brown, *Analyzing Love* (Cambridge University Press, Cambridge, Eng., 1987), pp. 70–93.

12. My inclination is to treat friendships in the way that Aristotle does, and see them as loving relationships that can be more or less "complete." The romantic state of being "in love" complicates matters, since this is most likely a historically and culturally specific phenomenon that cannot easily be subsumed under Aristotle's account of friendship. See Aristotle, *Nicomachean Ethics*, Book VIII.

13. For more on this, see David Pears, *Motivated Irrationality* (Clarendon Press, Oxford, 1984), chs. 2, 3, and 4.

14. Pears correctly observes that not all self-deception need be motivated by a wish, but can be the result of an inability to assess the evidence properly. *Ibid.*, pp. 44–46.

15. See my "Art, Narrative, and Human Nature," *Philosophy and Literature* 13 (1989): 57–74, esp. 62–63.

16. On this, see Amélie Oksenberg Rorty, "The Deceptive Self: Liars, Layers, and Lairs," in Brian P. McLaughlin and Amélie Oksenberg Rorty, eds., *Perspectives on Self-Deception* (University of California Press, Berkeley, 1988), pp. 11–28, esp. pp. 13–16. See, as well, Denise Meyerson, *False Consciousness* (Clarendon Press, Oxford, 1991), pp. 63–68.

17. See Chapter Five, p. 101. See, as well, Anthony Paul Kerby, "The Adequacy of Self-Narration: A Hermeneutical Approach," *Philosophy and Literature* 12 (1988): 232–244.

18. See Chapter Five, pp. 95–100.

19. Kerby, "Adequacy of Self-Narration," p. 242. Kerby writes that he supports the view that "the self is a narrative construct and that self-understanding is tantamount to self-emplotment. What then serves as a guide and constraint on this emplotment is the prenarrative structure of human experience itself, but this prenarrative quality of experience is always more or less schematic and unthematic; it must therefore be filled out and interpreted in explicit

narration. It is only in this creative appropriation of ourselves at the level of interpretation that the meaning of our lives is consciously constituted. The adequacy of our self-narration is not a matter of carrying over into language what we already know of ourselves, but is . . . a matter of a *creative adequation* that first generates an explicit sense from our otherwise mute prenarrative experience."

20. This claim is defended against the claims of postmodernism and contemporary pragmatism in Chapter Ten.

21. Cited in John Keats, *Poems* (John Dent, London, 1947), p. 192.

CHAPTER EIGHT
Of Drama, the Dramatic, and Everyday Life

1. G.F.W. Hegel, *Aesthetics*, translated by T. M. Knox (Clarendon Press, Oxford, 1975).

2. Most theorists of the drama take this to be relatively uncontroversial. See, for example, Martin Esslin, *The Field of Drama* (Methuen, London, 1987), p. 16.

3. Aristotle, *Aristotle on the Art of Poetry*, translated by Ingram Bywater (Clarendon Press, Oxford, 1962), 3, III, p. 27.

4. *Ibid.*, 4, pp. 28–29. See, as well, Stuart Hampshire, "Feeling and Expression," in Stuart Hampshire, *Freedom of Mind and Other Essays* (Clarendon Press, Oxford, 1972), pp. 146ff.

5. *Aristotle on the Art of Poetry*, p. 29.

6. See Chapter Five, pp. 99–100.

7. See George Dickie, *Art and the Aesthetic: An Institutional Analysis* (Cornell University Press, Ithaca, N.Y., 1974), ch. 1; and George Dickie, *The Art Circle* (Haven, New York, 1984).

8. Francis Sparshott, *The Theory of the Arts* (Princeton University Press, Princeton, N.J., 1982), pp. 26ff.

9. This is a view that receives some support from the anthropological writings of Richard Schechner, *Performance Theory*, rev. and expanded ed. (Routledge, New York, 1988). See especially his "Drama, Script, Theater, and Performance," pp. 68–105. While Schechner agrees that drama occurs independently of theater, and "does not depend on *written* texts, but on carefully *scripted* actions" (p. 103), he fails to grasp the narrative nature of these scripts. Nor does he see drama as an integral part of everyday life, but he does believe that in some societies it derives from everyday (hunting) skills (pp. 102–103).

10. See Victor Turner, *Schism and Continuity in an African Society* (Manchester University Press, Manchester, 1957); and his *Dramas, Fields and Metaphors: Symbolic Action in Human Society* (Cornell University Press, Ithaca, N.Y., 1974).

11. Victor Turner, "Social Dramas and Stories about Them" in W.J.T. Mitchell, ed., *On Narrative* (University of Chicago Press, Chicago, 1981), p. 146.

12. On this, see Nesta Pain, *The King and Becket* (Eyre and Spottiswoode, London, 1964), pp. 20ff.

13. The ritual re-enactment of the slaying of Hussein by Shi'ite Muslims during Muharram observances has not only furnished a ritual around which Shi'ite religious practice takes its form and color but has also furnished grounds for political action, as occurred in Iran in December, 1979. On this, see Peter J. Chelkowski, "Iran: Mourning Becomes Revolution," *ASIA* 3 (1980): 30–37, 44–45. I am indebted to William Sax, Jr. for drawing my attention to this article.

14. For more on Noh theatrical techniques, see Peter Lamarque, "Expression and the Mask: The Dissolution of Personality in Noh," *Journal of Aesthetics and Art Criticism* 47 (1989): 157–168.

15. *Aristotle on the Art of Poetry*, 6, p. 35.

16. David Novitz, *Knowledge, Fiction & Imagination* (Temple University Press, Philadelphia, 1987), Chapter Four.

17. See Jacob Bernays, "Aristotle on the Effect of Tragedy," in Jonathan Barnes, Malcolm Schofield, and Richard Sorabji, eds., *Articles on Aristotle: vol. 4: Psychology and Aesthetics* (Duckworth, London, 1979), p. 155.

18. These are not the only cathartic effects that occur in everyday life. Tom Milburn, in his comments on an earlier version of this chapter, pointed out that in expressing my anger I may alter the social situation that occasioned it and so have no further reason for the emotion in question. It is important to notice, though, that this cannot serve as an explanation of cathartic effects in a theater audience since the audience's anger or fear and pity does not affect what happens on the stage.

19. Bernays, "Aristotle on the Effect of Tragedy," pp. 158–159. It is clear that Bernays favors this account of *katharsis*.

20. Michael P. Nichols and Jay S. Efran, "Catharsis in Psychotherapy: A New Perspective," *Psychotherapy* 22 (1985): 46–58, esp. 47–50.

21. Arthur C. Bohart, "Toward a Cognitive Theory of Catharsis," *Psychotherapy: Theory, Research and Practice* 17 (1980): 192–201, esp. p. 193. This view is to be found, I believe, in Freud's early work (1895) on the subject. See J. Breuer and S. Freud, *Studies on Hysteria*, in J. Strachey, ed., *The Complete Works of Sigmund Freud*, standard ed., vol. 2 (Hogarth Press, London, 1955). Here I am indebted to Gillian Fowler who drew my attention to some of these articles.

22. Martha C. Nussbaum, *The Fragility of Goodness: Luck and Ethics in Greek Tragedy and Philosophy* (Cambridge University Press, Cambridge, Eng., 1986), p. 388.

23. *Ibid.*, pp. 388–389.

24. *Ibid.*, p. 391.

25. See my *Knowledge, Fiction & Imagination*, pp. 74–87.

26. In arguing for this position, I have not followed the tendency among some sociologists to use a dramaturgical model in order to explain social phenomena. Rather, I have argued for the existence of social drama in the literal sense of "drama." Cf. Erving Goffman, *The Presentation of Self in Everyday Life* (Allen Lane, London, 1969), p. ix. Goffman owns to using drama as a model in terms of which to explain the presentation of self. This is an acceptable procedure, but one that does not fully consider the fact of drama in everyday life.

27. Bertolt Brecht, *Brecht on Theatre: The Development of an Aesthetic*, translated by John Willett (Hill and Wang, New York, 1964), p. 15.

28. *Ibid.*

29. Marvin Carlson, *Theories of the Theatre: A Historical and Critical Survey from the Greeks to the Present* (Cornell University Press, Ithaca, N.Y., 1984), p. 412.

30. Eugene Ionesco, *Notes and Counter Notes*, translated by D. Watson (John Clader, London, 1964), pp. 22–24.

31. *Ibid.*, p. 28.

32. On this, see Paul Feyerabend, "The Theatre as an Instrument of Criticism of Ideologies—Notes on Ionesco," *Inquiry* 10 (1967): 289–312; and Spyridon George Couvalis, "Feyerabend, Ionesco, and the Philosophy of Drama," *Critical Philosophy* 4 (1988): 51–68.

CHAPTER NINE
Art, Conflict, and Commitment

1. For more on this goal, see Antonio Gramsci, *Selections from the Prison Notebooks of Antonio Gramsci*, edited by Quintin Hoare and Geoffery Nowell Smith (Lawrence and Wishart, London, 1971), pp. 210–278, esp. pp. 254ff.

2. Cf. David Hume, *A Treatise of Human Nature*, introduced and edited by L. A. Selby-Bigge (Clarendon Press, Oxford, 1951), pp. 623–624.

3. For more on the connection between falsifiability and metaphysics, see Karl Popper, *Conjectures and Refutations: The Growth of Scientific Knowledge*, 5th ed. (Routledge and Kegan Paul, London, 1974), ch. 11.

4. Hans-Georg Gadamer, *Truth and Method* (1960) (Crossroads, New York, 1975), pp. 239ff., and p. 269.

5. For more on the distinction between the Apollinian and Dionysian impulses in human beings, see Friedrich Nietzsche, *The Birth of Tragedy and the Case of Wagner*, edited by Walter Kaufmann (Vintage Books, New York, 1966), pp. 17–27.

6. Friedrich Nietzsche, "On Truth and Falsity in Their Ultramoral Sense," in Oscar Levy, ed. translated by Maximilian A Mügge, *The Complete Works of*

Friedrich Nietzsche, 18 vols. (Allen & Unwin, London, 1911), vol. 2, p. 180.

7. On this see, Hans-Georg Gadamer, *Philosophical Hermeneutics* (University of California Press, Berkeley, 1976), p. 9, where he writes that it "is not so much our judgements as it is our prejudices that constitute our being." They are "the simple conditions whereby we experience something."

8. See Immanuel Kant, *Kant's Groundwork of the Metaphysics of Morals*, translated by H. J. Paton (Hutchinson, London, 1964), 463, Sections 127–128, p. 131.

9. Ludwig Wittgenstein, *On Certainty*, edited by G.E.M. Anscombe and G. H. von Wright, translated by Denis Paul and G.E.M. Anscombe (Blackwell, Oxford, 1974), para. 449. All further references to paragraphs in this work will be given in the text.

10. See David Novitz, *Knowledge, Fiction & Imagination* (Temple University Press, Philadelphia, 1987), Chapter Six.

11. *Ibid*, pp. 73–88, for a more detailed account of this process and of emotional responses to fiction.

12. Edgar Wind, *Art and Anarchy* (Faber and Faber, London, 1963), p. 2. See, as well, David Freedberg, *The Power of Images: Studies in the History and Theory of Response* (University of Chicago Press, Chicago, 1989), esp. the introduction, and chs. 1 and 2.

13. Plato, *The Republic*, translated by B. Jowett, Modern Library (Random House, New York, 1962), Book X.

14. Wind, *Art and Anarchy*, p. 24.

15. *Ibid*.

16. See, for example, Clive Bell, *Art* (1914) (Arrow Books, London, 1961), pp. 19–46.

17. Wind, *Art and Anarchy*, p. 12. Wind writes that we think of a particular work of art as "having an arresting quality; it arouses our attention; we take cognisance of it, and then let it go."

18. *Ibid*., p. 21.

19. *Ibid*., p. 27.

20. *Ibid*., p. 28.

21. I am indebted at this point to Jeremy Waldron who reminded me of this phenomenon.

CHAPTER TEN

Seduction, Art, and Reason

1. Richard Rorty, *Contingency, Irony, and Solidarity* (Cambridge University Press, Cambridge, Eng., 1989). Page references to this book will be given in the text.

2. Jean Baudrillard, *Selected Writings*, edited and introduced by Mark Poster (Stanford University Press, Stanford, Calif., 1988), pp. 149–165.

3. I argued against Derrida's position in "The Rage for Deconstruction," *The Monist* 69 (1986): 39–55, and in favor of a romantic realism in *Knowledge, Fiction & Imagination* (Temple University Press, Philadelphia, 1987), Chapter Three. The arguments that follow are an extension and application of some of my earlier arguments.

4. On this, see Chapter Five, "The Nature and Politics of Narrative Identity."

5. In case we need to be reminded, think of Blake's *London*:

> I wander thro' each charter'd street,
> Near where the charter'd Thames does flow,
> And mark in every face I meet
> Marks of weakness, marks of woe.
>
> In every cry of every Man,
> In every Infant's cry of fear,
> In every voice, in every ban,
> The mind-forg'd manacles I hear.

The poem continues, in just this way, to appeal to our experience in order to justify a view of the world adopted in *Songs of Innocence and Experience* and elsewhere.

6. Here I am indebted to Jerrold Levinson.

7. On this, see Jean-Paul Sartre, "The Self-Alienation of the Lover's Freedom," in D. P. Verene, ed., *Sexual Love and Western Morality: A Philosophical Anthology* (Harper Torchbooks, New York, 1972), pp. 254–257.

8. On this, see Søren Kierkegaard, "Diary of the Seducer," in *Either/Or: A Fragment of Life*, translated by David F. Swenson and Lillian Marvin Swenson, 2 vols. (Oxford University Press, London, 1946), vol. 1, esp. pp. 291–371.

9. This view is supported by the psychological studies of E. Walster, E. Aronson, and D. Abrahams, "On Increasing the Persuasiveness of a Low Prestige Communicator," *Journal of Experimental Psychology* 2 (1966): 325–342.

10. On this, see H. C. Kelman, "Processes of Opinion Change," *Public Opinion Quarterly* 25 (1961): 57–58.

11. All of this has been well documented by various psychologists. See, in particular, William Sargant's landmark book on brainwashing, *Battle for the Mind: A Physiology of Conversion and Brainwashing* (Heinemann, London, 1957). See as well, L. Festinger, *A Theory of Cognitive Dissonance* (Stanford University Press, Stanford, Calif., 1957); and L. Festinger, *Retrospections on Social Psychology* (Oxford University Press, New York, 1980), where the author gives empirical evidence for the view that people adjust their beliefs to suit their feelings. It has also been discussed, in a different context, in Chapter Six above.

12. E. H. Gombrich, *Art and Illusion: A Study in the Psychology of Pictorial Representation*, 3rd ed. (Phaidon Press, London, 1968), p. 173.

13. See Martin Battersby, *Trompe L'Oeil: The Eye Deceived* (Academy Editions, London, 1974).

14. Plato, *Laws*, translated by R. G. Bury, 2 vols. (Loeb Library, London, 1926) 671D; Plato, *The Republic*, translated by F. M. Cornford (Oxford University Press, Oxford, 1941), 392D–396E.

15. See Chapter Five, "Narrative, Norms, and Human Nature."

16. *Ibid.* See, as well, Chapter Eight, pp. 154–156.

17. *The Republic*, 342C. We need to remember that there is no distinction in Plato between "art" and "craft." *Techné* serves for both. In *The Republic*, 389 B/C, Socrates allows that "if anyone at all is to have the privilege of lying, the rulers of the State should be the persons; and they, in their dealings either with enemies or with their own citizens, may be allowed to lie for the public good."

18. See Chapter Two. See, as well, Arnold Hauser, *The Social History of Art*, 4 vols. (Routledge and Kegan Paul, London, 1968), vol. 2; Arnold Hauser, *The Sociology of Art* (University of Chicago Press, Chicago, 1982), ch. 5, esp. pp. 284ff.; and Janet Wolff, *The Social Production of Art* (Macmillan, London, 1981), p. 26.

19. Cited by Paul Ziff, "The Task of Defining a Work of Art," reprinted in Francis J. Coleman, ed., *Contemporary Studies in Aesthetics* (McGraw-Hill, New York, 1968), p. 103.

20. See, for example, David Freedberg, *The Power of Images: Studies in the History and Theory of Response* (University of Chicago Press, Chicago, 1989); Sue Williamson, *Resistance Art in South Africa* (David Philip, Johannesburg, 1989); Leif Furhammer and Folke Isaksson, *Politics and Film*, translated by Kersti French (Praeger, New York and Washington, D.C., 1971); David Stewart Hull, *Film in the Third Reich: A Study of the German Cinema, 1933–1945* (Simon and Schuster, New York, 1973); Robert Phillip Kolker, *The Altering Eye* (Oxford University Press, Oxford, 1983).

21. Jean Baudrillard, *America*, translated by Chris Turner (Verso, London, 1988), p. 101. The startling grammar belongs, I presume, to the translator.

22. Denis Dutton, "Bookmarks," *Philosophy and Literature* 14 (1990), p. 236.

23. It is important to see that Rorty's position here constitutes a departure from his earlier view. Cf. Richard Rorty, "Introduction: Pragmatism and Philosophy" in Richard Rorty, *Consequences of Pragmatism* (University of Minnesota Press, Minneapolis, 1982), p. xix, where he writes that "the attempt to say . . . what *makes* certain sentences true, or certain actions or attitudes good or rational, is, on this view, impossible." Here Rorty says that language "goes all the way down," and that there is no extratextual experience that can justify the beliefs expressed by particular sentences. In *Contingency, Irony, and Solidarity*, it is only whole "vocabularies" that cannot be justified, or shown to be unjustified, in this way; individual sentences can be.

24. I have elsewhere defended the view that there is an external world that we can experience and know, and to which we can appeal in verifying some of our utterances. See my *Knowledge, Fiction & Imagination*, Chapter Three.

25. This same criticism was leveled at Derrida in my "The Rage for Deconstruction," pp. 39–55, esp. pp. 50–51.

26. Rorty, *Consequences of Pragmatism*, pp. xii–xlvii.

27. Gilbert Ryle, *The Concept of Mind* (1949) (Penguin Books, Harmondsworth, Eng., 1963), ch. 1.

28. I argued against this view in some detail in "Another Look at Metaphorical Meaning," *Philosophia* 15 (1985): 325–338; and "Metaphor, Derrida, and Davidson," *Journal of Aesthetics and Art Criticism* 44 (1985), pp. 101–114.

29. A good deal more needs to be said here. Rorty does not, of course, deny that truth (with a small "t") has a role to play in deciding which of two "vocabularies" to adopt. However, truth in this sense is always relativized to a particular "vocabulary." In *Knowledge, Fiction & Imagination* (Chapter Three), I argue that there is a neutral concept of truth, that the correspondence theory of truth can be made to work, but that if this concept of "truth" is to have any application at all, we cannot declare sentences true in virtue of a noumenal state of affairs. Truth is discerned in terms of our experience of the world. I cannot repeat these arguments in toto here.

CHAPTER ELEVEN
Art and Philosophy

1. David Hume, *A Treatise of Human Nature*, introduced and edited by L. A. Selby-Bigge (Clarendon Press, Oxford, 1951), pp. xvii–xviii. Hume here speaks of "the present imperfect condition of the sciences" although it is clear from the context that he means by "sciences" what we would nowadays understand as philosophy.

2. Friedrich Nietzsche, "On Truth and Falsity in their Ultramoral Sense," in Oscar Levy, ed., translated by Maximilian A. Mügge, *The Complete Works of Friedrich Nietzsche*, 18 vols. (Allen & Unwin, London, 1911), vol. 2, pp. 171–192, esp. p. 180.

3. See, for instance, Jacques Derrida, "White Mythology: Metaphor in the Text of Philosophy," *New Literary History* 6 (1974–75): 5–74; Richard Rorty, "Philosophy as a Kind of Writing," in Richard Rorty, *Consequences of Pragmatism* (University of Minnesota Press, Minneapolis, 1982), as well as his "Deconstruction and Circumvention," *Critical Inquiry* 11 (1984): 1–23. See also, Christopher Norris, "Philosophy as a Kind of Narrative: Rorty on Post-Modern Liberal Culture," in Christopher Norris, *The Contest of Faculties* (Methuen, London, 1985).

4. Hume, *Treatise of Human Nature*, p. xviii.

5. One important and influential exception is Martha C. Nussbaum, *The Fragility of Goodness: Luck and Ethics in Greek Tragedy and Philosophy* (Cambridge University Press, Cambridge, Eng., 1986), esp. pp. 210–223. Her approach rightly emphasizes the emotional dimension of human cognition and understanding, and is, as a result, prepared to see the same mechanisms at work in both philosophy and literature. On this, see Nina Pelikan Straus, "Rethinking Feminist Humanism," *Philosophy and Literature* 14 (1990): 284–303.

6. This view of literature, its main features and its origins, is discussed in Gerald Graff, *Literature against Itself: Literary Ideas in Modern Society* (University of Chicago Press, Chicago, 1979), ch. 1.

7. I have done so in *Knowledge, Fiction & Imagination* (Temple University Press, Philadelphia, 1987), chs. 1, 6, and 9.

8. See, for example, W. V. Quine, "A Postscript on Metaphor," in Sheldon Sacks, ed. *On Metaphor* (University of Chicago Press, Chicago, 1979); Mark Johnson, "Introduction: Metaphor in the Philosophical Tradition," in Mark Johnson, ed., *Philosophical Perspectives on Metaphor* (University of Minnesota Press, Minneapolis, 1981).

9. I do not wish to suggest that they are always right to do so. On this, see my *Knowledge, Fiction & Imagination*, pp. 109–113.

10. *Ibid.* See, as well, Steven Lukes, "Some Problems about Rationality," in Bryan R. Wilson, ed., *Rationality* (Blackwell, Oxford, 1970), pp. 194–213.

11. Rorty, *Consequences of Pragmatism*, pp. xxxvii–xliv.

12. See, for example, W. T. Jones, *A History of Western Philosophy*, 2nd ed., rev., 5 vols. (Harcourt Brace Jovanovich, New York, 1975); Justus Hartnack, *History of Philosophy* (Humanities Press, New York, 1973); Frederick Copleston, S. J., *A History of Philosophy*, 8 vols. (Burns and Oats, London, 1966); George L. Abernethy and Thomas A. Langford, *Introduction to Western Philosophy: Pre-Socratics to Mill* (Dickenson, Belmont, Calif., 1970); A. Robert Caponigri, *A History of Western Philosophy*, 5 vols. (University of Notre Dame Press, Notre Dame, Ind., 1971). All adopt a highly individualistic approach to the history of philosophy. It is what Rorty calls "doxography," and he urges us (rightly in my view) to allow it to wither away. See his "The Historiography of Philosophy: Four Genres," in Richard Rorty, J. B. Schneewind and Quentin Skinner, eds., *Philosophy in History* (Cambridge University Press, Cambridge, Eng., 1984), pp. 61ff. Of course, not all of the history of philosophy suffers from this excessive emphasis on individuals, as is obvious from the subtitle of Russell's *History of Western Philosophy*. See Bertrand Russell, *History of Western Philosophy and Its Connection with Political and Social Circumstances from the Earliest Times to the Present Day* (Allen & Unwin, London, 1947).

13. See, for instance, Chapter Three.

14. See Francis Sparshott, *The Theory of the Arts* (Princeton University Press, Princeton, N.J., 1982), pp. 25–26.

15. Cf. Chapter Four, "Aesthetic Values and Real Life."

16. The term "gatekeeper" is borrowed from Janet Wolff, *The Social Production of Art* (Macmillan, London, 1981).

17. Specification of the way in which the contemporary philosophical canon has actually taken shape must be left to the as yet largely unwritten sociology of philosophy. See Harry Redner, *The Ends of Philosophy: An Essay in the Sociology of Philosophy and Rationality* (Croom Helm, London and Sydney, 1986). Even though Redner does not deal explicitly with this empirical question, he does suggest theoretical parameters for such an inquiry.

18. Graff, *Literature against Itself*, ch. 1. See, as well, Chapter Two.

19. See, especially, Chapter Three, "Art and Life."

20. I have attempted this reconstruction in my critical discussion of "Professing Literature: An Institutional History by Gerald Graff," *Philosophy and Literature* 12 (1988): 118–128.

21. Rorty, *Consequences of Pragmatism*, pp. 3–18.

22. *Ibid.* See, as well, Richard Rorty, *Philosophy and the Mirror of Nature* (Blackwell, Oxford, 1980); Jacques Derrida, *Of Grammatology*, translated by Gayatri Chakravorty Spivak (Johns Hopkins University Press, Baltimore, 1974).

23. For a detailed, critical discussion of the claims of postmodernism, see my "The Rage for Deconstruction," *The Monist* 69 (1986): 39–55, esp. pp. 40–53. See, as well, John M. Ellis, *Against Deconstruction* (Princeton University Press, Princeton, N.J., 1989).

24. Graff, *Literature against Itself*, ch. 1.

25. I have in mind the work, for instance, of Friedrich Nietzsche, Jacques Derrida, Michel Foucault, Jean Baudrillard, and Hans-Georg Gadamer.

26. Richard Rorty in his books, *Philosophy and the Mirror of Nature, The Consequences of Pragmatism*, and *Contingency, Irony and Solidarity* (Cambridge University Press, Cambridge, Eng., 1989), provides the best and most sustained example. A good example of feminist criticism of the Anglo-American mainstream is to be found in Ann Garry and Marilyn Pearsall, eds., *Women, Knowledge, and Reality* (Unwin Hyman, Boston, 1989). Feminists tend to criticize mainstream philosophy not just on the grounds of its sterile emphasis on rationality but also on the grounds that it tends to make women and women's interests invisible.

27. Novitz, *Knowledge, Fiction & Imagination*, Chapters One and Six.

28. For more on the role of genre in art criticism, see Kendall Walton, "Categories of Art," (1970) reprinted in Joseph Margolis, ed., *Philosophy Looks at the Arts: Contemporary Readings in Aesthetics* rev. ed. (Temple University Press, Philadelphia, 1979).

INDEX

DATE DUE

DEC 0 8 2010			
JAN 1 0 2010			